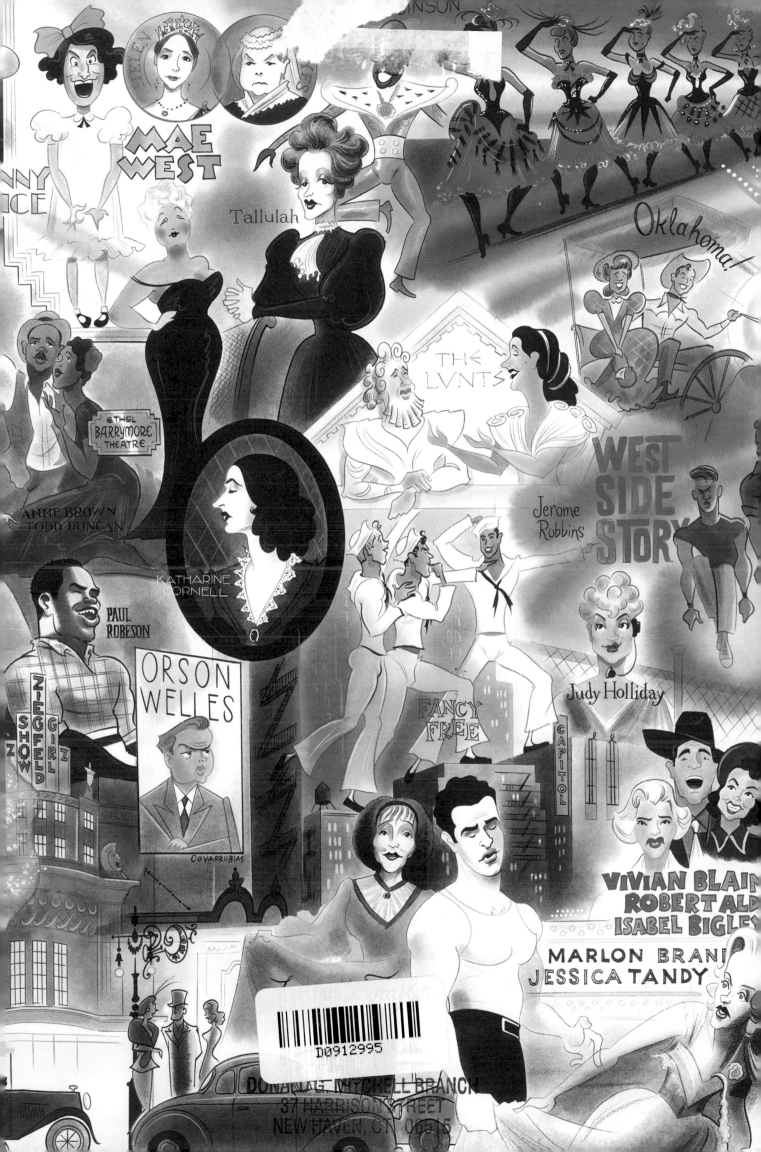

ON BROADWAY

ON BROADWAY

FROM RENT TO REVOLUTION

DREW HODGES

EDITED BY
GARTH WINGFIELD

INTRODUCTION BY
DAVID SEDARIS

FOREWORD BY
CHIP KIDD

RIZZOLI
NEW YORK

New York · Paris · London · Milan

CONTENTS

FOREWORD

by DAVID SEDARIS

For a number of years in the 1990's, I worked at Spot. Not as a designer, but as the once-a week-cleaner. A maid. So when I think of their name, I don't think theater poster. I don't think album cover or even the dog from the Sally, Dick, and Jane books. Rather I think, quite literally, spot, the kind you come across on a bed sheet or sofa cushion thinking, *What the hell? Did someone have a baby on this?*

I started on July 30th, 1992. That night's diary entry records that Drew Hodges was tall and slim. I noted that his kitchen seemed relatively unused and that his loft in general had a western motif, like a dude ranch, but gayer. Three weeks later, I moved on to the adjoining office. On first sight, I described it as "filthy," but that was too strong a word. In retrospect, it was just messy. Extremely messy, and with venetian blinds, which you really have to stay on top of in New York.

Today a design office is apt to look not much different from an accountant's office—just a room with furniture and computers in it. Back then, though, the work was still being done by hand. There were T-squares lying around, and Exacto knives. Worse still, there was Spray Mount. This meant that everything from the floors were essentially collaged. The layers had built up in key areas, so it was slow going.

Unlike the chiropractor's office I did every Friday night, and the spooky periodontal practice I reported to twice a month, my Spot appointments were scheduled during business hours. At first I was disappointed, but then I got to know Drew and the other designers. Two that stood out were a fellow named Vinny and a young woman named Naomi. The Spot people always greeted me fondly, and even introduced me to clients. "This is the person who washed the glass you're drinking out of!"

"Gosh, well..hello," Patty Scialfa said. Lisa Loeb said something similar and both shook my hand. Me, the maid!

The Spot office had a warm, hive-like feel to it, especially in late fall and winter, when it got dark early. Six o'clock would come and go, but no one ever seemed to leave. I remember when Drew brought in computers, and when Naomi explained to me what a chat room was. It was the first time I saw a screen saver that looked like fish swimming in an aquarium, the first time I heard the word "internet" or touched a portable phone. There was always talk of a play someone had seen, or a concert or benefit they'd attended, so many names that were new to me, and were then, suddenly, everywhere. Spot put its fingers on the city's pulse. Me, I just wiped off the prints.

FIVE-HUNDRED-TWENTY-FIVE-THOUSAND-SIX-HUNDRED CONCEPTS

by CHIP KIDD

It was the Amy Guip rip-off photos that first got my attention.

The scene: Manhattan 1996, and the new *Rent* ad campaign had just squatted into the city, everywhere, and someone was seriously stealing Amy Guip's style in the process. As great as the campaign was, it pissed me off. Amy is a terrific photographer who uses her own solarization techniques to depict portraits of her subjects in a completely recognizable way while also splash███ ██ elicious color of her choosing all over them. I had just recently had the pleasure of working with her on the design of an audiobook trilogy of Anne Rice's *Vampire Chronicles* and she brilliantly depicted Lestat, Louis, and Claudia (she'd hired models who were perfect) in a vessel that housed three audio cassettes (memories!) in a box shaped like a coffin. And this was before the movie. It was jaw-dropping and Anne loved it and that was because of Amy Guip.

But now I'm walking down the street and here on a construction fence is a poster featuring Daphne Rubin-Vega in a leather onesie and torn fishnets and thigh-high boots and her knees pulled up for the inevitable. And it totally looks like Amy shot it.

But it couldn't have been Amy. Why? Because this was a Broadway show. And designs for Broadway shows, seemingly by some sort of theater-biz code of aesthetics, had to be shitty. This was so not shitty.

Full disclosure: I had previously seen *Rent* in its original production in the East Village, and while I got caught up in it during the performance and h██ █ ood time, as I left the theater I immediately began . . . evaluating it. Oops. And it seemed kind of silly. The characters were all supposed to be starving artists, and yet they were neither. All they appeared to do—when they weren't vigorously singing and dancing about not paying their rent—was hang out. As my dearly departed friend David Rakoff wrote in a brilliant and hilarious essay about the show for 'This American Life:'

"Hanging out can be marvelous, but hanging out does not make you an artist. The only thing that can make you an artist is making art." And then he summed up, about his own experience struggling to make it in NYC: *"As deeply as I yearned to be creative, for years I was too scared to even try, so I did nothing. But here's something that I did do: I paid my fucking rent."*

As did I.

Back to the *Rent* campaign. One day, waiting for the subway, I spied one of the posters and noticed that way down in the lower left corner there was a tiny art credit. I bent and squinted to read it:

Photos by Amy Guip

What?? How could that be possible? As in, how could someone in charge

of this Big Fat Show have the savvy and guts to actually hire a relatively unknown—yet absolutely perfect choice—like Amy to shoot it?

I honestly don't remember how I found out, but when I did, I was just as astounded—not because I doubted Drew Hodges and his Spot Design firm (now SpotCo) had such savvy and guts, but because I couldn't believe they got the chance to use their talent on this in the first place. I knew from my own experience that the Broadway show ad game was a near-monopoly and pretty much impossible to break into. And yet somehow he had done it.

And then *Chicago* happened. Wow.

And then *Side Man* and *Wit* and Fiona Shaw in *Medea* and *The Vagina Monologues* and *Avenue Q* and *Closer* and *Reasons To Be Pretty* and *Fully Committed* and a zillion other great campaigns—most recently *Fun Home* and *Hamilton.*

The breadth, scope and ingenuity of this work by a single entity is unprecedented in Broadway history. Yes, of course there have been legendary theater poster designers—Paul Davis' work for the Public and James McMullan's for Lincoln Center quickly come to mind, and for every good reason.

But what separates SpotCo's oeuvre from what has come before and makes it so astounding is that as a whole it has no recognizable visual style, in a business that was long thought to rely on exactly that, no matter how hackneyed and clichéd. The art direction and design of any SpotCo campaign is completely reinvented with each show, according to what the show is, who it's by, who's in it, and any other number of factors specific to the production. The only thing that unites them all is an unwavering sense of intelligence and the apparent belief that their audience is comprised of people who can think, intuit, and take a chance on something they haven't quite experienced before.

I can only begin to imagine how difficult it is to pitch this approach to Broadway producers, who I can also only imagine want to leave as little to chance as possible.

And yet again and again, SpotCo has convinced them—and proved to them—that to *not* take a chance on something that looks new or unexpected is the real mistake. Over the last twenty years, Drew has made the ritual of opening the *New York Times* Arts section on Sunday a true joy, as I play a game I call 'Spot the SpotCo': *That new Albee play? That has to be them, because it's so damned smart.*

Again and again, Drew Hodges and his team at SpotCo have shown that they do so much more than just hang out. They do things. They make art.

And they have more than paid their fucking rent. They *own* the place.

ACT ONE

DREW HODGES
FOUNDER AND CHIEF EXECUTIVE OFFICER

WE OPEN ON A YOUNG design firm called Spot Design. It was named for a dog the landlord said we couldn't have. So I named the office as my pet.

After attending art school at School of Visual Arts in New York City, I had left working for my college mentor Paula Scher and began freelancing solo out of my apartment. I was working in the kitchen of my loft, across from the now-defunct flea markets on 26th Street and Sixth Avenue. This is the same kitchen where producers Barry and Fran Weissler came to see the early designs for *Chicago*—but I get ahead of myself. Ultimately, we were five designers and one part-time bookkeeper doing entertainment and rock 'n' roll work. We were young and laughed a lot. Ten years later, we had been privileged to work with Swatch Watch, MTV, Nickelodeon, the launch of Comedy Central and *The Daily Show*, as well as record work for Sony Music, Atlantic Records, and Geffen/DreamWorks records, where our most notable projects were album packages for downtown diva Lisa Loeb and iron-lunged Aerosmith. We grew adept at strategy, design, and collaboration with many downtown artists, illustrators, and photographers,—all people we would come to take full advantage of as we began our theater work. I went to the theater—it was a New York City joy for me. I had gone since early high school, riding the train to the city. But I never dreamed I would get any nearer than second-acting *Dreamgirls* from the mezzanine.

Two bold incidents happened to change that. First, Tom Viola and Rodger McFarlane were heroes of mine for the work they did through what was to become Broadway Cares/Equity Fights AIDS. A friend and art director from Sony Music named Mark Burdett was assigned to work with Spot on an ad for the Grammy Awards program in the prime position of the back cover. It was Martin Luther King Jr. Day, and the clients were all away. So we moaned that doing yet another ad filled with album minis of the labels and latest Streisand release with hollow congratulations was a waste of a great opportunity. We posited that Sony could be the first record company to take a stand against AIDS by making a donation and attaching a red ribbon to the back of each issue of the program. And to pitch that idea, we called Rodger and Tom at their offices to help us fulfill it. The ribbon was theirs after all. Remarkably, they were working on the holiday and answered the phone. They agreed to help, and the rest is history. I believe it was the first awards ceremony to publicly script the concern over AIDS, and deep friendships were formed. Later that year, Tom and Rodger called. They had an ad due in three days for their new show, *The Destiny of Me,* Larry Kramer's sequel to *The Normal Heart*. We sent them a design based on a photo of my right hand—I guess we felt it seemed personal—and they loved it. This was our first theater poster.

But it would have been a short-lived career without the second event. Two years later, we had just finished doing the Aerosmith album for Geffen. Robin Sloane, David Geffen's star creative director, called and asked us to meet with the producers of *Rent*—Geffen would be releasing the album. I took a meeting with the ad agency in charge, and got the assignment and a ticket to the hottest show in town a week after it had opened Off-Broadway. Within a year, we would have designed *Rent* and *Chicago*, and Jeffrey Seller sat me down in a mall in Miami to ask if we had thought about starting an ad agency. It seemed a big risk—but it also seemed like a world where you could actually meet the people doing the creative work you were assigned to promote. And we began to try and figure out just how an ad agency worked anyway.

BRIAN BERK
CO-FOUNDER AND CHIEF OPERATING OFFICER / CHIEF FINANCIAL OFFICER

IN THE SPRING OF 1997, after designing the successful ad campaigns for *Rent* and *Chicago*, we decided to attempt to open a theatrical ad agency. The first question was: What would we need to be able to pull this off? For starters, we would need equipment, office space, a staff, and most importantly, clients.

The equipment was easy. In order to keep upfront costs down, we could lease—a few computers and a fax machine. From there, we could scrape by until we had some clients.

Office space: The design studio was currently housed in Drew's apartment. We knew that for potential clients to consider hiring us, we would need to be in the theater district, and we would need to have a large conference room for the weekly ad meetings. I set out to look at space. One space was located in 1600 Broadway. The building was fairly run-down (and we would later learn it had a mouse problem), but it did have a long and interesting history. It was built in the very early 1900s as a Studebaker factory and showroom. In the 1920s, it was converted to offices and at one point housed the original offices of Columbia Pictures, Universal Pictures, and Max Fleischer Studios, creator of Betty Boop. This seemed a fitting place for a theatrical ad agency. By 1997, the building held a combination of offices and screening rooms. (It has since been torn down.) The space we looked at consisted of two small offices, a big bullpen area for our designers, and one large conference room with the most amazing view of Times Square. We actually found a photograph of a movie executive sitting at his desk in the room that would eventually become our conference room. It has the same wood paneling and window with the view. However, the bearskin rug, which is seen on the floor in the photo, is long gone. The space had character. We had to furnish it on the cheap. We hired a set decorator friend to style the office circa 1940s, so all the used office furniture we purchased would look

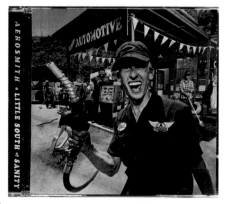

like a very conscious design choice. We moved to the space in June 1997.

Staff: We already had a creative director (Drew), four graphic designers, an office manager, and me. I handled finance, administration, and facilities. We needed someone to head account services, an assistant account executive and a graphic production artist to produce all the ads. We'd hire a writer once we had some clients. For the production artist, we knew just who to hire: Mary Littell. She had worked for us before and was great. The person to head account services was harder to find. We needed someone who had worked at an ad agency before and understood media. From what Drew learned, one of the most respected account managers in the industry was Jim Edwards, or as was said by several producers, "He is the least hated." He had worked at two of the existing theatrical ad agencies. But would Jim join a startup? He was game and joined our team. Jim walked in the door on July 21, 1997. Mary was at her desk working on dot gain so she would be ready if we were ever hired to place an ad. Now, all we needed were some clients.

JIM EDWARDS
CO-FOUNDER AND FORMER CHIEF OPERATING OFFICER

OF DREW, BRIAN, MARY, BOB Guglielmo, Karen Hermelin, and Jesse Wann, I was the only one who had worked at an ad agency before. Little things like a copy machine that can make more than one copy every thirty seconds was not part of our infrastructure. I started on a Monday, and the pitch for *The Diary of Anne Frank* was that Friday. We didn't have any clients so that entire week was all about the pitch. Thursday night we were there late and inadvertently got locked in the office (how that is even possible still strikes me as odd). We couldn't reach anyone who had a key so we had to call the fire department to let us out. They did—and were adorable too.

Once we had a show, we became a legitimate advertising agency, which led to David Mamet's *The Old Neighborhood*, John Leguizamo's *Freak*, and Joanna Murray-Smith's *Honour* within months of being open for business.

Since SpotCo was a brand-new company, we had no credit with any of our vendors. The *New York Times* made us jump through so many hoops about establishing a relationship with them. I think we had to have a letter from the producers of *Anne Frank* saying they were hiring us as their ad agency. When it came time to reserve our first *Times* ad, about a month had passed since all those rules were handed down. Back then, you

simply called the *Times* reservation desk and reserved the space. That's what I had been doing for years so I did it again, inadvertently forgetting that the ad needed to be paid for well in advance. I knew everyone there so they accepted my reservation without question. The ad ran. No one said anything. The bill came about a month later, and we paid it. About two months in, the *Times* noticed that we were sliding under their rules but since we were paying our bills and were current, they granted us credit. By that first Christmas, we had established credit everywhere, which was and is a big deal. Not many new companies can make that kind of claim.

In the first eighteen months of SpotCo, I never worked harder in my life. The hours were long (I gained a lot of weight during that time—do not put this in the book), and it wasn't easy, but we also saw direct results from all the hard work. The work was good, and people noticed what we were doing—and we were making money! The Christmas party of 1998 was particularly memorable. That day, we had just released the full-page ad for *The Blue Room*, which was pretty provocative because all we ran was the photo and a quote about how hot the ticket was. It was a big deal for us and kind of heady. The party was at some restaurant, and Brian had secured a private room. There were only three tables of ten, and we shared our Secret Santa gifts. Everyone was really into it and every time someone opened a gift, Amelia Heape would shout, "Feel the *love*, people! Feel the *love*!" Indeed.

TOM GREENWALD
CO-FOUNDER AND CHIEF STRATEGY OFFICER

WHAT AM I, NUTS? IT WAS early 1998. I had a good job, an amazing wife, three adorable kids under five years old, and a modest but nice house in Connecticut. In other words, I was settling in nicely to the 9 to 7, suburban commuting life. But I kept hearing about this guy Drew Hodges. First I heard about him through my friend Jeffrey Seller, who had worked with Drew on the designs for *Rent*. Then I heard about him through my friend David Stone, who was just about to start working with him on *The Diary of Anne Frank*. Then, I realized, they're talking about the tall guy who talked a lot and had barreled his way through meetings at Grey Advertising (where I worked at the time) while designing the artwork for *Chicago*. So when Jim Edwards called me and said, "Hey, I'm joining up with this guy Drew and we're turning his design shop into an ad agency and did you want to meet him." I had to think about it. No way was I going to give up my job security, right? The odds of any theatrical

ad agency surviving at all were miniscule, much less one with . . . wait, let me add them up . . . one client. And besides, I'd probably have to take a cut in pay. Only an insane person would consider it. "Sure," I told Jim. "Set it up."

So I went in to talk to Drew, and after about eighteen seconds, I'd made up my mind. When Drew asked if I had any questions, I had only one. "Where do I sign?" I joined SpotCo as the head (only) copywriter, head (only) broadcast director, and head (only) proofreader. On the downside, we were a very lean department. On the upside, I never had any problems with my staff.

Now here we are, almost eighteen years later. My wife is still amazing, my three kids are still adorable (although no longer under five), and my house is still modest but nice (although we redid the TV room). I never did settle in to that 9 to 7 job, though. Instead, I decided to take a chance, a flyer, and a crazy ride— and it's worked out pretty well. So yeah, I guess I was a little nuts. But it turns out craziness has its perks.

THE EVENT

AT SPOTCO, WE BEGIN WORK- ing on a show by understanding its Event. I didn't invent this phrase—it was loaned to me by producer Margo Lion. But what I came to understand it as is quite simply the reason you see a show. Or even more simply, the reason you tell someone else to see a show. It can be straightforward, or subtle. As much as I love advertising, branding and design and what it can do for a show, word of mouth is the number one reason a show becomes a hit. So the most effective branding hopes to invite, encourage, and curate that word of mouth. It has to be true to the experience of that show—otherwise it will fail miserably. If every great musical begins with an "I want" song, then every show's voice begins with "I want you to think of this show this way" tune.

What we as an agency have also learned is you choose your Event or it will be chosen for you, and you (and ticket buyers) may not like the sound of that choice. Lets call that the non-event.

At the beginning of each show presented here, we have listed the non-event first— the thing we feared the Broadway customer would default to when describing a show, knowing little else. This is followed by the Event (capital E!) that we wanted to communicate. Hopefully, this informs our successes and disappointments and, more to the point, why a certain idea was ultimately chosen. —D.H.

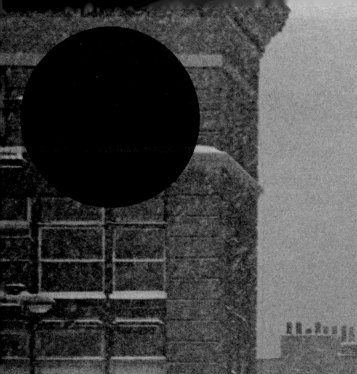

This photo of Sixth Avenue, first published in the January 22, 1996, issue of *The New Yorker*, records a blizzard that silenced Manhattan. It also records

the first moments of SpotCo. The sixth-floor apartment in the upper-left corner was our office as we began work on the early *Rent* designs that January.

RENT

— THE NON-EVENT —
KIDS, DRUGS, AND OFF-BROADWAY.

— THE EVENT —
THE UN-MUSICAL.

IT ALL BEGAN WITH A phone call from Robin Sloane. She's a truly revolutionary creative director, who was working for Geffen Records at the time. She never gets the credit she deserves for giving us *Rent*. So thanks, Robin. *Rent* had opened at New York Theatre Workshop a few days earlier to the sound of a cultural sonic boom. David Geffen attended an early post-opening performance and immediately rang up his partners, Jeffrey Katzenberg and Steven Spielberg, to alert them to something he thought was special and could be big. David told producer Jeffrey Seller, who would handle the commercial transfer, he would like to do the album via his new partnership, DreamWorks.

I saw the show a few nights later, and what sticks out the most was standing at the box office right behind the late great Wendy Wasserstein. I held in my hand the single hottest ticket in New York.

The next day, I wrote Jeffrey and his producing partner Kevin McCollum a letter, outlining my ideas, my vision, my passion. I am still so proud of it.

Marketing to yourself is the easiest form of marketing we do, and we get to do it rarely. But that was the gift of *Rent*. During art school at the School of Visual Arts, I was baffled by what I saw as Broadway posters. While the shows appealed to me, the campaigns didn't. *Rent* was a true Broadway musical to me, not some strange basement concert. But I thought most of Broadway had forgotten about the Baby Boomers who loved it but who were never marketed to in a contemporary way. And that is how I proposed to sell it: as a true Broadway musical, but marketed with a contemporary voice.

Two of my finest clients ever, friends to this day—Jeffrey and Kevin—asked me to design the rest of the campaign, beyond the album—to write the copy, make the newspaper ads, then the TV commercial. It was all given to a Broadway newbie with the faith of true believers and supporters.—D.H.

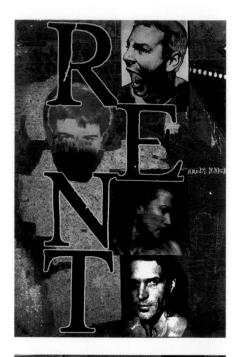

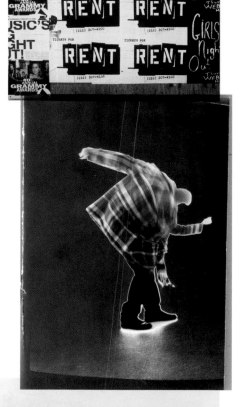

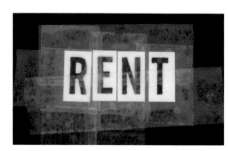

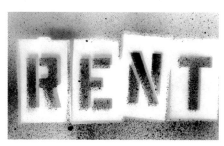

top right
Amy Guip's early collage comp above, alongside the New York Theatre Workshop title page.

bottom
Designer Naomi Mizusaki's actual logo stencil for *Rent*. I have been told they resemble tenements, tombstones, and suitcases. I have seen dorm rooms painted in them, and tattoos inked of them. In fact, they are stencils bought from a hardware store that you use to write "Post No Bills" (you can see the yellow paper peeking through). Then they were held together with black masking tape and spray-painted. — D.H.

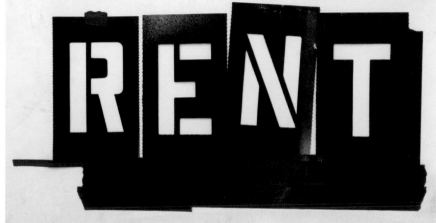

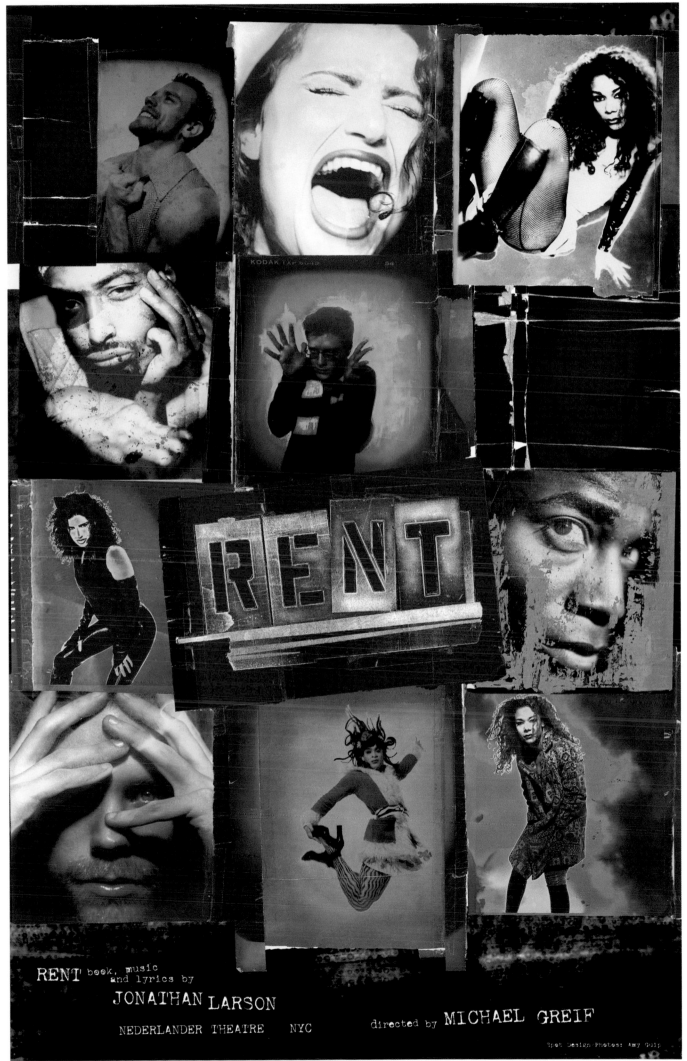

RENT book, music and lyrics by

JONATHAN LARSON

NEDERLANDER THEATRE NYC directed by MICHAEL GREIF

Spot Design Photos: Amy Guip

The launch ad for *Rent*. I told Jeffrey Seller and Kevin McCollum that what we needed was the un-ad, something that said so little it would seem wildly confident, and that the ticket-buying public would fill in all the rest of the storytelling. And the white space was a shock in the *New York Times*. We used a real typewriter to do the text—grittier.

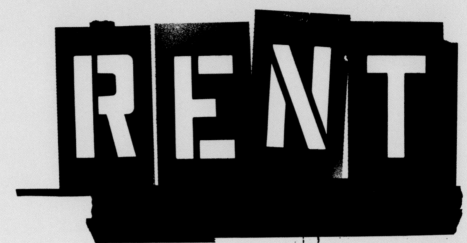

TICKETS FOR

RENT

RENT by JONATHAN LARSON
directed by MICHAEL GREIF

(212) 307-4100

BOX OFFICE OPENS TODAY AT 10AM

TICKETMASTER PHONES OPEN 24 HOURS
OUTSIDE NY/NJ/CT: (800) 755-4000
GROUPS CALL 800-734-8457

PREVIEWS BEGIN TUESDAY, APRIL 16

NEDERLANDER THEATRE
208 WEST 41ST STREET, NYC

WE BEGIN WITH 35-YEAR-OLD WRITER JONATHAN LARSON WHO WANTS TO WRITE MUSICAL THEATRE FOR A NEW GENERATION

JONATHAN WAITS TABLES WHILE HE WRITES

HE WRITES OF FRIENDSHIP AND FEAR: PASSION AND PAIN: COURAGE COMMITMENT AND HOPE. ARTISTS, LOVERS, SURVIVORS. HE CALLS HIS MUSICAL RENT HE QUITS HIS JOB.

above
Another comp that never ran, celebrating
Jonathan Larson's legacy.

below
A collage by Amy Guip for *How* magazine of producer
Jeffrey Seller, me, Amy's self-portrait and Naomi
Mizusaki, the designer of the *Rent* ad and logo and,
coincidentally, of this book. — D.H.

JEFFREY SELLER
PRODUCER

I STARTED THINKING ABOUT
the *Rent* logo in the fall of 1995, three
months before rehearsal started. When I
had been a student at the University of
Michigan in the 1980s, we commissioned
students from the art school to design our
theater posters. I thought it would be cool
for *Rent* to have a contest among New
York City art students to find the best logo.
I engaged the graphic arts instructors of
Parsons and Cooper Union and then
delivered to each school an outline of the
story plus a cassette tape of four songs
hoping to attract many students. I received
back one entry.

At intermission of a performance three
days after *Rent* opened, my friend Tom
King introduced me to David Geffen. He
was effusive about the show, blatantly told
me to cut ten minutes, and then offered to
both make the original Broadway cast
album and help me find a graphic designer
who could design a logo as powerful as
those I admired for *Cats* or *The Phantom of
the Opera*.

Enter Drew Hodges.

A tall, Chelsea hipster with the nerdy
glasses and a plaid shirt, Drew was
overflowing with great ideas and smart
questions. We became instant collabora-
tors and friends. I found a guy who
thought like me. He saw the show at New
York Theatre Workshop and sent me a
terrific analysis of *Rent*'s place in the
landscape of downtown and uptown
culture, and the message he thought we
should communicate in our advertising
materials. I loved it.

He and his young staff got to work.
When I saw for the first time the art that
would become our logo, I thought, "That's
the logo that Roger and Mark would make
for Roger's next gig." It looked like it came
from these characters. It looked like it
came from an "industrial loft on the corner
of 8th Street and Avenue B." It looked like
the musical that Jonathan [Larson] spent
the last six years writing.

KEVIN McCOLLUM
PRODUCER

WE WANTED TO CAPTURE
the soul of the show, and just having lost
Jonathan, we felt it our job to get as many
people to see *Rent* as possible. Jeff and I
went on a walkabout with different illus-
trators, but when we met Drew, we knew
we had something really special. He came
up with the imagery of the buildings,
which were also suitcases. We weren't
quite sure, but we knew we liked it. Drew
led us to [photographer] Amy Guip, and it
was from there that we created the "Brady
Bunch" checkerboard, to demonstrate how
all these people were family. Amy was
tinting negatives, which, in 1996, was a
very new and fresh thing to do. It was clear
Amy herself was an artist, and that this
musical was going to be about artists.

There were a lot of people who thought
we were wrong to just call it *Rent*, but we
didn't want to call it a musical, or a rock
opera, and we didn't want to brand it as any-
thing but what it was, because we wanted
audiences to bring their own experiences.

ROBIN SLOANE
FORMER CREATIVE DIRECTOR, GEFFEN RECORDS

I CALLED DREW AND SAID
that given the music and the grittiness,
the graphics should feel more like a Guns
N' Roses record than a Broadway show.
We were going to market it exactly as we
would a rock album, not a show's cast
album. Originally, we thought we were
just selling the album, but it became the
show's graphics.

> ### *RENT*
> WAS A TRUE BROADWAY
> MUSICAL TO ME, NOT SOME
> STRANGE BASEMENT CONCERT.
> BUT I THOUGHT MOST OF
> BROADWAY HAD FORGOTTEN
> ABOUT THE BABY BOOMERS
> WHO LOVED IT.
> *DREW HODGES*

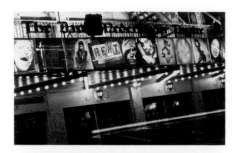

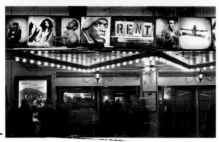

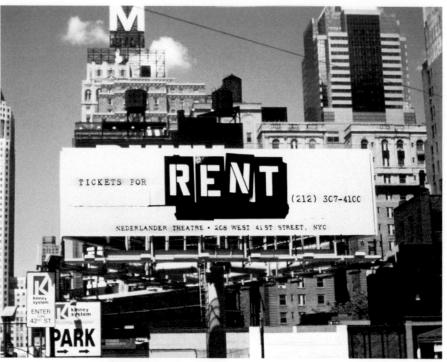

above
The front of the theater, which carried *Rent*'s gritty un-Broadway vibe forward.

right
The ticket line at *Rent* where buyers camped out overnight as a rite of passage. Unfortunately, we had to discontinue the line ultimately as drugs were being sold on it and to it.

far right
The great undiscovered (until then) Idina Menzel. Subway car panels that helped people understand how to get tickets. Broadway shows had never advertised in the cars before.

SPOTCO INCORPORATED THE MUSICALITY BUT ALSO THE *REBELLIOUS* SPIRIT OF THE SHOW. PLUS, IT BECAME A HIT RECORD, AND THE SHOW BECAME A SENSATION.
ROBIN SLOANE

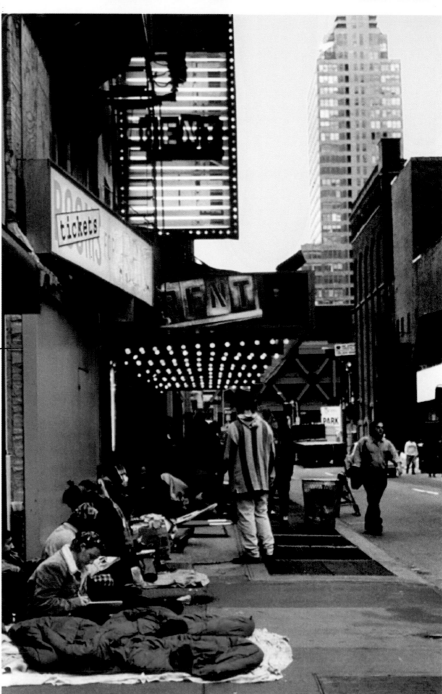

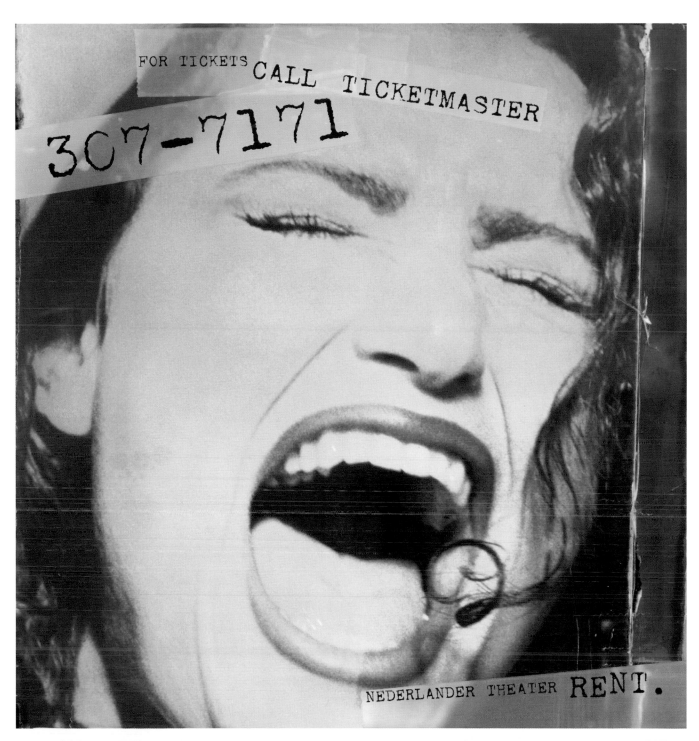

FOR TICKETS CALL TICKETMASTER
307-7171

NEDERLANDER THEATER RENT.

YOU REALLY CAN GET TICKETS. RENT.

CHICAGO

— THE NON-EVENT —

KANDER AND EBB REVIVAL, WITHOUT FLYING CHANDELIERS.

— THE EVENT —

LESS IS WAY MORE. WOMEN IN CHARGE ARE *SEXY AS HELL.* AND NO ONE THINKS CALVIN KLEIN CAN'T AFFORD COLOR WHEN HE RUNS ADS IN BLACK AND WHITE.

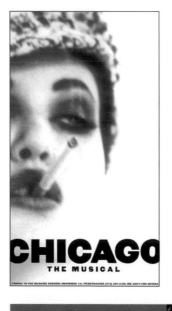

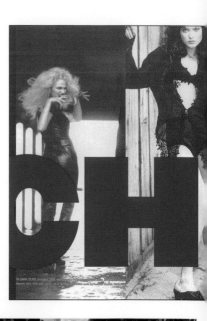

left
The very first *Chicago* ad, which ran in *Variety*. We were rushed, and it only hints at where we were going. — D.H.

right
The comp of a *New York Times* announcement ad I showed Barry and Fran Weissler in my office kitchen, made up of Max Vadukul's portfolio images of supermodels. Below is the final, featuring William Ivey Long's wonderful costumes. — D.H.

BARRY WEISSLER
PRODUCER

CHICAGO *WAS OUR FIRST* collaboration with SpotCo. At the time, they were the new kids on the block in Broadway advertising. Having just blast onto the scene with *Rent*, the firm was still very much in its infancy. I remember brainstorming our campaign in meetings around a kitchen table. Drew and his team were fresh, hot, scrappy and ambitious—just like *Chicago*.

When the show first premiered back in 1975, it was overshadowed by *A Chorus Line*. Now, more than twenty years later, we had the unique opportunity to brand ourselves as the definitive production of *Chicago*. From the start, we wanted to shake off the notion that we were a revival. It was the '90s. Broadway was dominated by spectacle: chandeliers crashing, helicopters flying. It was towering barricades of freedom on turntables. Our production of *Chicago* was something new. It was lean and mean, imbued with danger and sex. The embodiment of the genius of Bob Fosse, John Kander, and Fred Ebb. Minimalist by design, but bold and fearless in execution. We needed our advertising to follow suit.

Max Vadukul's work convinced us that our key art would reside in a black-and-white world. His film noir photography captured the "murder, greed, corruption, violence, exploitation, adultery, and treachery—all those things we all hold near and dear to our hearts," as the now iconic opening line goes. It also provided the perfect backdrop to juxtapose the bold type of our *Chicago* logo in that rich "David Merrick red." The look is timeless and part of the reason our show still feels just as fresh as it was when we premiered in 1996.

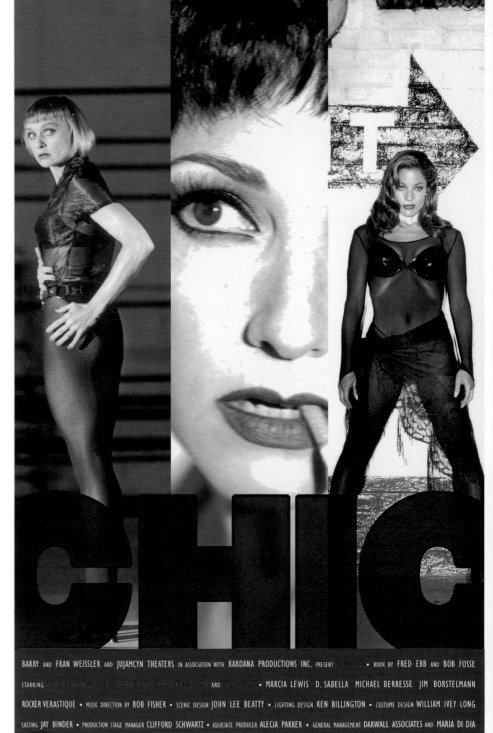

BARRY AND FRAN WEISSLER AND JUJAMCYN THEATERS IN ASSOCIATION WITH KARDANA PRODUCTIONS INC. PRESENT CHICAGO • BOOK BY FRED EBB AND BOB FOSSE STARRING ANN REINKING BEBE NEUWIRTH JAMES NAUGHTON AND JOEL GREY • MARCIA LEWIS D. SABELLA MICHAEL BERRESSE JIM BORSTELMANN ROCKER VERASTIQUE • MUSIC DIRECTION BY ROB FISHER • SCENIC DESIGN JOHN LEE BEATTY • LIGHTING DESIGN KEN BILLINGTON • COSTUME DESIGN WILLIAM IVEY LONG CASTING JAY BINDER • PRODUCTION STAGE MANAGER CLIFFORD SCHWARTZ • ASSOCIATE PRODUCER ALECIA PARKER • GENERAL MANAGEMENT DARWALL ASSOCIATES AND MARIA DI DIA
RICHARD RODGERS THEATRE 226 WEST 46TH STREET • SEE ABC'S FOR DETAILS

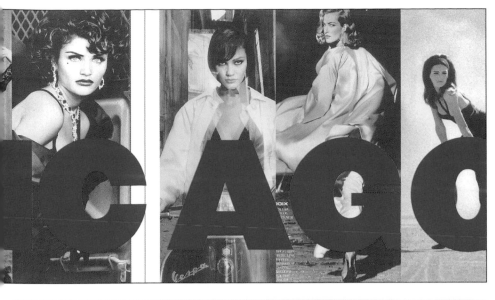

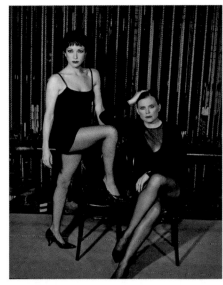

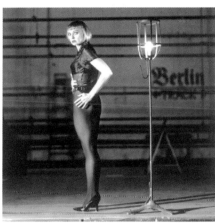

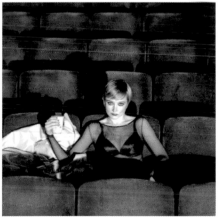

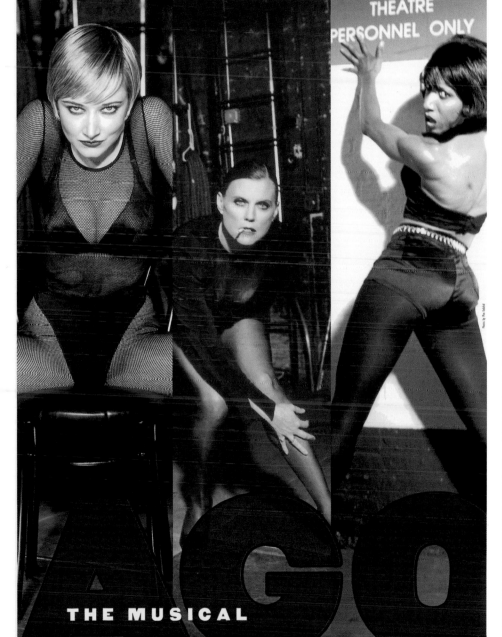

THEATRE
PERSONNEL ONLY

THE MUSICAL

MUSIC BY JOHN KANDER • LYRICS BY FRED EBB • BASED ON THE PLAY CHICAGO BY MAURINE DALLAS WATKINS • ORIGINAL PRODUCTION DIRECTED AND CHOREOGRAPHED BY BOB FOSSE

CAITLIN CARTER • BRUCE ANTHONY DAVIS • MAMIE DUNCAN GIBBS • DENISE FAYE • DAVID GIBSON • MICHAEL KUBALA • JEFF LOEFFELHOLZ • JOHN MINEO • TINA PAUL

SOUND DESIGN SCOTT LEHRER • ORIGINAL ORCHESTRATION RALPH BURNS • DANCE MUSIC ARRANGEMENTS PETER HOWARD • MUSICAL COORDINATOR SEYMOUR RED PRESS

TECHNICAL SUPERVISOR ARTHUR SICCARDI • BASED ON THE PRESENTATION BY CITY CENTER'S ENCORES • CHOREOGRAPHY ANN REINKING IN THE STYLE OF BOB FOSSE • DIRECTED BY WALTER BOBBIE

PREVIEWS BEGIN OCTOBER 23RD • CALL TICKETMASTER NOW 212-307-4100

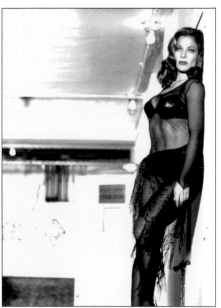

> I REMEMBER BRAINSTORMING OUR CAMPAIGN IN MEETINGS AROUND A KITCHEN TABLE. DREW AND HIS TEAM WERE *FRESH, HOT, SCRAPPY* AND AMBITIOUS—JUST LIKE *CHICAGO*.
>
> BARRY WEISSLER

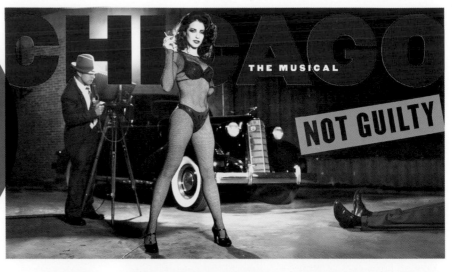

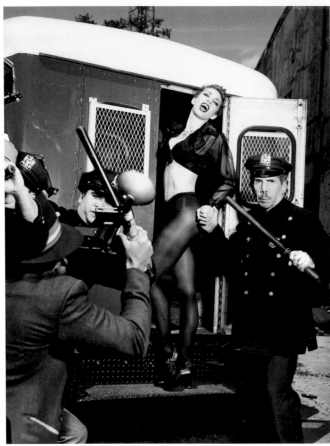

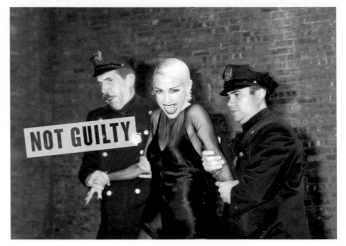

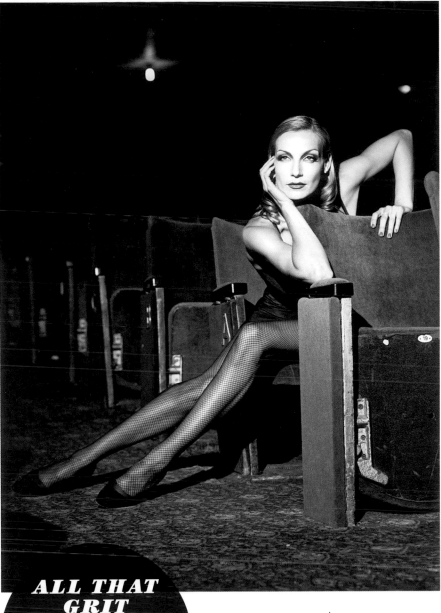

ALL THAT GRIT
AROUND THE THEATER AND IN THE STREETS—IT WAS JUST THERE. AND WE'D GO STRAIGHT TO PRINT. NO RETOUCHING.
MAX VADUKUL

above
Ute Lemper giving you legs for days in the aisle, and above right, the shoot goes out of control.

below
A calendar from *Chicago* featuring SpotCo friends and family, and die-cut bullet holes on the cover.

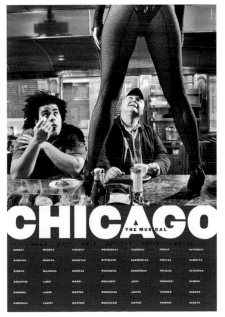

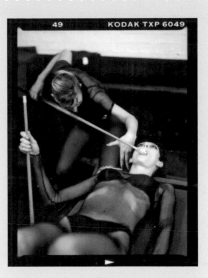

MAX VADUKUL
PHOTOGRAPHER

AT THE TIME, I WAS DOING lots of black-and-white work for French *Vogue*, working with models like Helena Christensen and Linda Evangelista—women who are full of personality and charisma. To do black-and-white photography was almost taboo at the time. Everything had to be in color. So when the request came in to do *Chicago*, I remember the layouts were actually swipes of my editorial work, narrow slits of photos like they ended up being in the ads. And I thought, "Wow, this design looks so good." It was fantastic, and I had to do it.

I originally wanted to style it to be very edgy like my editorial work, but we realized the photographs had to have staying power like the show. So William [Ivey Long, the show's costume designer] came in with a series of looks. And I shot the girls in relation to the theater—sitting on the stage, all over the place. I'd call out to people to get a look—and with very simple light. It was the biggest blast ever. The enthusiasm on the set was incredible.

CHICAGO WAS MY FIRST lesson in embracing a possible negative and turning it into a positive from the very beginning. I now know if you don't correct a perception right from the start, you will never be able to do so.

We began as if the show had never existed before on Broadway, and we banished the word "revival." But someone wrote a column asking how would audiences pay top dollar ($75 at the time) for a glorified concert. I decided the real perception challenge here was to make it clear from the get-go that with all the budget in the world, our bandstand and bentwood chairs were all the spectacle we needed. But how?

Finally, it occurred to me that when Calvin Klein ran a black-and-white fashion ad (Marky Mark and so on), no one perceived it as if Klein lacked the budget to run color—it was clearly an aesthetic choice. So we decided to use the device of fashion photography to own the minimalism from the start.

The other rule we somehow understood intuitively was about sex. The *Chicago* women were sexier than Broadway had ever been, thanks to William Ivey Long's stunning costumes and a gorgeous, leggy cast. But what allowed them to be genuinely sexy in the newspaper was their power. No behind-bars settings for this *Chicago*. It would have made the women victims. By allowing them to control their image from the start, they could be sexy—sexy as hell—because they were no longer victims.

Doing a *Chicago* photo shoot is like summer fantasy camp for art directors. At the first *Chicago* shoot (and every one after that), we set our location as backstage at the theater to make sure the show never turned into a pantyhose ad. Oddly, later in *Chicago*'s life, actual pantyhose were promoted using the *Chicago* brand. But I digress.

When we were shooting Ann Reinking, there was a large, heavy crate from a house electrician hanging fifteen feet above the stage, presumably to protect whatever was inside from theft. It seemed to sway lightly and menacingly. Ann immediately understood its power and walked directly under it to pose, instantly communicating, danger, sex, and Fosse as only she can.

When we shot in London at the old Drury Lane Theatre, we found in the basement an ideal shooting location next to enormous pits with eight-foot-tall, rusted industrial springs. All we had to do was ask—we had stumbled upon springs used to remove elephants from the stage for Harry Houdini.

On another shoot, I left Barry to check on the next girl getting ready for her shoot and returned to find the team in a staff poolroom, with one girl lying on the table with a cue ball in her mouth, and another preparing to shoot it out. I screamed, Barry laughed, and on we went with the day.

Perhaps my favorite *Chicago* photo is one of Caitlin Carter. She had finished her shoot, was cold, added her raincoat on top of her costume, and sat in the empty house with a cup of deli coffee in her hand. Max turned around and shouted, "Stay right where you are!" and swung his lights and lens her way from the stage. The entire picture took no more than three minutes. —D.H.

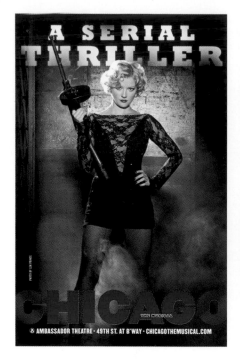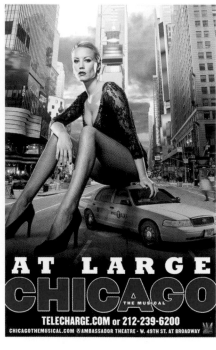

below
The Times Square billboard made from old school "shimmer discs." We used to call them "the car wash." Ultimately the letters were quite heavy and had to come down when the Howard Johnson's building did, but they were incredibly effective.
bottom
Chicago in Russia.

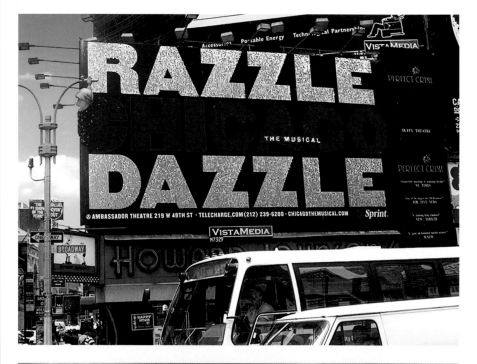

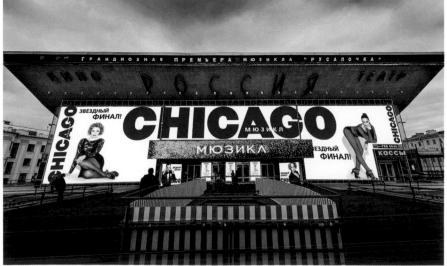

CHICAGO
THE MUSICAL

"AS ENTERTAINING AS EVER. BRASH, BUOYANT AND UTTERLY IRRESISTIBLE!"
ASSOCIATED PRESS

TELECHARGE.COM 212-239-6200 • CHICAGOTHEMUSICAL.COM
AMBASSADOR THEATRE • 219 WEST 49TH STREET
GRAMMY® AWARD-WINNING CAST RECORDING ON RCA VICTOR

23

THE OLD NEIGHBORHOOD

THE NON-EVENT

WHAT'S IT ABOUT?

THE EVENT

NO ONE TELLS A STORY QUITE LIKE DAVID MAMET, SO *PULL UP A STOOL.*

THE OLD NEIGHBORHOOD was a wonderful trio of short plays by David Mamet about—well, coming home to the old neighborhood. We struggled for some time to find an image that would sum up the characters and their world, and of course, sell tickets. What we ended up with was a straight-forward symbol of humanity—an old matchbook like you might find at a bar. Or maybe it just represents hours of conversation that sitting at a bar in the afternoon can be—friend to friend, stranger to stranger, lost people talking about home, reconnecting to old neighbors. Those bar conversations often get a little loose, and more is said than was intended, or expected. All of that seemed right for David Mamet and these stories. I still have the matchbook we made.

But before we got to that image, we tried another route that would end up being a direction SpotCo would try and exploit for years to come: controversy. The thing you go to a David Mamet play for is dialogue. Explosive dialogue. The reason you stop looking at ads is they don't say anything that surprise you. So this is the first time in our career we thought the play's actual language might inflame, intrigue, and possibly get your attention. Weeks after showing the comp to the right to producer Stuart Thompson, a client I grew close to, he confided to me that he assumed upon meeting me that I was straight (I am not, go figure), and completely insensitive to a world that was welcoming to gay professionals because I used the language from the play, notably the word "fag." Our dear producer was glad to learn I wasn't the jerk he thought I was.

We never ran the ad, which in hindsight is probably just as well. But it was only the first of many attempts—from *The Vagina Monologues* to *Cock* that we tried to let sheer outrageousness move the needle. —D.H.

YOU 'MEMBER THOSE TWO BROADS WE HAD? THE ROGERS PARK BROADS? THE FOLKDANCING BROADS YEAH...THE TWO DEBBIES YEAH...FOR FIVE BUCKS, WHICH ONE WAS MINE?

I USED THE LANGUAGE FROM THE PLAY, NOTABLY THE WORD *"FAG"* IN A COMP. OUR DEAR PRODUCER WAS GLAD TO LEARN I WASN'T THE JERK HE THOUGHT I WAS.
DREW HODGES

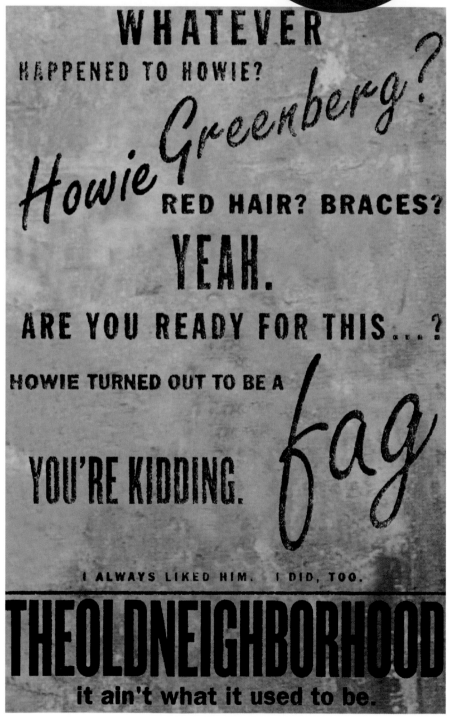

WHATEVER HAPPENED TO HOWIE? Howie Greenberg? RED HAIR? BRACES? YEAH. ARE YOU READY FOR THIS...? HOWIE TURNED OUT TO BE A YOU'RE KIDDING. fag

I ALWAYS LIKED HIM. I DID, TOO.

THEOLDNEIGHBORHOOD
it ain't what it used to be.

CAROLE SHORENSTEIN HAYS and STUART THOMPSON
present

PETER RIEGERT ★ PATTI LuPONE

THE OLD NEIGHBORHOOD

by David Mamet

CLOSE COVER BEFORE STRIKING

also starring **VINCENT GUASTAFERRO** **REBECCA PIDGEON** with **JACK WILLIS**

SET DESIGN BY
KEVIN RIGDON

COSTUME DESIGN BY
HARRIET VOYT

LIGHTING DESIGN BY
JOHN AMBROSONE

CASTING BY
LAURA RICHIN

PRODUCTION STAGE MANAGER
RICHARD HESTER

PRODUCTION SUPERVISOR
GENE O'DONOVAN

directed by **SCOTT ZIGLER**

ORIGINALLY PRODUCED BY THE AMERICAN REPERTORY THEATRE, CAMBRIDGE, MA
ROBERT BRUSTEIN, ARTISTIC DIRECTOR, ROBERT J. ORCHARD, MANAGING DIRECTOR

⊗ **BOOTH THEATRE 222 WEST 45TH STREET**

THE DIARY OF ANNE FRANK

—— THE NON-EVENT ——

A REVIVAL OF THAT THING YOUR LOCAL TEMPLE DOES EVERY YEAR.

—— THE EVENT ——

ANNE FRANK WAS A REAL, *JOYOUS, BREATHING* TEENAGER, JUST LIKE YOURS.

DAVID STONE
PRODUCER

DREW WANTED TO CREATE an ad agency. So he got this space in Midtown with like four people, and he said to me, "Let us do a pitch [for *The Diary of Anne Frank*]." And he said, "We know we can give you the best artwork. But we will also focus completely on you, on what you need. You will always be our first client." And then he said, "And we'll also throw in this free set of Ginsu knives." And he pulled them out and gave them to us. I still use them. So we took the leap. Even if I hadn't been thrilled with the final result—which I was—being their first client is something in which I take enormous pride. We decided to put a stake in the ground and say, "We believe these people will do great work." It was not only meaningful in that moment, but it is also deeply meaningful to me all these years later.

FRANK OCKENFELS III
PHOTOGRAPHER

I HAD KEPT JOURNALS FOR years, and each time I saw Drew, he would sit and look at whatever one happened to be in my bag at the time. When this project came up, Drew asked if I would create journals and collages for the advertising of the show. We landed in the Meatpacking District—12th Street and Washington—cobblestone streets, low nondescript buildings, a look of Europe in World War II. As I remember, it started to rain, and the streets became a little slick because of the meat residue from the surrounding buildings where they butchered meat. An odd smell wafted through the air, at which point Natalie smiled and told me she was a vegetarian. She laughed and skipped away and played with the other girls as I finished shooting.

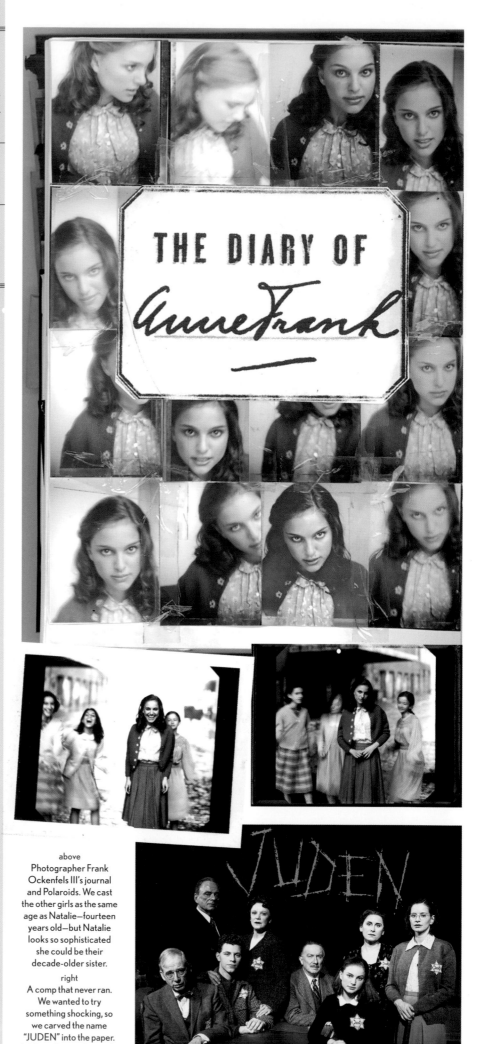

above
Photographer Frank Ockenfels III's journal and Polaroids. We cast the other girls as the same age as Natalie—fourteen years old—but Natalie looks so sophisticated she could be their decade-older sister.

right
A comp that never ran. We wanted to try something shocking, so we carved the name "JUDEN" into the paper. It felt exploitive ultimately, but we wanted to wake our audience up somehow.

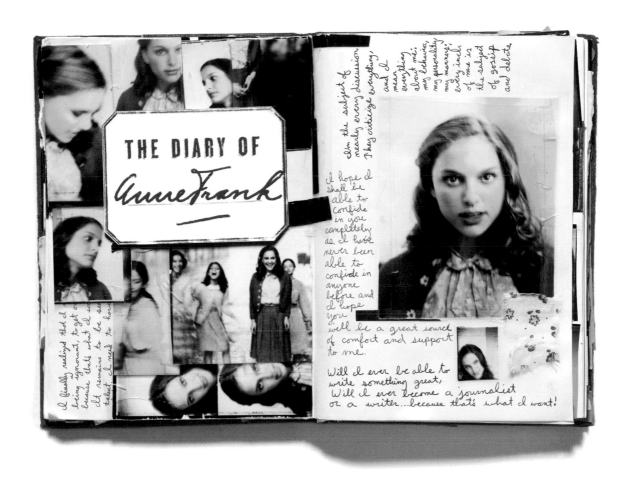

Natalie Portman

George Hearn *Linda Lavin*

Harris Yulin *Austin Pendleton*

THE DIARY OF ANNE FRANK

A PLAY BY **FRANCES GOODRICH** AND **ALBERT HACKETT** NEWLY ADAPTED BY **WENDY KESSELMAN**

PRESENTED BY **DAVID STONE, AMY NEDERLANDER-CASE, JON B. PLATT, JUJAMCYN THEATERS & HAL LUFTIG** IN ASSOCIATION WITH HARRIET NEWMAN LEVE & JAMES D. STERN

ALSO STARRING **SOPHIE HAYDEN** JONATHAN KAPLAN RACHEL MINER PHILIP GOODWIN JESSICA WALLING

SET DESIGN BY ADRIANNE LOBEL COSTUME DESIGN BY MARTIN PAKLEDINAZ LIGHTING DESIGN BY BRIAN MACDEVITT SOUND DESIGN BY DAN MOSES SCHREIER

HAIR AND WIG DESIGN BY PAUL HUNTLEY CASTING BY ILENE STARGER PRODUCTION STAGE MANAGER DAVID HYSLOP GENERAL MANAGEMENT STUART THOMPSON

TECHNICAL SUPERVISOR GENE O'DONOVAN PRESS REPRESENTATION THE PUBLICITY OFFICE MARKETING FOURFRONT DIRECTED BY **JAMES LAPINE**

MUSIC BOX THEATRE, 239 WEST 45TH STREET

FREAK

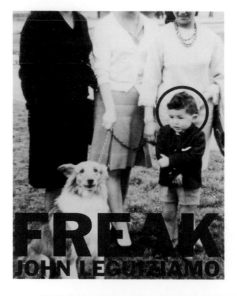

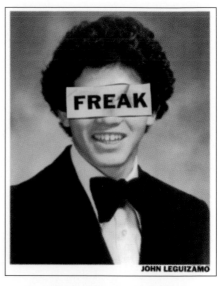

JOHN LEGUIZAMO
WRITER/PERFORMER

I THINK [illustrator] *WARD* Sutton is a truly original artist. When I saw the artwork for the *Freak* poster for the first time I freaked (pun intended). It was so graphic and alive. It felt like energy was coming out the lines. It was alive in a weird way. It was beautiful and grotesque and a total fun house version of my face, but I said immediately, "That's my show!"

SpotCo's Kevin Brainard took lots of different [reference photographs in various] emotions, looks, mugs, you name it. I had some ideas. Since *Mambo Mouth*, I've always thought of these one-man shows as a big mouth. It's what they teased me about in high school. That I had a big mouth. So that kind of influenced the photo shoot.

The show was about the cruelties of childhood. How coming of age looked like from a kid's point of view. Not the adult looking back but trying to be back in those shoes looking out. Not looking back or looking down. And I felt Ward caught that. He caught the pain, the ridiculousness, the nightmarish quality that childhood can be. The whole experience was very emotional for me, because it was a tough journey to Broadway. I was the first Latin one-man show on Broadway, and it was my first show on Broadway. Many naysayers said it couldn't be done, not just that I was Latin but because the subject matter was very raw. But there I was at the Cort Theatre on the side side of Broadway—the wrong side of Broadway, and it felt like a triumph. Like I had planted a flag on the moon kind of thing.

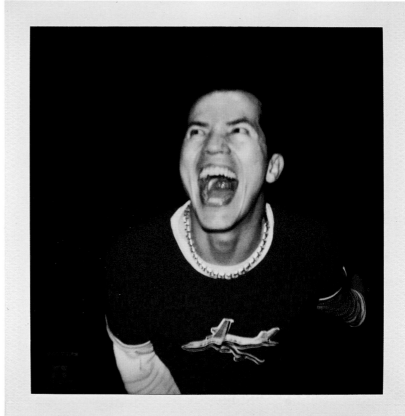

> I THINK THAT WAS A BRILLIANT PIECE OF ARTWORK AND ONE OF THE LAST SHOWS THAT BEST UTILIZED *WILD POSTING* AS AN ADVERTISING MEDIUM BEFORE A MAYOR GIULIANI CRACKDOWN.
> *JIM EDWARDS*

above
Comps using John's personal photos from his childhood and high school yearbook.
middle
The Polaroid used by Ward Sutton to make our final drawing (right).

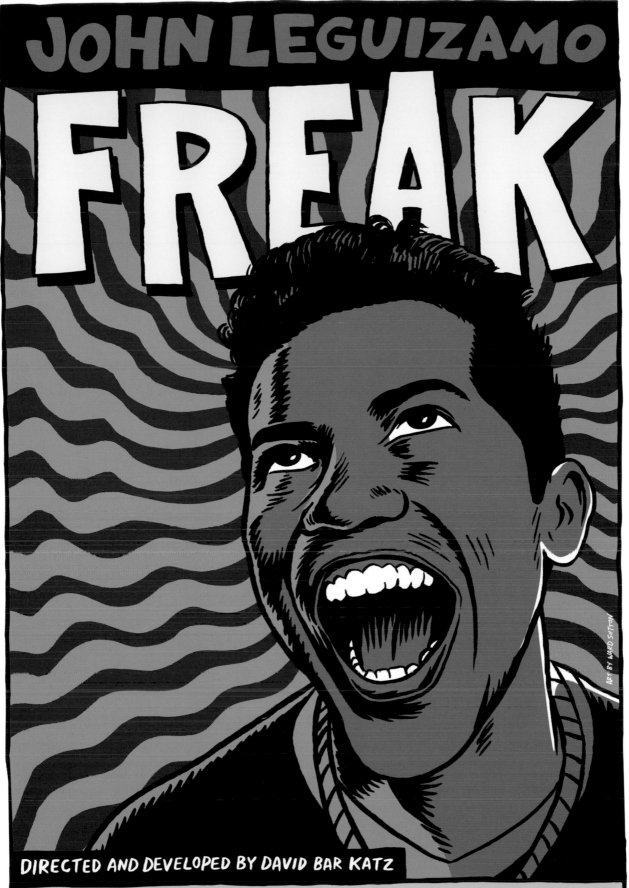

——— THE NON-EVENT ———

WHO IS IN IT?
(AS IT TURNS OUT, THE WONDERFUL
BUT UNKNOWN EDIE FALCO.)

——— THE EVENT ———

JAZZ IS COOL, AND
WE'RE INVITING YOU TO THE SESSION.

KEVIN BRAINARD
FORMER SENIOR DESIGNER, SPOTCO

I HAVE ALWAYS LOVED the designs of jazz album covers, especially those of Blue Note Records. The once experimental and innovative artwork of designers like Reid Miles, who designed almost five hundred Blue Note record sleeves.

Set in the '50s and '60s, Warren Leight's memory play *Side Man* is a heartfelt tribute to his father Donald Leight: a jazz trumpeter, a musician for hire, a virtuoso who could function as a solo performer one night and blend into the background the next.

This was one of the few posters that I didn't agonize over. The Blue Note "look" conveys a myriad of connotations—a sense of nostalgia that could not be achieved otherwise.

The finishing touch was the work of my colleague Jesse Wann, whose rhythmic poetry perfectly summed up the play in fifteen words.

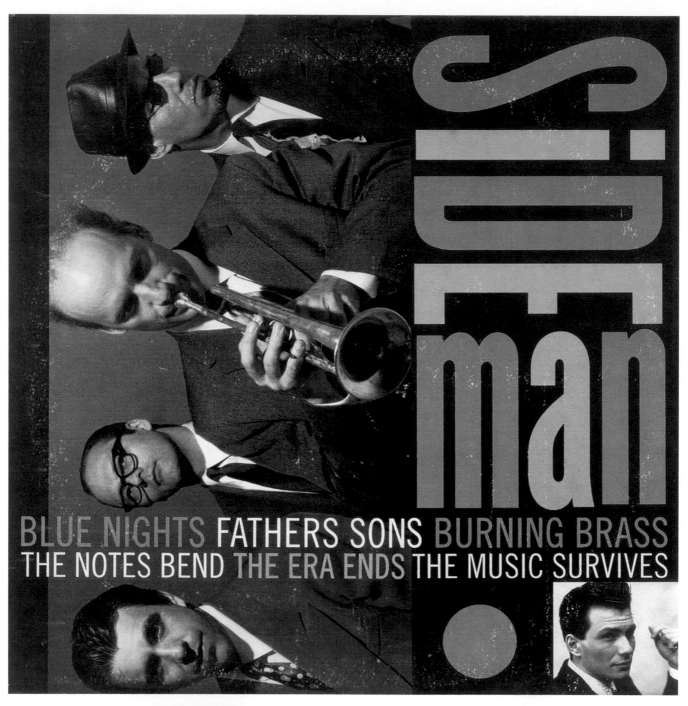

right
This comp was inspired by an Ornette Coleman album called *This Is Our Music.*

WIT

— THE NON-EVENT —

OVARIAN CANCER.

— THE EVENT —

GREAT THEATER STILL HAS
THE POWER TO
CHANGE YOUR LIFE.

KATHLEEN CHALFANT
ACTOR

I SUFFER FROM THIS HORRIBLE form of dysmorphia and can't look at myself. So my agent, Flo Rothacker, made all the decisions and chose that picture. And it was everywhere. It was wild to be on the side of a bus. I'd never been on the side of a bus before and probably never will again. It became an important symbol—this photograph of a bald woman in baseball cap and a hospital gown.

STELLA BUGBEE
FORMER DESIGNER, SPOTCO

WITH WIT—*OR* W;T—*I HAD ONE* of those rare moments where I was sitting in the theater, watching the play, and suddenly the idea for the logo materialized with crystal clarity. The play is technically about cancer, and the main character is fixated on the use of a semicolon versus a comma—a metaphor for the ways meaning can hinge on small details. The logo made a simple addition, but one that was hard to ignore, but it also read "wrong."

Wit

W;t

Wit

above
Logo types—trying to make the
semicolon work.

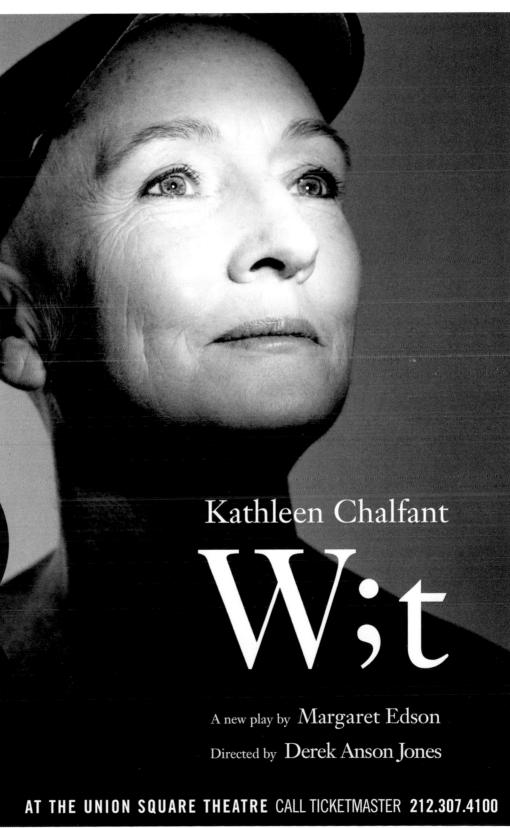

BEFORE ANYONE CALLED US TO SEE ABOUT PITCHING IT, DREW WAS IN MY OFFICE WITH A *TIME OUT.* THERE WAS A PHOTO OF *KATHLEEN CHALFANT* IN A WHEELCHAIR.

DREW SAID TO ME, "YEAH, I WANT A TICKET TO *THAT PLAY*."
JIM EDWARDS
FORMER CHIEF OPERATING
OFFICER, SPOTCO

Kathleen Chalfant

W;t

A new play by **Margaret Edson**

Directed by **Derek Anson Jones**

AT THE UNION SQUARE THEATRE CALL TICKETMASTER **212.307.4100**

I'M STILL HERE DAMN IT!

— THE NON-EVENT —

ISN'T THIS AT THE BEACON?

— THE EVENT —

THIS BITCH CAN THROW A PARTY.

SANDRA BERNHARD
WRITER/PERFORMER

AFTER A VERY SUCCESSFUL run Off-Broadway at the Westbeth Theatre, offers were out to do a revamped version of the show on Broadway. I started thinking about new pieces that would open it up, one in particular that would be based on motherhood and the places you start going in your mind about the pitfalls and travails that await you. It was wrapped around the Journey song "Don't Stop Believing," a kind of "white trash" fantasy of where your child might end up, out on the road late at night, abandoned at some sleazy truck stop where Mommy comes to save her. It brought the house down and made it apparent that great material comes from unexpected places.

It was an opportunity to push myself as a writer and performer, to take the daring of downtown and bring it up to the part of town where polished, glitzy productions played it safer. It was a turning point in many ways for the New York theater experience—audiences wanted to be challenged and taken to the edge in the comfort of the Great White Way, and I would like to think my funky, gritty, exuberant show broke the mold and made way for other tougher shows to open up the conversation. It was everything I dreamt of and more at the Booth Theatre, with great reviews and wonderful crowds. My postmodern take on everything from musical theater, to pop culture, to sexuality, fame and celebrity, and even motherhood took me creatively to new heights in a setting that had always beckoned me and now felt like home.

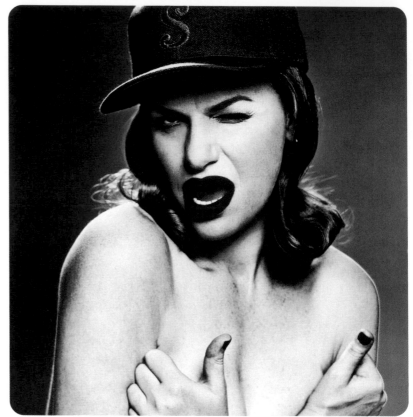

STARRING SANDRA BERNHARD AS HERSELF

sandra bernhard
I'M STILL HERE DAMN IT!

LIMITED ENGAGEMENT! AT BROADWAY'S BOOTH THEATRE

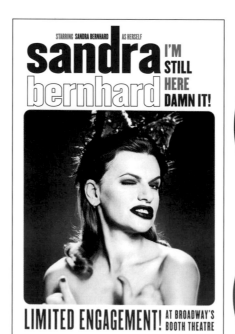

STARRING SANDRA BERNHARD AS HERSELF

sandra bernhard I'M STILL HERE DAMN IT!

LIMITED ENGAGEMENT! AT BROADWAY'S BOOTH THEATRE

> IT WAS AN OPPORTUNITY TO PUSH MYSELF AS A WRITER AND PERFORMER, TO TAKE THE *DARING OF DOWNTOWN* AND BRING IT UP TO THE PART OF TOWN WHERE POLISHED, GLITZY PRODUCTIONS PLAYED IT SAFER.
> *SANDRA BERNHARD*

> IT WAS WRAPPED AROUND THE JOURNEY SONG "DON'T STOP BELIEVING," A KIND OF *"WHITE TRASH"* FANTASY OF WHERE YOUR CHILD MIGHT END UP.
> *SANDRA BERNHARD*

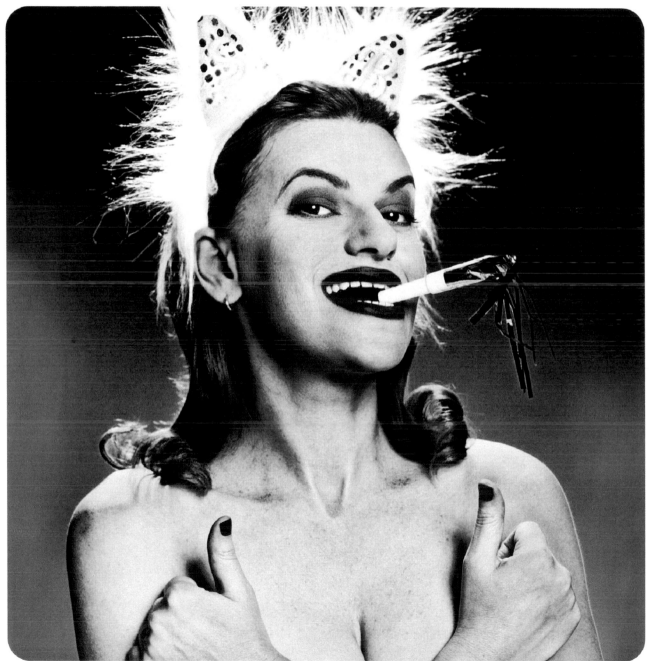

STARRING SANDRA BERNHARD AS HERSELF

sandra
bernhard

I'M STILL HERE DAMN IT!

LIMITED ENGAGEMENT! AT BROADWAY'S BOOTH THEATRE

DE LA GUARDA

THE NON-EVENT

STAND, GET WET AND PUSHED.

THE EVENT

A UNIQUE COMBINATION OF *MUSIC AND ATHLETICISM*.

JIM EDWARDS
SPOTCO

IT'S CIRQUE DU SOLEIL *BUT* in a mosh pit. That's how one writer described *De la Guarda* after it had opened. But how do you sell that before anyone has seen it with an Off-Broadway budget? Co-producer Jeffrey Seller felt that once the show was in performance, word of mouth would take over, and it would sell itself. So we created ad materials that were abstract and arty but didn't fully explain what the

evening was like. Sales were nonexistent, and our campaign just seemed to confuse people. Months later, we had a new campaign that used a great photograph demonstrating that the show takes place over the audience, and you stand instead of sit. We ran a TV spot that followed a twentysomething couple on a date. Sales took a noticeable jump. They never receded for years to come. It was a success story that we solved together with the producers. The show was worth the price of admission. It just needs time to find its audience with the correct ad materials in support.

> THE PRODUCERS DIDN'T WANT TO SHOW THE SHOW—THAT WAS WHAT THE PRICE OF ADMISSION GOT YOU. *WHY SPOIL THE SURPRISE?*
> *JIM EDWARDS*

> ON THE WAY TO MY JOB INTERVIEW AT SPOTCO THERE WAS A *DE LA GUARDA* AD ON MY TRAIN, AND I REMEMBER THINKING, *"THIS IS INTERESTING."* THEN I SAW THE POSTER ON THE WALL IN THE AGENCY. "WAIT, THIS IS THE PLACE THAT MADE THIS COOL THING?"
> *JOHN LANASA*
> FORMER ACCOUNT SUPERVISOR, SPOTCO

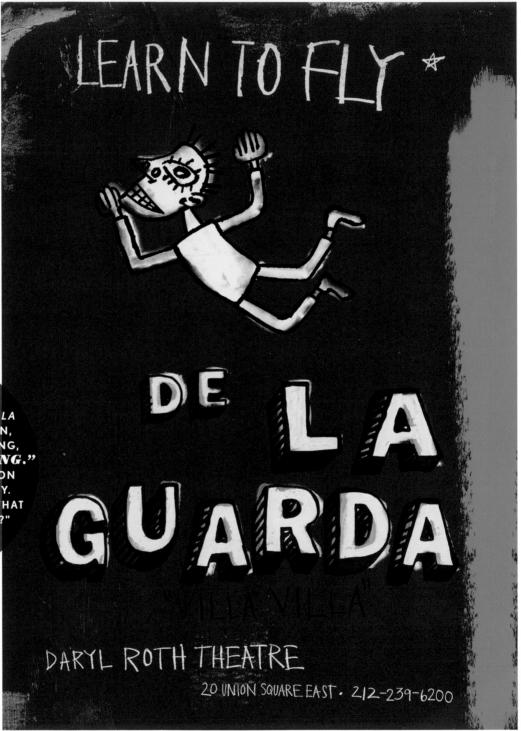

LEARN TO FLY

DE LA GUARDA

"VILLA VILLA"

DARYL ROTH THEATRE

20 UNION SQUARE EAST · 212-239-6200

THE DONKEY SHOW

THE NON-EVENT

MEXICAN PORN IN A WEST SIDE CLUB?

THE EVENT

A DISCO MIDSUMMER DREAM,
WITH GLITTER!

JORDAN ROTH
PRODUCER

THE DONKEY SHOW *WAS A* midsummer night's dream for all of us involved. A hybrid experience that lived in the space between theater and nightclub, it was the first commercial production for most of us. We had big dreams and boundless enthusiasm and disco love, but what we didn't have was much of an ad budget. I so clearly remember Drew presenting his answer to this challenge: "Let's pick one thing that we can really win at." Back then, street snipes were a big part of the city's visual landscape. They were bold and fun and possibly illicit—just like our show. They would be our one thing, and we would win at them by printing on magic paper! Throughout the city, little bursts of glitter and glam beckoned to a night of midsummer fun. And from that first poster, six years and several countries of disco fever and donkey love was born!

above
The final poster printed on prismatic paper, to provide that "disco ball" shimmer.

DREW UNROLLED A COLLECTION OF SPARKLING PAPER THAT LOOKED AS IF A MIRROR BALL HAD BEEN RUN THROUGH A PRESS.
DIVINE!
JORDAN ROTH

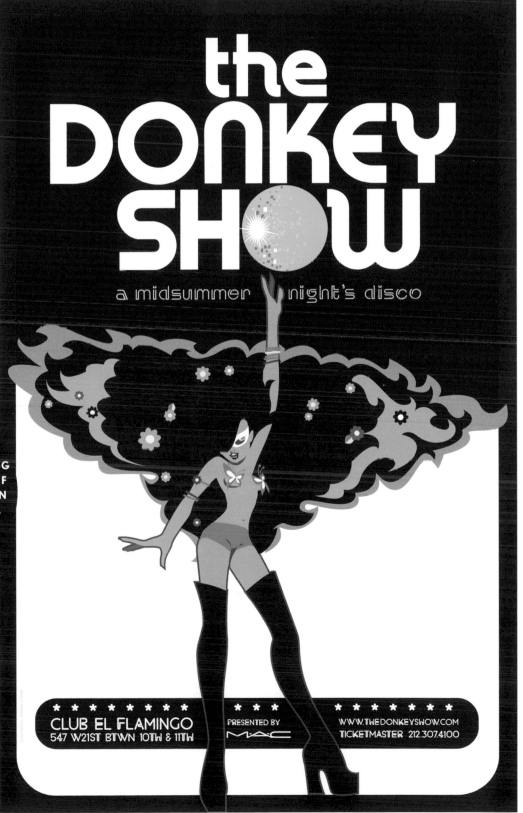

THE BLUE ROOM

THE NON-EVENT

NICOLE KIDMAN NAKED ON STAGE AS A STUNT.

THE EVENT

SEX AND SMARTS IS ONE HELL OF A COCKTAIL. AND *NICOLE KIDMAN IS NAKED ONSTAGE.*

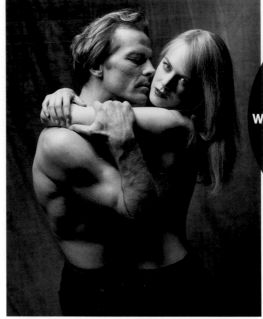

NICOLE TOOK ONE LOOK AT THE PICTURES AND, TURNING TO ME WITH A MISCHIEVOUS GRIN, SAID, "THEY WOULD BE BETTER IF I WAS *NAKED, YES?"*
DREW HODGES

left
The original Lorenzo Agius photograph before retouching, shot onstage at the Donmar Warehouse.

SCOTT RUDIN
PRODUCER

THE PLAY WAS AN INSTANT success. It was sold out when it opened. And the ad we ran was actually [Broadway press agent] John Barlow's idea, to ensure against anxiety about what the *Times* would write in their review. It was a huge hit in London. But this was to protect against the review. We had a big advance, this was a hit, and there's possible cynicism there. So John said, "Run an ad opposite the review to push the cultural event of it all." Nicole was exploding in her career. *Newsweek* ran this piece about how there were no tickets, and there was this one line in the article: "The hottest ticket for a play in Broadway history." And we thought this was a great way to say, "Sold out." It was this rare moment. And I remember the *Times* kicked it back three times about the cropping and how there was no title and no theater. There was also no inventory!

I FLEW TO LONDON AND met with Nicole Kidman and Iain Glen to show them the idea for the poster. Both seemed to like it immediately. We staged a photo shoot in the theater for the four of us and photographer Lorenzo Agius on the Donmar stage, with eight-foot, foam-core walls.

The next day, Agius and I returned with photos from the shoot to show them to the two actors—no agents, handlers, bodyguards, or press. Nicole took one look at the pictures and, turning to me with a mischievous grin, said, "They would be better if I was naked, yes?" I was a bit tongue-tied, but at this point we had become a group of four intimate friends, if only for a brief few days. I immediately said, "Yes, absolutely." And she said, "Retouch them off," referring to her jeans. So we did. —D.H.

"THE HOTTEST TICKET FOR A PLAY IN BROADWAY HISTORY."
NEWSWEEK

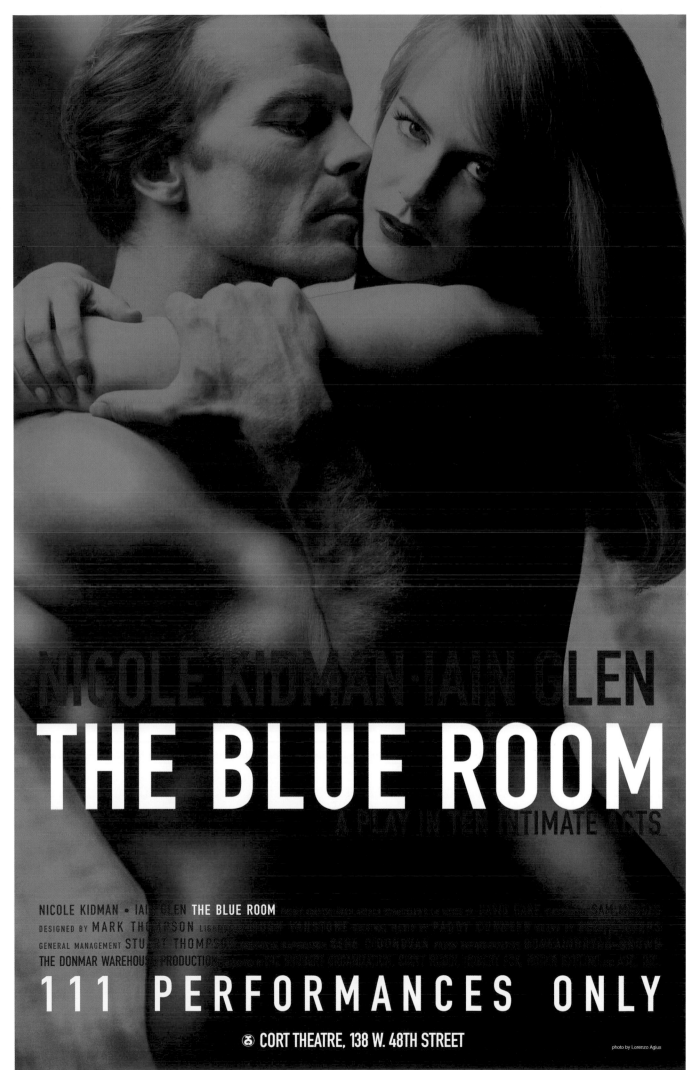

NICOLE KIDMAN · IAIN GLEN

THE BLUE ROOM

A PLAY IN TEN INTIMATE ACTS

NICOLE KIDMAN · IAIN GLEN THE BLUE ROOM
DESIGNED BY MARK THOMPSON
GENERAL MANAGEMENT STUART THOMPSON
THE DONMAR WAREHOUSE PRODUCTION

111 PERFORMANCES ONLY

CORT THEATRE, 138 W. 48TH STREET

photo by Lorenzo Agius

THIS IS OUR YOUTH

— THE NON-EVENT —

BRATS, DRUGS, AND THE UPPER WEST SIDE.

— THE EVENT —

REAL LIFE, AT SIXTEEN, IN NEW YORK CITY. AT LEAST THAT'S HOW YOU REMEMBER IT.

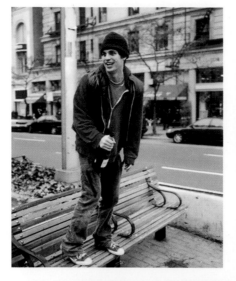

MARK RUFFALO
ACTOR

I REMEMBER IT WAS AN overcast day, and the cast (me, Mark Rosenthal, and Missy Yager) was asked to come to Central Park where we would shoot the poster for the play. We were moving from a small Off-Broadway house to a much bigger venue. This was a chance at a serious commercial run and our producers were throwing a good amount of money at a full-scale campaign. This was new to me. There were "mockups" and we were doing a "photo shoot." It was such an exciting time, and the fact that we were going to go out into the streets of New York to improvise some little scenes in character also added an element of danger and excitement. I didn't know what to expect and it was a little scary, but the three of us were so comfortable with our characters at this point that we could be put anywhere and know exactly what we would do. The premise was that we were hanging out together in the park after skipping school or being up all night. We had a bottle of champagne. We were free and out of control, we were teens and we knew the world and were in full rebellion from the crushing and dehumanizing Reagan era. I was thirty-one playing nineteen. I was an actor who had just quit his day job hoping that this was my big break. I was with two amazing and gutsy actors in a groundbreaking play that people loved. We were shooting the poster of the play with this amazing group of young and gutsy folks, guerrilla style. We were all in full revolt of the lives we were living, all of us striving for this elusive thing just outside our grasp but still very close. On that gloomy day in Central Park, we were fighting against the suck of deadness, we were striving for our dreams. That's the best way I can describe it. It was fantastical and urgent and a little desperate but wholly satisfying and wonderful.

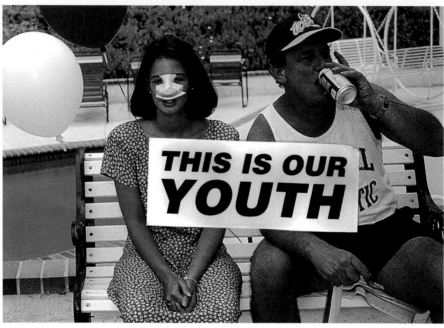

THIS IS OUR YOUTH

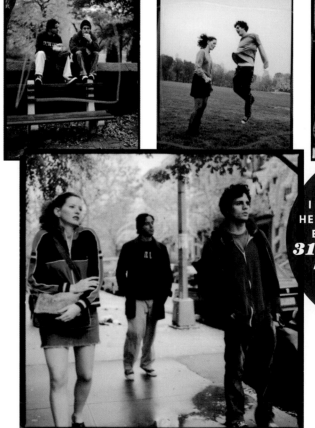

AS FOR MARK, I AM SURE I THOUGHT HE WAS THE CHARACTER. BUT IN FACT, HE WAS ***31 PLAYING 19,*** A MASTER FROM THE BEGINNING.
DREW HODGES

Outtakes from our Upper West Side shoot, and a comp using photographer Lauren Greenfield that began to capture the mood we were trying to find.

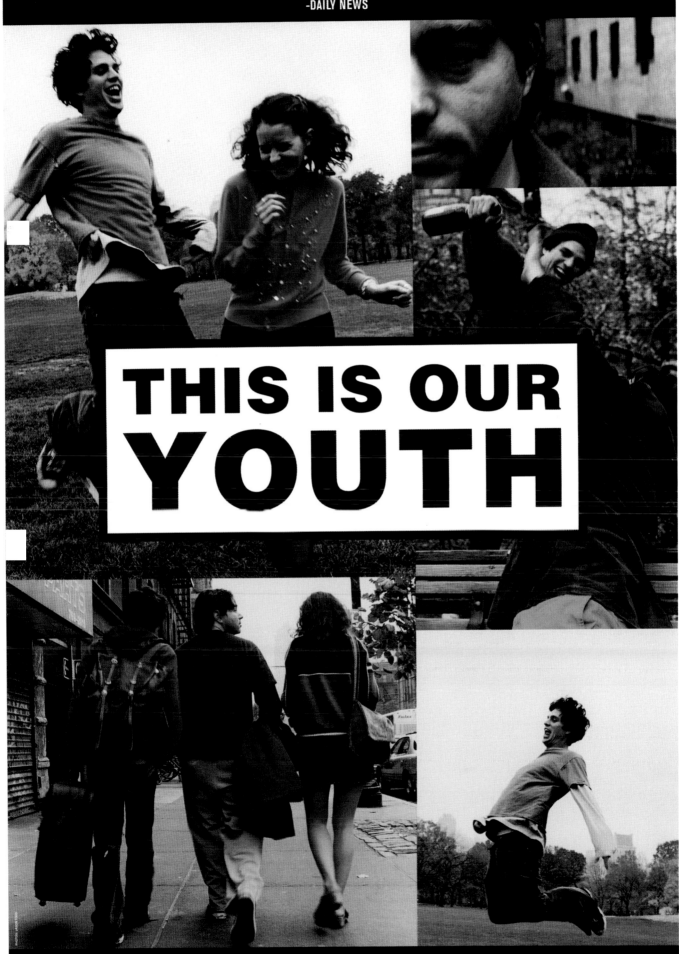

39

ANNIE GET YOUR GUN

—— THE NON-EVENT ——

ANOTHER REVIVAL WITH SONGS YOU DON'T QUITE REMEMBER.

—— THE EVENT ——

RETRO CAN BE CONTEMPORARY. *BERNADETTE PETERS* WAS BORN TO PLAY THIS.

BERNADETTE PETERS
ACTOR

I HAD JUST BEGUN REHEARS-als to star on Broadway in *Annie Get Your Gun* when I was asked to attend a meeting at SpotCo to talk about the direction of the preliminary artwork for the show. I was delighted at the prospect of being part of the creative process. Their early vision was to have the artwork be a fabulous rendition of Annie in the middle of the poster surrounded by the other members of the show. It progressed from there to a very Vargas flare. I thought, "Wow." What great imaginations! We all became so excited sitting around that table. The color scheme they decided on for the artwork had such an old-fashioned feel, yet it was also modern and relevant. The people at SpotCo really know how to make an impact. I think you'll agree by the results of the stunning poster they created.

MARK STUTZMAN
ILLUSTRATOR

MUCH OF THE SHOW WAS still being developed as I was sketching ideas, so I was inventing costumes and character personalities as I went. With Bernadette Peters front and center, the rest would seem incidental. The mood evolved into a fun cross between a classic Western tour poster and a Vargas pinup.

As an illustrator, the big thrill comes when the art gets into the public eye. I can remember being completely blown away to see the *Annie* artwork enlarged to fill the side of a huge building in the middle of Times Square. It doesn't get better than that!

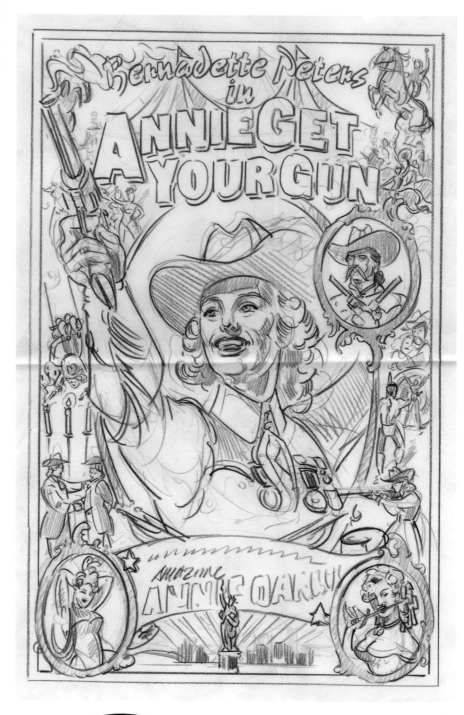

BERNADETTE PETERS CAME INTO THE OFFICE TO OVERSEE THE RETOUCHING. SHE SAT BEHIND ME AND SANG ALONG TO THE SUPERFLY SOUNDTRACK WHILE WE WORKED.
MARY LITTELL
SENIOR SPECIAL PROJECTS DESIGNER

above
Mark Stutzman's first master pencil sketch.

right
One of the portraits for the final artwork—all were done individually and pieced together digitally so we could accommodate all of the different shapes needed.

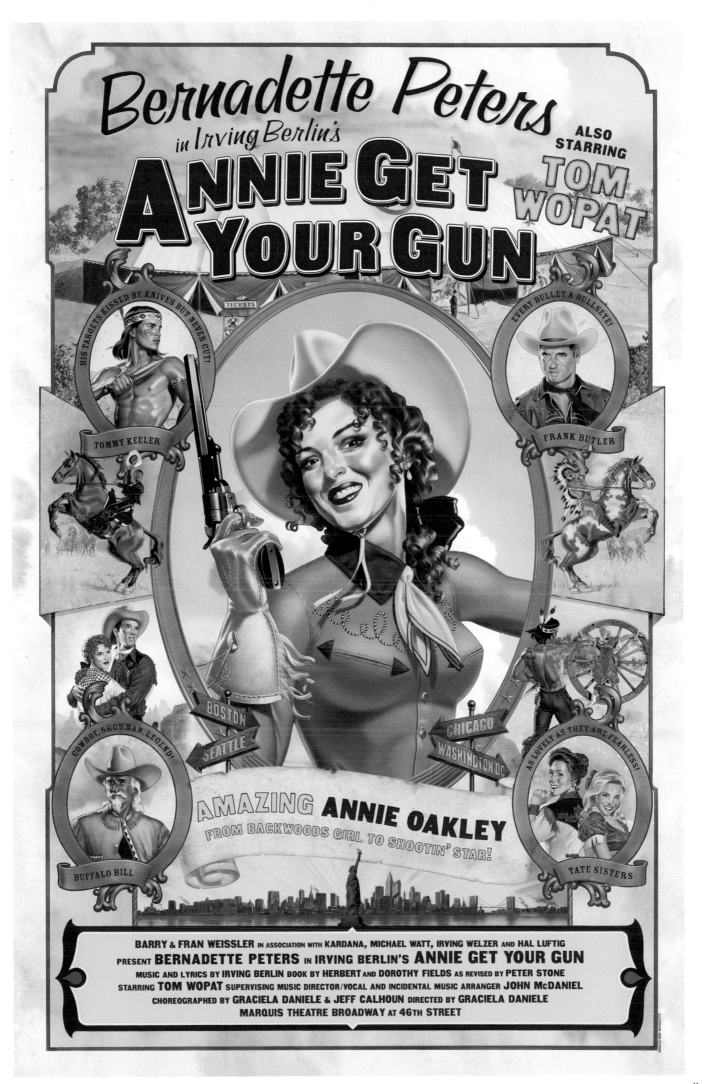

CLOSER

THE NON-EVENT

**COOL, HEADY BRITISH PLAY.
"COOL" AS IN "COLD."**

THE EVENT

**EVERYONE IS A VOYEUR.
*CLICK.***

ROBERT FOX
PRODUCER

I HAD NOT BEEN ABLE TO get the right image for the transfer of *Closer* in London, so SpotCo started from a blank sheet for the New York production. The play always felt, to me, as if the audience was involved in some very intense voyeuristic experience as the characters onstage bared their most personal secrets to a room full of strangers. Personally it was also slightly a case of art imitating life, not vice versa. So when the idea of the camera was first shown to us, its bold and elegant simplicity captured brilliantly the means by which we all now get the key to people's privacy and indeed their souls. It also allowed us to adapt and expand the visuals for the show to become the contact sheets showing the characters in the play as the subjects of the photographer, portrayed by Natasha Richardson. *Closer* got to the nitty-gritty of life and love and sex and betrayal, and SpotCo provided us with a lens for us all to see it through.

AT THE CENTER OF CLOSER is a photographer taking a picture. This was a case where the exchange of power associated with a classic photographic portrait session *was* the subject of our photo session. We decided just to allow the title to be the subject. The final decision was whether or not to flip the image. Robert [Fox] let us know that he would like a readable title, right side up, thank you very much. After that, the images were a breeze. If you cannot take a good picture of Anna Friel and Natasha Richardson, you should pack it in. They eat the camera, and you get the dessert. —D.H.

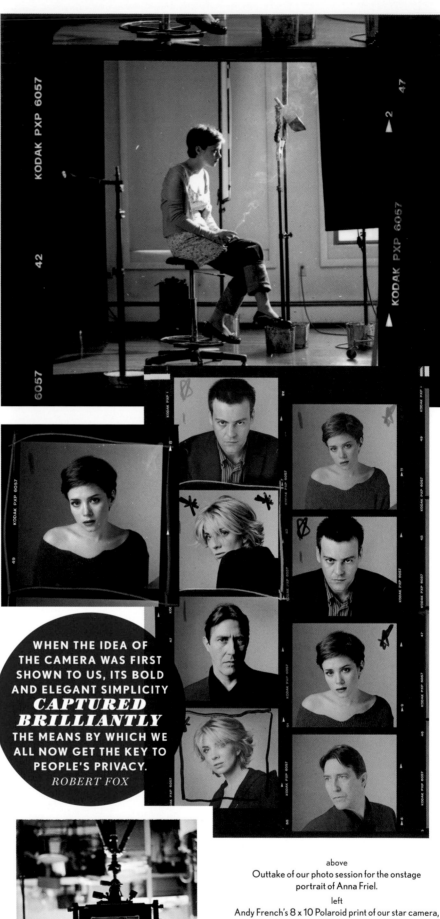

> WHEN THE IDEA OF THE CAMERA WAS FIRST SHOWN TO US, ITS BOLD AND ELEGANT SIMPLICITY *CAPTURED BRILLIANTLY* THE MEANS BY WHICH WE ALL NOW GET THE KEY TO PEOPLE'S PRIVACY.
> *ROBERT FOX*

above
Outtake of our photo session for the onstage portrait of Anna Friel.

left
Andy French's 8 x 10 Polaroid print of our star camera, with our subject Kate Moss inverted as it would have actually been. We had many discussions as to whether or not to put an image in the camera. I battled for it to be upside down. I lost. — D.H.

NATASHA RICHARDSON
RUPERT GRAVES * ANNA FRIEL
CIARAN HINDS

CLOSER

WRITTEN AND DIRECTED BY
PATRICK MARBER

ROBERT FOX SCOTT RUDIN ROGER BERLIND CAROLE SHORENSTEIN HAYS ABC, INC. THE SHUBERT ORGANIZATION
PRESENT NATASHA RICHARDSON RUPERT GRAVES ANNA FRIEL CIARAN HINDS
IN THE ROYAL NATIONAL THEATRE PRODUCTION OF CLOSER WRITTEN AND DIRECTED BY PATRICK MARBER
DESIGNED BY VICKI MORTIMER LIGHTING BY HUGH VANSTONE ORIGINAL MUSIC BY PADDY CUNNEEN
CASTING BY ILENE STARGER SOUND BY SIMON BAKER GENERAL MANAGER STUART THOMPSON
TECHNICAL SUPERVISOR AURORA PRODUCTIONS PRODUCTION STAGE MANAGER R. WADE JACKSON PRESS REPRESENTATIVE BONEAU/BRYAN-BROWN
MUSIC BOX THEATRE 239 WEST 45TH STREET (212) 239-6200

KAT AND THE KINGS

SOUTH AFRICAN TROUPE
PUTS ON A SHOW.

—— THE EVENT ——

**REMEMBER
ROCK 'N' ROLL?**

KAT AND THE KINGS *WAS* an original musical from South Africa by way of London's West End. It was about apartheid, and American doo wop respectively, and besides being a wonderful show, it also had the basis of true events. Rather than make it look like South Africa, we tried to emulate the look of touring doo wop band bills, when many acts would appear in one night. This may have been a mistake—looking back, knowing all that we have learned of South Africa, I would like to believe people might be intrigued by that subject on its own, without the sheen of America added to it.

My favorite part of the show was after the curtain came down each night. As the audience filed outside, the cast formed an a cappella group on the street, much as the fictional group in this tale. The audience literally squealed with delight at the breaking of the fourth wall just as they thought the evening was over. We pitched the producers a TV commercial that would plant cars along the street, and at the moment the cast appeared to sing on the curb, cameramen would climb up on the roofs of these cars to shoot over the crowd that instantly formed a performance circle on the sidewalk every night. Instead of the much-maligned and often fake-feeling testimonial commercials where theatergoers "bought the mug" or the ladies whose husbands "work in this area" rave, these would be true testimonials of passionate love for a show, without saying a word. We would just show people what the audience was actually feeling with the added benefit of having the theater as a background. We pitched and we pitched, but the clients just couldn't see it. To this day, I so wish we could have tried it. It remains one of the untried gems we still hope to attempt for some plucky Broadway producer.
—D.H.

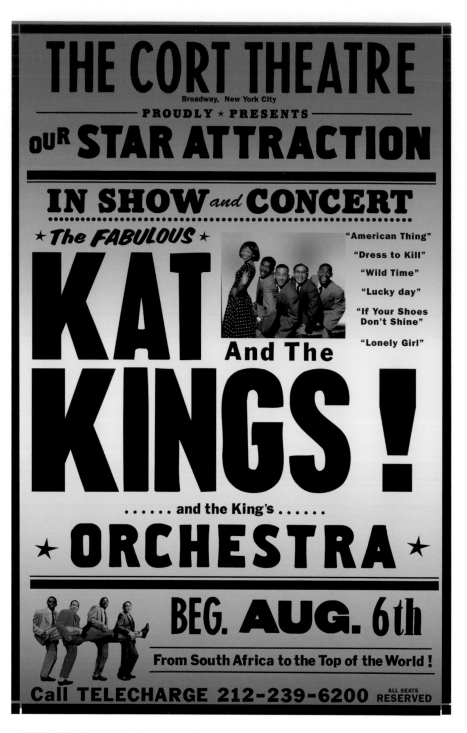

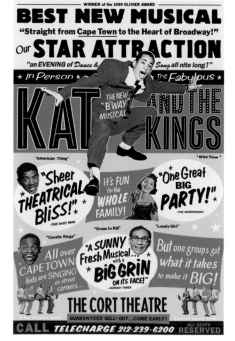

MY FAVORITE PART OF THE SHOW WAS AFTER THE CURTAIN CAME DOWN, AS THE AUDIENCE FILED OUTSIDE, THE CAST FORMED AN A CAPPELLA *GROUP ON THE STREET*.
DREW HODGES

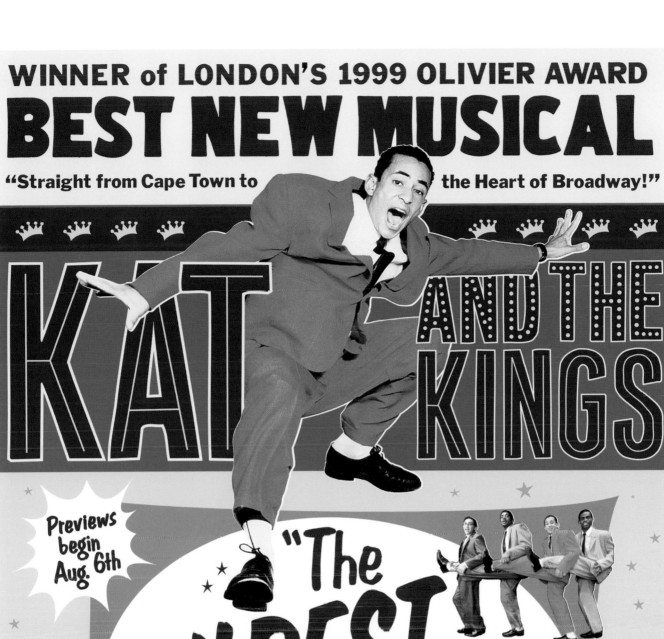

THE VAGINA MONOLOGUES

THE NON-EVENT

OFF-BROADWAY AGITPROP.

THE EVENT

SPREAD THE WORD
(DIRECTOR JOE MANTELLO'S BRILLIANT TAG LINE). WORLDWIDE.

EVE ENSLER
PLAYWRIGHT/ACTOR

I REMEMBER WHEN DAVID Stone first showed me the poster. Somehow unembellished, undisguised, just there with no apology, fanfare or hesitation, the whole thing was a bit startling, real, terrifying, and very exciting. It mirrored exactly what I was feeling bringing the play uptown to the mainstream. I had a not-so-positive reaction to "Spread the Word" at first sight. I was afraid it might come off as exploitative or objectifying. David and I talked for a long time about it, and I began to see that it was more provocative than exploitative. In the end, I really came to love it. Open the mysterious world between our legs and say the word, "Vagina." And I think it was brilliant how that single microphone implied both standup and monologue. I think looking back, that the artwork really helped me step into my brave, and it visually defined certain qualities of the show that I aspired to throughout.

DAVID STONE
PRODUCER

WHEN WE OPENED, CNN DID an eight-minute piece on Eve and never said the word "vagina." In selling the show, we realized we had to take a negative—people were scared of the word—and make it a positive. We decided we would have to be very graphic, very political, very in your face. And that's why there's so much blank space in the art. We never filled the page. We forced you to look right at it. There was always a headline at the top of the ad that drew you in. Some of them the *Times* wouldn't let us run. It's certainly the most politically effective ad SpotCo has ever done. In the way the design reflected the show's content, it was the most groundbreaking.

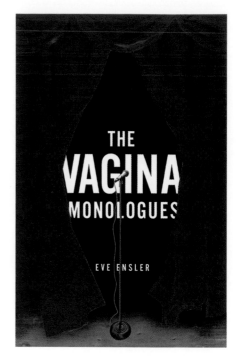

> WE DECIDED WE WOULD HAVE TO BE *VERY GRAPHIC, VERY POLITICAL, VERY IN YOUR FACE.*
> *DAVID STONE*

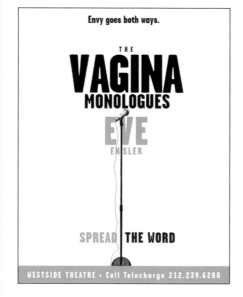

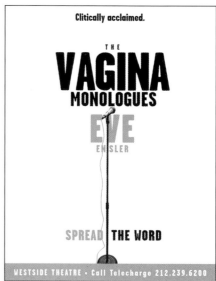

right
The Vagina Monologues'
#1 piece of swag,
a change purse. And yes,
it had a nickname.

THE
VAGINA
MONOLOGUES

EVE
ENSLER

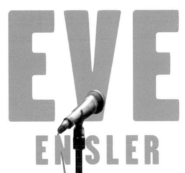

SPREAD THE WORD

FULLY COMMITTED

THE NON-EVENT

A NON-EVENT.

THE EVENT

A PLAY ABOUT NOW, THAT'S REALLY FUNNY. NOTHING MORE, BUT IN FACT
A REAL RARITY.

FULLY COMMITTED *WAS A* one-man, Off-Broadway comedy that was a blast to watch. It was all about a receptionist at an uber-hot restaurant, and all of the characters (celebs, celebs' assistants, dowagers, journalists) who call and attempt to squeeze in a reservation. Since no one really aspires to attend a one-person show, we thought it would be fun to showcase the characters who call in—the advertising license of showing an imaginary cast. We hit upon the idea of using the format of the *Zagat Guide*, and none other than Tim Zagat himself gave us permission to ape his look (savvy businessman and promoter that he is). It was a perfect device to both frame the restaurant-of-the-moment theme and showcase terrific quotes. —D.H.

> **EVERYTHING YOU EVER HEARD IS TRUE. JOAN RIVERS WAS A SELF-PROMOTIONAL** ***DYNAMO*** **AND A PRO. THE PHOTOGRAPHER ALLISON LEACH WENT TO HER OFFICE, AND JOAN GAVE HER 10 PERFECT LOOKS IN 10 MINUTES OF SHOOTING.**
> *DREW HODGES*

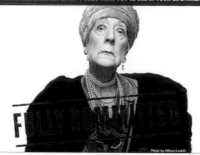

"I HAVE MORE MONEY IN MY PURSE THAN YOU'LL SEE IN YOUR LIFETIME."

"HOOK ME UP WITH A TABLE, I TAKE CARE OF YOU —BADA-BOOM."

"NAOMI WON'T EAT MUCH. TRUST ME."

"NO TABLE? WE JUST PAID 28 BUCKS TO PARK!"

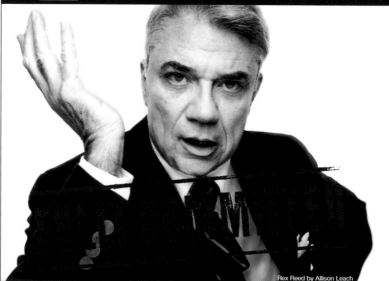

"I'VE **NEVER** BEEN TREATED THIS BADLY...AND I'M A *CRITIC!*"

Rex Reed by Allison Leach

Fully Committed ●⑤ 27 | 26 | 28 | $45

Cherry Lane Theatre, 38 Commerce St.

■ By all accounts, "**this is an immensely entertaining, scaldingly funny play about the bad behavior that good food can inspire**" *(William Grimes, NY Times)*. "**Beg, bribe or steal yourself a ticket**" *(Rex Reed, NY Observer)* to this "**hilarious**" *(Liz Smith, NY Post)*, "**laugh-out-loud pleasure**" *(Time Out)*. The Vineyard Theatre Production starring Mark Setlock. Written by Becky Mode. Directed by Nicholas Martin.
Call Telecharge now at 212-239-6200/800-432-7250 or Telecharge.com

Used by permission of Zagat Survey

THE COMEDY THAT NEVER STOPS DISHING

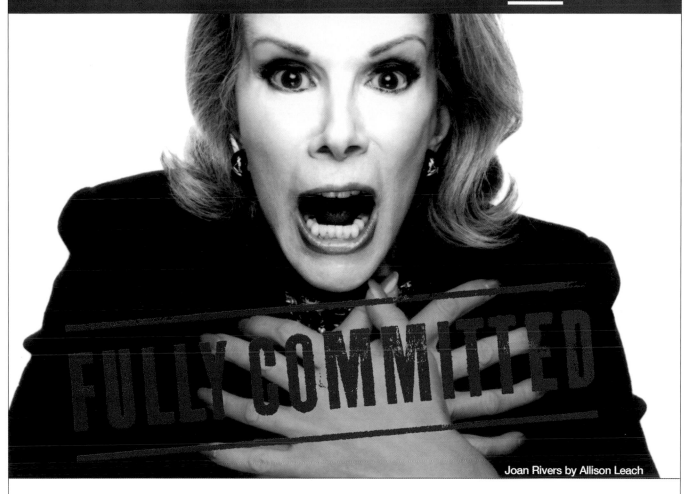
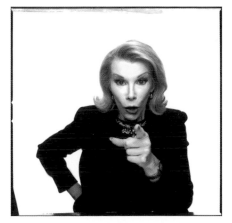
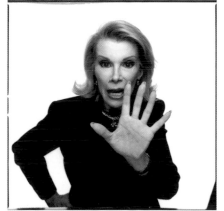
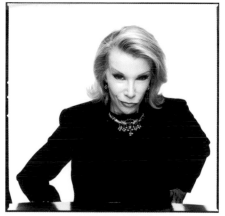
49

THE WILD PARTY

— THE NON-EVENT —

NEW YOUNG COMPOSER, UNKNOWN CAST, NONPROFIT THEATER.

— THE EVENT —

A SEXY, POWERFUL PARTY, AND YOU ARE INVITED.

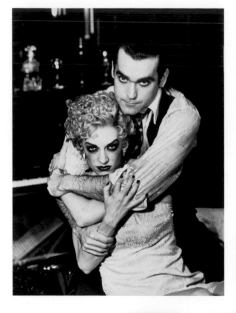

ANDREW LIPPA
BOOK WRITER/LYRICIST/COMPOSER

WHAT COLOR SHOULD THE set be? There we were, with three painted panels placed on the empty stage of Manhattan Theatre Club's Stage 1, comparing puke green, something vaguely blue and, finally, orangey red? The production team was discussing the monochromatic notion of the set for the original production of *The Wild Party* and how it would all be painted with the same color wash.

Oh well, off to a meeting at SpotCo to see what they had cooked up for the marketing and advertising. Getting a show poster of your very own show reminds me of high school when I had posters of *Evita* and *42nd Street* on my wall. I arrive at the meeting and what do I see? The color of the set. No, not puke green or vague blue. Dried blood. This, my friends, was it. This was the color our set should be and SpotCo told us how to do it.

KEVIN BRAINARD
FORMER SENIOR DESIGNER, SPOTCO

WE DID A WHOLE PHOTO shoot with the full cast at Nell's, turning it into a 1920s speakeasy. It was amazing. Like a time machine. Every detail was considered, down to the matches on the table. There was the full cast in costume, there was booze, and photographer Ellen von Unwerth. Ellen was a whirlwind, running around with two assistants holding lights and shooting from the hip. A couple hours in, I switched the music and started with Prince's "Sexy Mother Fucker." All hell broke loose. Clothes started flying off, the cast was full-on making out, pulling each others' clothes off, candle wax was poured onto bodies. Ellen was constantly yelling, "Get naked!" It truly turned into a wild party.

above
Brian d'Arcy James and Julia Murney terrifyingly in character.

below
The same is true of Idina Menzel and Taye Diggs. This show belonged on Broadway, and we had the images for an amazing campaign—too bad we just didn't get the chance to run it. —D.H.

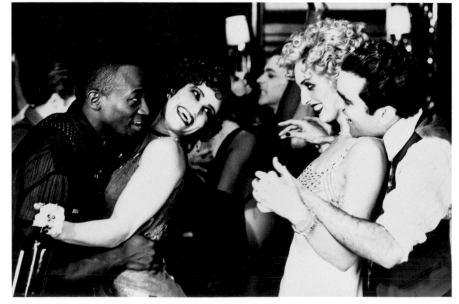

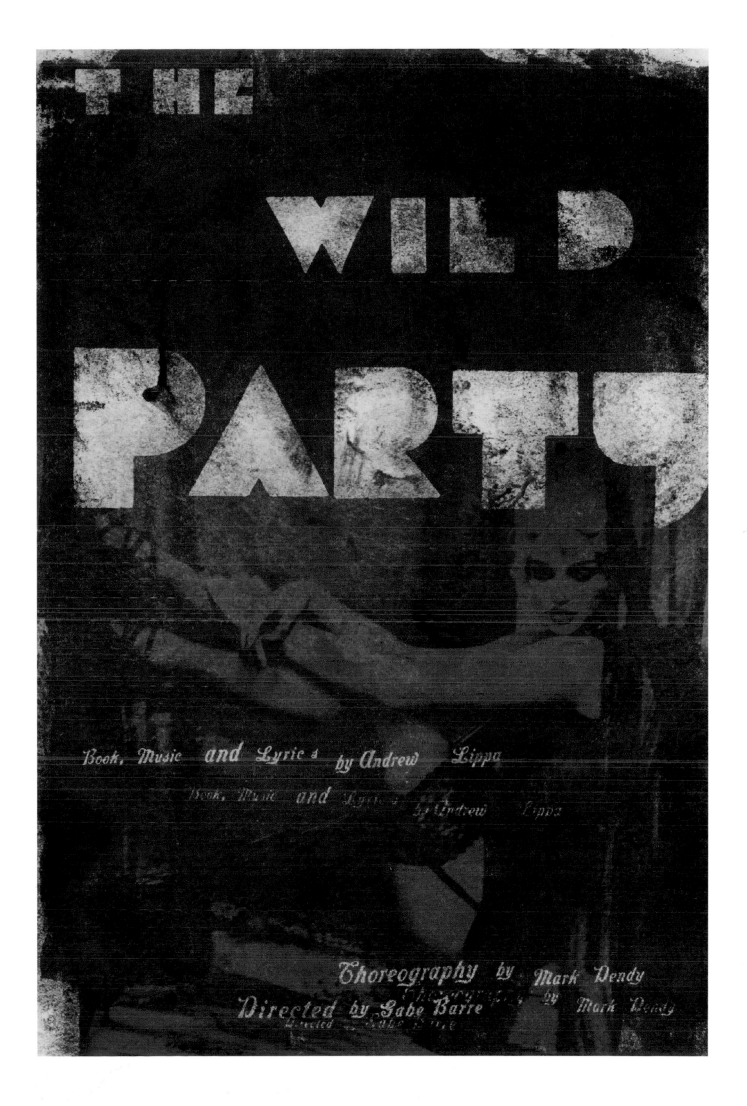

TRUE WEST

— THE NON-EVENT —

SUPPORTING ACTORS IN A DOWNTOWN REVIVAL.

— THE EVENT —

TWO EXTRAORDINARY ACTORS *BORN TO BE STARS* (WHO WEREN'T QUITE YET).

MARK BURDETT
FORMER ART DIRECTOR, SPOTCO

I WAS GOING TO THE PHOTO shoot for *True West* with Philip Seymour Hoffman and John C. Reilly. Len Irish, who is a great portrait photographer, was hired for the shoot. It was an early morning call, and I arrived very early to set up some wardrobe, and Len was setting up backdrops and lights, when suddenly I spied out of the corner of my eye Philip sitting alone at a table in the corner with a cardboard cup of coffee in one hand and a pen in the other doing what appeared to be the *New York Times* crossword puzzle. I froze. The caterer was not expected for another half hour. I went over and introduced myself and said that the caterer should "be here shortly" but until then could I make a run to Starbucks or the corner deli and pick up something for him. He said no. "But what you could do is go over and get yourself a cup of coffee, come back and help me with this fucking crossword puzzle. It's really a pain today!" So I got myself a cup of coffee and did just that. After several cups and many laughs, we finished the puzzle.

Although we shot many images of the two actors together, the final image was composed of two solo shots. When I showed Phil the comp, he remarked it seemed "strange" to see his face on the poster, and so large. He later told me on another project (*Long Day's Journey Into Night*), that he didn't think plays should be advertised with photography. —D.H.

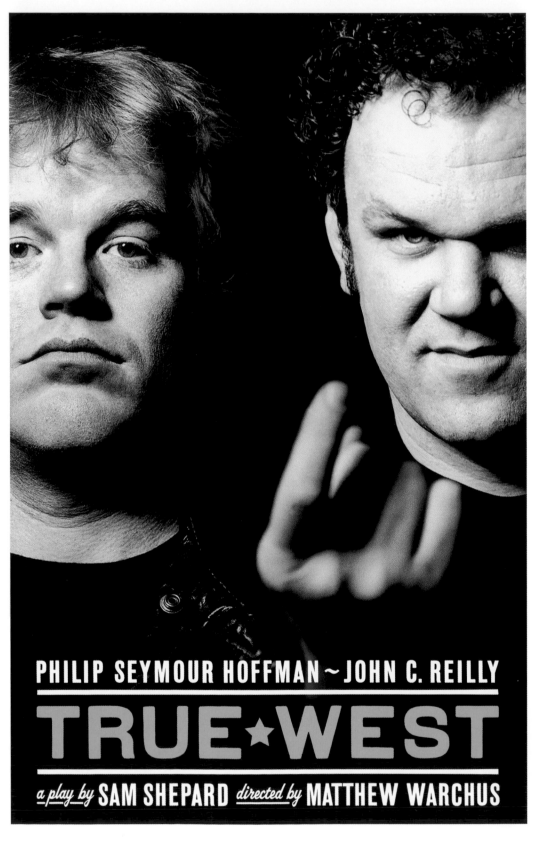

PHILIP SEYMOUR HOFFMAN ~ JOHN C. REILLY

TRUE ★ WEST

a play by SAM SHEPARD *directed by* MATTHEW WARCHUS

THE LARAMIE PROJECT

—— THE NON-EVENT ——

RELIVING MATTHEW SHEPARD'S MURDER.

—— THE EVENT ——

PORTRAIT OF AN AMERICAN TOWN, AND A PLACE.
COME ON A JOURNEY.

MOISÉS KAUFMAN
DIRECTOR

THE DIFFICULTY WITH LARAMIE is that people would think it'a play about the violent murder of a young boy. It isn't.

It's about a town, about how the people there responded to the murder. And the challenge was to show this was not a play that would brutalize the audience. So in the poster, I knew we wouldn't show the fence [that Matthew Shepard had been tied to when he was left to die]. It's about a place, not the scene of a crime. It's about the town of Laramie. So I remember when we saw the image of the long road to Laramie thinking that was right. It's an invitation to the journey into the heart of this town.

We began *The Laramie Project* with designs that satirized Wyoming's ultra-masculine cowboy culture. However Moisés was quick to point out that the project was not an indictment of any culture, but an exploration into a town, and all the complicated characters who lived there. Our first poster was a cheap shot. — D.H.

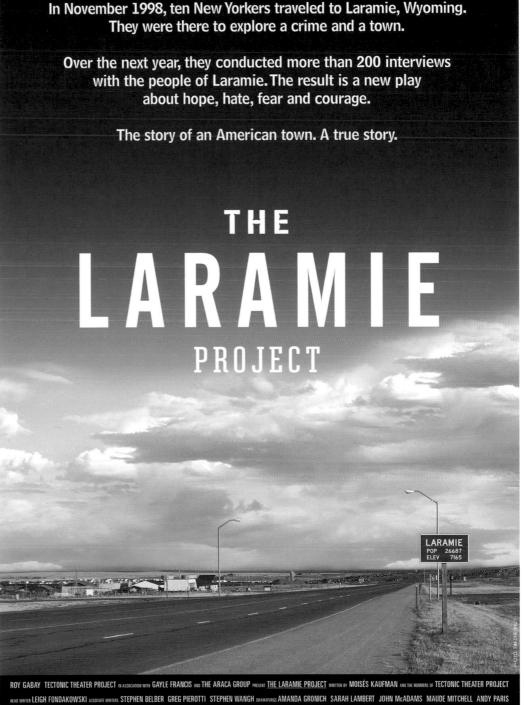

THE TALE OF THE ALLERGIST'S WIFE

— THE NON-EVENT —

CUTE COMEDY.

— THE EVENT —

SMART, FUNNY, WHILE *EAVESDROPPING AT ZABAR'S.*

CHARLES BUSCH
PLAYWRIGHT

LEGITIMACY AT LAST. THE *Tale of the Allergist's Wife* took very accessible comic New York Jewish characters and placed them in a somewhat enigmatic sexual landscape that evoked, at least to my mind, Pinter and Albee. When Drew and the folks at SpotCo presented me with wild enthusiasm a prototype of the poster designed by the *New Yorker* cartoonist Roz Chast, my heart sank. It was a cartoon of a frazzled lady poking her head out of a shopping bag. I'm embarrassed to admit that I wasn't familiar with Roz Chast. That night I had dinner with my two sisters. I was moaning about the poster and how I was once again being marginalized. When I mentioned that it was designed by a lady named Roz Chast, their eyes bugged out. They excoriated me for being such an ignoramus not to realize that this was an incredible coup, that Chast never did commercial work, that this was the greatest thing that had happened to the "three" of us in our entire lives!

LYNNE MEADOW
ARTISTIC DIRECTOR, MANHATTAN THEATRE CLUB

I WILL NEVER FORGET THE day that Drew Hodges showed me five choices for the art for the show. I immediately zeroed in on one that was totally perfect. It was Drew's favorite too. The art we loved captured the essence—the wit and the joy—of the play. SpotCo had gone to Roz Chast, the brilliant *New Yorker* cartoonist, who created the image of a bewildered, beleaguered, intellectual housewife. The poster itself actually made you laugh. It was a show in and of itself.

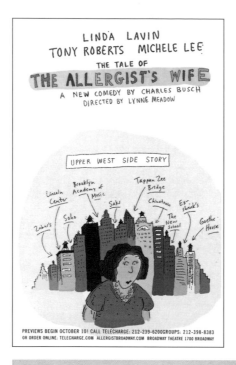

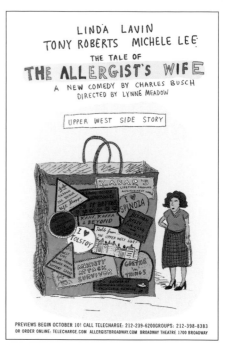

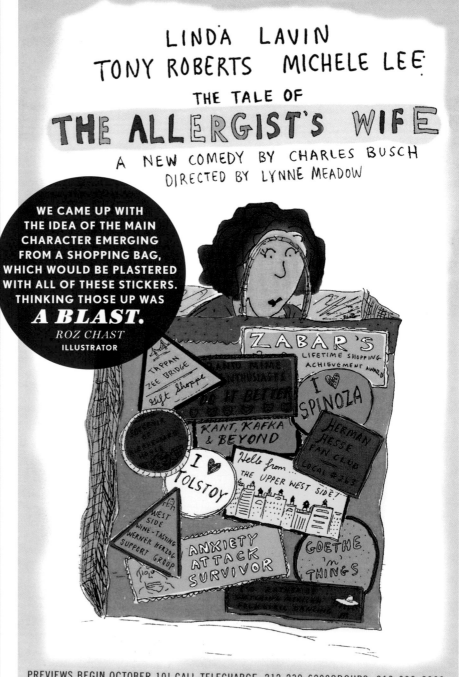

WE CAME UP WITH THE IDEA OF THE MAIN CHARACTER EMERGING FROM A SHOPPING BAG, WHICH WOULD BE PLASTERED WITH ALL OF THESE STICKERS. THINKING THOSE UP WAS *A BLAST.*
ROZ CHAST
ILLUSTRATOR

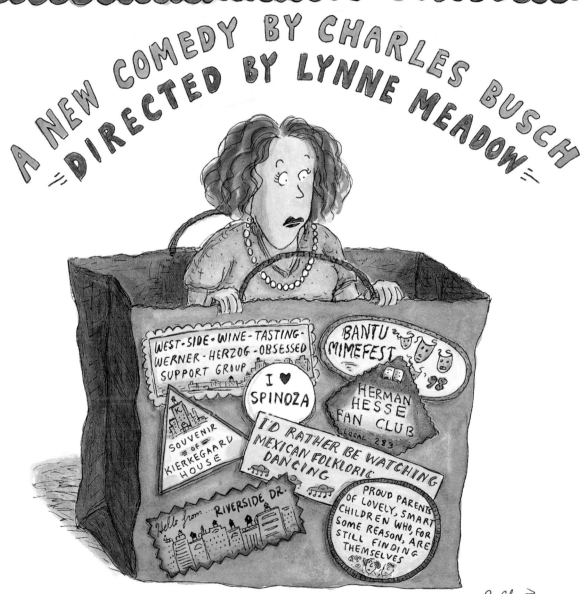

LINDA LAVIN
TONY ROBERTS MICHELE LEE
THE TALE OF
THE ALLERGIST'S WIFE

A NEW COMEDY BY CHARLES BUSCH
=DIRECTED BY LYNNE MEADOW=

WEST-SIDE-WINE-TASTING-
WERNER-HERZOG-OBSESSED
SUPPORT GROUP

BANTU
MIMEFEST
'98

I ♥
SPINOZA

HERMAN
HESSE
FAN CLUB
Local 283

SOUVENIR
OF
KIERKEGAARD
HOUSE

I'D RATHER BE WATCHING
MEXICAN FOLKLORIC
DANCING

Hello from RIVERSIDE DR.

PROUD PARENTS
OF LOVELY, SMART
CHILDREN WHO, FOR
SOME REASON, ARE
STILL FINDING
THEMSELVES

R. Chst

MANHATTAN THEATRE CLUB: LYNNE MEADOW-ARTISTIC DIRECTOR BARRY GROVE-EXECUTIVE PRODUCER CAROLE SHORENSTEIN HAYS DARYL ROTH STUART THOMPSON and DOUGLAS S. CRAMER
PRESENT LINDA LAVIN TONY ROBERTS MICHELE LEE SHIRL BERNHEIM ANIL KUMAR in *THE TALE OF THE ALLERGIST'S WIFE* by CHARLES BUSCH
SET DESIGN BY SANTO LOQUASTO COSTUME DESIGN BY ANN ROTH LIGHTING DESIGN BY CHRISTOPHER AKERLIND SOUND DESIGN BY BRUCE ELLMAN
AND BRIAN RONAN TECHNICAL SUPERVISOR GENE O'DONOVAN PRODUCTION STAGE MANAGER WILLIAM JOSEPH BARNES CASTING BY NANCY PICCIONE/
DAVID CAPARELLIOTIS PRESS REPRESENTATIVE BONEAU/BRYAN-BROWN MTC ASSOCIATE ARTISTIC DIRECTOR MICHAEL BUSH DIRECTED BY LYNNE MEADOW

CALL TELECHARGE: 212-239-6200 OR ORDER ONLINE: ALLERGISTSWIFE.COM
Ⓖ BARRYMORE THEATRE 243 W 47TH STREET

SEUSSICAL THE MUSICAL

--- THE NON-EVENT ---

FOR KIDS.

--- THE EVENT ---

POP CAN BE A GROWN-UP GOOD TIME, TAKIN' IT *TO THE STREETS.*

BARRY WEISSLER
PRODUCER

THE BIGGEST CHALLENGE in approaching the artwork for *Seussical* was figuring out a way to present Dr. Seuss's characters, whose illustrations are already so iconic and beloved by readers, in a fresh and unique way. In creating a Broadway adaptation of his stories, our goal was not to produce a replica of his books onstage, but rather Seuss through the lens of a contemporary pop artist like Andy Warhol or Keith Haring. This led us to David LaChapelle, whose photographs scream color, life, and imagination. It was a risky choice. David's work at the time was known for being so hypersexual and ultra-provocative. We'd have to keep it safe for primetime, but what better way to completely obliterate the notion that we were just "children's theater." The results speak for themselves. The campaign opened up the show to a much more varied demo.

KEVIN CHAMBERLIN
ACTOR

SO THERE WE WERE, TAKING over a city street for a day, with all of our *Seussical* props and set pieces and costumes. My favorite image—The Cat in the Hat's iconic red-and-white-striped hat peaking out of a manhole cover—gave the show a hip, subversive, bold look for the show's poster. Horton spends most of the show sitting on a nest in a tree, so for my shot, they built a ten-foot-high Seussian "truffula tree" with a tiny wooden seat at the top. Speaking of challenges, it was quite a feat—precariously climbing up a ladder to perch my butt on top of the big pink puff—in the middle of a street in Newark, New Jersey. (And who knew

Knowing we wanted to replicate some of Dr. Seuss's architecture and madcap machinery, we began modeling shapes with clay in our conference room, later built by a set shop out of foam and fiberglass. The comp in the middle left shows designer Sandra Planeta in what we hoped would be Times Square. But we wanted to do the shoot live and not use Photoshop to make it happen. So once props were built, we closed a street in Newark and set up shop. Lastly, this is the original image of our key art before David LaChappelle's magic makers got a hold of it. David's newest assistant got the unwanted task of climbing down into an actual sewer to get this shot. — D.H.

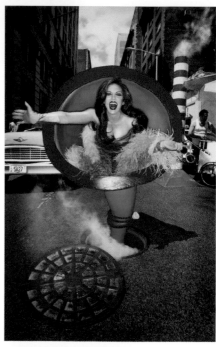

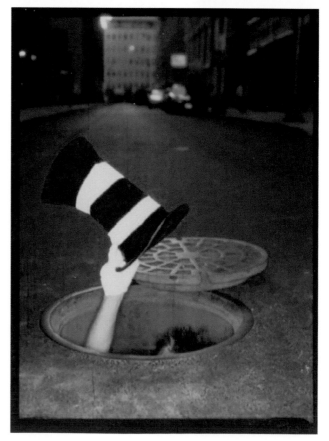

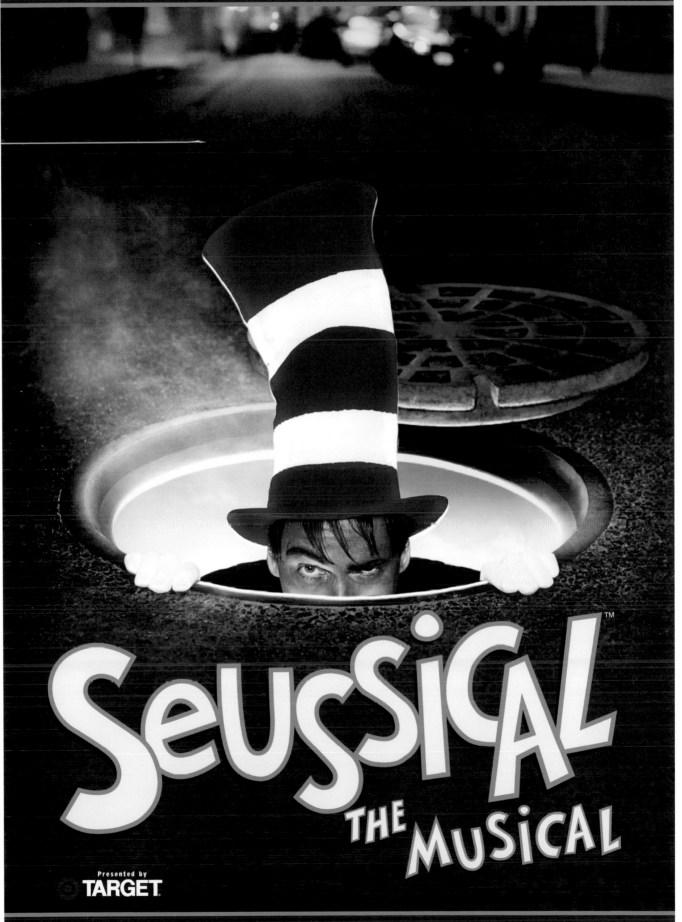

that truffle trees tickle?) It was a pure joy to collaborate with David, Drew and the entire design team as we all jumped in the sandbox together that day, embracing our playful, unselfconscious, outlandish "thinks" and digging up that childhood imagination in all of us to bring Horton the Elephant and all of the denizens of Whoville and the Jungle of Nool to life.

SEUSSICAL *WAS THE FIRST* show I really came to love in a reading, and perhaps my toughest lesson in how intoxicating a reading can be. A reading is basically a performance in a barn, except your barn is a dance studio usually lined with a wall of mirrors and plywood inside a nondescript office building in Manhattan. You sit on folding chairs, and the wings are imaginary. The cast sings and dances in leotards and sweats, as close as eight feet from you, with no mics, only what God gave them. If you ever wondered if what we do is fun, think of doing this, and then you will know. It is beyond fun—it's an honor, a mind-blowing joy to see that much talent perform in raw form. Seeing the sweat, feeling the floor shake when people dance, you know what a gift really looks like.

For the advertising, we wanted to connect that world of Dr. Seuss to ours, quite literally. We convinced supernova photographer David LaChapelle to shoot the campaign. That alone took months. Then we coaxed him to use our ideas. He told me he had tried and tried to come up with his own so as not to use ours. He said he didn't like to use clients' ideas. But he finally decided ours were actually good. And so we built everything we could, from tubs to nests in trees, and went to Newark to close a street and open a manhole. David's world seems so magical beyond the film he shoots that's it's easy to imagine these images are somehow "digital." In fact, you can see just how banal real life is in the image where David's poor intern had to climb into the manhole and hold the hat. And the rest of it—that's real, too. Kevin Chamberlin sat on the nest, the tub filled with water, and the bubbles flowed. Kids from the neighborhood yelled and squealed from the sidewalks. And David delivered amazing images.

A producer once told me "show me a hit show and I will show you good art," and she's right. Meaning, the hits look great, the flops don't, regardless of the art. So this work was never celebrated, and the show struggled from day one, never matching the joy of the reading. But I still find in the art the joy I found at that reading. —D.H.

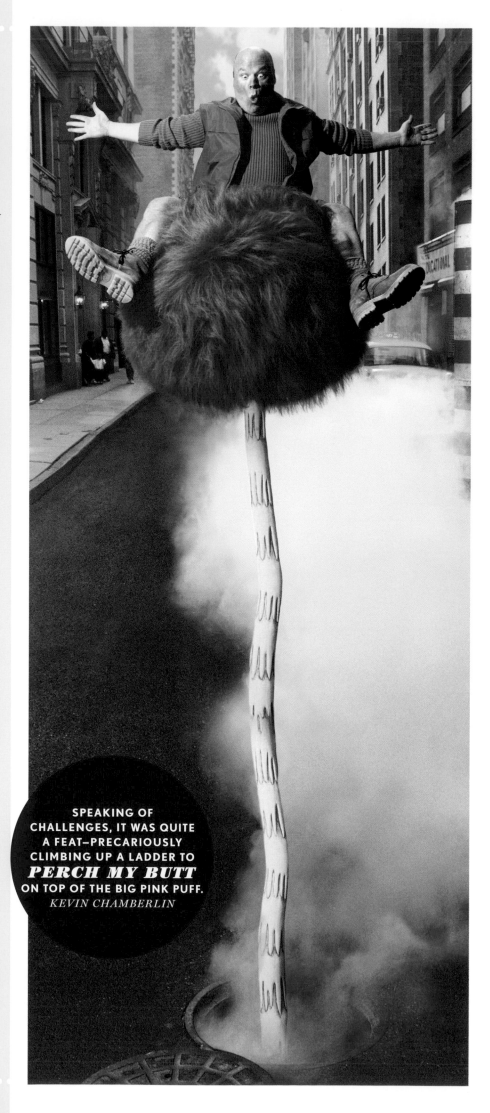

SPEAKING OF CHALLENGES, IT WAS QUITE A FEAT—PRECARIOUSLY CLIMBING UP A LADDER TO *PERCH MY BUTT* ON TOP OF THE BIG PINK PUFF.
KEVIN CHAMBERLIN

ALBEE

— THE NON-EVENT —

ALBEE IS ABSTRACT.

— THE EVENT —

ALBEE IS LITERATE, SURPRISING,
AND A POWERHOUSE.

WE HAVE WORKED WITH playwright Edward Albee and producer Liz McCann three times. And it demands the best of all of us each time. The nature of what we do is reductive. Every good piece of theater—let alone the great—has layers and layers of subtlety and meaning. So our job is to find the clear paths, the ideas that can communicate to the largest audience— and that rarely endears us to playwrights. Still, we have our job to do, and they have theirs.

When I presented the *Who's Afraid of Virginia Woolf?* posters to Edward Albee, he said, "I don't like them." I asked why. He said, "Because my play is not about drinking." Then he looked at me with that defiant twinkle of his, daring me to debate with him what his masterwork was indeed about. And we were sunk. I still love the idea of this poster, but Edward sure didn't. We ended with a beautiful photo by Mary Ellen Mark, and kept it simple.

The most fun we had was on *The Goat, or Who is Sylvia?* It's a play about a man who falls out of love with his life and in love with a goat. But it is deeply human. First, we made comps that took advantage of the very strange fact that goats' pupils are actually rectangular. Google it: It's true and arresting. Then we tried a comp with a bouquet of chewed flowers, just what you might find on your first date with a goat. Eventually, we decide to just shoot it literally—get a goat and shoot a family portrait. When we did it, we did it all live in one shot, and the goat literally posed as if she had been born to it. Mercedes Ruehl played it like the mistress was in the room and refused to acknowledge her presence. —D.H.

ELIZABETH I. McCANN
PRODUCER

THAT POSTER FOR THE GOAT, *or Who Is Sylvia?* came about because that's what Edward [Albee] wanted. It was his motivation. He wanted us to

EDWARD ALBEE's
THE PLAY ABOUT THE BABY

CENTURY CENTER · 111 EAST 15TH STREET

ELIZABETH IRELAND McCANN · DARYL ROTH · TERRY ALLEN KRAMER · FIFTY-SECOND STREET PRODUCTIONS
ROBERT BARTNER · STANLEY KAUFELT in association with the ALLEY THEATRE present

BRIAN MURRAY MARIAN SELDES
in EDWARD ALBEE'S THE PLAY ABOUT THE BABY
with DAVID BURTKA KATHLEEN EARLY
directed by DAVID ESBJORNSON

set design by JOHN ARNONE costume design by MICHAEL KRASS lighting design by KENNETH POSNER sound design by DONALD DiNICOLA production manager KAI BROTHERS
production stage manager MARK WRIGHT press agent SHIRLEY HERZ ASSOCIATES casting JERRY BEAVER & ASSOCIATES general manager ROY GABAY associate producer FRANCI NEELY CRANE

ILLUSTRATION BY BRIAN CRONIN

show the goat itself. I can't remember if we auditioned other goats for the photo shoot, but the one we ended up using was very docile and very easy to deal with. I think the actors were more afraid of her than she was of them. And this wasn't the same goat we used in the production, obviously. Mercedes Ruehl came out at the end carrying a very real-looking goat, which was a prop. It's a lot for an audience to take in and a bitch trying to get right. Edward is very specific with his props—it had to be a white goat. There's the umbrella in *Who's Afraid of Virginia Woolf?* There's the crawling baby in *The Play About the Baby*. And there's the goat in *The Goat*. He loves these outlandish props. A lot of people at the time were saying, "I don't want to see a play about a man fucking a goat." But that isn't what the play is about. I think a lot of people were frightened by the play, but when they saw it, they realized it wasn't what they thought it was.

DARREN COX
SPOTCO

WE EXPLORED SEVERAL ideas that took a metaphorical approach to the branding, but in the end, we felt a more straightforward solution would be best. Naturally, we settled on a family photo with a goat. In order to make the photo more shocking we decided to include a character who is never seen in the show [except in death] but is the subject of the lead character's affection.

It would be best to have a real goat on set instead of Photoshopping one in, so we held a casting call. After much debate, we landed on a beautiful beast named Champagne. As it turned out, Champagne was pregnant, which made her a little lethargic. Champagne could only be on set for short bursts and needed to take several breaks during the shoot, unlike Bill Pullman and Mercedes Ruehl, who worked tirelessly. There were times that I needed to coax Champagne to the set by pushing her from behind, which would have been tough, if I didn't have the cast and crew to cheer me on.

AFTER MUCH DEBATE, WE LANDED ON **A BEAUTIFUL BEAST NAMED CHAMPAGNE.**
DARREN COX

This wonderful portrait was made on set, and features Edward Albee, his partner Jonathan Thomas, and producer Liz McCann.

left
Polaroids on set, where we shot with and without our goat. As you can imagine, it was not easy to get Champagne to hit her marks and smile for the camera.

below
Larry Fink's searing image of Sally Field and Bill Irwin, who took over in the play as it extended its run on Broadway. — D.H.

BILL PULLMAN MERCEDES RUEHL

EDWARD ALBEE'S

THE GOAT
— OR —
Who is Sylvia?

directed by
DAVID ESBJORNSON

BAT BOY

QUIRKY WEIRD.

— THE EVENT —

SO PULP CRAZY YOU WILL LOVE IT.

NANCY NAGEL GIBBS
PRODUCER

WHEN I ATTENDED AN EARLY reading of *Bat Boy: The Musical*, I had never picked up a *Weekly World News*, and I had never heard of one of their signature characters, Bat Boy. I almost didn't go because the picture was so grotesque. But when I saw the reading and found a show that delves into parent/child relationships, community bias, bullying, and ultimately love in its many variations, I was riveted. When SpotCo began to develop the design concept and title treatment for the show, and they found an image that showed our Bat Boy, the handsome young man with pointy ears and an amazing voice, hiding in plain sight on a regular day amidst regular people, it was clear that the Bat Boy was unthreatening in everyday life. We also needed to make sure the audience did not think it was a show about baseball. The image was eye-catching and evocative and intriguing. I have never received so many calls about advertising artwork.

RICHIE FAHEY
PHOTOGRAPHER

I'D BEEN DOING ART FOR small theater shows and for book covers, and I had been wanting to work with SpotCo—they were always doing cool images—when they approached me for this job. I think initially it was going to be a series with Bat Boy in different locations. I was pleased with the location they found: the Jones Diner on Lafayette and Great Jones. I didn't think they rented out for photo shoots but somehow SpotCo got it for us. It was a small shoot. I had one assistant who doubled as an extra, and my then-wife, Maria, who came with a waitress costume we had. SpotCo supplied two other extras. I supplied coffee cups and SpotCo brought the newspaper.

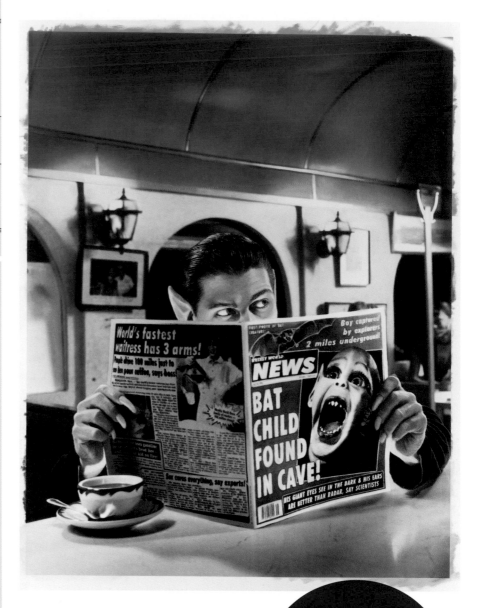

above
An outtake from our shoot shot in black and white, printed and then hand colored by Richie Fahey.

below
Two comps that used old circus tent signage and horror film stills as their inspiration.

WHEN IT CAME TIME TO SELL IT AS A FUNNY LOVE SAGA, WE USED THE LINE, "THE PASSION. THE ROMANCE. *THE POINTY EARS."*
GARTH WINGFIELD
FORMER SENIOR WRITER, SPOTCO

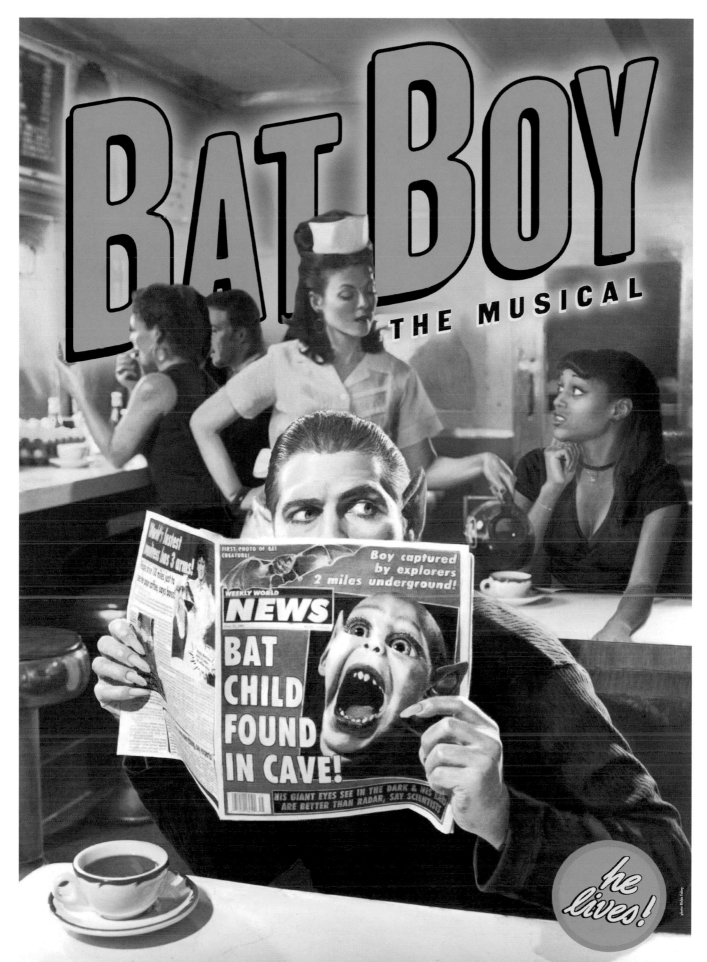

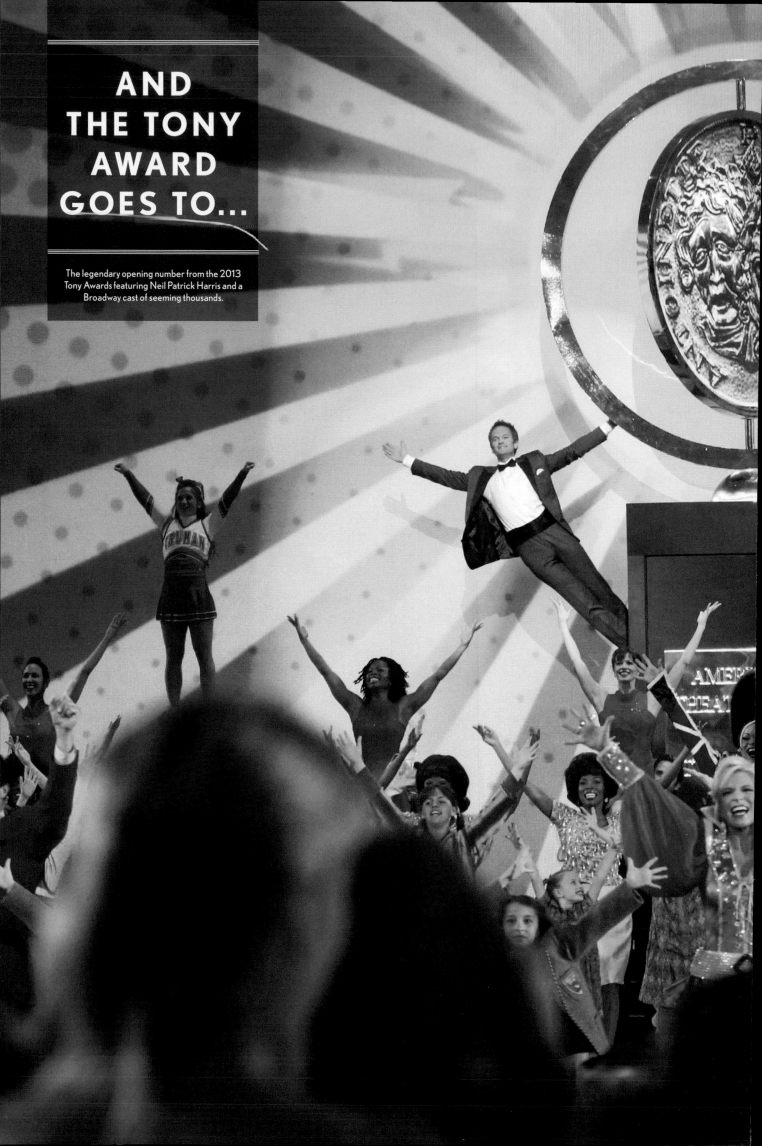

AND THE TONY AWARD GOES TO...

The legendary opening number from the 2013 Tony Awards featuring Neil Patrick Harris and a Broadway cast of seeming thousands.

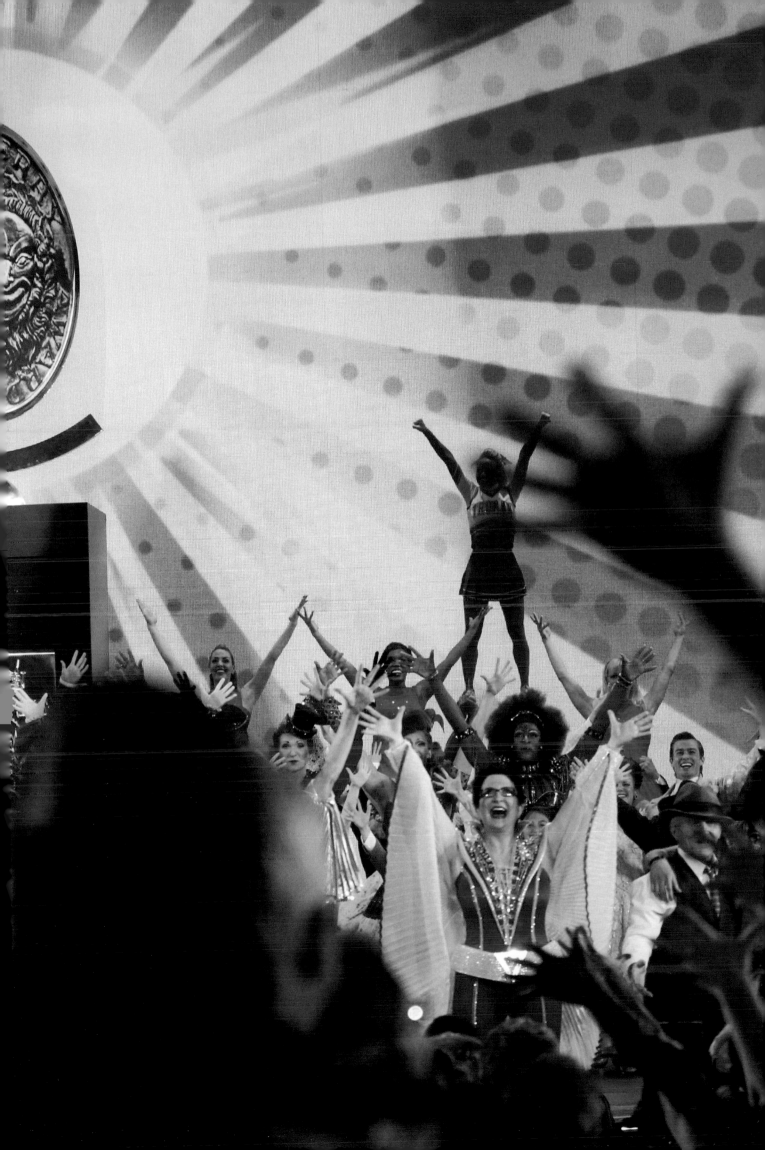

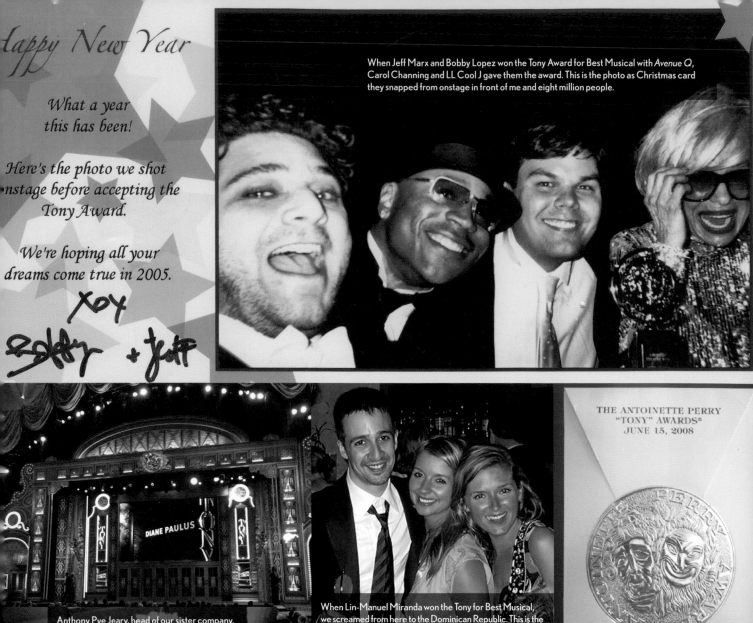

Happy New Year

What a year this has been!

Here's the photo we shot onstage before accepting the Tony Award.

We're hoping all your dreams come true in 2005.

xoy

Bobby + Jeff

When Jeff Marx and Bobby Lopez won the Tony Award for Best Musical with *Avenue Q*, Carol Channing and LL Cool J gave them the award. This is the photo as Christmas card they snapped from onstage in front of me and eight million people.

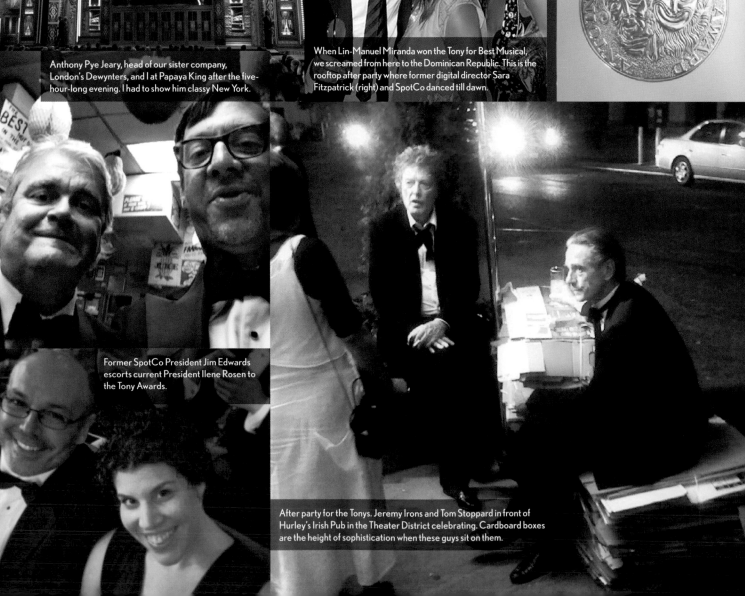

Anthony Pye Jeary, head of our sister company, London's Dewynters, and I at Papaya King after the five-hour-long evening. I had to show him classy New York.

When Lin-Manuel Miranda won the Tony for Best Musical, we screamed from here to the Dominican Republic. This is the rooftop after party where former digital director Sara Fitzpatrick (right) and SpotCo danced till dawn.

THE ANTOINETTE PERRY "TONY" AWARDS®
JUNE 15, 2008

Former SpotCo President Jim Edwards escorts current President Ilene Rosen to the Tony Awards.

After party for the Tonys. Jeremy Irons and Tom Stoppard in front of Hurley's Irish Pub in the Theater District celebrating. Cardboard boxes are the height of sophistication when these guys sit on them.

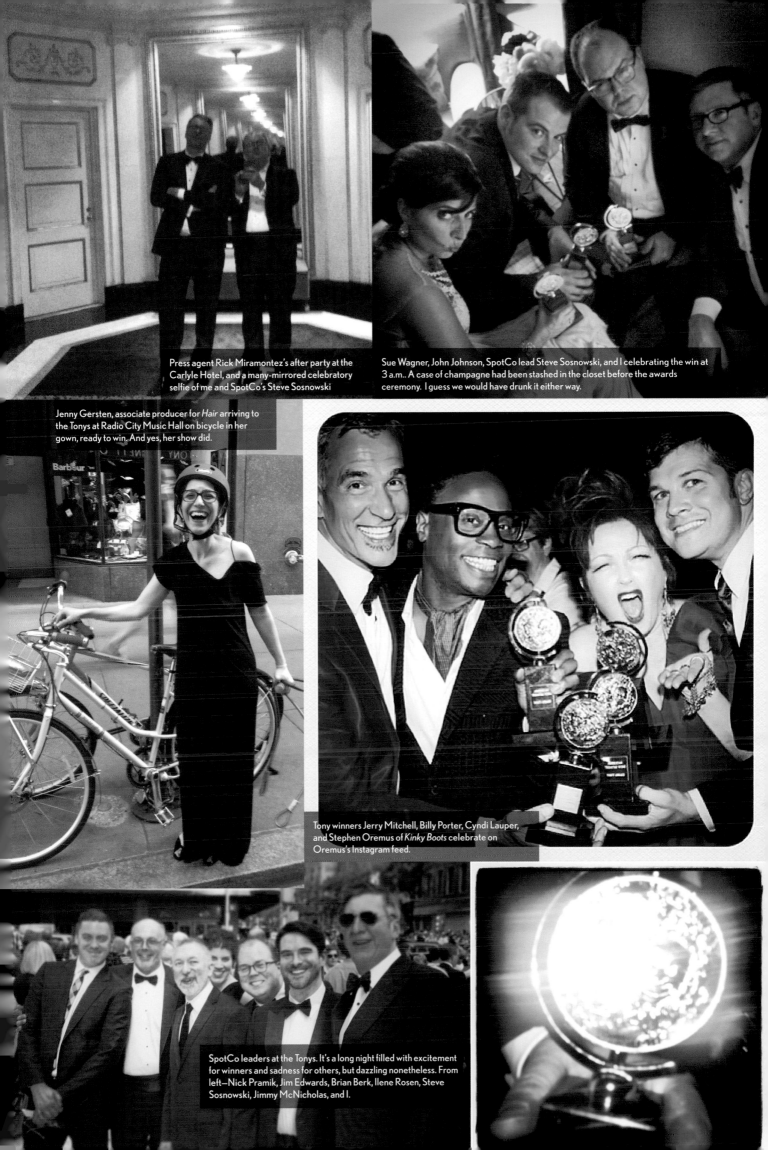

Press agent Rick Miramontez's after party at the Carlyle Hotel, and a many-mirrored celebratory selfie of me and SpotCo's Steve Sosnowski

Sue Wagner, John Johnson, SpotCo lead Steve Sosnowski, and I celebrating the win at 3 a.m.. A case of champagne had been stashed in the closet before the awards ceremony. I guess we would have drunk it either way.

Jenny Gersten, associate producer for *Hair* arriving to the Tonys at Radio City Music Hall on bicycle in her gown, ready to win. And yes, her show did.

Tony winners Jerry Mitchell, Billy Porter, Cyndi Lauper, and Stephen Oremus of *Kinky Boots* celebrate on Oremus's Instagram feed.

SpotCo leaders at the Tonys. It's a long night filled with excitement for winners and sadness for others, but dazzling nonetheless. From left—Nick Pramik, Jim Edwards, Brian Berk, Ilene Rosen, Steve Sosnowski, Jimmy McNicholas, and I.

THE SHAPE OF THINGS

NEIL LaBUTE
PLAYWRIGHT/DIRECTOR

I REMEMBER HAVING A "meaningful dialogue" with the producers about the art up front and then being shown the comps, and what ended up being the final poster was clearly the standout, although I really liked the one with the classical sculpture too. But I just thought the final poster took on the themes of the play very well—a human being acted upon, projecting the words onto the body, creating art *on* someone. It was a great graphic, an iconic image that didn't give too much away. I mean, it's such a hard thing to do—to capture the spirit of a play. I'm not a thematic writer. I don't start out to write about religion or race. The themes emerge. So I really appreciate it when people can say, "This is what the play is about," when they can figure it out graphically. And I was really impressed that the producers wanted to try something like this. We had four actors who were very sellable. They could have just shown a photo of them. But they wanted to do something else to catch the eye. Seeing this now really brings back a lot of great memories to that place in our careers. In one calendar year, there were four distinctly different ad campaigns around this play. The first one, the Faber & Faber printed edition of the script from the London production, used a painting by a local artist I'd seen in a clothing store. At the same time, all four of the actors who were appearing in the London production were asked to show up at 7 a.m. before rehearsal for a shoot; they were all young and beautiful but when you see that photo now, you think, "They look like they were asked to show up at 7 a.m. for this photo shoot." Then there was the New York poster (described above). Finally, we all went to L.A. and made the movie, which had yet a different poster. All in all, an amazing year filled with many different artistic visions.

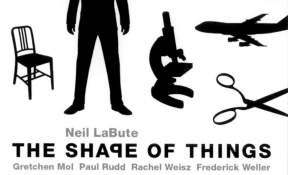

Neil LaBute
THE SHAPE OF THINGS
Gretchen Mol Paul Rudd Rachel Weisz Frederick Weller
CALL TELECHARGE 212/580-1313 or 212/239-6200
Promenade Theatre, Broadway at 76th Street

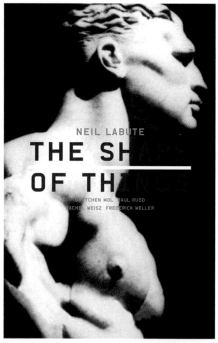

NEIL LaBUTE
THE SHAPE OF THINGS
GRETCHEN MOL PAUL RUDD
RACHEL WEISZ FREDERICK WELLER

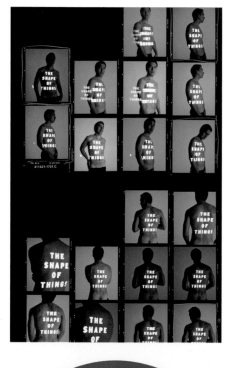

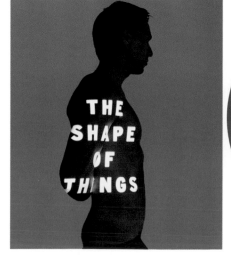

THE IDEA WAS TO PROJECT TYPE ONTO A BODY, AND I WAS ASKED TO MODEL FOR THE COMP. WE HIRED A PROFESSIONAL MODEL FOR THE SHOOT, BUT BECAUSE THE CLIENTS LIKED THE COMP, I ALSO GOT TO POSE. I REMEMBER *HOLDING MY BREATH* WHEN THEY CHOSE, HOPING THEY'D PICK MINE. AND THEY DID.
REX BONOMELLI
FORMER DESIGNER
(AND MODEL), SPOTCO

Gretchen Mol Paul Rudd Rachel Weisz Frederick Weller

THE SHAPE OF THINGS

a new play written and directed
by Neil LaBute

Susan Quint Gallin Sandy Gallin Stuart Thompson Ben Sprecher and USA/OSTAR Theatricals PRESENT Gretchen Mol Paul Rudd Rachel Weisz Frederick Weller
IN THE Almeida Theatre Production OF The Shape of Things WRITTEN & DIRECTED BY Neil LaBute SET DESIGN Giles Cadle COSTUME DESIGN Lynette Meyer LIGHTING DESIGN James Vermeulen
SOUND DESIGN Fergus O'Hare for Aura PRODUCTION STAGE MANAGER Jane Grey TECHNICAL SUPERVISOR Rob Conover PRESS REPRESENTATIVE Richard Kornberg and Associates
GENERAL MANAGEMENT Stuart Thompson Productions/Charlie Whitehead

TIX By Phone 212-580-1313 • Telecharge 212-239-6200 or Telecharge.com • Promenade Theatre Broadway at 76th Street

NOISES OFF

THE NON-EVENT ——

ENGLISH REVIVAL.

—— THE EVENT ——

HILARIOUS FARCE WITH A FISH.

PETER DE SÈVE
ILLUSTRATOR

ONE OF THE MOST DIFFICULT things to overcome when I get an assignment, *any* assignment, is the art director's sketch. This is by no means a knock on art directors; it's simply that once an image is suggested, assuming it's not the perfect image, it's all I can do to forget it and come up with something else. That's my recollection of my poster for the screwball farce *Noises Off* anyway. Before I could say, "No thank you!" I received an email that included a rough drawing of faces peeking through a curtain and smiling comically at the viewer. Not only would this require that I do "funny" portraits of people that don't exist (never portray the star of the show, he could slip in the shower and all is lost), but frankly, it didn't really seem to say anything in particular about the show itself. And that was the other thing: I had never seen *Noises Off* and had no idea about what kind of a show it was. Fortunately, SpotCo was kind enough to send me to a performance, starring Patti LuPone, and before too long, I had my idea. What I learned was that if *Noises Off* is about anything, it's about people running through doors, shouting and carrying sardines. So that's what I did.

WHAT I LEARNED WAS THAT IF *NOISES OFF* WAS ABOUT ANYTHING, IT'S ABOUT PEOPLE RUNNING THROUGH DOORS, *SHOUTING AND CARRYING SARDINES.*
PETER DE SÈVE

above
Illustrator Dan Adel's wonderful sketch of the audience in stitches.
below
Storyboard drawings reflecting the first and second act of *Noises Off* we sent to Peter deSève at the start of his work.

AMBASSADOR THEATRE GROUP and ACT PRODUCTIONS
WAXMAN WILLIAMS ENTERTAINMENT, D. HARRIS/M. SWINSKY,
USA OSTAR THEATRICALS and NEDERLANDER PRESENTATIONS, INC.
Present

PATTI LUPONE PETER GALLAGHER

RICHARD EASTON

NOISES OFF

THE ROYAL NATIONAL THEATRE PRODUCTION

The Comedy by
MICHAEL FRAYN

With
KATIE FINNERAN
T.R. KNIGHT
THOMAS McCARTHY
ROBIN WEIGERT

Also Starring
FAITH PRINCE
and
EDWARD HIBBERT

Sets & Costumes by
ROBERT JONES

Lighting by
TIM MITCHELL

Sound by
FERGUS O'HARE *for Aura*

Casting by
JIM CARNAHAN

Technical Supervision
UNITECH

Production Stage Manager
DAVID O'BRIEN

Press Representative
BARLOW • HARTMAN *public relations*

Marketing
TMG - THE MARKETING GROUP

General Management
101 PRODUCTIONS, LTD.

Associate Producers
PRE-EMINENCE
INCIDENTAL COLMAN TOD
CURTIS/JOHNSON

Directed by
JEREMY SAMS

TICKETMASTER 212-307-4100 OR TICKETMASTER.COM | BROOKS ATKINSON THEATRE · 256 WEST 47TH STREET

ELAINE STRITCH AT LIBERTY

--- THE NON-EVENT ---

ONE-WOMAN SHOW, AND I DON'T KNOW THAT WOMAN.

--- THE EVENT ---

A ONCE-IN-A-LIFETIME LEGEND,
WHETHER YOU KNOW HER OR NOT.

TOM GREENWALD
SPOTCO

ELAINE STRITCH WAS A piece of work. But, you know what? She looked great in just a bra and black leggings, even at age seventy-seven.

When we were launching *Elaine Stritch At Liberty*, I had to go downtown to the Public Theater—where she was performing the show prior to Broadway—and show her the radio script. I arrived right on time, which of course was far too early. I waited. And waited and waited. Finally, an assistant stage manager came out. "Tom? You can go on back." I headed to the dressing room. Finally, she appeared. In the aforementioned bra and leggings. "TOM, HOW ARE YA!" She spoke in capital letters. "LET'S SEE WHAT YA GOT!"

As I fumbled with the script, she elbowed me in the ribs and barked, "I DON'T HAVE ALL DAY!" You know how it is—the more people make you wait, the less time they have.

"Here it is, Elaine." She looked the script over for about three seconds, then said, "NICE. I JUST HAVE ONE CHANGE." At which point she grabbed my Magic Marker and wrote a giant 'X' through the whole thing. "HOW'S THAT?" she asked. "Uh . . . " I began, but I was quickly drowned out by her laughter. "COME ON, TOM! I'M JUST HAVING SOME FUN! LET'S FIX THIS THING."

For the next twenty minutes, she rewrote the script—in the margins, on the back, possibly a little even on my arm. By the time she was finished, the script was a hell of a lot better. "WE GOOD? I GOT A SHOW TO DO." I nodded. We sure were. She gave me a little wave, which meant, You're free to go. Of course, I stuck around for the show.

It was one of the greatest evenings of theater in my life.

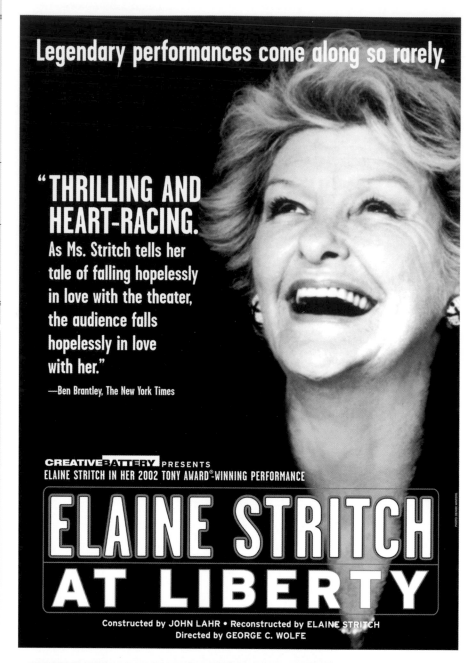

Legendary performances come along so rarely.

"**THRILLING AND HEART-RACING.** As Ms. Stritch tells her tale of falling hopelessly in love with the theater, the audience falls hopelessly in love with her."
—Ben Brantley, The New York Times

CREATIVEBATTERY PRESENTS
ELAINE STRITCH IN HER 2002 TONY AWARD®-WINNING PERFORMANCE

ELAINE STRITCH AT LIBERTY

Constructed by JOHN LAHR • Reconstructed by ELAINE STRITCH
Directed by GEORGE C. WOLFE

Portraits of Elaine Stritch taken by Denise Winters at 1 a.m. on September 11, 2001.

opposite
Elaine's radio script, after she was done "correcting" it.

ELAINE
RADIO :60
"I'm Still Here"

ELAINE: Hello, I'm Elaine Stritch, and I'm ~~bringing my show ELAINE~~ ~~coming to B'way~~
~~STRITCH AT LIBERTY, to Broadway for 80 performances only.~~
~~Now listen, some people call me a living legend. I don't know~~
~~about all that crap.~~ All I know is that in this show I tell a lot of
funny stories about a lot of people, like Garland, Brando and
Rock Hudson. I sing a lot of great songs by people like
Sondheim, Rodgers and Hart, and Berlin. (I also sing Bongo
Bongo Bongo, I'm Not Leaving The Congo, and dance the hell
out of it.) I reminisce about going from the convent in Detroit to
the bright lights of Broadway, trying to be a young actress in
New York and stay a virgin — believe me, it wasn't easy. I
come clean about the bottle, how it protected me, saved me
and almost killed me. I complain about the Tony speech I've
never gotten to give — don't get me started. I talk about the
three most important things in my life: love, work and the hours
between midnight and 4 a.m. But mostly I just stand up there
and celebrate the fact that (SINGS) *Good times and bum
times, I've seen them all and my dear...*
I'm still here.

Handwritten left margin:
I've been there.
before But this
time i'm comin
alone —
Elain Stritch At Liberty
and i hasten to
add For 80
performances
only

Durning the care
of the evening
I'm going to
let you in on

TAG: The New York Times calls ELAINE STRICH AT LIBERTY " a
phenomenon - the season's one indispensable ticket." ELAINE
STRITCH, on Broadway for 80 performances only. Call
Ticketmaster at 212.307.4100 today.

Handwritten left margin:
rubbin elbows
with (~~the likes of~~)
Judy Garland marlon Brando

ELAINE: For God's sake, I'm 76 years old. What the hell are you waiting
for?

Handwritten left margin:
Hal prince
Rock Hudson
Ethel merman gloria Swanson and the like — i'm gonin

Handwritten right margin:
comin to B'way
do m Best
just nice & quiet
if i'm gonna emotional
2 or 3 i'm gonna emotional
i'm gonna
the next Simon Theatre

I'm re few songs around some
between you & me — and 2 or 3
I'm to Blow the roof off the next Simon Theatre

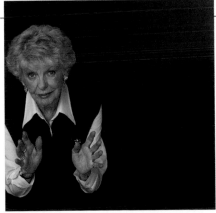

SWEET SMELL OF SUCCESS

THE NON-EVENT ———
MOVIE REVIVAL.

——— THE EVENT ———

GRAPHIC, EDGY, AND DARKLY THRILLING.

NIGEL PARRY

PHOTOGRAPHER

I HAVE THREE VERY MEMO- rable thoughts about this poster in particular: It was shot using film. It was shot to look like Weegee photographs. I made a long-lasting friendship with the actor John Lithgow. It was such a blast to set up little vignettes of things that could be happening and in the news, that led up to and surrounded a make-believe scandal. The fun, flash-on-camera style of lighting was not as easy to accomplish as it sounds since it involved a light constantly being directly above my head under the (sometimes wayward) control of the first assistant. It kept things fluid, but I had one or two bangs and burns on the head. Anything for a photo.

MARK RHEAULT

FORMER PRINT PRODUCER
& ART BUYER, SPOTCO

SWEET SMELL OF SUCCESS was one of the first large shoots I produced. It was to be a reportage account of a slice of New York at night. We needed showgirls, debutantes, paparazzi, and the people who control it all.

The setting was the (now defunct) nightclub Nell's. We utilized every square inch of that place: a built-in phone booth, the street in front of the building, odd corners and booths. There were trumpets, feathers, and cocktails. It was about found moments and ideas on the fly. It seemed crazy and exciting, and I had no idea how a photographer could roll with the chaos we created.

We probably banged out twelve different scenes. It was a whirlwind day. There is an inherent theatricality to what photo shoots are. You go into an empty room and fill it with wardrobe, ideas, performers, lights, makeup, and hairdos. And ten hours later, it all goes back to normal as if none of us had been there. Very *Brigadoon*.

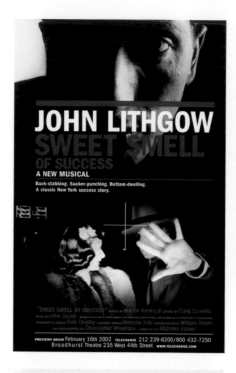

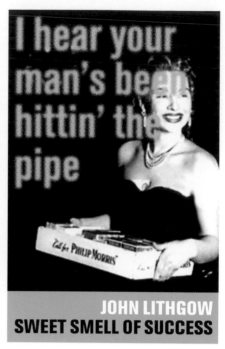

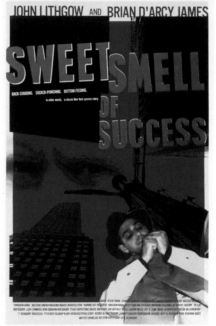

IT WAS SHOT
TO LOOK LIKE
*WEEGEE
PHOTOS.*
NIGEL PARRY

below
Faxed storyboard for *Sweet Smell* commercial by famed title designer, animator, director, and editor Pablo Ferro. Pablo came to early fame by editing in an entirely new vocabulary when he cut the polo sequence in the original *Thomas Crown Affair*, going on to further innovate with titles from Kubrick's *Dr. Strangelove or: How I Learned to Stop Worrying and Love the Bomb* and Jonathan Demme's *Stop Making Sense*, as well as being supervising editor for Michael Jackson's *Beat It* video. To date, this is his only Broadway project. —D.H.

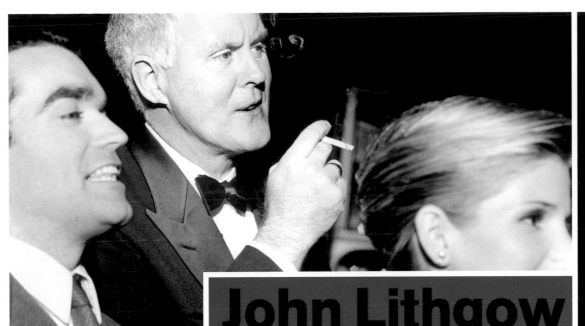
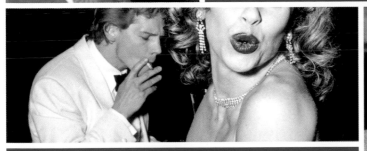
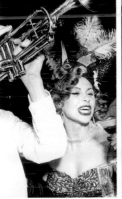

THE TONY AWARDS

THE NON-EVENT

OSCARS—WITH LESSER-KNOWN STARS.

THE EVENT

NOT JUST LIMOUSINES AND RED CARPETS, *THE TONYS ARE NEW YORK.*

WILLIAM WEGMAN
PHOTOGRAPHER

I REMEMBER THE LOCATION was a Broadway theater, and it was the first time I'd shot on location in New York like that. Usually we'd shoot in a studio. We had this big Polaroid camera we'd use, this refrigerator-sized camera. Polaroid made five of them in 1978 to make life-size posters, and after years of shooting executives, they invited artists to start using them too. I was one of the first ones to shoot with them. It was all very complicated with the lighting and the setup. But I trusted the dogs enormously. I didn't think they were an issue. The dogs just react to each other like they're an acting troupe. Batty, who's the daughter of Fay Ray, was the usher. She was very elegant and striking, I thought. Her brother Chundo was working the lights in the backstage scene. Her son Chip was in those scenes too. Her daughter Crooky, who was named for her crooked tail and the spot on her chest, was the sleepy sweep. And then, Batty and Crooky were the feathered dancers. I think I could get them all to stay so still because they see me as someone they want to relate to. They understand that this isn't a one-time joke. It's their job. They're working dogs, in the sense that they get it. They want to go along with it. And they're good at being still because they're pointers. They're bred that way. Their instinct is to point while a hunter blasts a bird out of the sky and goes to get it while they just stand there. But when I look at the photos now, I don't know how I got that effect. It looks like it was shot with a 35mm camera. They look like action shots. I mean, probably half the pictures were disasters, but you build the composition as you go along. I miss shooting with that huge Polaroid camera. This makes me wish I could do that again.

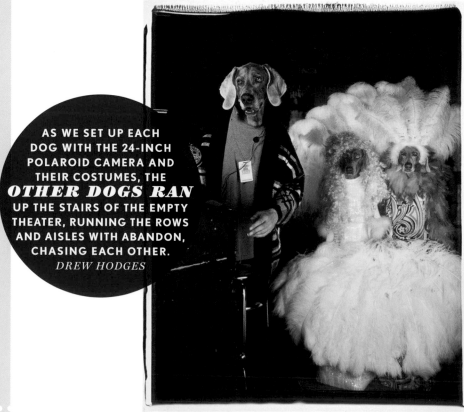

AS WE SET UP EACH DOG WITH THE 24-INCH POLAROID CAMERA AND THEIR COSTUMES, THE *OTHER DOGS RAN* UP THE STAIRS OF THE EMPTY THEATER, RUNNING THE ROWS AND AISLES WITH ABANDON, CHASING EACH OTHER.
DREW HODGES

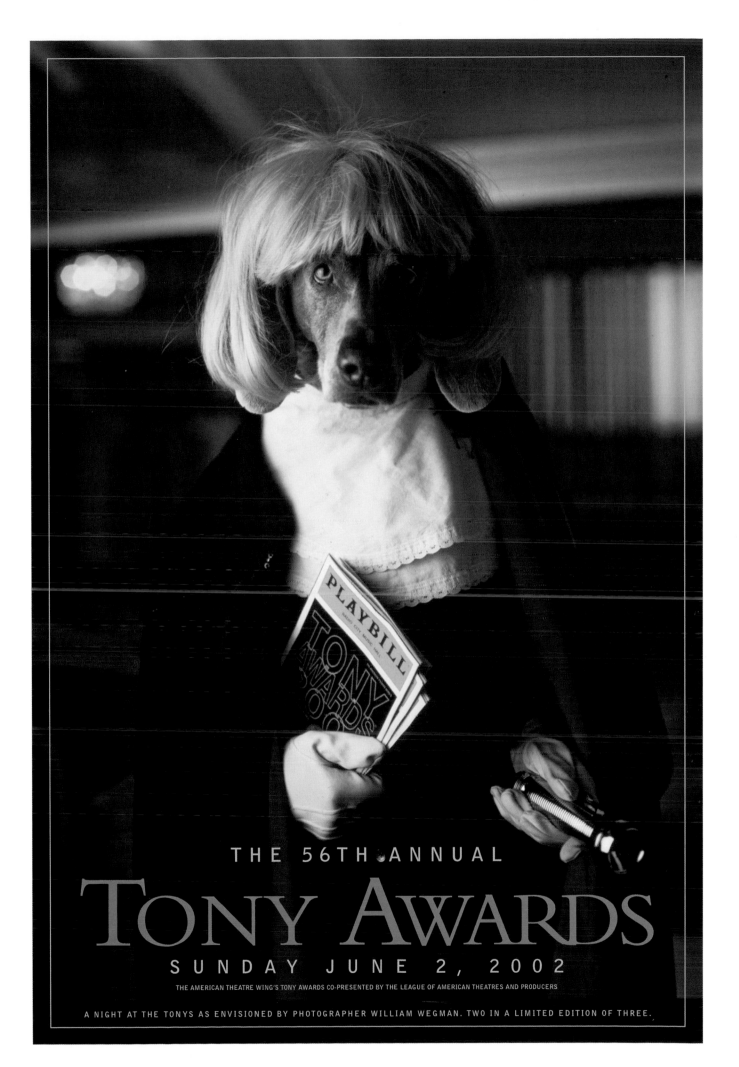

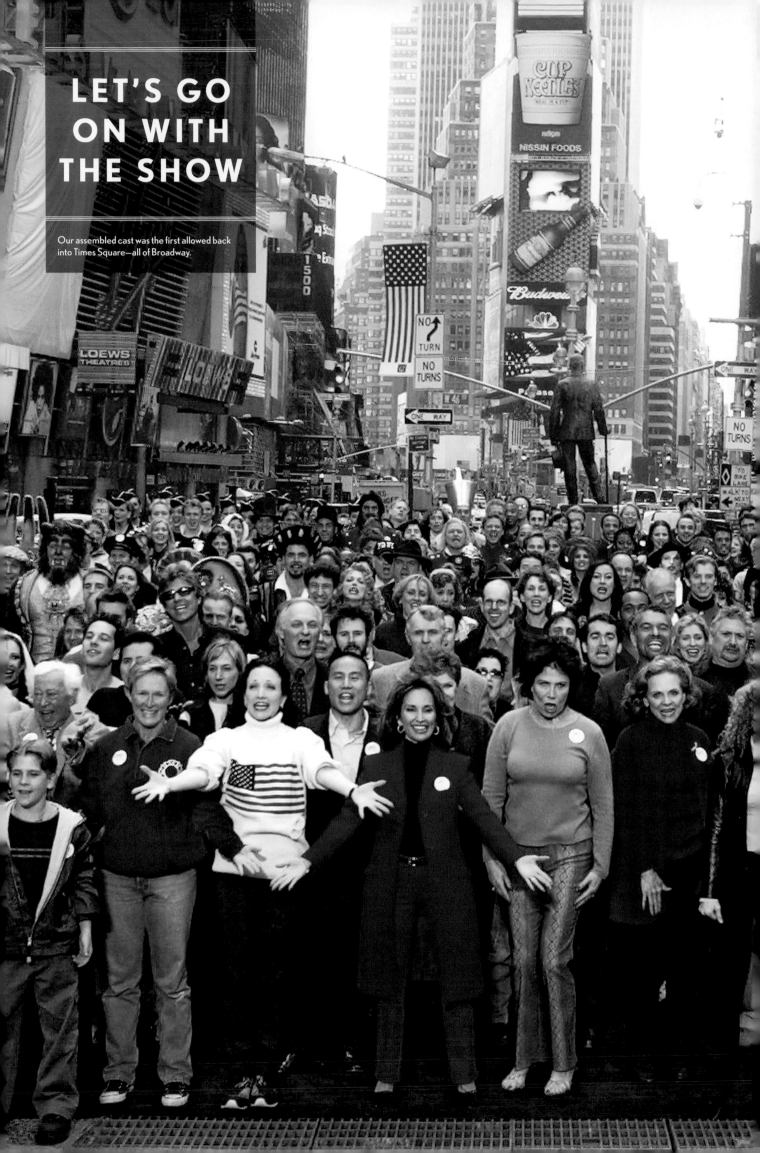

LET'S GO ON WITH THE SHOW

Our assembled cast was the first allowed back into Times Square—all of Broadway.

I REMEMBER WONDERING IF the theatres would ever open again. People were not allowed into Times Square. But after a week, we realized we needed to do something. I began discussing among the office leaders and with producer Barry Weissler about building an advertising campaign to let people know that we were back in business—that Broadway cares. We hatched a plan to ask every Broadway show to appear together, en masse, in Times Square to perform the iconic song "New York, New York." The spot finished with Nathan Lane's voice exclaiming, "Lets go on with the show!" to announce that Broadway was back, and consequently, so was New York. Everyone would have to work for free—performers, crews, unions, even the networks to run the spots.

Ricky Kirshner and his firm White Cherry (who directs and produces the Tonys live) agreed to make the thing, Jerry Mitchell (who directs and choreographs Broadway hits) agreed to stage the dancing, and we set about making the commercial.

The morning of the shoot, we were all nervous. None of us had ever worked with all of Broadway before—I am not sure all of Broadway had ever been assembled in costume before at once. We were the first group allowed back into Times Square, and there was heavy security. On top of that, we had recruited Mayor Giuliani to deliver the line "It's up to you, New York, New York," and his presence would be a closely guarded secret. All Broadway shows were asked to report to their the-aters, don their costumes and head to the Booth Theatre. I was standing in Shubert Alley, preparing to go inside to brief Broadway, when I heard this rhythmic rumble come across what had been a previously desolate Times Square. I looked up to see the entire company of Radio City Rockettes, high-kicking and tapping in formation across the entirety of Times Square, glowing smiles plastered on their faces. I immediately welled into tears—it seemed it was the most beautiful sight many of us had ever seen.

Elaine Stritch arrived hours late, and of course, stepped right into the front line next to Nathan Lane and the commercial,

not having learned the choreography. Nathan graciously tried to teach her what to do, while cameras rolled—we were only going to get so many takes. In my personal vault lies the take where just as Nathan bent down before throwing his hands in the air with every other performer on Broadway, Elaine swung up two beats early, and cracked Nathan across the face, whereupon he did the best pratfall crumble you have ever seem. And: cut.—D.H.

JERRY MITCHELL
DIRECTOR/CHOREOGRAPHER

I WAS IN MICHIGAN SEEING my family. I was about to head to back to New York, and my mother saw this alert on the TV and said, "That's it. I don't think you'll get there." But I had these twelve dancers booked for a rehearsal for *Never Gonna Dance*. And I just thought, "I need to be in New York. I need to be with my friends." So I booked a car and drove there—I'd never done this before. So I got a call from Drew [Hodges], and he said we have to make this commercial to get people to come back to Broadway. And I remember we were all set up in the Booth Theatre, and each of the twelve dancers took a cast of a Broadway show and taught them the choreography as they were walking down the street to Times Square. And I had no perspective, so I climbed up on the statue of George M. Cohan and oversaw it from there. And I looked out, and there's Nathan Lane and there's Bernadette Peters—and there's Elaine Stritch, God rest her soul, who showed up at the last minute and had to be front and center.

JOEL GREY
ACTOR

IT WAS A BEAUTIFUL SUNNY morning when the phone rang and my friend Peter called and said to go to the front windows of my apartment on the Westside Highway. I opened the window and looked to the left, downtown, just in time to see the second plane slice into the World Trade Center. Somewhere inside me I knew then the world, my world, would never be the same. I found myself walking around the city for days with such a crazy disease, discomfort, and sense of helpless-ness. So when I got the call of an impending television commercial involving the theater community coming together for a group sing of "New York, New York" in Times Square, I was there in a flash! And for a brief moment, being in the middle (literally) of my treasured colleagues and shouting defiantly, but also affectionately, that paean to our wounded "Little Town," hope seemed definitely restored.

> IT WAS A JUBILANT DAY, AND BETTER THAN THAT, THE IMAGES RAN EVERYWHERE, PROVIDING THE FIRST REALLY GREAT PICTURES TO THE WORLD THAT BROADWAY AND NEW YORK WERE HERE *SURVIVING AND WOULD GO ON TO THRIVE.*
> —D.H.

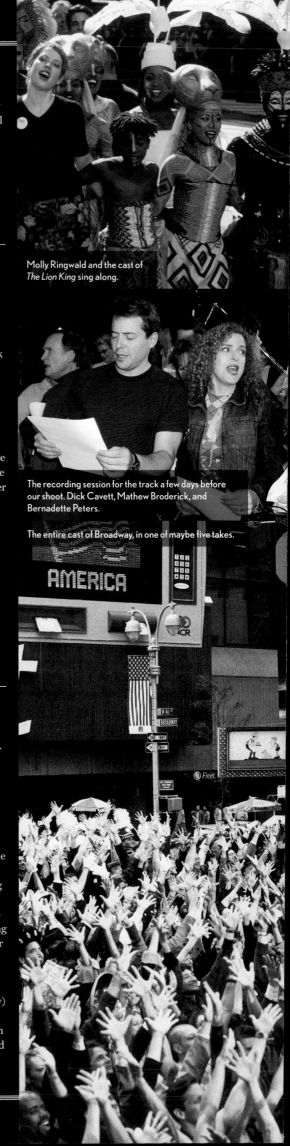

Molly Ringwald and the cast of *The Lion King* sing along.

The recording session for the track a few days before our shoot. Dick Cavett, Mathew Broderick, and Bernadette Peters.

The entire cast of Broadway, in one of maybe five takes.

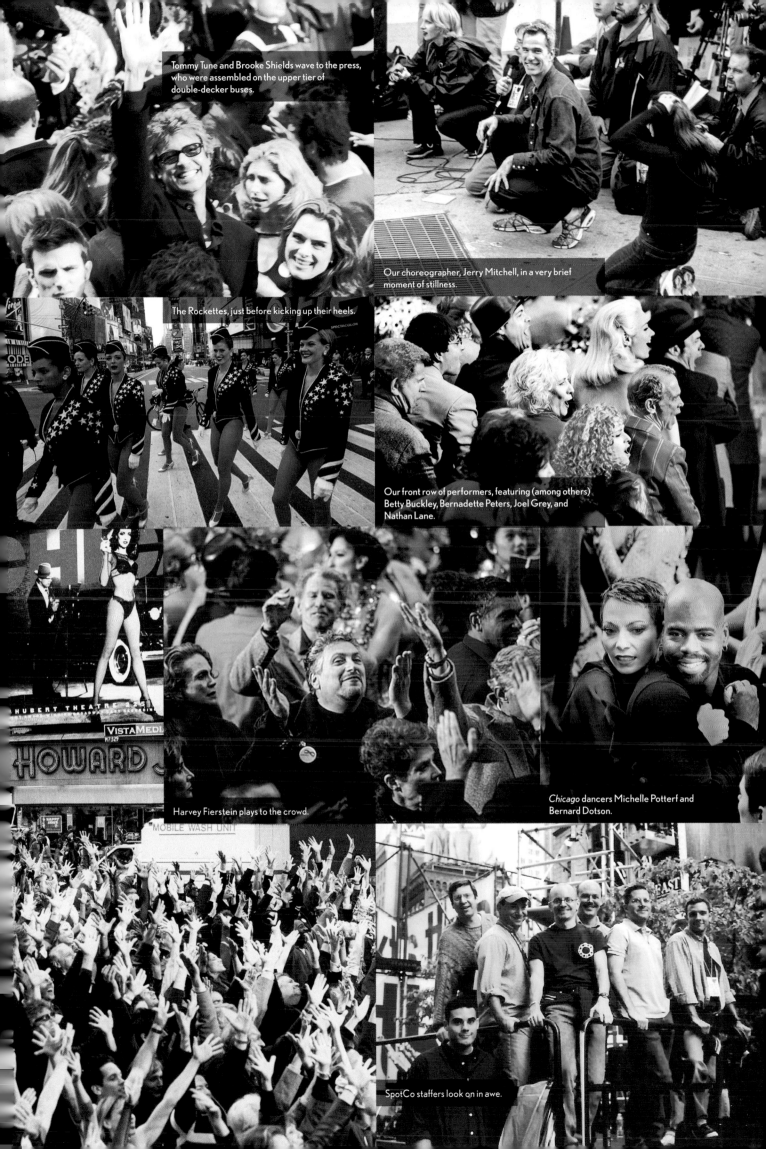

Tommy Tune and Brooke Shields wave to the press, who were assembled on the upper tier of double-decker buses.

Our choreographer, Jerry Mitchell, in a very brief moment of stillness.

The Rockettes, just before kicking up their heels.

Our front row of performers, featuring (among others) Betty Buckley, Bernadette Peters, Joel Grey, and Nathan Lane.

Harvey Fierstein plays to the crowd.

Chicago dancers Michelle Potterf and Bernard Dotson.

SpotCo staffers look on in awe.

MAN OF LA MANCHA

— THE NON-EVENT —

CLASSIC BUT CREAKY REVIVAL.

— THE EVENT —

A FRESH TAKE
ON THE SHOW YOU LOVE.

GAIL ANDERSON
FORMER DIRECTOR OF DESIGN, SPOTCO

*I WAS TASKED WITH CREAT-*ing something iconic rather than illustrative. I sketched out some pretty forced configurations of the title treatment, and then just for fun, tried a version that put Don Quixote on top of the title. There was something kind of exciting about the mule becoming part of the mark itself. I kept sketching, and I had what I thought was a working concept that I could then collaborate with an illustrator on creating.

Drew and I decided to reach out to two artists we'd both worked with over the years, Ward Schumaker and James Victore—both very different, but both utilize play in their work. It would be the first and certainly not the last time I would assign the same project to two illustrators, knowing that someone's work would likely be killed. Strangely enough, in the end, we went with a combination of both artists' renderings, as the producers requested James' Don Quixote be paired with Ward's title treatment. I was worried that the illustrators would balk at the idea, but both were amazingly gracious, as they were fans of each other's work.

A full-page ad ran in the Sunday *New York Times* with our seemingly successful collaboration, and drew praise from designers, including an esteemed colleague out in California, Ed Fella. I was on a total design high—so smitten with my own idea that I went to one of those Broadway souvenir shops in Times Square and bought ceramic *Man of La Mancha* magnets, coffee cups, and key chains. My bubble was burst not long after though, when it was thought that the artwork was *so* iconic and *so* old school that it must have been created for original 1965 production and not something new. Arrrgggh.

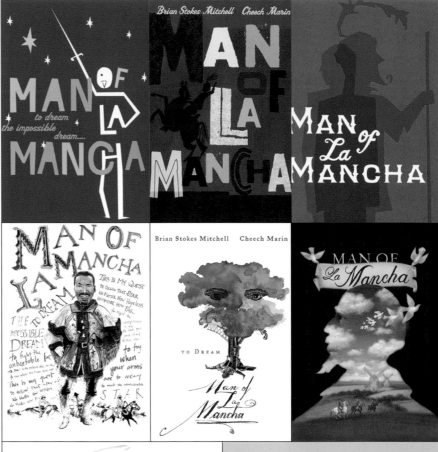

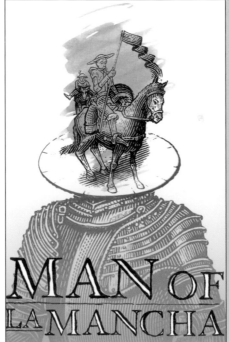

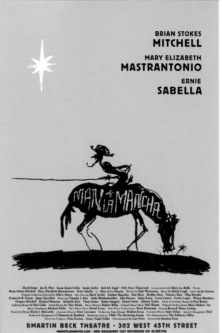

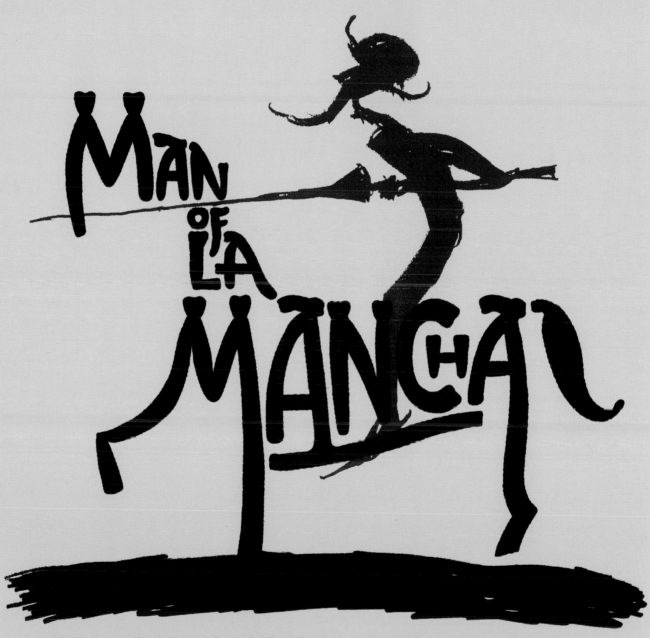

BRIAN STOKES MITCHELL

MARY ELIZABETH MASTRANTONIO

ERNIE SABELLA

David Stone Jon B. Platt Susan Quint Gallin Sandy Gallin Seth M. Siegel USA Ostar Theatricals *in association with* Mary Lu Roffe *Present*
Brian Stokes Mitchell Mary Elizabeth Mastrantonio Ernie Sabella *in* Man of La Mancha *Written by* Dale Wasserman *Music By* Mitch Leigh *Lyrics By* Joe Darion
Original production directed by Albert Marre *Also Starring* Mark Jacoby Stephen Bogardus Don Mayo Bradley Dean Natascia Diaz Olga Merediz
Frederick B. Owens Jamie Torcellini *Featuring* Timothy J. Alex Andy Blankenbuehler John Herrera Jamie Karen Lorin Latarro Carlos Lopez Wilson Mendieta
Gregory Mitchell Richard Montoya Michelle Rios Thom Sesma Jimmy Smagula Dennis Stowe Allyson Tucker *Scenic & Costume Design By* Paul Brown
Lighting Design By Paul Gallo *Sound Design By* Tony Meola *Music Director* Robert Billig *Original Dance Music* Neil Warner *Original Orchestrations* Music Makers, Inc.
Music Coordinator Michael Keller *New Dance Music* David Krane *New Dance Orchestrations* Brian Besterman *Casting* Bernard Telsey Casting
Projection Design Elaine J. McCarthy *Associate Director* Peter Lawrence *Production Stage Manager* Mahlon Kruse *Assistant Director* Jules Ochoa *General Management* EGS
Production Management O'Donovan & Bradford *Marketing Services* TMG-The Marketing Group *Press Representation* The Publicity Office
Executive Producers Nina Essman Nancy Nagel Gibbs *Choreographed By* Luis Perez *Directed By* Jonathan Kent

MARTIN BECK THEATRE · 302 WEST 45TH STREET
MANOFLAMANCHA.COM · NEW BROADWAY CAST RECORDING ON RCAVICTOR

LA BOHÈME

— THE NON-EVENT —

OPERA.

— THE EVENT —

BAZ LUHRMANN CAN MAKE A SHOW SO *BIG AND RICH* THAT YOU HAVE TO SEE IT.

CATHERINE MARTIN
SCENIC AND COSTUME DESIGNER

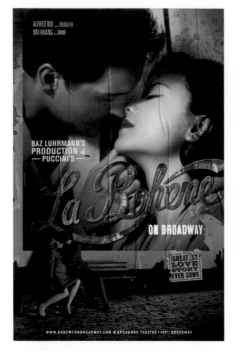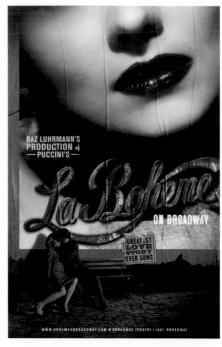

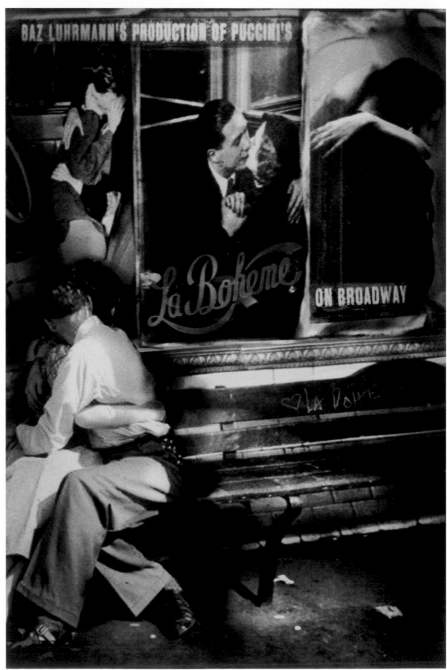

AT THE CONCLUSION OF making the film *Moulin Rouge!* in 2001, we committed to a new production of *La Bohème* which, although a new interpretation, we realized in the spirit of our original 1990 show for the Opera Australian. We decided to reset our production from the 1830s to the Left Bank world of 1957 Paris—the jazz clubs and cafés of Sartre, Nico, and Sagan, a time in which death by tuberculosis was still a credible reality. During our research we were surrounded by images of ultra-romantic Paris: the black-and-white photography of Doisneau, Henri Cartier-Bresson and their predecessor, Brassaï. We put this inspiration to work by developing a colour theory which allowed us to focus on the aesthetic vitality of the bohemian characters that would inhabit the smoky monochromatic palette of the ensemble and set.

In order to translate this aesthetic into advertising images we approached our dear friend and longtime collaborators Douglas and Françoise Kirkland to help us capture the young and dynamic cast in images. The striking images that Douglas Kirkland took were then blended with our signature cursive style title "*La Bohème*." This title was based on the "*L'Amour*" sign featured in the show. Baz was looking for a way to take "*O soave fanciulla*," one of the most famous duets in opera, outside onto the rooftops of Paris.

As we had multiple casts, we decided to produce a number of poster images that celebrated all of our performers. Our aim in developing these graphics for *La Bohème*, as it is for all of our shows, is to take elements that are inherent to the DNA of the show and try and make them speak to an audience on a one-dimensional plane.

David
MILLER
as Rodolfo

Ekaterina
SOLOVYEVA
as Mimi

PHOTOS: DOUGLAS KIRKLAND

BAZ LUHRMANN'S
PRODUCTION of
— PUCCINI'S —

La Bohème

ON BROADWAY

GREATEST
LOVE
STORY
EVER SUNG

WWW.BOHEMEONBROADWAY.COM ❀BROADWAY THEATRE | 1681 BROADWAY

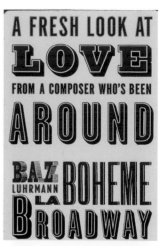

ART SEX
LOVE
DEATH

BAZ LUHRMANN
LA BOHEME
BROADWAY

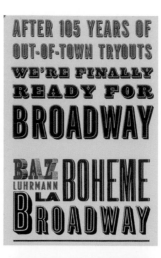

AFTER 105 YEARS OF
OUT-OF-TOWN TRYOUTS
WE'RE FINALLY
READY FOR
BROADWAY

BAZ LUHRMANN
LA BOHEME
BROADWAY

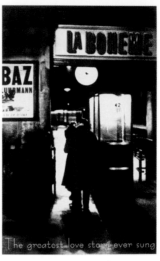

A FRESH LOOK AT
LOVE
FROM A COMPOSER WHO'S BEEN
AROUND

BAZ LUHRMANN
LA BOHEME
BROADWAY

I LEARNED SO MUCH FROM BAZ AND FROM CATHERINE MARTIN. I LEARNED THAT SOMETIMES HAVING PEOPLE THINK, *"HOW CAN THEY POSSIBLY DO THAT?"* IS A PRETTY GOOD WAY TO SELL TICKETS.
DREW HODGES

above
Early comps for *La Bohème*'s advertising.
below
Stills from Baz Luhrmann's wonderful television commercial for *La Bohème*.

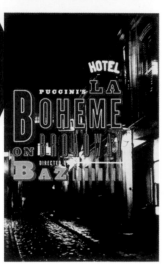

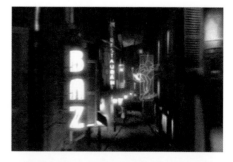

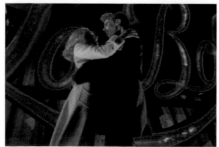

MEDEA

—— THE NON-EVENT ——

THE CLASSICS.

—— THE EVENT ——

NEW, DANGEROUS
**AND OH SO
SPECTACULARLY REVIEWED.**

GAIL ANDERSON
FORMER DIRECTOR OF DESIGN, SPOTCO

SPOTCO WAS ASKED TO CREATE artwork for a very contemporary staging of *Medea*. The final ad was due at the *New York Times* in about a week or so, which didn't leave much time for tinkering or fussing (or approval, for that matter). We enlisted designer/illustrator James Victore to work with us to create a high-impact, full-page ad that would hopefully stop readers in their tracks.

There was blood and death in the show, and while we didn't want to be literal, the allusion was made through color—and of course, through the use of the *knife*. The producers were brave and confident—and printed the art with almost no changes, though some found the knife quite unsettling.

Medea is good memory, perhaps in part because it all came together so quickly, and ultimately, painlessly (so to speak).

THERE WAS
***BLOOD
AND DEATH***
**IN THE SHOW . . . THE
ALLUSION WAS MADE
THROUGH COLOR.**
GAIL ANDERSON

GYPSY

— THE NON-EVENT —

GOTTA GET A GIMMICK.

— THE EVENT —

THE ONE, THE ONLY.

GYPSY *WAS PERHAPS THE* toughest nut to crack in all these years. Everyone knows the one and only *Gypsy* and its heroine (antiheroine?) Rose. We wanted to get it right and honor the past. We also wanted to make it fresh, for the future. And we wanted to get it right for Sam and Bernadette. Sam Mendes is one of the great lights theater has.

We tried everything we could think of. We went up to this wonderful old theater in Great Barrington, Massachusetts, and spent weeks doing poster after poster playing with their sadly rusted marquee.

Finally, SpotCo designer Rex Bonomelli made a "G" out of a boa (we always have feather boas lying around the office—we work in the theater), and something clicked. We scoured the lyrics of "You Gotta Get a Gimmick" and started playing with tickets and trumpets to see what letters we could make.

Why does this poster work so well? Well, for one, Sam was happy. But beyond that, it acknowledges that the audience knows something about the show—like a secret we both can share, together. And yes, it has a gimmick. —D.H.

GAIL ANDERSON
FORMER DIRECTOR OF DESIGN, SPOTCO

GYPSY *WAS ONE OF THE* first shows I worked on at SpotCo, and it was a great learning experience for me. We were given a demonstration of how the show's sets would work by its director, Sam Mendes. I was in awe. Sam's direction to us was to keep the art as stripped down as possible—he wanted it to feel fresh, and even stark. We kept creating versions that did too much storytelling, until finally, Drew suggested trying nothing but the star's name in lights and our title treatment against black. The typography, created using elements from the show, became the key art. No heavy lifting required.

INSPIRED BY THE MARQUEE, WE PUT BERNADETTE'S *NAME IN LIGHTS* AND "CURTAIN UP, LIGHT THE LIGHTS" IN NEON.
DREW HODGES

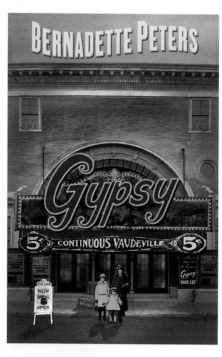

above
The marquee of the Mahaiwe Theatre in Great Barrington Massachusetts, with SpotCo art director Darren Cox assuming the pose.
below
Polaroids from Andrew Eccles' photoshoot with Bernadette. It's Rose's turn. (following spread) Early designs for the *Gypsy* campaign. — D.H.

BERNADETTE PETERS

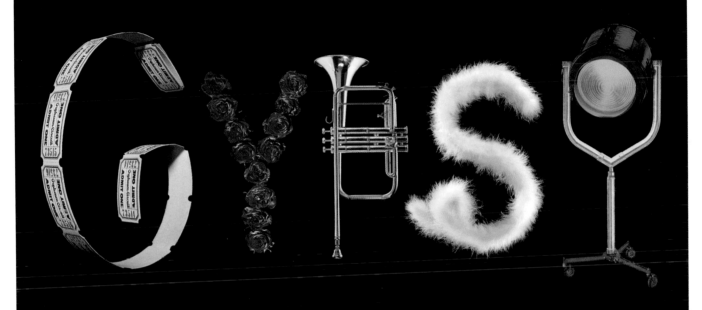

GYPSY

CURTAIN UP
LIGHT THE LIGHTS.

.

FOR ALL TICKETS: 212-239-6200/800-432-7250 OR TELECHARGE.COM/GYPSY
PREVIEWS BEGIN MARCH 31. OPENS MAY 1. 🐾 SHUBERT THEATRE, 225 W44TH STREET
GYPSYTHEMUSICAL.COM

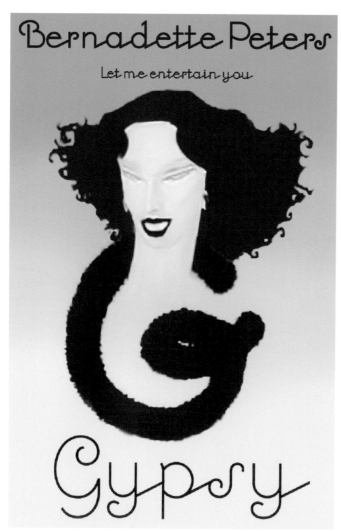

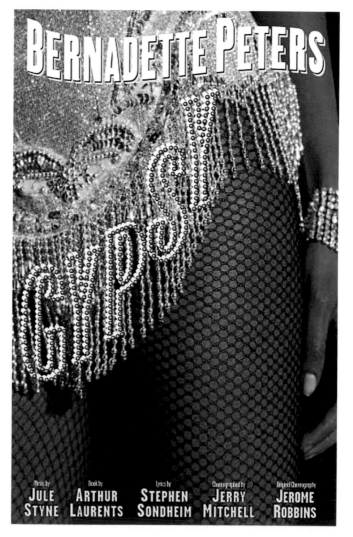

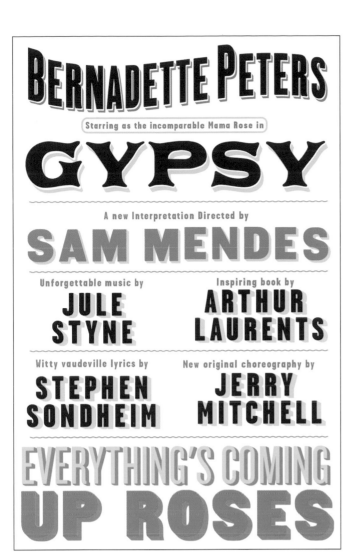

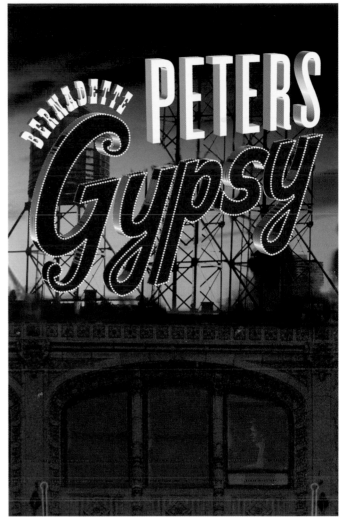

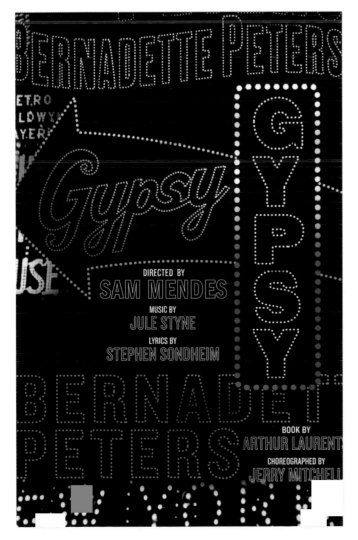

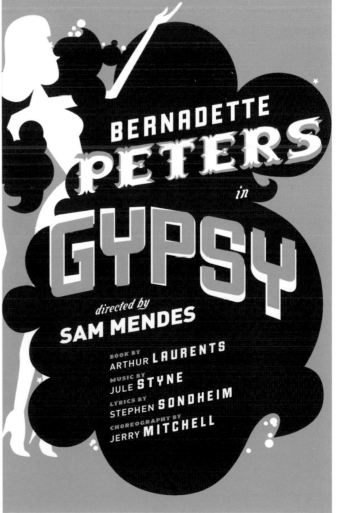

AVENUE Q

— THE NON-EVENT —

DIRTY PUPPET SHOW.

— THE EVENT —

PURE IRREVERENT ORIGINALITY,
AND A TONY WINNER, TOO.

JEFF MARX
COMPOSER/LYRICIST

NOBODY WAS EXPECTING us to win the Tony. In fact, one of the Broadway websites did a roundup of all the industry journalists and critics, and not only was the consensus predicting that *Wicked* would win Best Musical, but every single one of the journalists polled crowned *Wicked* the winner. It was a unanimous prediction. Faced with that, I remember the marketing meeting where we were told the momentum was decidedly against us, and we could sit back and watch it happen, or we could be bold and cheeky and funny, consistent with the nature of the show, and remind everyone how much they had enjoyed *Avenue Q* (which, by the way, had opened almost an entire year before Tony voting season and was already somewhat distant in people's memories). So it was decided we'd go wave some flags and have some fun, and if we went down, at least we'd do it in style. It was a presidential election cycle, and we were campaigning for votes from the 735 Tony voters—of course all the shows were!—but we decided to be not so subtle about it, but to go balls out, admit we were campaigning, and do it unabashedly. So there were the American flags, red-white-and-blue bunting, the campaign buttons, the Uncle Sam–like full frontal poster of Rod saying, "We want YOU! (To vote for Q!)" and of course the "campaign" pizza party for the press at which we had stump speeches and premiered a new song about campaigning for votes. The refrain of the song was "Vote Your Heart," and it was reminding people not to be distracted by factors that had nothing to do what was actually the "best musical" (a big flashy production, what title might have better touring prospects, etc.), but to truly look deep within their hearts and think about what show they really liked best. Ostensibly, the song was about Rod being torn about who to vote for in his Rotary Club election. One guy was a

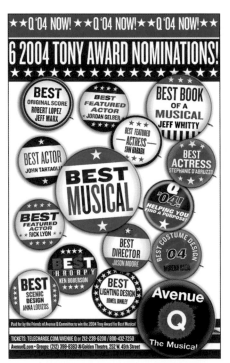

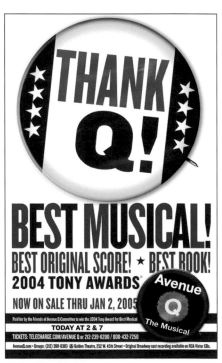

I WENT TO AN
EARLY PREVIEW WITH A PAIR
OF GRANDPARENTS AND THEIR
GRANDSON, WHO WAS ABOUT
ELEVEN. ALL WAS FINE UNTIL
THE FIRST "FUCK."
BOTH GRANDPARENTS SHOT
EACH OTHER A LOOK AND THEN
GLANCED AT THEIR GRANDSON—
WHO WAS LAUGHING.
JIM EDWARDS

top
The furry taxicab. We
hoped that they would
spark a conversation, but
not accidents.

far left
A short-lived phone kiosk
campaign that identified
the different streets of
New York, including
Avenue Q.

opposite, top
A parody ad welcoming
Taboo (and all the other
shows that opened after us)
to Broadway as part of
our Tony campaign.

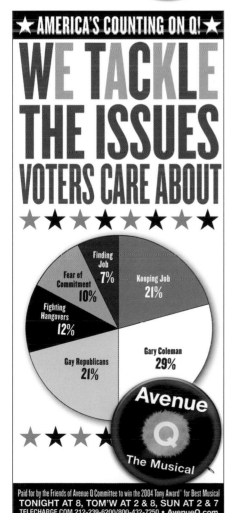

friend, one guy was rich and would probably invite him out to his house in the Hamptons, and one guy was cute. What a dilemma. His friends told him, "None of those things has anything to do with who would make the best president for your Rotary Club!" and they urged him to "vote for the person who deserves it!" My favorite line in the song was "Remember, it's a secret ballot—nobody has to know who you voted for!" And so SpotCo and our producers incorporated the song into a fully blatant mock, actually not-so-mock, "campaign" campaign, and they sent the CD out to all 735 Tony voters, urging them all to vote their hearts. I understand shortly after all this happened, the Tony people made a rule that said you can't send shit out to the voters anymore. I don't think any amount of vigorous flag-waving would have made people vote for a show they didn't actually like, but damn, that campaign did the job and we won three Tonys. I have one on my shelf. Without Drew and the team's chutzpah and that shameless cheeky marketing "campaign" I don't think *Avenue Q* would have run as long as it did. And last time I checked, *Wicked* was doing fine without the Tony.

JEFFREY SELLER
PRODUCER

AVENUE Q WAS THE SECOND show we marketed (*Rent* was the first) that many theater experts predicted "would never work uptown." After receiving warm reviews downtown at the Vineyard Theatre, we planned to open on Broadway at the smallish Golden Theatre. The first full-page *Times* ad, which featured our Trekkie puppet sitting on the D train en route to *Avenue Q*, sold about $20,000 in tickets. Scary. Our advance prior to the first preview was about $200,000. Even scarier. *Avenue Q* would require word of mouth (which happily came) and patience (which we expressed). Normal methods of advertising—print, radio, TV, direct mail—did not generate an audience. We opened in late July 2003, with the knowledge that we would need to run all the way until the following June to compete in the Tony Awards. We were also aware that a handful of promising new musicals were opening that fall. Our focus from September on was, "How do we stay in the conversation, and how do we win the Tony?" History was against us. The Tony Award for Best Musical was traditionally won by the musical that was big, splashy, and a winner at the box office. *Wicked* qualified on all points. How about a bold campaign, puppet style? While it would seem unseemly for the producers to campaign, it was perfectly adorable for the puppets to campaign. And they did.

KEVIN McCOLLUM
PRODUCER

WE STRUGGLED WITH *Avenue Q* because we thought puppets were the asset, but apparently they were the disadvantage because early on, everyone thought we were a dirty puppet show. We knew we were one of the most well-crafted musicals of all time. The political incorrectness was so smart, but we were perceived as potty-mouths. Jeffrey, SpotCo, and I came up with the great idea to take out quarter-page ads in the the *New York Times* for every original musical that was opening on Broadway that season. We acted like the mayor, using the humor of our show. Yes, we had images of the puppets, but we also used our images to riff on the logos of the other shows. This put a human quality to our puppets, and demonstrated our sense of humor. *Taboo* was, "Faboo," for example. These ads told the public about the other show's opening, but it was also a self-conscious decision to say that our show was more than a show—it was part of the community. SpotCo once again navigated us through a clever, creative park of how we spoke about the show, because we weren't trying to sell tickets— we were selling an ethic of humor and good will.

ILENE ROSEN
PRESIDENT, SPOTCO

MY WILDEST MEMORIES of working at SpotCo are undoubtedly from when we launched *Avenue Q* in Las Vegas at The Wynn hotel. Our creative director, Vinny Sainato, had the genius idea of creating a very buzzy outdoor advertising campaign by covering taxis in *Avenue Q*'s signature orange fur. The idea was green-lit but then we actually had to figure out how to do it. We had no idea what material you could use that wouldn't look like a wet dog when it rained and wouldn't burst into flame over the engine of a taxi. We also had to convince the Taxicab Authority of Las Vegas. The cost was pretty outrageous, so we made a test cab and had it rolled up to the back door of The Wynn, where Steve [Wynn] could see it. We thought maybe we would end up making five of them. We all watched in breathless anticipation as he walked out and up to the car. He was dead silent. He reached out to touch the "fur," looked at us and said, "I love it! Order up a fleet of twenty of them."

WONDERFUL TOWN

THE NON-EVENT —

CHARMING REVIVAL.

— THE EVENT —

NORMAN ROCKWELL
*EVERYMAN
(AND EVERYWOMAN)
FUN.*

WONDERFUL TOWN *HAD*
three campaigns. We are fans of artwork
that evolves. Yes, I admire *The Lion King*'s
great mark and brand, but not every
show can take the time to build icons,
and even then, I like to think *Chicago* is
just as iconic, and it changes often.

My very favorite iteration was photographer Jim Fiscus's Norman Rockwell
salute. We were fascinated by Rockwell's
ability to show action and scale, while
keeping an innocence. We looked
particularly at the paintings titled
Roadblock and *Homecoming G.I.* Many
photographers are reported to use
classic paintings for composition guides in
their work, most notably Annie Leibovitz,
and while we stole no particular gesture,
we preplanned everything.

First, Jim used a cherry picker to get
as many images as he could on New
York Street on Paramount Studios'
backlot in Hollywood. When we shot
our actors in the studio, we used 2x4s
to make window openings for actors to
sit in, hardware store ladders to lean
against, and finally a real piano for
Donna to climb up on. Giving actors
real things to interact with not only
helps you understand where the shadows
belong, but it causes their clothes to
crumple as they would, and gives the
actors something to "play." Every actor is
true to his or her character within the
show, and I love that you enter the piece
with leading-man Gregg Edelman at the
base, and climb up to the roof to the
triumph of Tony-winner Donna Murphy.
Usually these ads look fake. But to me,
this one looks exactly right, It ran once
or twice, a victim of its intricacy for a
show that was running smaller ads, and
was rarely seen again, yet I always think
it was a triumph.—D.H.

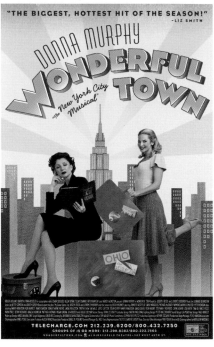

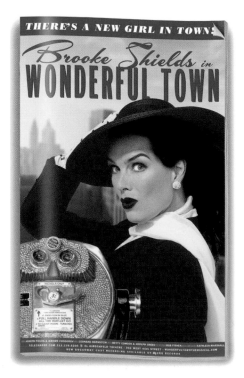

I LOVE THAT YOU
ENTER THE PIECE WITH
LEADING-MAN GREGG
EDELMAN AT THE BASE, AND
*CLIMB UP TO
THE ROOF*
TO THE TRIUMPH OF TONY-
WINNER DONNA MURPHY.
DREW HODGES

top row
SpotCo producer Mark Rheault striking a pose,
alongside Donna Murphy. All images were shot
separately and then assembled into the buildings.

second row
David Cowles' design, and our cast ultimately
incorporated into the poster.

bottom
A Norman Parkinson–inspired Andrew Eccles portrait
of Brooke Shields when she stepped into the lead.

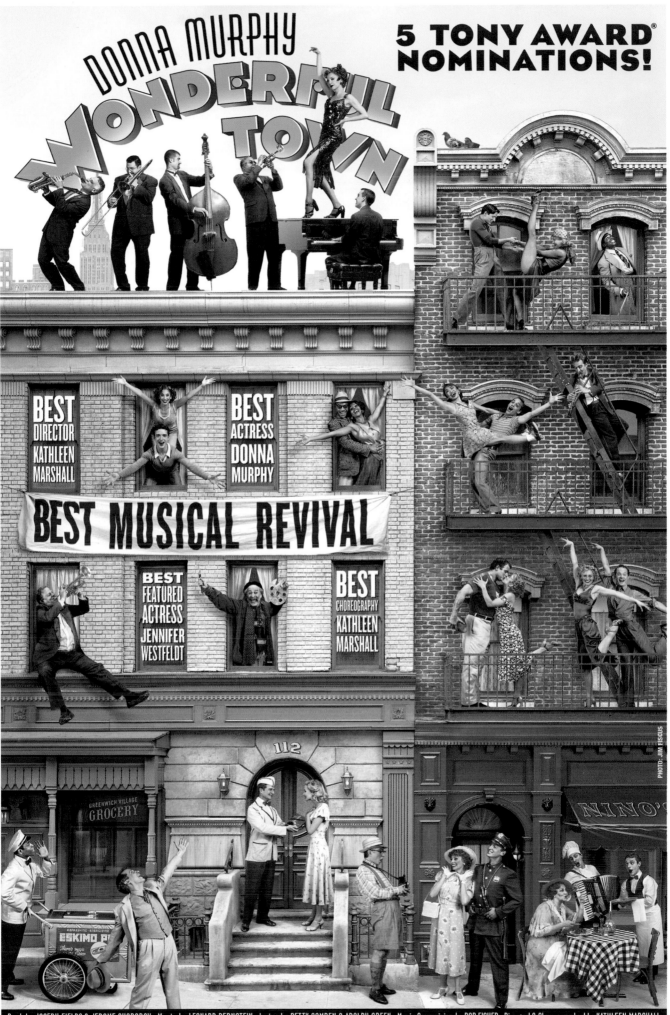

DONNA MURPHY
WONDERFUL TOWN

5 TONY AWARD® NOMINATIONS!

BEST DIRECTOR KATHLEEN MARSHALL

BEST ACTRESS DONNA MURPHY

BEST MUSICAL REVIVAL

BEST FEATURED ACTRESS JENNIFER WESTFELDT

BEST CHOREOGRAPHY KATHLEEN MARSHALL

GREENWICH VILLAGE GROCERY

112

NINO'S

Book by JOSEPH FIELDS & JEROME CHODOROV Music by LEONARD BERNSTEIN Lyrics by BETTY COMDEN & ADOLPH GREEN Music Supervision by ROB FISHER Directed & Choreographed by KATHLEEN MARSHALL

TODAY AT 3 ▪ TELECHARGE.COM 212.239.6200/800.432.7250
WONDERFULTOWNTHEMUSICAL.COM ♪ AL HIRSCHFELD THEATRE ▪ 302 WEST 45TH ST.

I AM MY OWN WIFE

— THE NON-EVENT —

OBSCURE EVENT IN GERMAN HISTORY.

— THE EVENT —

FASCINATING FEMALE *SPY THRILLER.*

Unpublished early sketches by illustrator Leigh Wells
and a runner-up tablecloth design.

DOUG WRIGHT

PLAYWRIGHT

I AM MY OWN WIFE *IS A* complicated play that required genuine marketing savvy. It's a one-man show, one of the most maligned and dreaded forms in contemporary theater. It told the eccentric story of an elderly German transvestite struggling to survive under first the Nazis and then the Communists. And it featured an actor destined for Broadway stardom but who hadn't achieved it yet, the astonishing but then unknown Jefferson Mays. (He would go on to receive a Tony Award for his performance.)

I was surprised and relieved when SpotCo accepted the job. Rather than focus on the gender-bending aspects of the piece (which would've been a spoiler alert), they instead created an image that stressed its political and historical heft. My protagonist, Charlotte, was known for wearing a single strand of white pearls; the illustrators duplicated that signature jewelry item, but in the iridescence of each tiny stone, we see the faint images of swastikas alternating with the hammer and sickle. I love the art, because it so cunningly represents the theme at the core of my story: with the delicacy and tenuousness of a string of precious beads, my heroine successfully navigated two of the world's most repressive regimes.

SpotCo trusted the play's enigmatic title and lets it speak for itself, albeit in bold, Germanic typeface. When I initially expressed reluctance about the inclusion of a Nazi symbol, fearful it would alienate potential theatergoers, SpotCo reassured me. "Believe it or not," they told me, "it's an attribute. Even sixty years or so after the fact, people still want to hear stories of survival and triumph during that dark time. If we promise them that, with artfulness and sensitivity, then they will come." And they did.

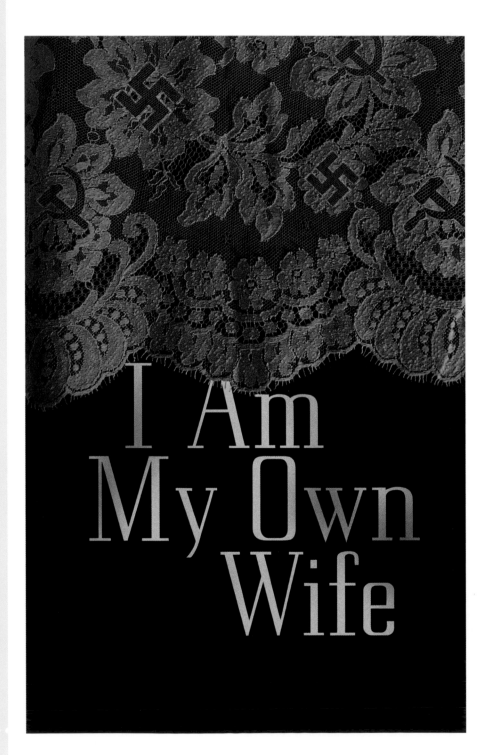

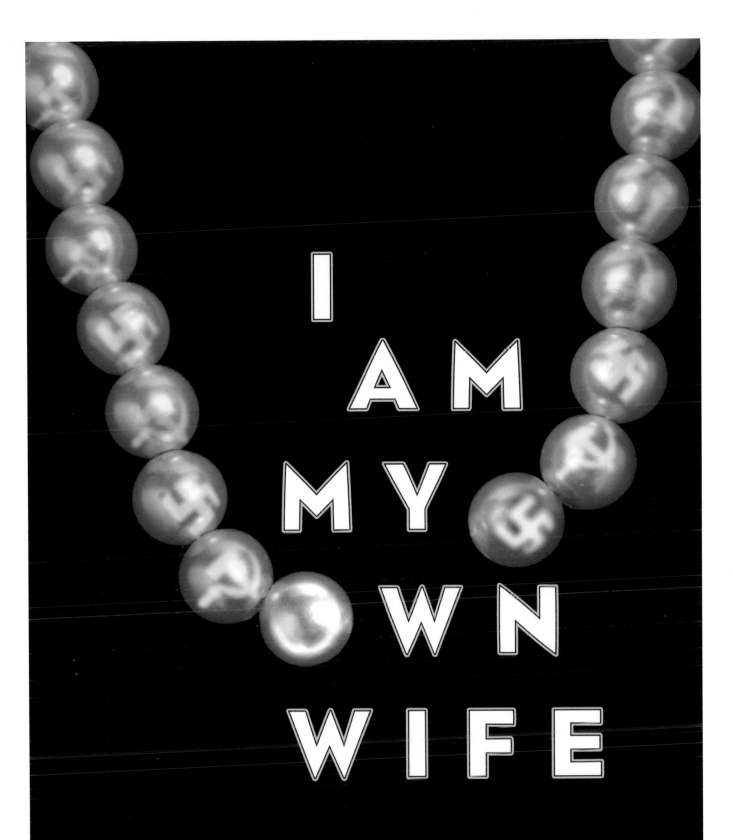

DELPHI PRODUCTIONS IN ASSOCIATION WITH PLAYWRIGHTS HORIZONS PRESENT I AM MY OWN WIFE
BY DOUG WRIGHT STARRING JEFFERSON MAYS SCENIC DESIGN DEREK McLANE LIGHTING DESIGN DAVID LANDER
COSTUME DESIGN JANICE PYTEL SOUND DESIGN ANDRE J. PLUESS PRODUCTION STAGE MANAGER ANDREA "SPOOK" TESTANI
PRODUCTION SUPERVISOR ARTHUR SICCARDI GENERAL MANAGER NIKO COMPANIES, LTD. PRESS REPRESENTATION RICHARD KORNBERG AND ASSOCIATES
A WORKSHOP OF I AM MY OWN WIFE WAS PRESENTED BY LA JOLLA PLAYHOUSE, DES McANUFF, ARTISTIC DIRECTOR & TERRENCE DWYER, MANAGING DIRECTOR
DIRECTED BY MOISÉS KAUFMAN

TELECHARGE.COM · 212.239.6200
LYCEUM THEATRE · 149 W 45TH STREET

LA CAGE AUX FOLLES

— THE NON-EVENT —

I AM WHAT I AM, AGAIN.

— THE EVENT —

IT'S TIME FOR A REALLY BIG SHOW, *AGAIN.*

ROBERT DE MICHIELL
ILLUSTRATOR

GAIL ANDERSON CALLED ME.
I knew her from *Rolling Stone*. I had
this idea of rows and rows of French
showgirls, sort of like René Gruau. We
wanted to do this whole Folies Bergère,
Lido thing. We wanted it to be very
French. So I did this sketch, but Gail
said there was no place for the type—for
the title treatment. And she was right.
So I did another one with just one figure
and with the tattoo on the arm that said
"Mom." It plays with the original art for
the show, which I love and which had
the turban. It's sort of an homage.
I mean, you know it's a man, but she's
wearing these jewels. And then I found
out later that William Ivey Long, the
designer for the show, turned it into a
costume for the show. It was for a
character called Phaedra, the Enigma.
I remember sitting there and seeing it:
I was shocked but also honored.

 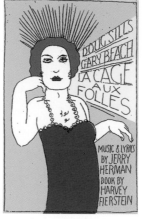

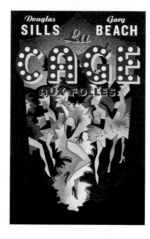

Four extraordinary illustrators sketch for *La Cage*'s first major revival—Terry Allen,
Seymour Chwast, Robert Risko, and Robert de Michiell, who did the final.

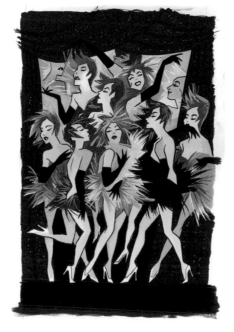 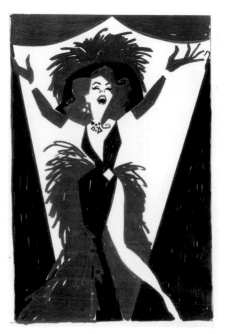

DIRTY ROTTEN SCOUNDRELS

— THE NON-EVENT —

DOES STEVE MARTIN SING?

— THE EVENT —

A CON-JOB BUDDY COMEDY—
YOU WILL
LAUGH YOUR ASS OFF.

LISBETH KAISER
FORMER COPY DIRECTOR, SPOTCO

THE INSPIRATION FOR THE "Lies" campaign was a direct-mail piece that was designed like a passport with a plane ticket. On the ticket, I had written a bunch of misleading perks with qualifiers in small print. [Former SpotCo senior creative director] Vinny Sainato came to me and said that this was going to be our ad campaign and asked if I could come up with a bunch more. "Lies" was born.

By the end of the campaign, everyone in my life knew I was writing batches of these jokes every week, and would send me their suggestions. Most weren't so great, but my father's idea actually ended up going to print: "The toast of the Hamptons! Goes great with the eggs of Sag Harbor." Thanks, Dad!

SPOTCO WAS CREATING A
HOLIDAY-THEMED CAMPAIGN.
I GOT A CALL THE NIGHT BEFORE
ASKING IF MY PET WAS AVAILABLE.
THAT'S HOW
MY RABBIT MADE
IT INTO THE NEW
YORK TIMES
ON EASTER SUNDAY.
MELISSA BARRY
FORMER PRODUCTION
SUPERVISOR, SPOTCO

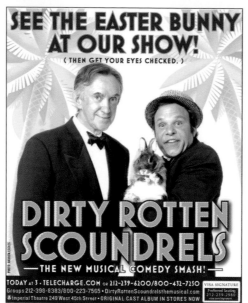

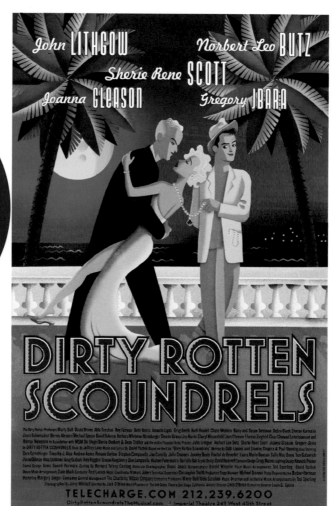

DOUBT

THE NON-EVENT —
CATHOLIC NUN DRAMA.

— THE EVENT —

MORALITY PLAY
BY MASTERS.

CHERRY JONES
ACTOR

AS SO OFTEN IS THE CASE, the photograph for the poster was made before our first day of rehearsals. It's always daunting to have a photo "in character" made before the actor really knows who their character is/will become after weeks of rehearsals. Manhattan Theatre Club felt strongly that I should not be photographed in my habit and bonnet because the Sisters of Charity's wimple is actually an early nineteenth century Regency bonnet. Thus, I was photographed with my contemporary shoulder-length lank hair and a cross necklace. Once we were in performance, I don't recall anyone questioning the photograph, though it still gives me a chuckle each time I see the poster.

BARRY GROVE
**EXECUTIVE PRODUCER,
MANHATTAN THEATRE CLUB**

DOUBT WAS THE SEVENTH play by John Patrick Shanley we produced. The play takes place in 1960s Bronx, New York. The nuns of this particular order wear habits that include bonnets that resemble eighteenth century pioneer women. I was concerned that a picture in full habit taken out of context would confuse the audience into thinking this was a period play. We shot Cherry in a simple black sweater and white collared shirt with a very evident, yet simple cross around her neck. It conveyed the religious faith of the woman without being a literal depiction of her as she was costumed in the play. The first postcard for the show was just of her because Brían [F. O'Byrne] wasn't set yet. When we reimagined the key art for the Broadway transfer of the play, we wanted to convey both her determination and his anger at being falsely (?) accused. This photo layout focused mostly on their faces—you barely see the clothes at all. The poster really worked, and after that we were never worried about being literal again.

doubt

DOUBT

Cherry Jones

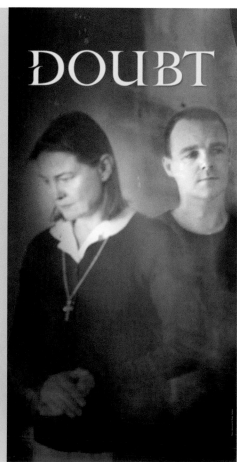

DOUBT

DOUBT

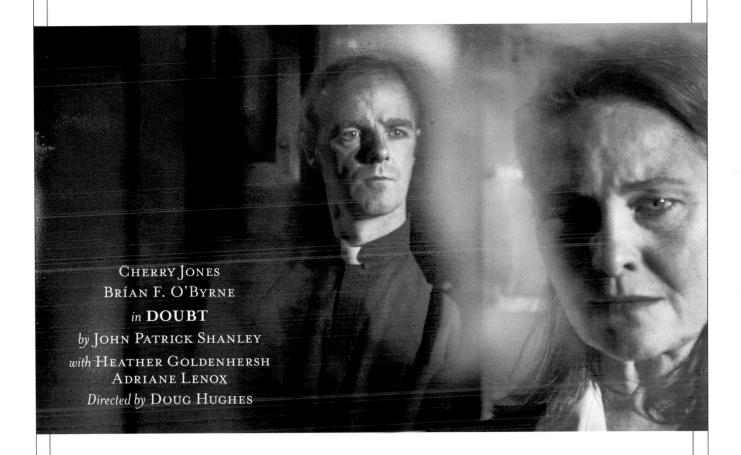

Cherry Jones
Brían F. O'Byrne
in DOUBT
by John Patrick Shanley
with Heather Goldenhersh
Adriane Lenox
Directed by Doug Hughes

Carole Shorenstein Hays Manhattan Theatre Club Lynne Meadow-*Artistic Director* Barry Grove-*Executive Producer* Roger Berlind Scott Rudin
Present Cherry Jones Brían F. O'Byrne *in* DOUBT *by* John Patrick Shanley *with* Heather Goldenhersh Adriane Lenox *Scenic Design* John Lee Beatty
Costume Design Catherine Zuber *Lighting Design* Pat Collins *Original Music and Sound Design* David Van Tieghem *Production Stage Manager* Charles Means
Casting Nancy Piccione/David Caparelliotis *Production Management* Aurora Productions *Press Representative* Boneau/Bryan-Brown
General Management Stuart Thompson Productions / James Triner *Executive Producer* Greg Holland *Directed by* Doug Hughes

Telecharge.com/Doubt or 212.239.6200 • 800.432.7250

DoubtOnBroadway.com Walter Kerr Theatre • 219 West 48th Street

JULIUS CAESAR

— THE NON-EVENT —

SHAKESPEARE WITH A MOVIE STAR.

— THE EVENT —

A LITTLE SHAKESPEARE, LOTS OF *ARTFUL DENZEL.*

EDDIE GUY

ILLUSTRATOR

INITIALLY I WAS HOPING to present Denzel [Washington] as handsome in a very different way, by hiding all the roughness of my collage technique through Photoshop. After collecting all the parts and carefully merging all the elements together, I realized I had something that looked, sadly, like an average black-and-white headshot. After some discussion with Gail Anderson, who commissioned the piece, we decided that using my hand-cut technique, rather than Photoshop, might give us a better result.

This technique involves hours of photo researching to find, cut, and glue together pieces of existing photography, often from magazines, in order to create a realistic portrait. One finished piece of art could easily be made up of hundred pieces of photography or more. There is often a tension in these images as the photographic pieces don't come together perfectly. The pieces are visibly separate and are put together crudely in comparison to a retouched Photoshop file. I find that any new piece of the collage can create an unexpected possibility and that continues to entertain me as an artist and fuels the process as the picture begins to come alive.

At first these efforts proved to be unsuccessful again when the portrait simply did not look "enough" like Denzel. I had been concentrating on making careful proportional comparisons to represent a true likeness. Eventually I found myself exaggerating the features. Once I had moved away from proportional reality, I gave myself up to something that didn't rationally make sense but intuitively felt and looked right. Ultimately this hand-cut technique created a more striking and emotional portrait of Denzel, and the fractured artwork suggested the inner conflict of Julius Caesar.

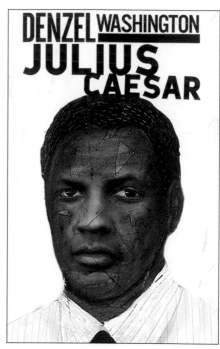

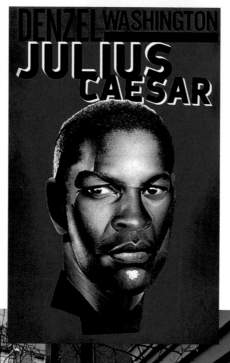

> ONCE I HAD MOVED AWAY FROM PROPORTIONAL REALITY, I GAVE MYSELF UP TO SOMETHING THAT DIDN'T RATIONALLY MAKE SENSE BUT INTUITIVELY FELT AND *LOOKED RIGHT.*
> *EDDIE GUY*

Street snipes were often used by SpotCo to create maximum impact when launching a new show. The highest compliment we could be paid is when you could see the corners pulled back—a sure sign of an appreciative audience member hoping to take a poster home.

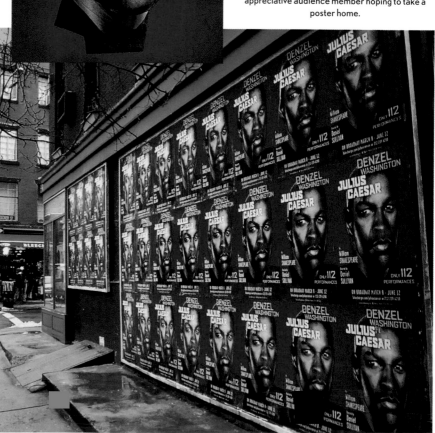

DENZEL
WASHINGTON

JUL1US
CAESAR

By
William
SHAKESPEARE

Directed by
Daniel
SULLIVAN

ONLY **112**
PERFORMANCES

Previews begin Tuesday, March 8 Telecharge.com/juliuscaesar or 212-239-6200/800-432-7250

Belasco Theatre 111 W. 44th Street

illustration: eddie guy

THE PILLOWMAN

CREEPY.

EDGY, COOL,
AND WITH TWO GREAT STARS.

ROBERT FOX
PRODUCER

WHEN I SAW THE PLAY AT the Cottesloe Theater at the National Theatre, it blew my mind, and I became obsessed about being involved if there were to be a production on Broadway. I took Nick Hytner to lunch and asked him to put a good word in for me with Bob Boyett and Bill Haber, who had a first-look deal with the National. They graciously asked me to join them. We spent a long time waiting to pull the right cast together, and when we did, we struggled to find the right image for the play. Often it's hard for the agency to come up with an image that satisfies all the voices that need to be heard, and *The Pillowman* was no different in this regard. We looked at endless generic images, most of which looked like bad movie posters (sorry, but true). At the eleventh hour I remember saying to Drew we have to think totally out of the Broadway box, and within twenty-four hours, he came back with what to me is still one of the most interesting and arresting images for a play that I had seen in a very long time.

SCOTT PASK
SCENIC/COSTUME DESIGNER

THE PILLOWMAN *REMAINS* a deeply special and significant project for me. I believe that the most successful artwork created for a theatrical production captures that show's tone and spirit with a carefully curated and designed glimpse into its themes using image and typography, becoming an enticing book cover of sorts. And the very best become standalone works of art. Drew's particular view into the world of one of the stories internal to the play seemed to be the touchstone for the inspired work he created. The unforgettable image graphically seized both the tonal quality of comedy that was dark as pitch, as well as its far darker dramatic shades.

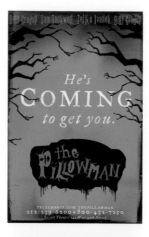

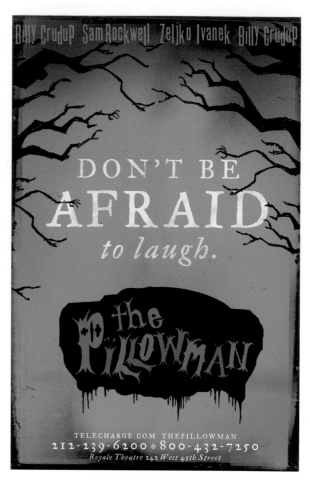

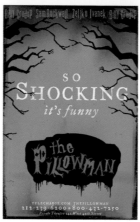

Trying to find the final look that would please all. Bottom left features a drawing of the actual Pillowman before we knew what he looked like. He made an appearance on the stage for just a few performances before he was cut, but he looked remarkably like this. — D.H.

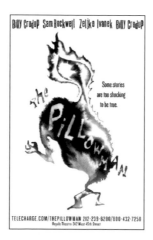

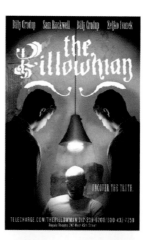

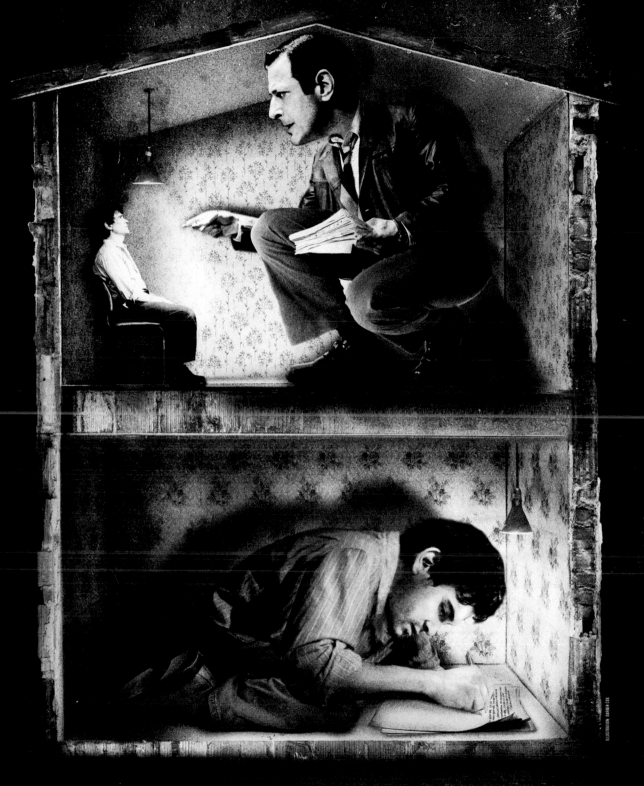

THE PILLOWMAN

BOYETT OSTAR PRODUCTIONS · ROBERT FOX · ARIELLE TEPPER · STEPHANIE P. McCLELLAND · DEBRA BLACK · DEDE HARRIS/MORTON SWINSKY
ROY FURMAN/JON AVNET IN ASSOCIATION WITH JOYCE SCHWEICKERT PRESENT BILLY CRUDUP · JEFF GOLDBLUM · ŽELJKO IVANEK · MICHAEL STUHLBARG
IN THE NATIONAL THEATRE OF GREAT BRITAIN'S PRODUCTION OF THE PILLOWMAN BY MARTIN McDONAGH
WITH JESSE SHANE BRONSTEIN · KATE GLEASON · RICK HOLMES · TED KÖCH · MADELEINE MARTIN · COLBY MINIFIE · VIRGINIA LOUISE SMITH SCENIC/COSTUME DESIGNER SCOTT PASK
LIGHTING DESIGN BRIAN MACDEVITT SOUND DESIGN PAUL ARDITTI MUSIC BY PADDY CUNNEEN FIGHT DIRECTOR J. STEVEN WHITE PRESS REPRESENTATIVE BARLOW·HARTMAN MARKETING HHC MARKETING
PRODUCTION MANAGER ARTHUR SICCARDI GENERAL MANAGEMENT NINA LANNAN ASSOCIATES CASTING JIM CARNAHAN PRODUCTION STAGE MANAGER JAMES HARKER DIRECTED BY JOHN CROWLEY

☎ BOOTH THEATRE 222 W. 45TH ST. BRITISH AIRWAYS · LIVE BROADWAY ·

GLENGARRY GLEN ROSS

— THE NON-EVENT —

GUYS' PLAY YOU SAW
AT THE MOVIES.

— THE EVENT —

THE PERFECT CAST
IN THE PLAY THAT HOPEFULLY WILL
NEVER BE CLOSING.

JIM EDWARDS
FORMER CHIEF OPERATING OFFICER, SPOTCO

I REMEMBER WHEN DREW presented the artwork to the full gaggle of producers. Most of them didn't like it—cold, uninviting. They didn't get it or appreciate its style. [Producer] Jeffrey Richards sensed the room was going South and then said , "I love it . . . consider it approved." And then someone corrected him about actor approval, and he said, "Well, if the actors approve it, it's approved." That was the end of it. Print it. Done.

LISBETH KAISER
FORMER COPY DIRECTOR, SPOTCO

THIS TAGLINE CAME FROM the producer, Jeffrey Richards. He didn't like anything we pitched and said, "We need a line like, 'Lie, cheat, steal . . . all in a day's work.'" There was a collective nod.

HENRY LEUTWYLER'S
PHOTO SHOOT WAS INSPIRED
BY RICHARD AVEDON'S
PORTRAIT OF THE LEADING
PLAYERS IN THE VIETNAM WAR—
*"THE MISSION
COUNCIL,"*
BOTH OF WHICH HAD A MIX OF
POWER AND DESPERATION.
—D.H.

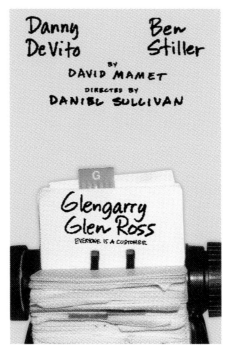

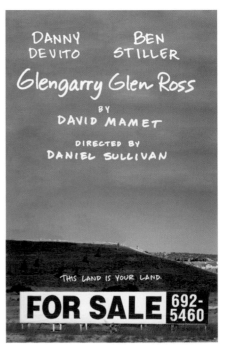

LIE, CHEAT, STEAL... ALL IN A DAY'S WORK.

ALAN ALDA · LIEV SCHREIBER
FREDERICK WELLER · TOM WOPAT · GORDON CLAPP
and JEFFREY TAMBOR

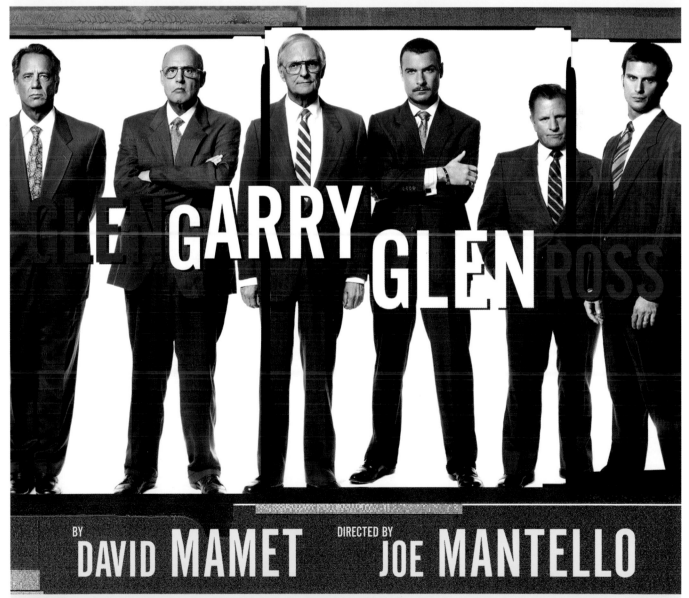

GLENGARRY GLEN ROSS

BY DAVID MAMET DIRECTED BY JOE MANTELLO

JEFFREY RICHARDS JERRY FRANKEL JAM THEATRICALS BOYETT OSTAR PRODUCTIONS RONALD FRANKEL PHILIP LACERTE STEPHANIE P. McCLELLAND/CJM PROD. BARRY WEISBORD ZENDOG PRODUCTIONS in association with HERBERT GOLDSMITH PRODUCTIONS by special arrangement with THE ROUNDABOUT THEATRE COMPANY Todd Haimes, Artistic Director Ellen Richard, Managing Director Julia C. Levy, Executive Director, External Affairs present ALAN ALDA LIEV SCHREIBER FREDERICK WELLER TOM WOPAT GORDON CLAPP and JEFFREY TAMBOR in GLENGARRY GLEN ROSS by DAVID MAMET also with JORDAN LAGE Set by SANTO LOQUASTO Costumes by LAURA BAUER Lighting by KENNETH POSNER Casting by BERNARD TELSEY CASTING Stage Management WILLIAM JOSEPH BARNES Company Manager BRUCE KLINGER Press Representative IRENE GANDY General Management ALBERT POLAND Technical Supervisor NEIL A. MAZZELLA Directed by JOE MANTELLO

TELECHARGE.COM/GLENGARRY OR 212-239-6200 / 800-432-7250
♿ ROYALE THEATRE • 242 WEST 45TH STREET

SWEET CHARITY

THE NON-EVENT
A REVIVAL THAT SEEMS DATED.

THE EVENT
SEXY SWEET '60s COULD NOT BE MORE CONTEMPORARY.

GAIL ANDERSON
FORMER DIRECTOR OF DESIGN, SPOTCO

THE DESIGN DEPARTMENT was tasked with creating artwork for a revival of *Sweet Charity*, starring Christina Applegate. We designed three brightly colored versions of the key art —one with "Charity" plucking petals from a flower, another with her blowing a bubble, and the third, with Charity sipping soda from a straw. Applegate's reaction to the last version was visceral— and hilarious. As I recall, she said something off-color. We led with the flower photo, though Applegate was gracious enough not to kill the "dirty" one.

right
Five attempts to nail the graphic feel of the '60s, and the final series of three images featuring Christina Applegate.

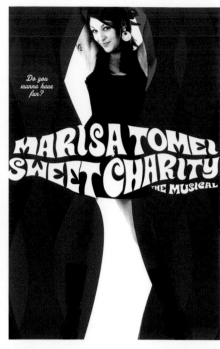

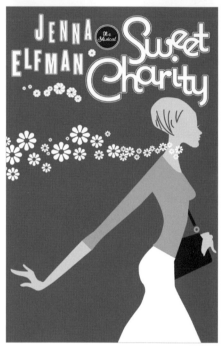

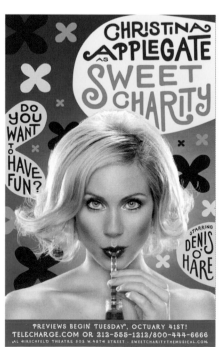

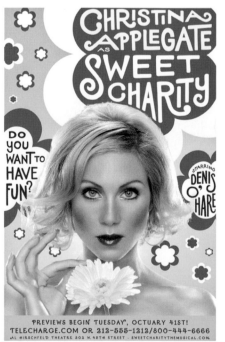

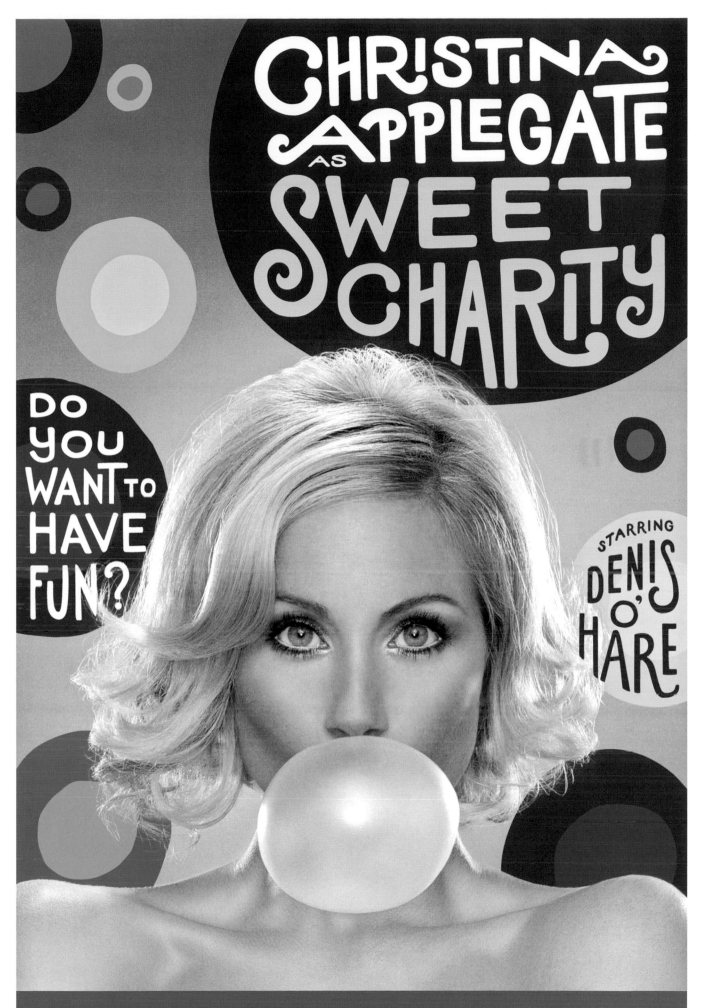

THE COLOR PURPLE

THE NON-EVENT

DOES THIS NEED TO BE A MUSICAL?

THE EVENT

OPRAH (QUALITY) PRESENTS TRIUMPHANT JOY AND *SISTERHOOD.*

SCOTT SANDERS
PRODUCER

This show had an amazing pedigree, but when I went to Alice Walker and asked for the rights, hoping to adapt it as a musical, many people thought I was crazy. They just didn't think it could lend itself to musical theater. For one thing, it's an epistolary novel that spans many years. So in developing the ad campaign, we decided to distill it to the two sisters, Celie and Nettie. Their story had the strongest emotional and spiritual connection with audiences. We started to look at ways to use this, and there's this image in the Steven Spielberg film of the two of them clapping hands in the field. We had done these focus groups originally, and the response was, "How are they going to do that? How can they make this a musical?" But when we showed this image to a focus group, you could see the smiles on their faces. They were ready to go on this journey.

JIM EDWARDS
FORMER CHIEF OPERATING OFFICER, SPOTCO

WHEN THIS SHOW WENT on sale, not much happened. It was "one of those shows" we've all worked on. But then, Oprah decided to become a producer. This was a stroke of genius and luck on Scott Sanders's part. A press release went out sharing the news. Nothing happened. A full-page ad ran in the *New York Times* with "Oprah Winfrey presents . . . " across the top. Again, nothing happened. It wasn't until Oprah devoted an entire hour of her talk show to the upcoming Broadway musical and what the show meant to her that ticket sales went through the roof. I believe the Telecharge website crashed because the demand was overwhelming.

> WE DECIDED TO *DISTILL IT TO THE TWO SISTERS,* CELIE AND NETTIE.
> *SCOTT SANDERS*

Early research showed audiences struggled to understand how this show would work as a musical and deliver the upbeat emotion they had come to expect from a Broadway production. These early attempts tried to move away from the film and show that the show was confidently a singing/dancing show. The final, on page 119, embraced the movie wholly, and that proved to be a surprising yet successful strategy. — D.H.

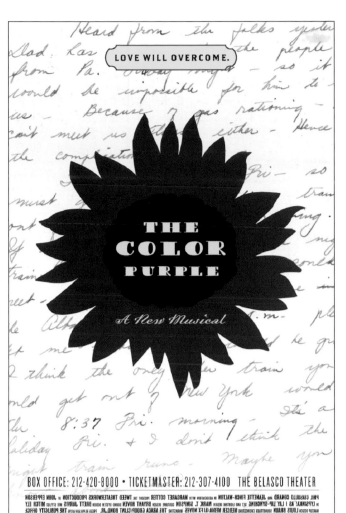

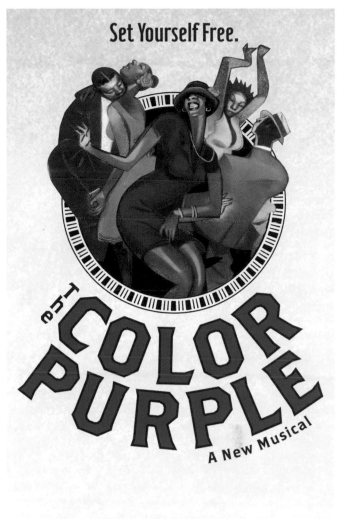

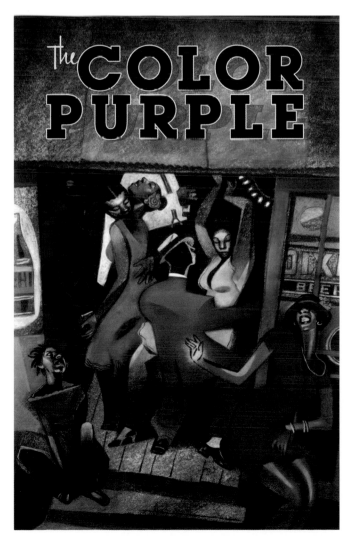

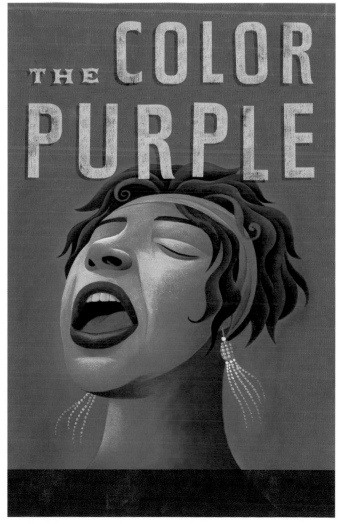

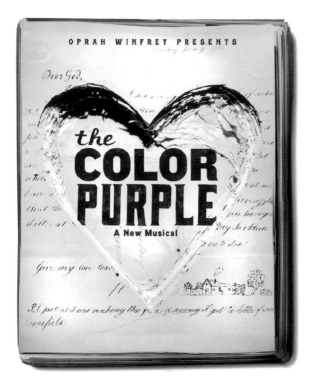

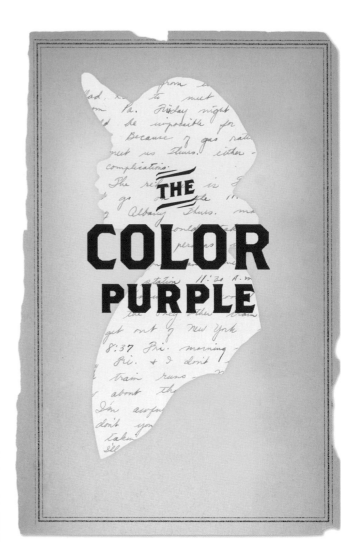

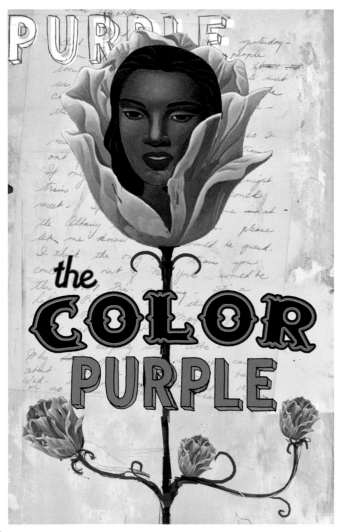

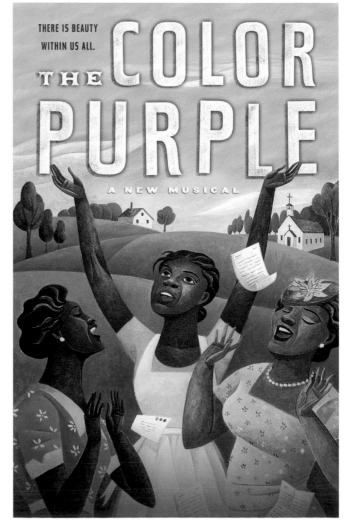

THE DROWSY CHAPERONE

—— THE NON-EVENT ——

THE WHAT? A VERY DIFFICULT TITLE TO UNDERSTAND, OR REMEMBER.

—— THE EVENT ——

"SNL" MEETS THE 1920S OF YOUR IMAGINATION.

KEVIN McCOLLUM
PRODUCER

THE DROWSY CHAPERONE was saddled with what I knew would be the worst title in musical theater history. That was kind of the joke, but until you saw the show, you couldn't understand the joke. We needed to figure out how to express our humor in clear and fresh ways. I remember Tommy Greenwald coming up with the line, "Sometimes you can just tell by the title that a show is going to be amazing. This is not one of those times." He said it out loud, and I howled. That's how we launched: We know you think it's bad, but this is our sense of humor. We were talking to the audience directly. Because the show was about the form of musical comedy, we played with advertising's form too. We were self-conscious, and it really worked.

CASEY NICHOLAW
DIRECTOR/CHOREOGRAPHER

THERE WAS ONE CAMPAIGN that didn't make it. It was this series of posters with headlines that said things like, "Are you a Tottendale?," "Are you a Janet?," "Are you an Adolpho?" And it featured the characters' wigs. And it's funny, because I'm married to Josh Marquette, the show's hair designer now, though I didn't know him at the time. We were in L.A. trying the show out there, and the wigs came out of the box for the first time. And I saw Adolpho's wig, and I thought, "That is never going to make it onto the stage." But then Danny Burstein [who played Adolpho] put it on, and it came to life. And then as the show went on, it sort of became this iconic thing —Danny in that wig—in the ads and everything. And even now, Josh and I have an "Are you an Adolpho?" poster on the wall of our lake house.

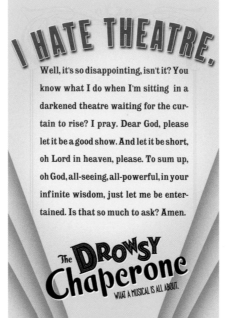

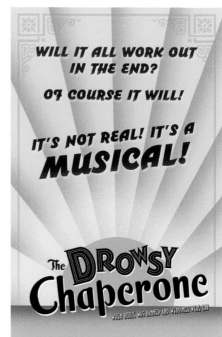

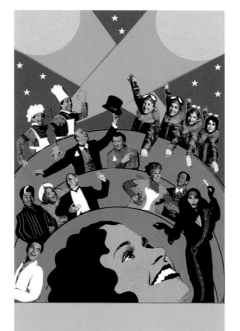

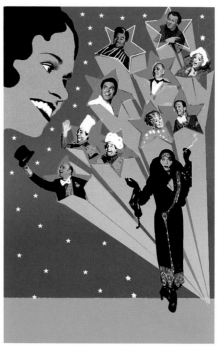

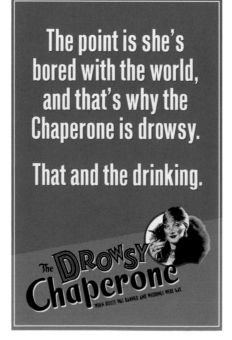

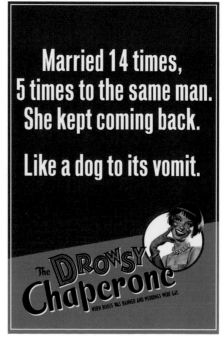

IF NOEL COWARD AND REX HARRISON HAD HAD SEX, AND DON'T THINK NOEL DIDN'T TRY, THIS WOULD BE THEIR BASTARD CHILD.

DROWSY Chaperone

Step Outside Your Everyday Musical.

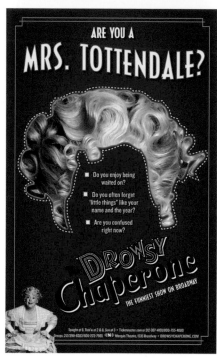

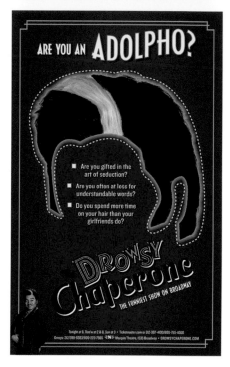

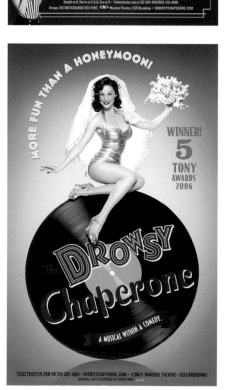

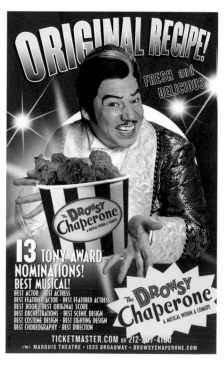

FAITH HEALER

— THE NON-EVENT —

RELIGIOUS REVIVALS MAKE EVERYONE SQUIRM.

— THE EVENT —

FINE ACTORS DIRECTED FINELY. *ELEGANCE AND MYSTERY HELPS*.

JONATHAN KENT
DIRECTOR

I WISH I COULD PRETEND that the *Faith Healer* poster was my idea. But no . . . it was Drew who came up with the image—something that gave the flavor of a makeshift revivalist meeting of the period. And it didn't hurt that the three actors, quite apart from their fame, had the most distinctive, arresting faces around. Ralph's gaze alone could stop traffic at a hundred yards. The image is the first contact the audience has with a production—it should prepare us for the experience we would have if we were to buy a ticket. The uncompromising, inescapable strength of those three staring figures—all in their separate worlds—gave warning of Brian Friel's strange, hypnotic, and ultimately tragic contemporary classic.

The story of an itinerant faith healer in rural Ireland is not, perhaps, at first sight, the most commercial of propositions, but those three figures, confronting us, defying us, and challenging us, couldn't help but draw us in—in the same way that the three characters of the play draw us into their terrible story of faith and betrayal.

> **THE IMAGE IS THE FIRST CONTACT THE AUDIENCE HAS WITH A PRODUCTION—IT SHOULD *PREPARE US* FOR THE EXPERIENCE WE WOULD HAVE IF WE WERE TO BUY A TICKET.**
> *JONATHAN KENT*

above
Sketches, an early twentieth century image of "magical powers," and an attempt at combining three figures into one pair of eyes, featuring SpotCo designers.

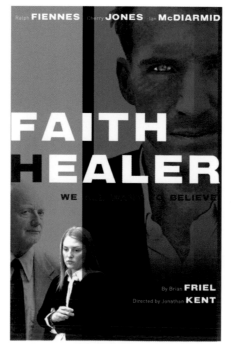

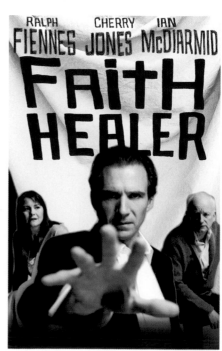

RALPH FIENNES CHERRY JONES IAN McDIARMID

FAITH HEALER

by
BRIAN FRIEL

directed by
JONATHAN KENT

PHOTO: NIGEL PARRY

MICHAEL COLGAN & SONIA FRIEDMAN PRODUCTIONS
THE SHUBERT ORGANIZATION ROBERT BARTNER ROGER BERLIND SCOTT RUDIN SPRING SIRKIN
present RALPH FIENNES CHERRY JONES IAN McDIARMID in the GATE THEATRE DUBLIN production of FAITH HEALER by BRIAN FRIEL
Set and Costume Design JONATHAN FENSOM Lighting Design MARK HENDERSON Sound Design CHRISTOPHER CRONIN Video Design SVEN ORTEL
U.S. Casting JIM CARNAHAN, C.S.A. Production Stage Manager JANE GREY Production Management AURORA PRODUCTIONS Press Representative BARLOW•HARTMAN
General Management STUART THOMPSON PRODUCTIONS / JAMES TRINER Associate Producer LAUREN DOLL Directed by JONATHAN KENT

TELECHARGE.COM 212-239-6200
FAITHHEALERONBROADWAY.COM ♿ BOOTH THEATRE 222 WEST 45TH STREET

LIVE BROADWAY

125

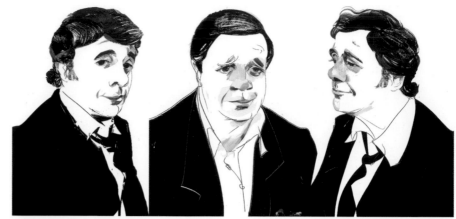

BUTLEY

THE NON-EVENT

SAD SACK CHARACTER.

THE EVENT

THE GREATEST THE STAGE HAS *(NATHAN LANE)* IN A FRANCIS BACON FRACTURED PORTRAYAL.

RICCARDO VECCHIO
ILLUSTRATOR

WE TOOK A CAR OUT TO the Hamptons so I could sketch Nathan Lane in person. On the ride out, there was natural buildup and expectation and tension, and since there was a limited amount of time with him, that added to it. It's interesting, when you're working with a famous figure, someone you know from the public eye or from iconic photographs, when you meet them in person and see them in flesh and bone, they don't always look like they did in these famous photos. And of course, since this wasn't a photo shoot, it wasn't styled and there was no special lighting. He was dressed casually, and he wasn't acting, obviously. So I was trying to bring the "idea" of Nathan Lane and the person sitting in front of me together, with the same denominator. With the camera, you can pose someone. But when you ask someone to stay still for as long as possible, it's not comfortable for anyone. We were with him for about an hour, maybe an hour and a half. He was very cordial. I think I did maybe seven or eight drawings while I was there, and then I combined the best elements of them to make the final poster—an eye from this one, a chin from another. I came back to New York City and scanned them and layered them all in Photoshop. It's almost like being a sculptor. You put them all on top of one another then take away the layers to see what looks most like him, most like the Nathan Lane we think we know.

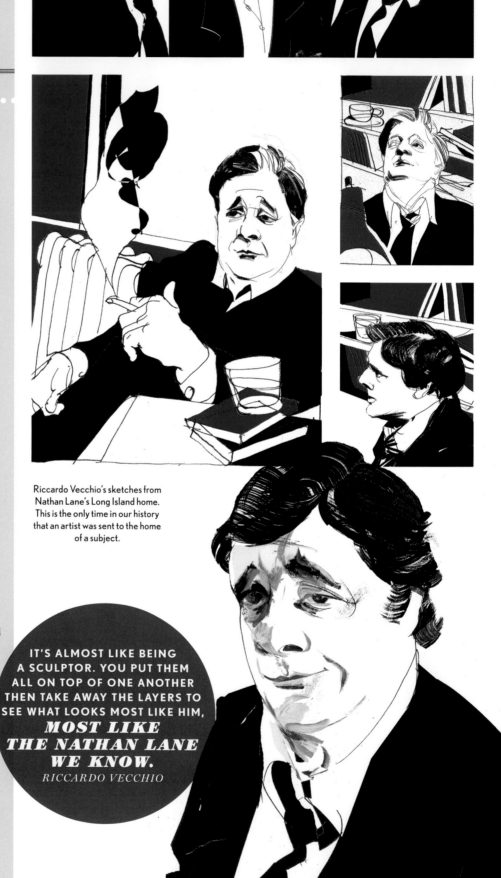

Riccardo Vecchio's sketches from Nathan Lane's Long Island home. This is the only time in our history that an artist was sent to the home of a subject.

> IT'S ALMOST LIKE BEING A SCULPTOR. YOU PUT THEM ALL ON TOP OF ONE ANOTHER THEN TAKE AWAY THE LAYERS TO SEE WHAT LOOKS MOST LIKE HIM, *MOST LIKE THE NATHAN LANE WE KNOW.*
> *RICCARDO VECCHIO*

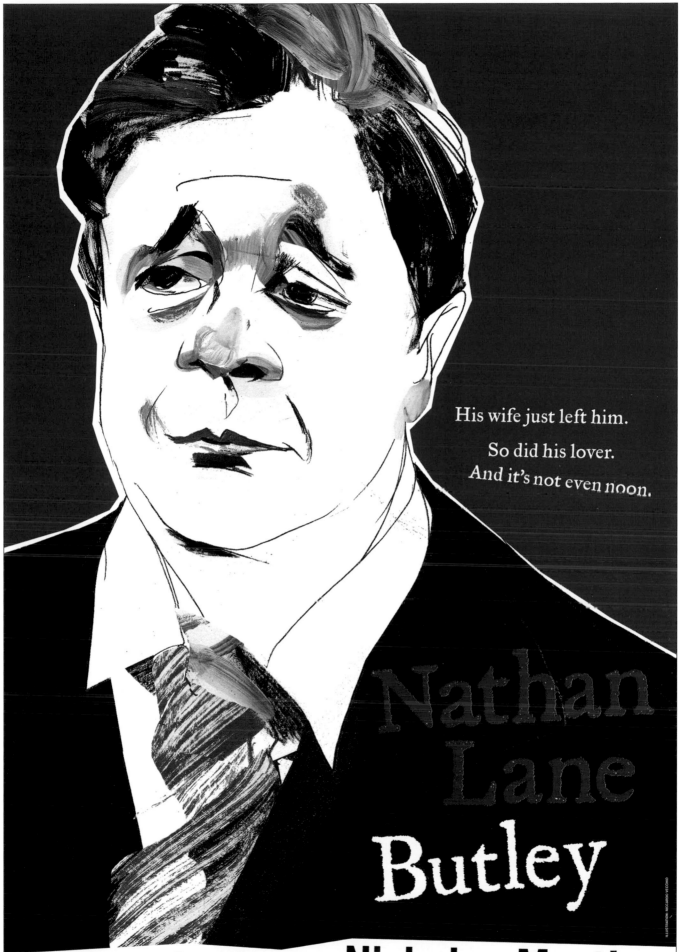

His wife just left him.

So did his lover.
And it's not even noon.

Nathan
Lane

Butley

ILLUSTRATION RICCARDO VECCHIO

By **Simon Gray** Directed by **Nicholas Martin**

Previews begin Thursday October 5th Strictly Limited Engagement

TELECHARGE.COM OR 212-239-6200/800-432-7250 ♿ Booth Theatre 222 W. 45th St.

THE YEAR OF MAGICAL THINKING

── THE NON-EVENT ──

THE LOSS OF A CHILD IS THE SADDEST THING IMAGINABLE.

── THE EVENT ──

GOURMET THEATER. **ELEGANCE AND HONESTY AS A SINGULAR EXPERIENCE.**

BRIGITTE LACOMBE
PHOTOGRAPHER

IT WAS VERY INTIMATE sitting. Very small. Just Vanessa Redgrave, Joan Didion, and David Hare. Scott Rudin, Drew Hodges, and [costume designer] Ann Roth were there too. I was very aware that it was an exceptional project, and I was very grateful to be part of it. We did several images—a portrait of Vanessa, saying lines from the play, that became the poster, and then portraits of Joan Didion and David Hare with and without Vanessa Redgrave. Some all sitting together. It is very unusual to work on a play with only one character. It was a very delicate and warm moment.

right
Outtakes from our photo shoot with three fascinating and fiercely intelligent people: actress Vanessa Redgrave, writer Joan Didion, and director David Hare.

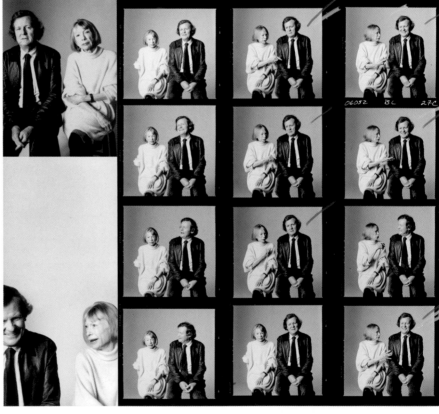

Vanessa Redgrave

• • •

the year of
MAGICAL THINKING

• • •

a play by JOAN DIDION based on her memoir
directed by DAVID HARE

YOUNG FRANKENSTEIN

TOM GREENWALD
SPOTCO

ONE OF THE FUN THINGS about my job is working with those I admire. There are a lot of smart, fun, funny people in this business. Some of them are even famous. But don't worry—I'm not one of those people who fawns over celebrities, or insists on taking a picture with them, or even—God forbid—brings along members of my family. I would never do that.

Except that one time.

We were recording a radio spot with Mel Brooks for his musical *Young Frankenstein*. My son, Charlie, worships Mel Brooks. Who doesn't, right? When Charlie found out I was working with Mel, he put on the full-court press. So yeah, I brought him to the recording session. Sue me. Charlie was about fourteen years old at the time. So naturally, when Mel walks in and spots Charlie, he immediately shouts, "Whose kid is this?" "Mine, Mel," I say. "His name is Charlie." "Charlie! I have a question for you." Charlie is nervous—but remarkably, not tongue-tied. "Yes, Mr. Brooks?" Mel narrows his eyes. "Were you bar mitzvahed?" Charlie looks at me. We both shrug, knowing Mel isn't going to like the answer. "No, Mr. Brooks, I wasn't." "WHAT THE HELL IS WRONG WITH PEOPLE?" Mel yells. "DOESN'T ANYONE GET BAR MITZVAHED ANYMORE?" Then Mel spots the *Spaceballs* DVD in Charlie's hand, and without Charlie even asking, grabs it and signs it "May The Schwartz be with you—Mel Brooks."

Finally, we get to work. I show Mel the scripts. He writes some new jokes, then says, "We should put the gay bar joke in here." Mel is referencing a line from the show, which he was very fond of. The client and I look at each other. Neither of us are sure about the gay bar joke. Looking for an ally, Mel turns to Charlie. "What do you think, Charlie?

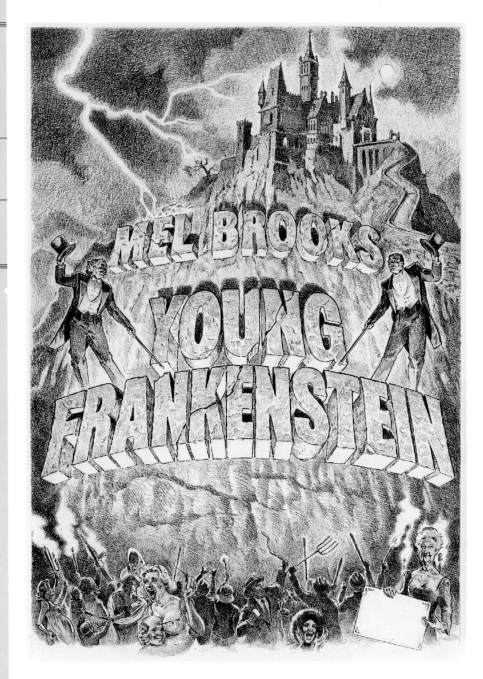

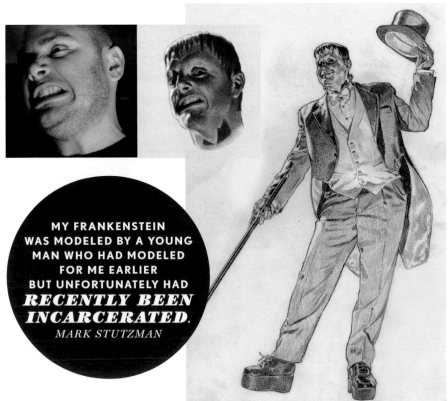

MY FRANKENSTEIN WAS MODELED BY A YOUNG MAN WHO HAD MODELED FOR ME EARLIER BUT UNFORTUNATELY HAD ***RECENTLY BEEN INCARCERATED***.
MARK STUTZMAN

tell me Monster — what is
The biggest difference between
"NIGHT LIFE" IN Transylvania
AND NITE LIFE Here on B'way

youre KIDDING — there are
more GAY BARS IN TRANSYL-
VANIA ?

Tell me MONSTER APPEALS
to you IN THE OPPOSITE SEX

monHe SLOBBERS DROOLS — SLURPS
SNORTS ORGASMIC SOUND

~~Monster~~
AH, Her INTELLECT AND Keen Judgment

He ROARS IN PROTEST

MeL— DON'T BE STUPID — I CAN'T
SAY WHAT YOU SAID — we're ON
the RADIO — YOU COULD TURN
THIS STATION INTO A GARAGE

Should the gay bar joke go in the commercial?" Charlie nods vigorously. "Absolutely, Mel." So, no more Mr. Brooks. Jeez, that was fast. Mel holds up his hands. "Charlie has spoken!" The gay bar joke went in the spot.

MARK STUTZMAN
ILLUSTRATOR

PICK A MONSTER, ANY monster, seemed to be the theme with the *Young Frankenstein* poster art. I felt as if I were a crime-sketch artist coaxing the identity out of a witness. Round and round we went, until we finally landed on the look that would satisfy its maniacal creator, Mel Brooks. There needed to be a balance of familiarity to the film monster with a fresh look for the stage audience. Mel Brooks's input and scrutiny were pivotal to the final outcome.

I was a huge fan of the show's black-and-white film version, so this was a labor of love for me. Creating the laboratory and gadgets that filled it were fodder for an artist's imagination. My Frankenstein was modeled by a young man who had modeled for me earlier but unfortunately had recently been incarcerated. The jail authorities allowed him out for a photo shoot, which was crazy and amusing, with a dash of drama. I don't think he had been jailed for grave robbing, but I never asked. Not many work-release situations call for formal attire either. He was a great fit for the character, so the extra finagling was well worth it.

STEPHEN SOSNOWSKI
SPOTCO

I'll always remember the opening night of this show. The producer, Bob Sillerman, decided to throw a pre-show celebration for the folks who worked closely with him on the marketing, sales, and management. He threw the party at the McDonald's in Times Square on 42nd Street, directly across from the theater. Here we all were in our tuxedoes for a black-tie opening munching on Big Macs and Chicken McNuggets. At five minutes to curtain, everyone started to leave. Tom Greenwald (our chief strategy officer) and I stayed for one more burger, just the two of us. As we finished our last bite, who came walking up the stairs by himself? None other than Mel Brooks! He saw the two us and simply asked, "Did I miss the party?" Mel might have, but Tom and I certainly didn't.

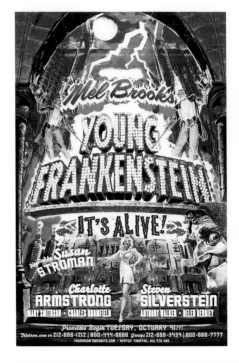

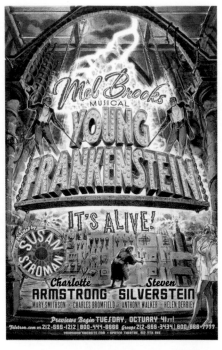

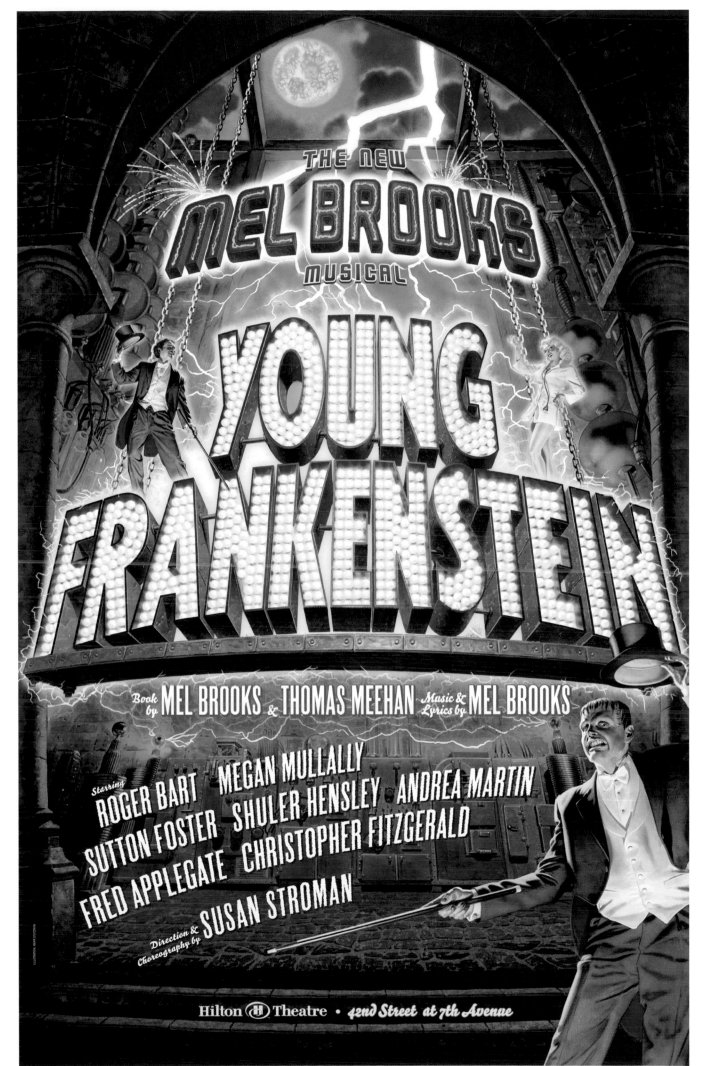

AUGUST: OSAGE COUNTY

THE NON-EVENT ———

UNKNOWNS IN A DIFFICULT TITLE.

——— THE EVENT ———

AMERICAN GOTHIC *ON PILLS.*

DEANNA DUNAGAN
ACTOR

I LOVE THAT POSTER! IT was very, very exciting to be a part of that shoot. All the actors went down to the studio at the same time. We all had our hair and makeup done professionally. This is just not something that happens in the theater world. Usually, you do your own. Nigel [Parry, the photographer] had us say lines from the play and *move* and it was like you see models doing. And then he just took these rapid-fire shots, hundreds of them, with the camera going off and making that clicking noise you hear. The adrenaline was flowing. I got to be Violet [Dunagan's character] at her most dynamic and wonderful and physical. I didn't get to do that in the play. I got to be a younger version of Violet, the version I would imagine she was before she got older and hooked on pain pills. This is the Violet who really enjoyed being the center of attention. Nigel got to the essence of everybody. The Violet in the poster—I think that's the way Violet would think of herself.

NIGEL PARRY
PHOTOGRAPHER

THIS WAS PROBABLY ONE of the first digital theater poster shoots I ever did. There's always something lovely about having actors on a one-to-one, and there's something even more lovely when they are able to be in character. Since most actors (ironically) are very reluctant to be in front of a stills camera, they mind less if they are in character, and are then "caught" as the person they are playing. So this is a great example of a poster that was shot in single images and then composed together under the creative direction of SpotCo.

I POINTED OUT THAT GRANT WOOD, PAINTER OF THE ICONIC *AMERICAN GOTHIC*, WAS FROM OKLAHOMA (WHERE OSAGE COUNTY ACTUALLY IS) AND WOULD BE HISTORTICALLY *AND SPIRITUALLY* APPROPRIATE TO OUR PLAY.
DREW HODGES

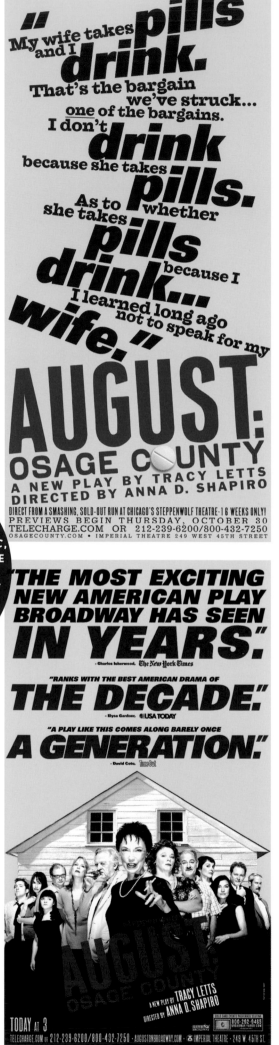

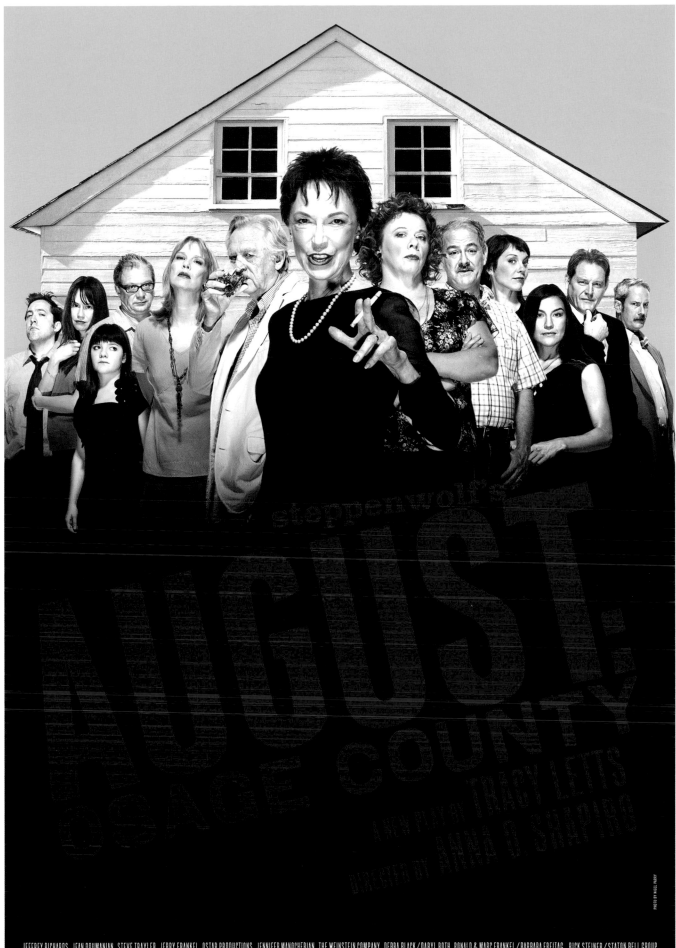

IN THE HEIGHTS

THE NON-EVENT

LATINO NEIGHBORHOOD PORTRAIT.

THE EVENT

JOYOUS FABLE, WHERE THE SPECIFIC BECOMES UNIVERSAL.
(THINK *FIDDLER ON THE ROOF*)

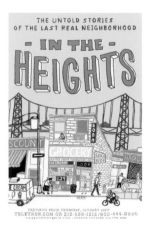
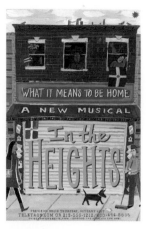

LIN-MANUEL MIRANDA
LYRICIST/COMPOSER/CONCEIVER/ACTOR

WHAT I REMEMBER MOST distinctly about the *Heights* artwork Off-Broadway—besides the thrill of that yellow bodega lettering in our first SpotCo meeting—is the first day the posters went up. I was still living with roommates at the top of Manhattan. As the train stops at 200th Street, there's my face, staring back at me, in the subway station I've known my whole life. I sank down in my chair. I was wearing the same hat in the ad because that's *my hat*. And there I was again at 190th Street, 181st Street—every stop in Washington Heights on the way downtown. It was the most surreal subway ride of my life, and I once saw a subway preacher get into a fight with a dude with a parrot.

JEFFREY SELLER
PRODUCER

OUR FIRST TASK WAS TO take advantage of the summer light to create a live-action television commercial on the streets of Washington Heights. On a gorgeous, sun-filled morning , we went to work. The thirty-second spot would introduce the show with Usnavi's opening rap in the bodega and then explode on the street with the entire cast. Our ace dancer Seth Stewart, who played Graffiti Pete, spent a good part of the day doing many 180-degree jumps with his legs flying high over his body. I'll always remember the day they were putting up the billboard in Times Square. It was all about Seth. Though this was his second Broadway show, it was his first Times Square billboard. As he watched the men raise his photo thirty feet high in the air, he called his mother on his cell phone and cried.

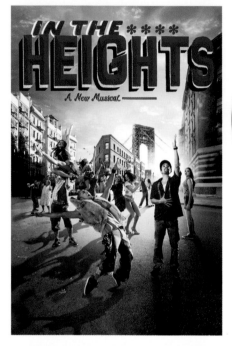

IT WAS A THRILLING DAY FULL OF SO MANY HIGH-LIGHTS, BUT ONE IN PARTICULAR STOOD OUT—A GROUP OF LATINO CHILDREN SAT ON A STOOP AND WATCHED US WITH *RAPT ATTENTION*. IT WAS LIFE MIRRORING ART, AS ART MIRRORED LIFE.
JILL FURMAN
PRODUCER

THE POST-OPENING AD MEETING WAS A CELEBRATION. AS I'M FUMBLING TO OPEN THE CHAMPAGNE, A LINE FROM THE SHOW HITS ME: *"HOW DO I GET THIS GOLD SHIT OFF?"* WE LAUGH, WE DRINK, WE CELEBRATE.
PETE MILANO
FORMER DIRECTOR OF MEDIA, SPOTCO

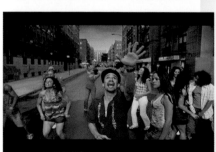

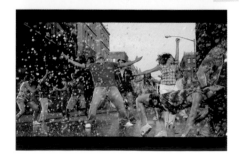

above, top row
Early sketches for *In The Heights* when it was Off-Broadway. (second row) The art for Broadway, with an emphasis on the sense of fable in the show, and a look meant to feel "larger" than the earlier look.

below, left
Stills from the television commercial shot in Washington Heights.

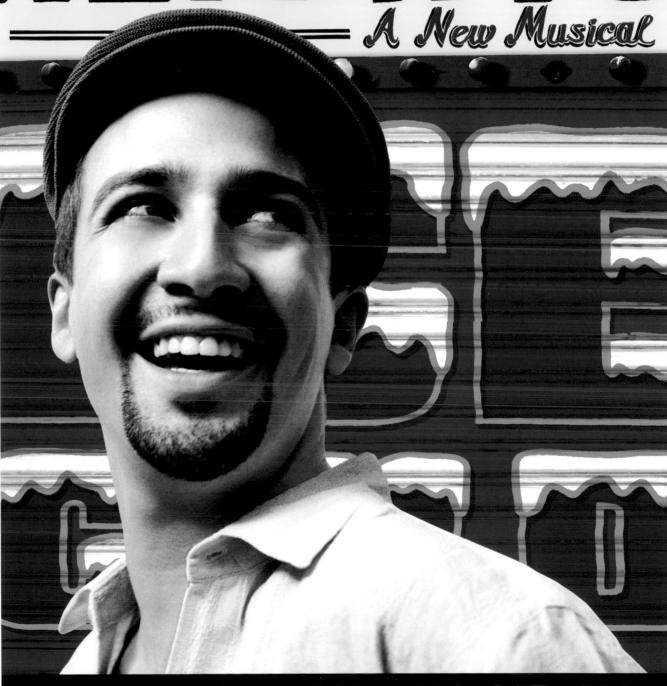

****IN THE
HEIGHTS
A New Musical

TICKETMASTER.COM OR 212-307-4100
37 ARTS, 450 W. 37th St. · InTheHeightsTheMusical.com

137

SHREK

THE NON-EVENT

PERFECT YOUNG FAMILY VIEWING, AT HOME.

THE EVENT

ORIGINALITY, WIT, AND SPECTACLE
MAKE IT A ROMP OF A NIGHT FOR A GROWN-UP, LIVE.

WHEN WE WERE LOOKING for office space for our first big office, we used to review one scenario in every elevator. We would say it out loud, to the mystery of real estate brokers: "If Jeffrey Katzenberg came calling, up this elevator into this space, would he deem us worthy of his work, or not?" At the time, it seemed absurd and impossibly unlikely. DreamWorks and Jeffrey Katzenberg were as imaginary as we could get for a potential client.

But one day he did come calling. And amazingly, we were told he needed to see our offices to give us the thumbs-up for working on *Shrek The Musical*. For whatever reason (possibly the lobby?), we passed muster. Sam Mendes and his producing partner Caro Newling were leading this ship, and we tried everything. *Shrek* imagery was clearly everywhere, but we had to find a way to reinvent the look that told an adult this was a return to the sophistication and wit of the first film, and then some. DreamWorks was passionate that while

We did walls and walls of art for *Shrek*—it was one of our most difficult challenges. Above are early marks, and below, Shrek with a tramp stamp, which I still find funny. Bottom right is the logo art that ran. — D.H.

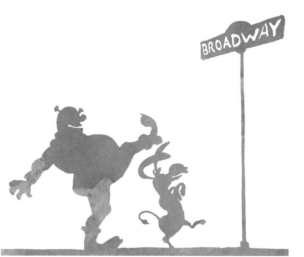

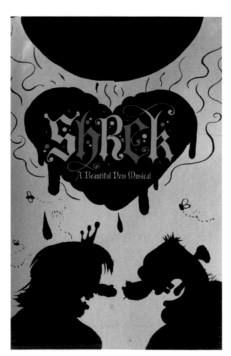

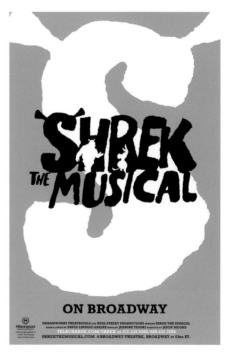

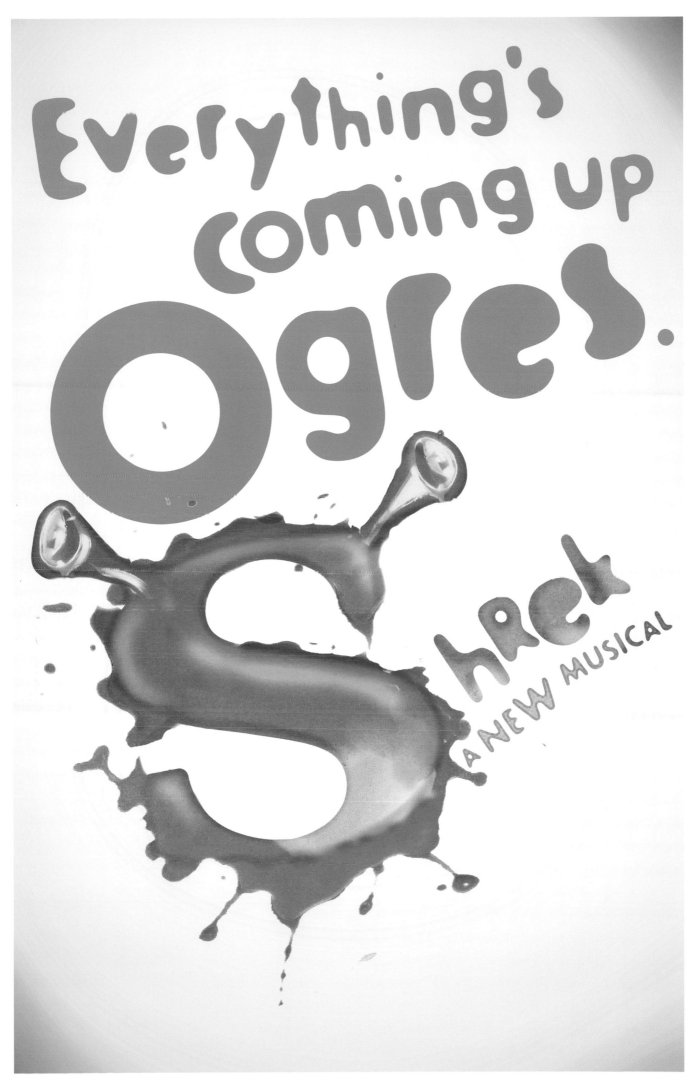

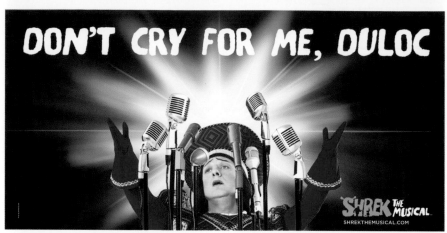

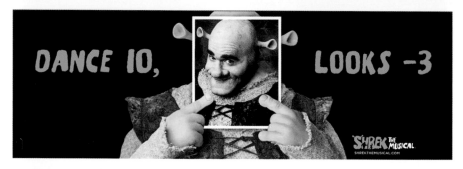

kids would like this show, it was not a *kids'* show.

We tried tattoos. We tried illustrators who went back to look at the very original, very smelly children's book it was all based on. We tried many, many greens, and discussed for nearly a year whether our green was unique enough from other green musicals on Broadway. I remember covering two conference rooms with as much art as we could make, and presenting it all to Jeffrey Katzenberg, Ann Daly, Bill Damaschke, and studio fixer Terry Press—the DreamWorks team—with Sam's smiling approval. Sadly, I think it might be the last time I remember Sam smiling on this project, but everyone kept working, trying to find *it*. In the end, everyone settled on a mark. I could write another book on marks—what they do, what they don't do, and when to use them. Let's simplify by saying that upon repetition and success, marks gain value and power—they effectively get back-filled with what everyone else knows about the show. But they also begin slowly, and don't allow for flexibility or muscularity in evolving a message. And most difficult of all in this case, while they feel big, they are almost never funny. And for this show to be perceived as appropriate for adults on a Tuesday in winter, it needed to be funny.

I have picked my favorite work to show here. We literally have fifty or more attempts we could show, and thanks to DreamWorks for allowing us to present it all. But nothing was ever better than the page of ABC ads, which ran as a full-page ad in the *New York Times*. Take the time to read them, and I promise at least a three-snort event.
—D.H.

above right
Four images of many that ran in the Times Square subway station.

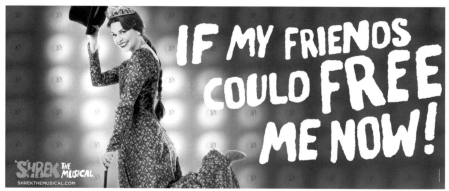

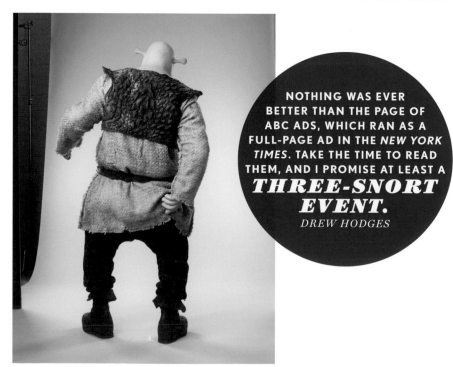

NOTHING WAS EVER BETTER THAN THE PAGE OF ABC ADS, WHICH RAN AS A FULL-PAGE AD IN THE *NEW YORK TIMES*. TAKE THE TIME TO READ THEM, AND I PROMISE AT LEAST A
THREE-SNORT EVENT.
DREW HODGES

Tonight at 7
"Harrowing!" -The Duloc Times

A WOODEN SOLDIER'S SONG

Directed by Geppetto
For tickets,
visit ShrekTheMusical.com
or www.Telecharge.com or call
212-239-6200 / 800-432-7250
Groups: 212-239-6262 / 800-432-7780
Previews Begin November 8
Broadway Theatre, B'way & 53rd St.

Today at 3 & 8
Direct from a Smash-Hit
London Engagement
LITTLE MISS MUFFET in

ARACHNOPHOBIA:
The Musical

For tickets,
visit ShrekTheMusical.com
or www.Telecharge.com or call
212-239-6200 / 800-432-7250
Groups: 212-239-6262 / 800-432-7780
Previews Begin November 8
Broadway Theatre, B'way & 53rd St.

Tonight at 8

AXIS OF EVIL STEPSISTERS

A Stylish Political Thriller
For tickets,
visit ShrekTheMusical.com
or www.Telecharge.com or call
212-239-6200 / 800-432-7250
Groups: 212-239-6262 / 800-432-7780
Previews Begin November 8
Broadway Theatre, B'way & 53rd St.

Today at 2 & 8
From the producers of "DOC DANCES!"

BASHFUL SINGS!

For tickets,
visit ShrekTheMusical.com
or www.Telecharge.com or call
212-239-6200 / 800-432-7250
Groups: 212-239-6262 / 800-432-7780
Previews Begin November 8
Broadway Theatre, B'way & 53rd St.

Tonight at 8
JACK is BACK!

BEAN STALKER

A New Play
For tickets,
visit ShrekTheMusical.com
or www.Telecharge.com or call
212-239-6200 / 800-432-7250
Groups: 212-239-6262 / 800-432-7780
Previews Begin November 8
Broadway Theatre, B'way & 53rd St.

Tonight at 8 & 10
2nd Fabulous Year!

DRAGONS IN DRAG

For tickets,
visit ShrekTheMusical.com
or www.Telecharge.com or call
212-239-6200 / 800-432-7250
Groups: 212-239-6262 / 800-432-7780
Previews Begin November 8
Broadway Theatre, B'way & 53rd St.

Today at 2 & 7, Tues at 8
Snow White Looks Back

DWARVES:
CAN'T LIVE WITH 'EM...

For tickets,
visit ShrekTheMusical.com
or www.Telecharge.com or call
212-239-6200 / 800-432-7250
Groups: 212-239-6262 / 800-432-7780
Previews Begin November 8
Broadway Theatre, B'way & 53rd St.

Today at 2 & 8

EATING MS. RIDINGHOOD

A play in 3 acts by B.B. Wolf
For tickets,
visit ShrekTheMusical.com
or www.Telecharge.com or call
212-239-6200 / 800-432-7250
Groups: 212-239-6262 / 800-432-7780
Previews Begin November 8
Broadway Theatre, B'way & 53rd St.

Tonight at 8
"INTOXICATING!" -The Daily Mews

ELF MEDICATION

For tickets, visit ShrekTheMusical.com
or www.Telecharge.com
or call 212-239-6200 / 800-432-7250
Groups: 212-239-6262 / 800-432-7780
Previews Begin November 8
Broadway Theatre, B'way & 53rd St.

Today at 2 & 7
You'll DIG it!

GOLD DIGGER

starring RUMPELSTILTSKIN
For tickets,
visit ShrekTheMusical.com
or www.Telecharge.com or call
212-239-6200 / 800-432-7250
Groups: 212-239-6262 / 800-432-7780
Previews Begin November 8
Broadway Theatre, B'way & 53rd St.

Today at 2 & 8
WINNER! BEST REVIVAL
2007 Phony Award
2007 Outer Cynics Circle Award
2007 Llama Desk Award

HAIR

Starring RAPUNZEL
For tickets,
visit ShrekTheMusical.com
or www.Telecharge.com or call
212-239-6200 / 800-432-7250
Groups: 212-239-6262 / 800-432-7780
Previews Begin November 8
Broadway Theatre, B'way & 53rd St.

Tonight at 8
World Premiere!

HEATHER HAS TWO MAMA BEARS

For tickets,
visit ShrekTheMusical.com
or www.Telecharge.com or call
212-239-6200 / 800-432-7250
Groups: 212-239-6262 / 800-432-7780
Previews Begin November 8
Broadway Theatre, B'way & 53rd St.

Tonight at 8

CAT FIDDLE
COW MOON
DISH SPOON
and LITTLE DOG
in

HEY, DIDDLE!

A New Musical Comedy
For tickets,
visit ShrekTheMusical.com
or www.Telecharge.com or call
212-239-6200 / 800-432-7250
Groups: 212-239-6262 / 800-432-7780
Previews Begin November 8
Broadway Theatre, B'way & 53rd St.

Today at 3
"GINGY is AWE-INSPIRING!" –WSTV

HOME, SWEET GINGERBREAD HOME

A New Play by Ima Baker
For tickets,
visit ShrekTheMusical.com
or www.Telecharge.com or call
212-239-6200 / 800-432-7250
Groups: 212-239-6262 / 800-432-7780
Previews Begin November 8
Broadway Theatre, B'way & 53rd St

Tonight at 8
2008 Phony Award Winner!
BEST PLAY

HUFF/PUFF

THREE PIGS. THREE HOUSES.
ONE TRAGIC DAY.
For tickets,
visit ShrekTheMusical.com
or www.Telecharge.com or call
212-239-6200 / 800-432-7250
Groups: 212-239-6262 / 800-432-7780
Previews Begin November 8
Broadway Theatre, B'way & 53rd St.

Tomorrow & Tues at 8

IN ROBIN'S HOOD

The Hip-Hop Musical
For tickets,
visit ShrekTheMusical.com
or www.Telecharge.com or call
212-239-6200 / 800-432-7250
Groups: 212-239-6262 / 800-432-7780
Previews Begin November 8
Broadway Theatre, B'way & 53rd St.

Tonight at 8
Now in Previews

JUST US FAIRIES

A Touching Docu-Drama
For tickets,
visit ShrekTheMusical.com
or www.Telecharge.com or call
212-239-6200 / 800-432-7250
Groups: 212-239-6262 / 800-432-7780
Previews Begin November 8
Broadway Theatre, B'way & 53rd St.

Today at 2 & 8
EXTENDED BY POPULAR DEMAND!
"It's stand-up meets sheep-herding!"
–Variah T.

LIL' BO PEEP: LIVE!

SHE'S BAAAAAAA-D!
For tickets,
visit ShrekTheMusical.com
or www.Telecharge.com or call
212-239-6200 / 800-432-7250
Groups: 212-239-6262 / 800-432-7780
Previews Begin November 8
Broadway Theatre, B'way & 53rd St.

Tonight at 8
"Comic genius!" -New York Toast
3rd Smash Year

MOON OGRE BUFFALO

For tickets,
visit ShrekTheMusical.com
or www.Telecharge.com or call
212-239-6200 / 800-432-7250
Groups: 212-239-6262 / 800-432-7780
Previews Begin November 8
Broadway Theatre, B'way & 53rd St.

Today at 3
"RARELY DOES A PERFORMANCE
LIKE THIS COME ALONG."
–The Daily Mews
MOTHER GOOSE is

MOTHER COURAGE

For tickets,
visit ShrekTheMusical.com
or www.Telecharge.com or call
212-239-6200 / 800-432-7250
Groups: 212-239-6262 / 800-432-7780
Previews Begin November 8
Broadway Theatre, B'way & 53rd St.

Today at 3 & 7
"YOU WON'T BELIEVE IT!"
–Entertainment Daily

PINOCCHIO:
Conversations With A Liar

For tickets,
visit ShrekTheMusical.com
or www.Telecharge.com or call
212-239-6200 / 800-432-7250
Groups: 212-239-6262 / 800-432-7780
Previews Begin November 8
Broadway Theatre, B'way & 53rd St.

FINAL WEEKS!
Tonight at 8
Winner! Llama Desk Award
BEST SOLO PERFORMANCE
Princess Fiona is

PRINCESS ON THE EDGE

For tickets,
visit ShrekTheMusical.com
or www.Telecharge.com or call
212-239-6200 / 800-432-7250
Groups: 212-239-6262 / 800-432-7780
Previews Begin November 8
Broadway Theatre, B'way & 53rd St.

Today at 3
PETER PETER in

PUMPKIN PI

A Mathematical Thriller
For tickets, visit ShrekTheMusical.com
or www.Telecharge.com
or call 212-239-6200 / 800-432-7250
Groups: 212-239-6262 / 800-432-7780
Previews Begin November 8
Broadway Theatre, B'way & 53rd St.

BRINGING
UGLY
BACK
NOVEMBER 8th

SHREK THE MUSICAL

Book & Lyrics by Music by
David Lindsay-Abaire Jeanine Tesori
Directed by
Jason Moore
For tickets,
visit ShrekTheMusical.com
or www.Telecharge.com or call
212-239-6200 / 800-432-7250
Groups: 212-239-6262 / 800-432-7780
Broadway Theatre, B'way & 53rd St.

"A STAR IS BORN!" –Wall St. Kernel
Donkey is

STEEDMUFFIN

The world of an a**, from the inside.
For tickets,
visit ShrekTheMusical.com
or www.Telecharge.com or call
212-239-6200 / 800-432-7250
Groups: 212-239-6262 / 800-432-7780
Previews Begin November 8
Broadway Theatre, B'way & 53rd St.

Tonight at 8
Strictly Limited Engagement:
Must End July 3
Bearly There Theatricals presents

THE GOLDILOCKS PROJECT

For tickets,
visit ShrekTheMusical.com
or www.Telecharge.com or call
212-239-6200 / 800-432-7250
Groups: 212-239-6262 / 800-432-7780
Previews Begin November 8
Broadway Theatre, B'way & 53rd St.

Tonight at 7
"BRILLIANT. DON'T MISS."
–The Gnu Yorker

TO KILL AN OGRE

by Puss in Boots
For tickets,
visit ShrekTheMusical.com
or www.Telecharge.com or call
212-239-6200 / 800-432-7250
Groups: 212-239-6262 / 800-432-7780
Previews Begin November 8
Broadway Theatre, B'way & 53rd St.

Today at 2 & 8
$40 Tickets: Use Code 9KIDS
An Old Woman stars in

TRY LIVING IN MY SHOE

For tickets, visit ShrekTheMusical.com
or www.Telecharge.com
or call 212-239-6200 / 800-432-7250
Groups: 212-239-6262 / 800-432-7780
Previews Begin November 8
Broadway Theatre, B'way & 53rd St.

Today at 3
"The writing is simply sublime."
–Jack's Mom

UP A HILL, DOWN A MOUNTAIN

A new play by Jack & Jill
For tickets,
visit ShrekTheMusical.com
or www.Telecharge.com or call
212-239-6200 / 800-432-7250
Groups: 212-239-6262 / 800-432-7780
Previews Begin November 8
Broadway Theatre, B'way & 53rd St.

Tonight at 8, Tues at 7
The Smash-Hit Play of the Year

WHITE BOYS CAN'T FLY
The Truth About Peter Pan

For tickets,
visit ShrekTheMusical.com
or www.Telecharge.com or call
212-239-6200 / 800-432-7250
Groups: 212-239-6262 / 800-432-7780
Previews Begin November 8
Broadway Theatre, B'way & 53rd St.

Tonight at 7
EMPTY V. presents

YOU CAN STAND UNDER MY CINDERELLA

A Pop Musical
For tickets,
visit ShrekTheMusical.com
or www.Telecharge.com or call
212-239-6200 / 800-432-7250
Groups: 212-239-6262 / 800-432-7780
Previews Begin November 8
Broadway Theatre, B'way & 53rd St.

Tonight at 7
13th Horrifying Year!

BLOODY SLIPPER
The Musical

For tickets,
visit ShrekTheMusical.com
or www.Telecharge.com or call
212-239-6200 / 800-432-7250
Groups: 212-239-6262 / 800-432-7780
Previews Begin November 8
Broadway Theatre, B'way & 53rd St.

Tonight at 8

CAPTAIN, HOOKED

A Story of Addiction and Recovery
For tickets,
visit ShrekTheMusical.com
or www.Telecharge.com or call
212-239-6200 / 800-432-7250
Groups: 212-239-6262 / 800-432-7780
Previews Begin November 8
Broadway Theatre, B'way & 53rd St.

Today at 2 & 8
Winner! Outer Cynics Circle Award
BEST COMEDY!

GNOME ALONE

For tickets,
visit ShrekTheMusical.com
or www.Telecharge.com or call
212-239-6200 / 800-432-7250
Groups: 212-239-6262 / 800-432-7780
Previews Begin November 8
Broadway Theatre, B'way & 53rd St.

Today at 3
"You'll never look under your
pillow the same way again."
-The Boston Lobe

I WAS THE TOOTH FAIRY

A Startling New Memoir
For tickets,
visit ShrekTheMusical.com
or www.Telecharge.com or call
212-239-6200 / 800-432-7250
Groups: 212-239-6262 / 800-432-7780
Previews Begin November 8
Broadway Theatre, B'way & 53rd St.

Tonight at 8, Tom'w at 7
THE FAIREST EXPERIMENTAL
DRAMA OF THEM ALL

MIRROR, RORRIM

There Are Two Sides To Every Story
For tickets,
visit ShrekTheMusical.com
or www.Telecharge.com or call
212-239-6200 / 800-432-7250
Groups: 212-239-6262 / 800-432-7780
Previews Begin November 8
Broadway Theatre, B'way & 53rd St.

Today at 3
"You'll crack up!" -Thyme Out NY

ME, SCRAMBLED

Written & Performed by
HUMPTY DUMPTY
For tickets,
visit ShrekTheMusical.com
or www.Telecharge.com or call
212-239-6200 / 800-432-7250
Groups: 212-239-6262 / 800-432-7780
Previews Begin November 8
Broadway Theatre, B'way & 53rd St.

Esta Noche A Las Ocho
El Royal Latino Theatre Guild
presenta

MI KINGDOM ES SU KINGDOM

For tickets,
visit ShrekTheMusical.com
or www.Telecharge.com or call
212-239-6200 / 800-432-7250
Groups: 212-239-6262 / 800-432-7780
Previews Begin November 8
Broadway Theatre, B'way & 53rd St.

GREAT SEATS AVAILABLE!
Today at 3
"A real tear-jerker!" –The Duloc Times

ONIONS ARE FOREVER
The Musical

For tickets,
visit ShrekTheMusical.com
or www.Telecharge.com or call
212-239-6200 / 800-432-7250
Groups: 212-239-6262 / 800-432-7780
Previews Begin November 8
Broadway Theatre, B'way & 53rd St.

Today at 3
Six Angry Princesses present

PRINCE CHARMING, MY FOOT!

For tickets,
visit ShrekTheMusical.com
or www.Telecharge.com or call
212-239-6200 / 800-432-7250
Groups: 212-239-6262 / 800-432-778
Previews Begin November 8
Broadway Theatre, B'way & 53rd St

Tonight at 7
The Womyn's Theatre Guild present

PRINCESS POWER-SUIT

SHE NEEDS NO RESCUING
For tickets, visit ShrekTheMusical.co
or www.Telecharge.com
or call 212-239-6200 / 800-432-7250
Groups: 212-239-6262 / 800-432-7780
Previews Begin November 8
Broadway Theatre, B'way & 53rd St

Tonight at 8

THE PORRIDGE FAMILY

TV's favorite musical family...
LIVE ON STAGE!
For tickets,
visit ShrekTheMusical.com
or www.Telecharge.com or call
212-239-6200 / 800-432-7250
Groups: 212-239-6262 / 800-432-778
Previews Begin November 8
Broadway Theatre, B'way & 53rd St

There's always something stirring a

THREE BLIND MICE CABARET

Today at 2 & 8

A TRIBUTE TO RAY CHARLES

For tickets,
visit ShrekTheMusical.com
or www.Telecharge.com or call
212-239-6200 / 800-432-7250
Groups: 212-239-6262 / 800-432-778
Previews Begin November 8
Broadway Theatre, B'way & 53rd St.

Tom'w at 8

TO SEE OR NOT TO SEE

For tickets,
visit ShrekTheMusical.com
or www.Telecharge.com or call
212-239-6200 / 800-432-7250
Groups: 212-239-6262 / 800-432-778
Previews Begin November 8
Broadway Theatre, B'way & 53rd St

Tues At 8

FARMER'S WIFE BURLESQUE

For tickets,
visit ShrekTheMusical.com
or www.Telecharge.com or call
212-239-6200 / 800-432-7250
Groups: 212-239-6262 / 800-432-7780
Previews Begin November 8
Broadway Theatre, B'way & 53rd St

Tonight at 8
Strictly Limited Engagement:
MUST END BY MIDNIGHT!!

CARRIAGE RIDE

A Charming Theatrical Journey
For tickets,
visit ShrekTheMusical.com
or www.Telecharge.com or call
212-239-6200 / 800-432-7250
Groups: 212-239-6262 / 800-432-7780
Previews Begin November 8
Broadway Theatre, B'way & 53rd St

TICKETS NOW ON SALE!
July 23 – 29
The Royally Awesome Musical
Event of the Year

DULOC-PALOOZA

For tickets,
visit ShrekTheMusical.com
or www.Telecharge.com or call
212-239-6200 / 800-432-7250
Groups: 212-239-6262 / 800-432-778
Previews Begin November 8
Broadway Theatre, B'way & 53rd St

The Beloved NYC Tradition Returns
COME HAM IT UP at

PIGSTOCK

For tickets,
visit ShrekTheMusical.com
or www.Telecharge.com or call
212-239-6200 / 800-432-7250
Groups: 212-239-6262 / 800-432-778
Previews Begin November 8
Broadway Theatre, B'way & 53rd St

2 PERFORMANCES ONLY

THE FROG FORMERLY KNOWN AS PRINCE

Live In Concert
For tickets,
visit ShrekTheMusical.com
or www.Telecharge.com or call
212-239-6200 / 800-432-778

WEST SIDE STORY

THE NON-EVENT

A GREAT FILM ON STAGE.

THE EVENT

THE LEGEND,
DONE SO WELL AND AUTHENTICALLY
THAT NOTHING COULD TOP IT.

KEVIN McCOLLUM
PRODUCER

WE KNEW THE PLAY WAS the thing. There had never really been a first-class *West Side Story* revival with the twenty-five-piece orchestra and full forty-member cast, and given that Arthur Laurents was going to direct it, we wanted to say: *event*. We had the logo crafted so that it wouldn't even fit on the page. You don't see the end of that "W," but you know what it is. Contractually, you would usually have to include the authors, especially because the geniuses of Broadway wrote it. I'm very grateful that the authors, and their estates, and Jerome Robbins' estate all understood that we were making it all about *West Side Story*, so that we didn't even put the author on that artwork. We just put up the words, "West Side Story," and people knew. It reinforced the iconic nature of the brand, and we were off to the races. I've never sold tickets as quickly as I did with the revival of that show.

WHEN WEST SIDE STORY was announced, we were thrilled and daunted. What to do with the artwork? We quickly came to realize that the show itself could be marketed as the one, the only *West Side Story*, primarily because it checked every revival box. Over my career I have developed a theory about revivals. There were three ways they worked:

1.) If they were indeed genuinely rare and almost never seen (and everyone wanted to see them). Every producer imagined their revival was indeed in this category, but in fact, few shows are indeed this rare: *Dreamgirls, The King and I.*

right
A mock street-snipe display—amazing how you can still tell exactly which show this is with such iconic imagery.

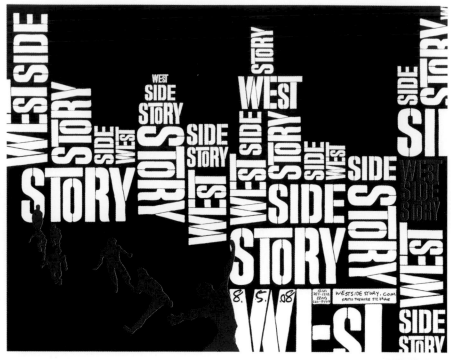

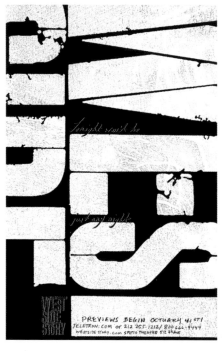

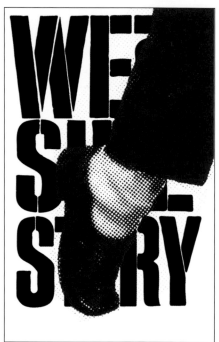

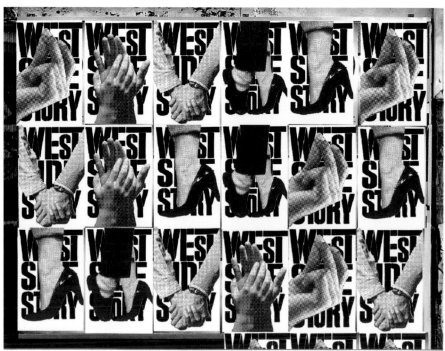

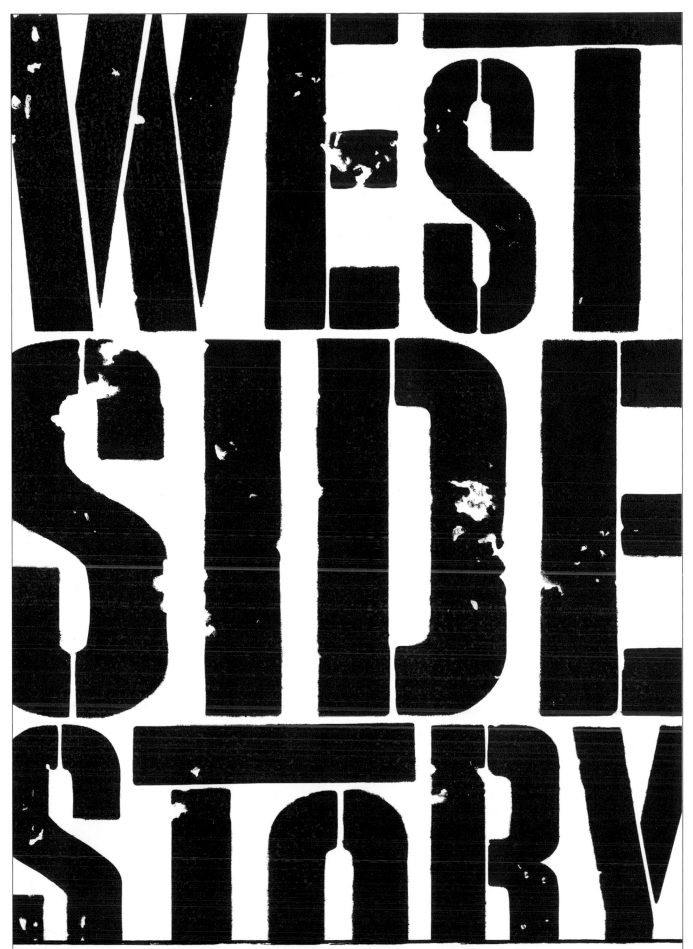

KEVIN MCCOLLUM JAMES L. NEDERLANDER JEFFREY SELLER TERRY ALLEN KRAMER SANDER JACOBS ROY FURMAN/JILL FURMAN WILLIS FREDDY DEMANN ROBYN GOODMAN/WALT GROSSMAN HAL LUFTIG ROY MILLER THE WEINSTEIN COMPANY
BROADWAY ACROSS AMERICA PRESENT WEST SIDE STORY BASED ON A CONCEPTION OF JEROME ROBBINS BOOK BY ARTHUR LAURENTS MUSIC BY LEONARD BERNSTEIN LYRICS BY STEPHEN SONDHEIM ENTIRE ORIGINAL PRODUCTION DIRECTED AND CHOREOGRAPHED BY JEROME ROBBINS
STARRING MATT CAVENAUGH JOSEFINA SCAGLIONE KAREN OLIVO CODY GREEN GEORGE AKRAM CURTIS HOLBROOK WITH NICHOLAS BARASCH STEVE BASSETT KYLE BRENN MIKE CANNON KYLE COFFMAN JOEY HARO ERIC HATCH MATTHEW HYDZIK
MICHAEL MASTRO LEE SELLARS TRO SHAW RYAN STEELE GREG VINKLER MARK ZIMMERMAN JOSHUA BUSCHER ISAAC CALPITO HALEY CARLUCCI PETER CHURSIN MADELINE CINTRON LINDSAY DUNN YUREL ECHEZARRETA JOHN ARTHUR GREENE
MANUEL HERRERA MARINA LAZZARETTO CHASE MADIGAN YANIRA MARIN MILEYKA MATEO KAITLIN MESH ANGELINA MULLINS KAT NEJAT CHRISTIAN ELÁN ORTIZ PAMELA OTTERSON DANIELLE POLANCO SAM ROGERS
MICHAEL ROSEN AMY RYERSON JENNIFER SANCHEZ MANUEL SANTOS MICHAELJON SLINGER TANAIRI SADE VAZQUEZ SCENIC DESIGN JAMES YOUMANS COSTUME DESIGN DAVID C. WOOLARD LIGHTING DESIGN HOWELL BINKLEY SOUND DESIGN DAN MOSES SCHREIER
WIGS & HAIR DESIGN MARK ADAM RAMPMEYER MAKE-UP DESIGN ANGELINA AVALLONE CASTING ASSOCIATE HOWARD/SCHECTER/HARDT ASSOCIATE DIRECTOR DAVID SAINT ASSOCIATE CHOREOGRAPHER LORI WERNER ASSOCIATE PRODUCER LAMS PRODUCTIONS TRANSLATIONS LIN-MANUEL MIRANDA
ORCHESTRATIONS LEONARD BERNSTEIN WITH SID RAMIN AND IRWIN KOSTAL MUSIC COORDINATOR MICHAEL KELLER PRODUCTION STAGE MANAGER JOSHUA HALPERIN ORIGINAL BROADWAY PRODUCTION CO-CHOREOGRAPHED BY PETER GENNARO TECHNICAL SUPERVISOR BRIAN LYNCH
MARKETING SCOTT A. MOORE PRESS REPRESENTATIVE BARLOW • HARTMAN GENERAL MANAGEMENT CHARLOTTE WILCOX COMPANY MUSIC SUPERVISOR / MUSIC DIRECTOR PATRICK VACCARIELLO CHOREOGRAPHY REPRODUCED BY JOEY MCKNEELY DIRECTED BY ARTHUR LAURENTS

TICKETMASTER.COM 800-982-2787 • ⇒N⇐ PALACE THEATRE • BROADWAY & 47TH ST.
BROADWAYWESTSIDESTORY.COM

143

2.) If they were directed by someone who could claim a completely new take on a production: The Orson Welles of Broadway, Sam Mendes for *Cabaret*, the entire team on *Chicago*.

3.) If they starred someone literally born to play the role—Reba McEntire in *Annie Get Your Gun*, or most recently, Kristin Chenoweth in *On the Twentieth Century*.

Amazingly, this production had all three. This was a show that was almost never seen on Broadway in a large production. It had a director who had helped create the original. And there was a new idea—the addition of Spanish language to the text.

 We were determined to do new artwork—another rule of mine. Always begin a revival as if no audience had ever seen it before. But when we made brand-new art for *West Side Story*, instead of looking like the event it was, it looked like a college production. The original film mark was so strong, nothing else looked right. So we began again, and set the challenge to refresh that logo for a contemporary vision. As a plus, we all know so much about the score and the story that we could just suggest certain elements—the snapping of fingers, the word, "tonight," and the audience would understand. In the end, we used a textured cropped version of the logo, and I suppose looking at all the work that preceded it, it was an effective but less adventurous solve. But to give the producers the credit they deserve, they convinced no one less than Stephen Sondheim that the original launch ad would be much more effective without billing. And quite humbly, he and Arthur Laurents agreed, along with the estates of the other extraordinary creators. That allowed for one of the boldest launch ads we have ever made.
—D.H.

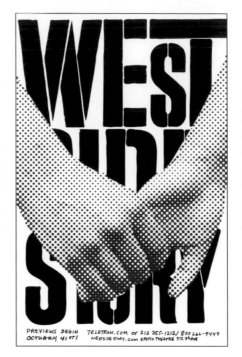

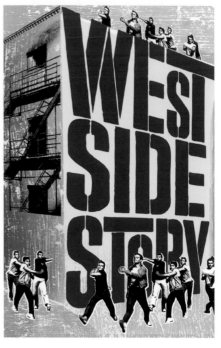

9 TO 5

— THE NON-EVENT —

CLASSIC MOVIE.

— THE EVENT —

SASSY SISTERS IN ARMS YOU CAN ROOT FOR.

DOLLY PARTON
COMPOSER

WE HAD A WHOLE LOT OF FUN that day as the three girls started to try on their characters for the first time. I love Allison and Stephanie and knew they were perfect for their parts, and it was a thrill for me to see little Megan Hilty become Doralee. That spunky girl with hair that's too big and boobs that are too big too but a heart that's never too big. Spending that day with them was the very special beginning of the long journey of *9 to 5*.

ROBERT GREENBLATT
PRODUCER

YOU DON'T APPROACH TURNING something into a musical as iconic and beloved as the movie *9 to 5* without having Dolly Parton write the score. And imagine my delight when she said she'd love to do it! Everyone assembled in a photo studio in Los Angeles in the winter of 2008. And no shoot of *9 to 5* would be complete without Dolly herself too, so she arrived with three different rhinestone-studded outfits to cover a range of color possibilities.

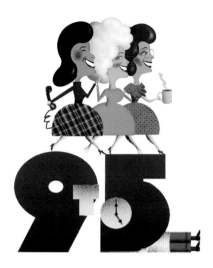

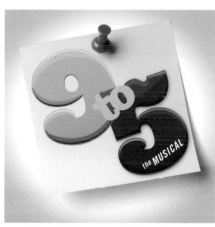

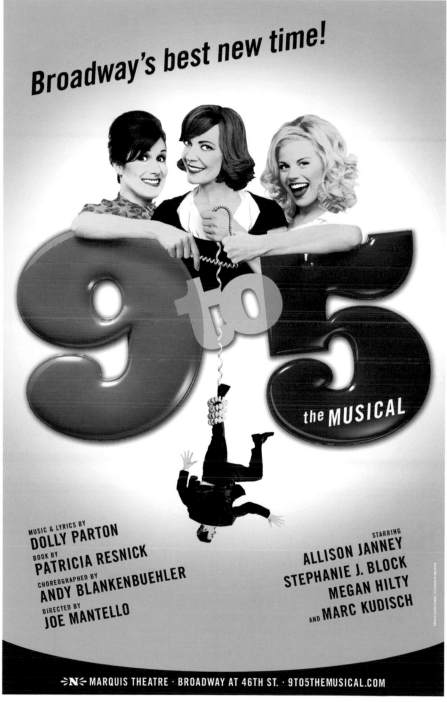

HAIR

THE NON-EVENT

A '60S LOVE-IN.

THE EVENT

NOW IS THE PERFECT TIME FOR *LOVE, GOOD FEELINGS (AND ACTIVISM!)*.

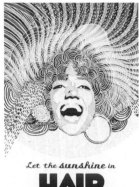

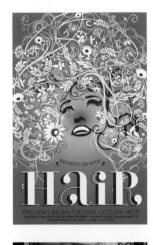

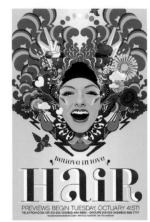

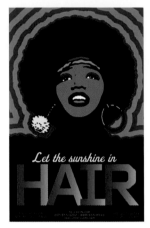

OSKAR EUSTIS
ARTISTIC DIRECTOR, PUBLIC THEATER

WE DIDN'T WANT THE ART to feel kitschy or comment on the period, but be urgent and contemporary. And when I look at some of the designs we didn't pick, they felt too self-consciously psychedelic. We ended up with the stylized sun and the hands and Allison [Case]'s smile—it lets me know it's a 1960s period piece, but it feels joyous and contemporary. And the line, "Let the sun shine in," was picked for the same reason. It remains one of my favorite posters, because it perfectly captured the spirit of the show, and it makes me happy every time I see it in my office.

DIANE PAULUS
DIRECTOR

HAIR *CAUGHT THE ZEITGEIST* of our country at the time. We were in rehearsal during the run-up to the 2008 presidential campaign, and with the constantly changing political landscape, the show took on a new meaning every week. It felt so relevant—I remember seeing audience members standing outside of the theater after the show weeping. *Hair* was a revival, but it truly spoke to what was happening in our country.

JENNY GERSTEN
ASSOCIATE PRODUCER

WE SWOONED WHEN SPOTCO presented the artwork featuring Patina Miller. She had played Dionne in the park and stirringly opened the show with "Aquarius." To have such a striking visual about pride and inclusion seemed not only fitting—it was iconic. The only problem was that Patina had many other options. Most of us will never forget Allison Case's joy and moxie onstage as Chrissy, so it was perfect that she became the face of *Hair*. I kept that comp of Patina though; I cherish it.

IT WAS COUNTER-CULTURE AND A TIME TO BEHOLD. I REMEMBER THE PRODUCERS CANCELLING THE SHOW SO WE COULD GO TO THE MARCH ON WASHINGTON. EVERYTHING WAS AN EVENT *AND A MOMENT*.
DIANE PAULUS
DIRECTOR

above and right
Artwork that we desperately wanted to run, but somehow could not quite land—the images in the subway are faked to show how the art might be effective in that context.

below
Variations on a theme from Amy Guip. It did end up with a joyous quality that reflected the experience of the show. — D.H.

LET THE
SUN
SHINE IN

HAIR

BOOK AND LYRICS BY
HAIR GEROME RAGNI AND JAMES RADO

MUSIC BY
GALT MacDERMOT

DIRECTED BY
DIANE PAULUS

TELECHARGE.COM OR 212-239-6200 · HAIRBROADWAY.COM
AL HIRSCHFELD THEATRE 302 W. 45TH ST.

REASONS TO BE PRETTY

— THE NON-EVENT —

AN ENTIRE EVENING OF MEN AND WOMEN FIGHTING.

— THE EVENT —

EVERYONE IS BEAUTIFUL, IN THEIR OWN WAY.

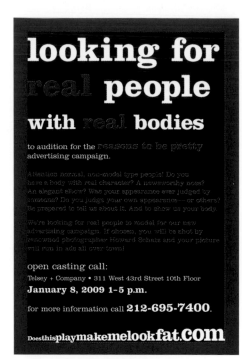

looking for real people
with real bodies

to audition for the reasons to be pretty advertising campaign.

Attention normal, non-model type people! Do you have a body with real character? A newsworthy nose? An elegant elbow? Was your appearance ever judged by someone? Do you judge your own appearance—or others? Be prepared to tell us about it. And to show us your body.

We're looking for real people to model for our new advertising campaign. If chosen, you will be shot by renowned photographer Howard Schatz and your picture will run in ads all over town!

open casting call:
Telsey + Company • 311 West 43rd Street 10th Floor
January 8, 2009 1–5 p.m.

for more information call **212-695-7400**

Doesthis**playmakemelookfat.COM**

REASONS TO BE PRETTY *IS* often seen as the third in a trilogy of Neil LaBute plays considering our society's obsession with physical appearance. At the heart of the play is an overheard conversation contrasting a man's girlfriend as "regular" versus a coworker whom he describes as "pretty." The lead producer, Jeffrey Richards, asked us for a breakthrough ad campaign that would get people around town talking.

We hatched the idea that everyone has "a reason to be pretty," and decided to place ads asking people to show us their reason, by posing nude for photographer Howard Schatz. I hoped we would get a few responses. We got a flood. None of them were weird or twisted. Everyone showed up who said they would—everyone was funny and gracious and sober. It really was remarkable how fresh and genuinely lit from within this group was. Oh, did I mention, they did this for cab fare! Everyone had parts of themselves they wanted to feature—freckles, backs, bellies, knees. The shoot itself was a one-day affair, with our finalists getting their time on the private set. The final results were so rich and surprising. After shooting topless starlets and bottomless chorus boys our whole career, I think these are the sexiest pictures we have ever taken.

The images got plastered, giant-sized, in as many places around the city as we could find, in addition to traditional advertising. I thought they looked monumental. Clients often wish to "blanket" New York much as they see movies do, and are inevitably disappointed, not realizing that the scale of budget it takes for a film to be everywhere is just not within their reach.
—D.H.

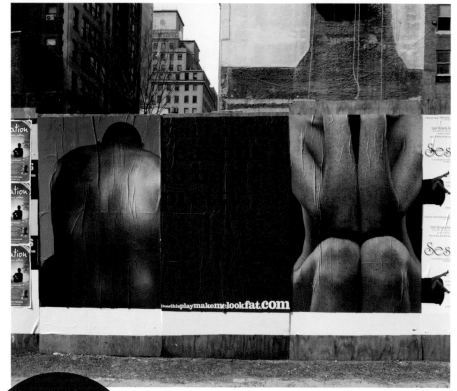

Doesthis**playmakemelookfat.COM**

I LIKE TO THINK THAT EACH OF THESE WORLD-CLASS MODELS HAS HIS OR HER FAMOUS *BODY PART* PLASTERED SOMEWHERE ABOVE THEIR DESK.
DREW HODGES

above
The ad we placed seeking models who were proud of their bodies, whatever shape they may be.

right
Photographer Howard Schatz meeting with our subjects. Each and every one of them was delightful, eager, and confident. We should always be so lucky.

reasons to be pretty

by
Neil LaBute

directed by
Terry Kinney

Does this play make me look fat?

TELECHARGE.COM or 212-239-6200 · ⑤ LYCEUM THEATRE · 149 West 45th Street
DoesThisPlayMakeMeLookFat.com

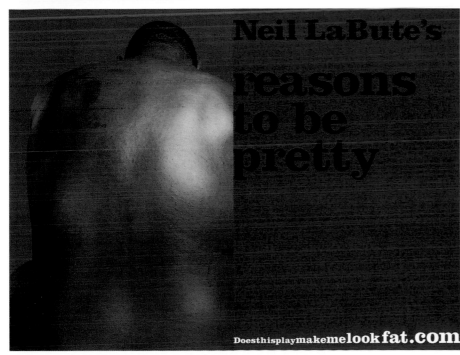

Neil LaBute's

reasons to be pretty

Doesthisplaymakeme**look**fat**.com**

A STEADY RAIN

— THE NON-EVENT —

A TRUE CRIME THRILLER.

— THE EVENT —

THE TWO SEXIEST MEN
IN THE WORLD ONSTAGE TOGETHER.

THERE WAS MUCH DISCUSSION about not needing an image of our two lead actors—arguably the two sexiest men on the planet—to sell the play. I think I might have won this battle by pointing out to the producers how much more revenue they would make from merchandise sales at the theater should they be able to persuade their stars to pose for an image.

Nigel Parry photographed the two men in an enormous airplane hangar of a studio out in Queens, next to a movie set one of them was working on. Daniel Craig and Hugh Jackman were such pros I doubt it took us more than thirty minutes to get two perfect images of masculinity and vulnerability.

And yes, I think they sold a great deal of T-shirts and mugs. —D.H.

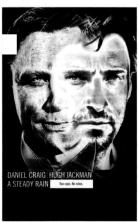

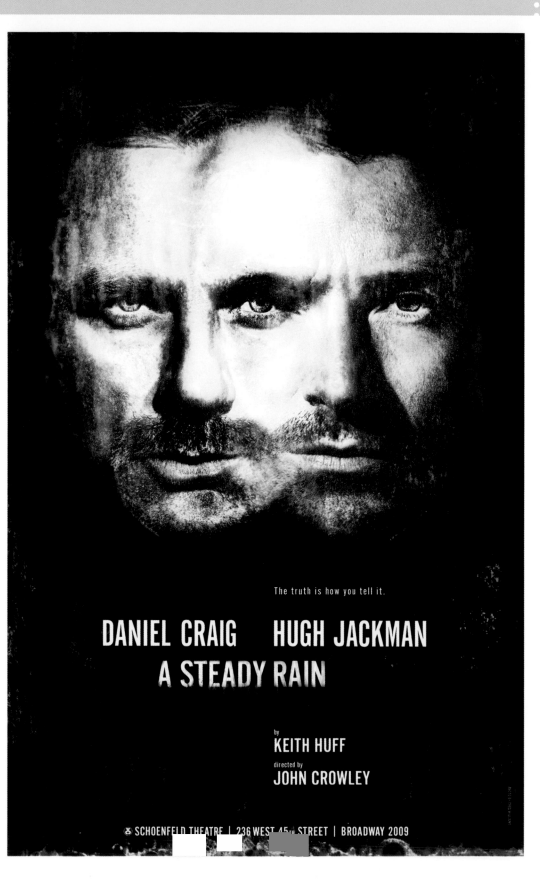

The truth is how you tell it.

DANIEL CRAIG HUGH JACKMAN
A STEADY RAIN

by
KEITH HUFF

directed by
JOHN CROWLEY

SCHOENFELD THEATRE | 236 WEST 45ᵗʰ STREET | BROADWAY 2009

FINIAN'S RAINBOW

--- THE NON-EVENT ---

AN IRISH REVIVAL, BEGORRAH!

--- THE EVENT ---

A MODERN RAINBOW.

JEFF ROGERS
FORMER DESIGNER, SPOTCO

THE CHALLENGE WITH THIS key art was to present a new modern take on the story for those who were familiar with the movie and present a rich and enticing visual experience for people who weren't. I knew I wanted to use the image of a rainbow but needed a fresh take on the familiar image. I wanted this crazy rainbow to engulf the art and seem monumental in the poster. I really got into the image when creating the comp

for the initial client meeting, and they ended up just wanting to use the comp! It was a rare thing for a designer to be able to execute a final illustration so I was giddy (and hey, the client saved some money —win, win).

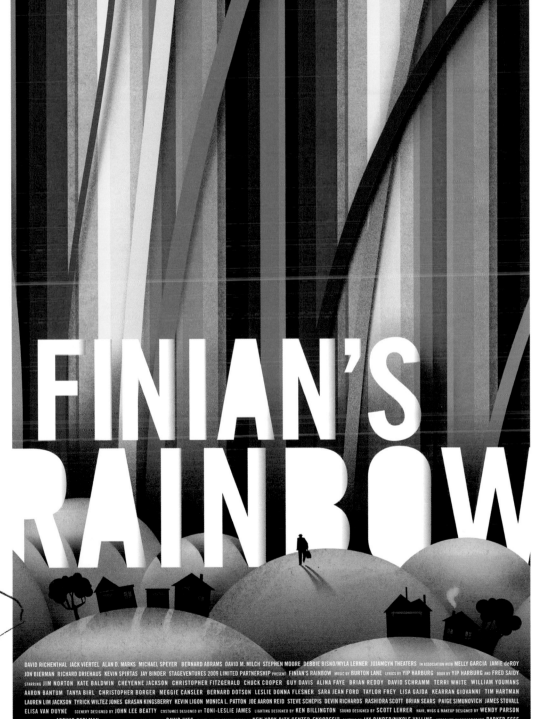

BYE BYE BIRDIE

--- THE NON-EVENT ---

HIGH SCHOOL PRODUCTIONS OF ELVIS-MANIA.

--- THE EVENT ---

BEATLEMANIA ON BROADWAY.

HAROLD WOLPERT
MANAGING DIRECTOR,
ROUNDABOUT THEATRE COMPANY

BYE BYE BIRDIE *SOLD* really well. It was the first significant revival of the show since its Broadway premiere and it opened our newly restored Henry Miller's (now Stephen Sondheim) Theatre, so we wanted it to open with a bang and lots of excitement. When we saw the artwork, we thought, "That's it!" It had this energy and excitement of the three girls in the foreground. They looked like girls from the period, but it was also a moment *in* the show itself. They seemed like characters in the show with this crazy energy.

The original comp was really close to the final poster, though we cast it with models, not with girls from the show. And it really helped us inform the ways we sold the show. And it's funny, so you can see the three girls in the foreground very clearly. But then on the top left there's this part of a face of a boy, who's equally excited about the moment—and you don't know what they're looking at. And a few us said, "That's us. We're that little gay boy."

BYE BYE
BIRDIE
ON BROADWAY

JOHN STAMOS ★ GINA GERSHON
&
BILL IRWIN
BYE BYE BIRDIE
BOOK BY MUSIC BY LYRICS BY
MICHAEL CHARLES LEE
STEWART STROUSE ADAMS
WITH
JAYNE HOUDYSHELL ★ DEE HOTY
AND
NOLAN GERARD FUNK
AS "CONRAD BIRDIE"
DIRECTED & CHOREOGRAPHED BY
ROBERT LONGBOTTOM

VISIT ROUNDABOUTTHEATRE.ORG OR CALL 212-719-1300
THEATRE COMPANY

HENRY MILLER'S THEATRE • 124 WEST 43RD STREET • WWW.ROUNDABOUTTHEATRE.ORG

AMERICAN EXPRESS
PREFERRED SEATING
BROADWAYOFFERS.COM
TERMS, CONDITIONS AND RESTRICTIONS APPLY.

PHOTO BY ALLISON LEACH

153

RAGTIME

THE NON-EVENT

RECENTLY REVIVED HISTORY, AND SCOTT JOPLIN.

THE EVENT

EXCITINGLY, EXPLOSIVELY AMERICAN.

KEVIN McCOLLUM
PRODUCER

RAGTIME *IS ONE OF MY* favorite shows, and though I don't typically do revivals, this was a special circumstance: my wife was in the original *Ragtime*, I saw that production, I went to school with Steve Flaherty. To be able to bring it to Broadway was a labor of love. I think the musical is beautifully distilled from the novel, and I wanted to create artwork inspired by all the issues that it touches, and the epic nature of the show. Lorenzo Petrantoni was working with word clouds and image clouds, before the computer did that for you—Lorenzo's artwork was hand illustrated, and I'd seen some of his earlier work, which I loved. The illustrations tell the immigrant story of America, the chaos and beauty of that time—I'm very proud of that artwork.

BASHAN AQUART
FORMER ART DIRECTOR, SPOTCO

THE RAGTIME *POSTER* shows a new world exploding from an upright piano. Musicians, inventors, immigrants, and revolutionaries inhabit the world of *Ragtime*. America is envisaged as a place of possibility and promise. It was 2008, we'd just elected the first black president, and I thought we could ride this national high and use it to draw an audience to a production that encapsulates American hopefulness. Sometimes we convince ourselves of certain things: We've drunk the proverbial Kool-Aid. But it's the Kool-Aid that keeps us entertainment people going! It was a major highlight for me to see it, enormous, on the front of the theater. I think every designer has that first moment of, "Yeah, I know what the hell I'm doing." This was mine. I might have also told my mother that people had been calling it the greatest poster ever made for Broadway. Of course she drank the Kool-Aid.

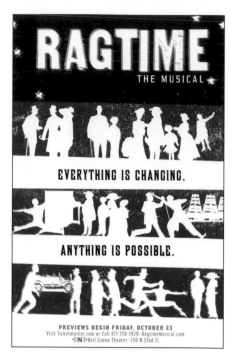

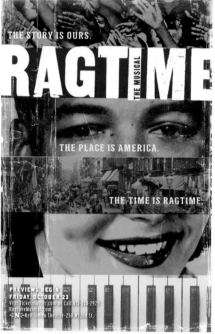

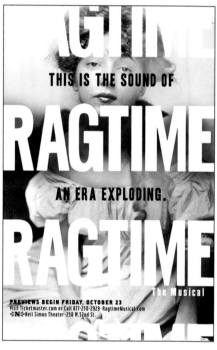

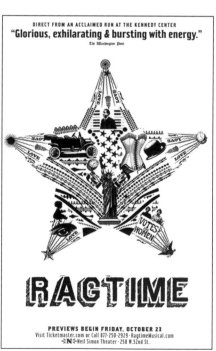

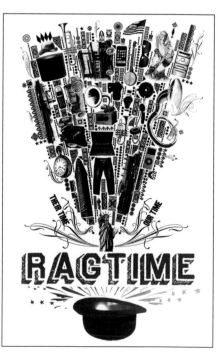

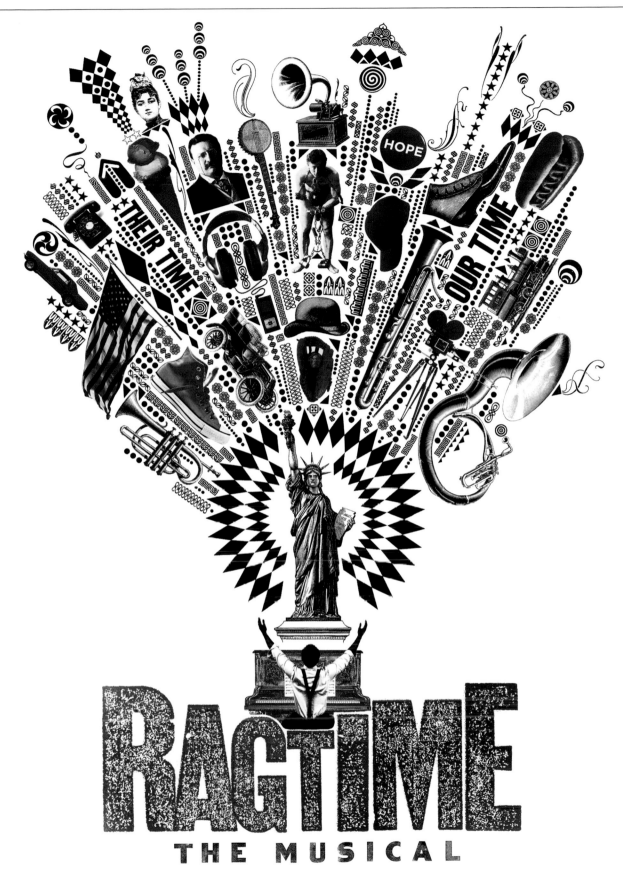

RAGTIME
THE MUSICAL

RAGTIME THE MUSICAL
BOOK BY TERRENCE McNALLY MUSIC BY STEPHEN FLAHERTY LYRICS BY LYNN AHRENS
BASED ON THE NOVEL BY E.L. DOCTOROW
DIRECTED AND CHOREOGRAPHED BY MARCIA MILGROM DODGE

KEVIN McCOLLUM ROY FURMAN SCOTT DELMAN ROGER BERLIND MAX COOPER TOM KIRDAHY/DEVLIN ELLIOTT JEFFREY A. SINE STEPHANIE McCLELLAND ROY MILLER LAMS PRODUCTIONS JANA ROBBINS SHARON KARMAZIN ERIC FALKENSTEIN/MORRIS BERCHARD RIALTOGALS PRODUCTIONS INDEPENDENT PRESENTERS NETWORK HELD-HAFFNER PRODUCTIONS HRH FOUNDATION AND EMANUEL AZENBERG IN ASSOCIATION WITH THE JOHN F. KENNEDY CENTER FOR THE PERFORMING ARTS PRESIDENT MICHAEL KAISER VICE PRESIDENT MAX WOODWARD PRESENT RAGTIME THE MUSICAL BOOK BY TERRENCE McNALLY MUSIC BY STEPHEN FLAHERTY LYRICS BY LYNN AHRENS BASED ON THE NOVEL BY E.L. DOCTOROW STARRING RON BOHMER QUENTIN EARL DARRINGTON CHRISTIANE NOLL ROBERT PETKOFF BOBBY STEGGERT STEPHANIE UMOH CHRISTOPER COX SARAH ROSENTHAL WITH JONATHAN HAMMOND DONNA MIGLIACCIO SAVANNAH WISE ERIC JORDAN YOUNG MARK ALDRICH SUMAYYA ALI TERENCE ARCHIE COREY BRADLEY JAYDEN BROCKINGTON JENNIFER EVANS AARON GALLIGAN-STIERLE CARLY HUGHES VALISIA LEKAE DAN MANNING MICHAEL X. MARTIN MIKE McGOWAN TRACY LYNN OLIVERA BRYONHA PARHAM MAMIE PARRIS NICOLE POWELL ARBENDER J. ROBINSON BENJAMIN SCHRADER WALLACE SMITH JOSH WALDEN CATHERINE WALKER KYLIL CHRISTOPHER WILLIAMS CAREY REBECCA BROWN BENJAMIN COOK LISA KARLIN JAMES MOYE KAYLIE RUBINACCIO JIM WEAVER SCENIC DESIGN DEREK McLANE COSTUME DESIGN SANTO LOQUASTO LIGHTING DESIGN DONALD HOLDER SOUND DESIGN ACME SOUND PARTNERS HAIR AND WIG DESIGN EDWARD J. WILSON ORCHESTRATIONS WILLIAM DAVID BROHN MUSIC COORDINATOR JOHN MILLER CASTING LAURA STANCZYK CASTING PRESS REPRESENTATIVE BONEAU/BRYAN-BROWN MARKETING SCOTT A. MOORE ASSOCIATE DIRECTOR/CHOREOGRAPHER JOSH WALDEN GENERAL MANAGER JOHN S. CORKER TECHNICAL SUPERVISOR BRIAN LYNCH PRODUCTION SUPERVISOR PETER LAWRENCE MUSIC DIRECTION BY JAMES MOORE DIRECTED AND CHOREOGRAPHED BY MARCIA MILGROM DODGE

Ticketmaster.com or 877-250-2929 • RagtimeBroadway.com ⇒N⇐ Neil Simon Theatre • 250 W. 52nd St.

THE MIRACLE WORKER

THE NON-EVENT

CREAKY REVIVAL.

THE EVENT

THRILLING QUALITY DRAMA.

JOHN DUGDALE
PHOTOGRAPHER

AFTER THIRTY YEARS OF all kinds of photography, there are very few things that would bring me out of my self-imposed exile in my beloved farm in Ulster County. As a child, whenever the beloved film *The Miracle Worker* appeared on television, it was understood that there would be hushed, serious viewing of this masterpiece. I never got tired of seeing it over and over, not knowing what the future held for my own eyesight. When word came from SpotCo wondering if I might be interested in doing the advertising for the revival of the play, I was intrigued. I've worked very successfully during the many stages that led to my complete sight loss, but one thing I had never been asked to do is to convey blindness. On the day of everyone's visit to the studio for the photograph, there were a few moments of butterflies in my stomach. But after meeting the two beautiful actresses, Abigail Breslin and Alison Pill, and the talented team that Drew had assembled, it was clear that this was not going to be difficult. My longtime friend and assistant, Dan, was with me, helping me build the shot. When I rolled my 1909 Deardorff camera up to my subject, the reverence I experienced during my childhood watching the film appeared underneath my focusing cloth (I never feel like I can't see). I coached the young actress [Abigail Breslin] on looking inward to find herself. The only other person here was the director, who seemed to totally understand the direction I wanted the picture to take—something that would pay tribute to the original but was fresh and current.

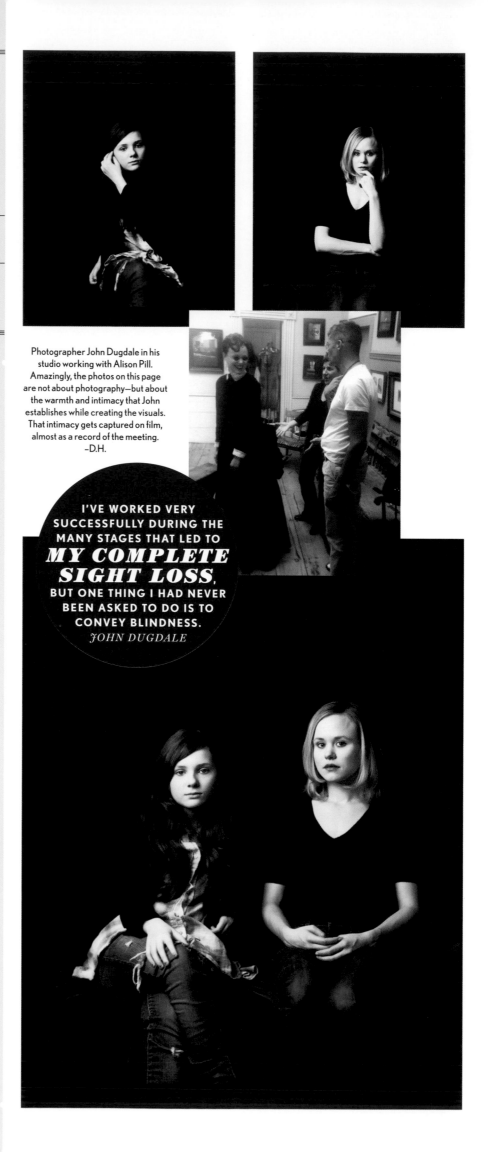

Photographer John Dugdale in his studio working with Alison Pill. Amazingly, the photos on this page are not about photography—but about the warmth and intimacy that John establishes while creating the visuals. That intimacy gets captured on film, almost as a record of the meeting. –D.H.

I'VE WORKED VERY SUCCESSFULLY DURING THE MANY STAGES THAT LED TO *MY COMPLETE SIGHT LOSS*, BUT ONE THING I HAD NEVER BEEN ASKED TO DO IS TO CONVEY BLINDNESS.
JOHN DUGDALE

LA CAGE AUX FOLLES

THE NON-EVENT

AM I WHAT I WAS?

THE EVENT

A NIGHTCLUB IN ST. TROPEZ IS *A VERY SEXY PLACE TO BE.*

HARVEY FIERSTEIN
BOOK WRITER/ACTOR

I WAS IN MY LATE TWENTIES when I wrote *La Cage aux Folles* with Jerry Herman. Since the lead characters were parents of an adult son, it never occurred to me that I might play Zaza. Also, my darling Jerry Herman is very particular about whom he allows to interpret his music onstage. He once told me that he'd rather have a great singer than a great actor in his shows. That eliminated me for good.

But then thirty years and two revivals came and went and one day the phone rang. Doug Hodge, who had won the Tony Award in New York and the Olivier in London for playing Zaza, was finishing his Broadway run, and the producers wondered if I would be willing to pluck and tuck my way into the role. What a challenge! My first call was to Jerry Herman, who laughed and gave me his blessing. Second call was to Matthew Wright, who'd designed the costumes for this production. And then I went on to call Richard Mawbey, who created the hair. I've been in this business long enough to know that before I'd ever set foot in a rehearsal room the advertising agency would be screaming for photographs. And so it was!

The resulting photo call was an outrageously silly affair of wigs, boas, and corsets. The shots of us on the bird perch were downright dangerous, as the girdle I wore would not bend enough to allow me to balance. It was sheer will that kept me on that balancing beam.

> **AS FOR THAT PHOTO OF ME STANDING OUT IN SNOW . . . WELL, IT WAS *CHRISTMAS IN NEW YORK.* I COULDN'T KEEP ALL OF THAT HOLIDAY CHEER LOCKED INSIDE A STUDIO, COULD I?**
> *HARVEY FIERSTEIN*

Various designs and sketches, with an attempt at referencing Norman Rockwell's Thanksgiving masterpiece. We began to close in on our final when everyone came to understand the director's concept of what a club like La Cage aux Folles would actually be like—sensuous and secret, and most certainly glowing in the nighttime rather than the sunshiny day of the South of France.

below
Harvey Fierstein after our shoot, playing in the snow.

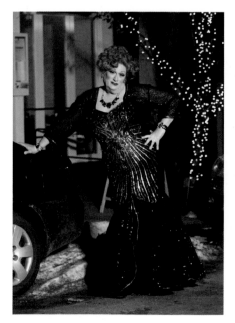
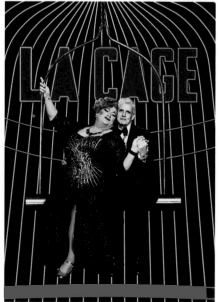

KELSEY GRAMMER DOUGLAS HODGE

LA CAGE

AUX FOLLES

The musical with something extra.

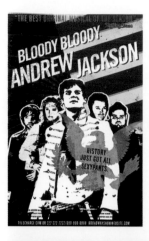

BLOODY BLOODY ANDREW JACKSON

— THE NON-EVENT —

OBSCURE HISTORY.

— THE EVENT —

SPRINGSTEEN MEETS THE DAILY SHOW, AND GREAT REVIEWS.

BENJAMIN WALKER
ACTOR

THE FIRST THING I NOTICED was, "That's not my ass!" My mother called me up and said, "I know that butt, and that's not yours. I *powdered* that butt." It was pretty wild. You'd see that poster all over the city. I'd be on the subway, and there'd be a bunch of different ads, and then it was like "Bam!" By the end, I just started telling people it was me. And actually, I thought it represented the show so well. I mean, Andrew Jackson showed his ass to America, and that's what the poster did.

ALEX TIMBERS
BOOK WRITER/DIRECTOR

IN CREATING BLOODY *Bloody Andrew Jackson*, composer Michael Friedman and I set out to explore the roots of populism in our country, the complexity of direct democracy. But the writing process began with a more simple (and fun) question: "Wasn't Andrew Jackson the ultimate emo President?" The moodiness of contemporary teenage "emo" music, at once both incredibly earnest and incredibly *funny* in its earnestness, would be an appropriate tool to investigate this country's own coming of age. And so, the show was a complete mashup: between then and now, political smarts and lowbrow comedy, sincerity and irony. The image of Andrew Jackson as a rock star was something featured throughout the musical and felt like a place to start from. We talked about a host of different approaches to a poster. That discussion may have been in part what ultimately inspired this take on the classic Bruce Springsteen cover art.

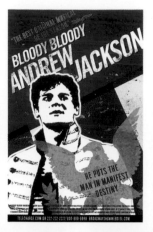

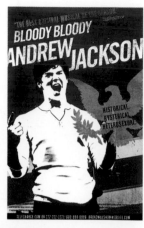

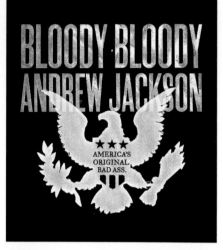

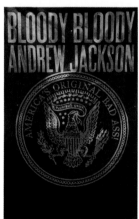

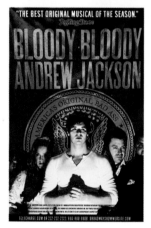

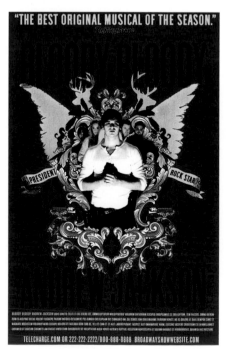

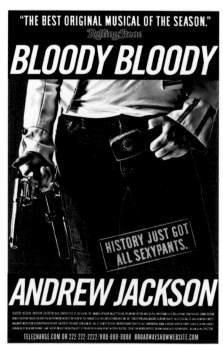

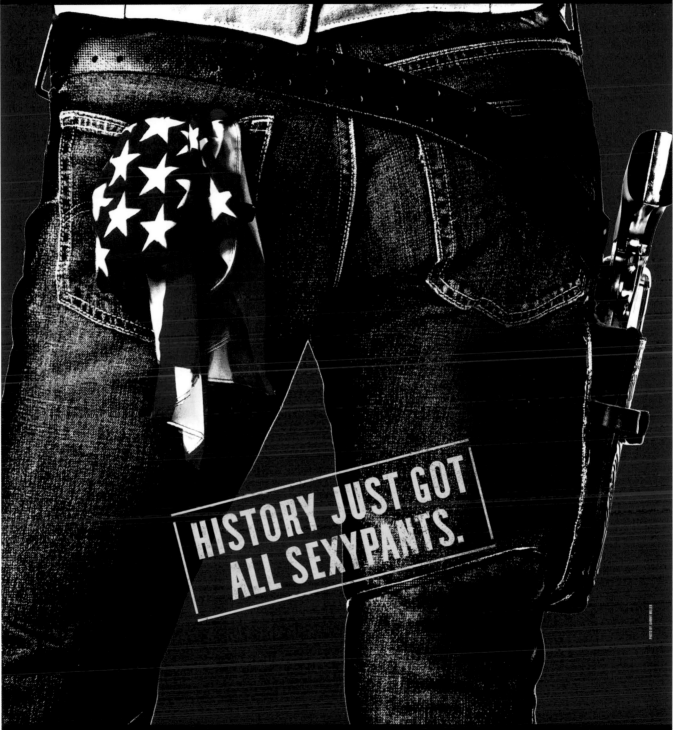

BLOODY BLOODY ANDREW JACKSON

HISTORY JUST GOT ALL SEXYPANTS.

PHOTO BY JOHNNY MILLER

THE PUBLIC THEATER OSKAR EUSTIS, Artistic Director ANDREW D. HAMINGSON, Executive Director JEFFREY RICHARDS JERRY FRANKEL NORTON HERRICK & HERRICK ENTERTAINMENT
SUSAN QUINT GALLIN/MARY LU ROFFE/JENNIFER MANOCHERIAN STEWART LANE & BONNIE COMLEY UNIVERSAL PICTURES STAGE PRODUCTIONS NANCY C. PADUANO/HAROLD THAU TOULA C. PHILLIPS
JOEY PARNES, Executive Producer and CENTER THEATRE GROUP present *BLOODY BLOODY ANDREW JACKSON* Written by ALEX TIMBERS Music & Lyrics by MICHAEL FRIEDMAN Starring BENJAMIN WALKER
with JAMES BARRY DARREN GOLDSTEIN GREG HILDRETH JEFF HILLER LUCAS NEAR-VERBRUGGHE CAMERON OCASIO BRYCE PINKHAM NADIA QUINN MARIA ELENA RAMIREZ KATE CULLEN ROBERTS
BEN STEINFELD EMILY YOUNG HEATH CALVERT AIDEN EYRICK ERIN FELGAR ELI JAMES JOE JUNG MARIA-CHRISTINA OLIVERAS KEVIN GARCIA CHARLIE ROSEN and KRISTINE NIELSEN
Scenic Design DONYALE WERLE Costume Design EMILY REBHOLZ Lighting Design JUSTIN TOWNSEND Sound Design BART FASBENDER Orchestrations MICHAEL FRIEDMAN GABRIEL KAHANE JUSTIN LEVINE
Music Director JUSTIN LEVINE Music Coordinator SEYMOUR RED PRESS Fight Director JACOB GRIGOLIA-ROSENBAUM Broadway Casting CARRIE GARDNER Production Stage Manager ARTHUR GAFFIN
Company Manager DAVID VAN ZYLL DE JONG Dramaturgs ANNE DAVISON & MIKE SABLONE Associate Producers MANDY HACKETT JEREMY SCOTT BLAUSTEIN MICHAEL CREA
SD WAGNER JOHN JOHNSON Press Representative JEFFREY RICHARDS ASSOCIATES IRENE GANDY/ALANA KARPOFF Choreography by DANNY MEFFORD Directed by ALEX TIMBERS

♿ BERNARD B. JACOBS THEATRE, 45TH ST. BTWN B'WAY & 8TH AVE. BLOODYBLOODYANDREWJACKSON.COM

THE SCOTTSBORO BOYS

THE NON-EVENT

A DARK TRAGEDY FORGOTTEN BY AMERICA.

THE EVENT

A VAUDEVILLE OF RICH QUALITY.

SUSAN STROMAN
DIRECTOR/CHOREOGRAPHER

AFTER THE INCREDIBLE reception *The Scottsboro Boys* received at the Vineyard Theatre, Barry Weissler graciously and generously took over the reins and moved us to Broadway. The first thing to do was to get a new logo—something that would represent the energy and significance of the show. The story of these nine young African-American men is a very important part of our American history, and one that resonates today as we struggle to give voice to those who are marginalized. At the photo shoot, the SpotCo team asked our cast members to perform various choreographic moves from the show. They took an amazing group of photos from that day and assembled them into one diverse and powerful image. SpotCo captured the true essence of the show perfectly. The shots they used were striking—the hands on the tambourine that show it is musical, the ripped pages that say it is provocative, the electrifying smile of Joshua Henry that exemplifies the resilient spirit of the nine men, and finally the soulful but reticent image of the youngest Scottsboro Boy. This poster hangs in a place of pride on my library wall and will remain my favorite always.

GAIL ANDERSON
FORMER DIRECTOR OF DESIGN, SPOTCO

THE SCOTTSBORO *SHOOT* was my all-time favorite, and it wasn't just because I was a huge fan of the show. The actors lit up in front of the camera, were willing to do just about anything, and applauded each other as they stepped up on set to be photographed individually.

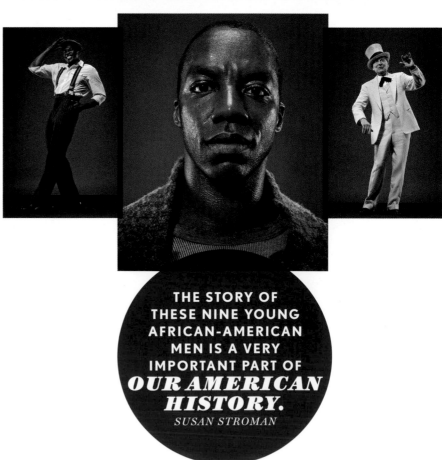

THE STORY OF THESE NINE YOUNG AFRICAN-AMERICAN MEN IS A VERY IMPORTANT PART OF *OUR AMERICAN HISTORY.*
SUSAN STROMAN

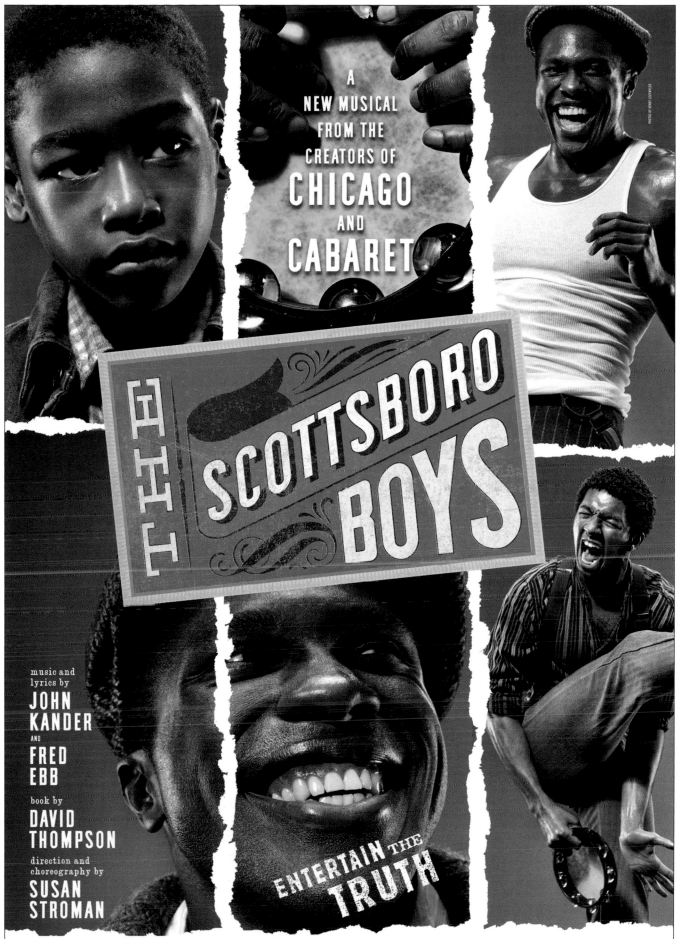

A
NEW MUSICAL
FROM THE
CREATORS OF
CHICAGO
AND
CABARET

THE SCOTTSBORO BOYS

music and lyrics by
JOHN KANDER
and
FRED EBB

book by
DAVID THOMPSON

direction and
choreography by
SUSAN STROMAN

ENTERTAIN THE TRUTH

BARRY AND FRAN WEISSLER JACKI BARLIA FLORIN JANET PAILET/SHARON CARR/PATRICIA R. KLAUSNER NEDERLANDER PRESENTATIONS, INC/THE SHUBERT ORGANIZATION, INC BEECHWOOD ENTERTAINMENT BROADWAY ACROSS AMERICA MARK ZIMMERMAN ADAM BLANSHAY/R2D2 PRODUCTIONS
RICK DANZANSKY/BARRY TATELMAN BRUCE ROBERT HARRIS/JACK W. BATMAN ALLEN SPIVAK/JERRY FRANKEL BABB THEATRICALS/PROBO PRODUCTIONS/RANDY DONALDSON CATHERINE SCHREIBER/MICHAEL PALITZ/PATTI LASKAWY VINEYARD THEATRE PRESENTS THE SCOTTSBORO BOYS
MUSIC AND LYRICS BY JOHN KANDER & FRED EBB BOOK BY DAVID THOMPSON WITH JOSHUA HENRY COLMAN DOMINGO FORREST MCCLENDON SHARON WASHINGTON JOSH BRECKENRIDGE DERRICK COBEY E. CLAYTON CORNELIOUS JEREMY GUMBS RODNEY HICKS KENDRICK JONES JAMES T. LANE JC MONTGOMERY
CLINTON ROANE CHERENE SNOW JULIUS THOMAS III CHRISTIAN DANTE WHITE AND JOHN CULLUM SCENIC DESIGN BEOWULF BORITT COSTUME DESIGN TONI-LESLIE JAMES LIGHTING DESIGN KEN BILLINGTON SOUND DESIGN PETER HYLENSKI ORCHESTRATIONS LARRY HOCHMAN MUSIC ARRANGEMENTS GLEN KELLY MUSIC COORDINATOR JOHN MONACO
CONDUCTOR PAUL MASSE PRODUCTION STAGE MANAGER JOSHUA HALPERIN CASTING JIM CARNAHAN C.S.A. STEPHEN KOPEL FIGHT DIRECTION RICK SORDELET PRODUCTION MANAGER AURORA PRODUCTIONS PRESS REPRESENTATIVE BONEAU/BRYAN-BROWN ASSOCIATE PRODUCERS CARLOS ARANA RUTH ECKERD HALL, INC. BRETT ENGLAND
ASSOCIATE DIRECTOR/CHOREOGRAPHER JEFF WHITING GENERAL MANAGER RICHARDS/CLIMAN, INC. EXECUTIVE PRODUCER ALECIA PARKER MUSICAL DIRECTION AND VOCAL ARRANGEMENTS DAVID LOUD DIRECTION AND CHOREOGRAPHY BY SUSAN STROMAN

TELECHARGE.COM OR 212-239-6200 | SCOTTSBOROMUSICAL.COM | LYCEUM THEATRE · 149 W. 45TH ST. (BET. 6TH & 7TH AVES.)

PRISCILLA QUEEN OF THE DESERT

THE NON-EVENT

MORE DRAG QUEENS.

THE EVENT

LET YOUR FREAK FLAG FLY IN THE OUTBACK. *A JOURNEY.*

NICK PRAMIK
SPOTCO

YOU ALWAYS REMEMBER your first SpotCo show. Mine was working on the big-haired, high-heeled, over-the-top musical, *Priscilla Queen of the Desert*.

It was the summer of 2011, and gay marriage was just legalized in New York State. The show's producer, the one and only Bette Midler, wanted *Priscilla* to have a huge outdoor presence in June in celebration of Gay Pride month. For the annual New York City Pride March, the show bought every street banner along the parade route. We also wrapped double-decker buses (what else?) in the show's artwork and decorated them with what had become known as *Priscilla*'s signature feathery pink boas. The giant, glam-tastic buses rode the entire parade route behind Governor Cuomo in what was arguably the most historic celebration in Pride history.

I will never forget the feeling of complete joy as I rode the bus with the entire *Priscilla* team. Sharing this experience together as crowds of thousands were acknowledging equality and thanking us for the role the show played on Broadway is one of the most fun and profound memories of my adult life. It's no secret that working on a Broadway show is a full-throttle, collaborative effort, but this moment felt somehow extra special.

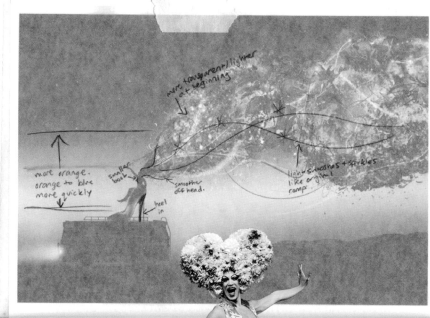

above
A sketch for our digital illustrator, as we crafted what I think can only be called a trail of "fabulousness."
left
London's wonderful theater façade.
below
Riding on the double-decker bus with the cast in the New York City Gay Pride Parade. — D.H.

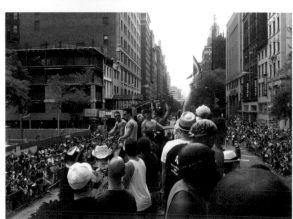

Bette Midler, James L. Nederlander, Garry McQuinn, Liz Koops, Michael Hamlyn, Allan Scott, Roy Furman/Richard Willis,
Terry Allen Kramer, Terri and Timothy Childs, Ken Greiner, Ruth Hendel, Chugg Entertainment, Michael Buckley,
Stewart F. Lane/Bonnie Comley, Bruce Davey, Thierry Suc /TS3, Barbara Jenkins, Broadway Across America/Rich Koenigsberg,
Myla Lerner/Debbie Bisno/Kit Seidel/Rebecca Gold, Paul Boskind and Norton Entertainment/Spiras-Mauro Productions/MAS Music Arts & Show, and David Mirvish

In association with MGM ON STAGE
Darcie Denkert and Dean Stolber

PRISCILLA
QUEEN OF THE DESERT
the musical

⇥N⇤ PALACE THEATRE, BROADWAY & 47TH STREET, NEW YORK

BACKSTAGE

John Leguizamo posing for his poster image—again and again.

✳ A

SWEET / LOVING

#2 WACKY

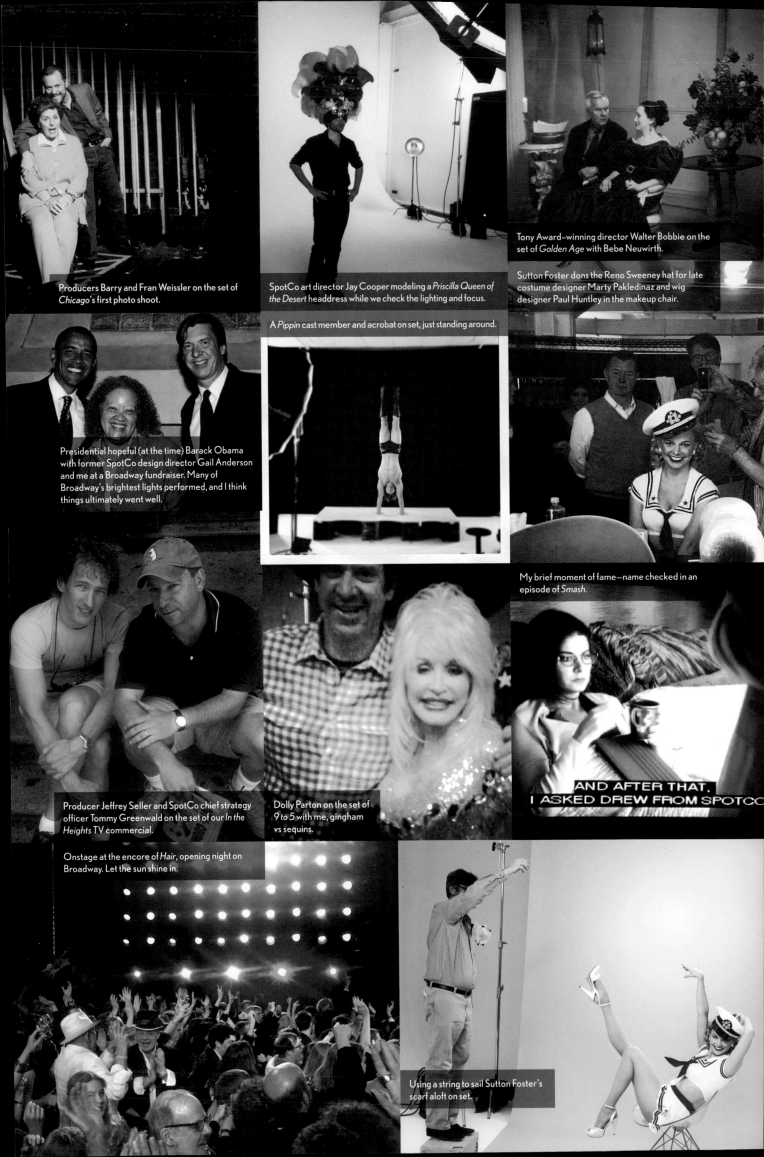

Producers Barry and Fran Weissler on the set of *Chicago*'s first photo shoot.

SpotCo art director Jay Cooper modeling a *Priscilla Queen of the Desert* headdress while we check the lighting and focus.

Tony Award–winning director Walter Bobbie on the set of *Golden Age* with Bebe Neuwirth.

Sutton Foster dons the Reno Sweeney hat for late costume designer Marty Pakledinaz and wig designer Paul Huntley in the makeup chair.

Presidential hopeful (at the time) Barack Obama with former SpotCo design director Gail Anderson and me at a Broadway fundraiser. Many of Broadway's brightest lights performed, and I think things ultimately went well.

A *Pippin* cast member and acrobat on set, just standing around.

My brief moment of fame—name checked in an episode of *Smash.*

Producer Jeffrey Seller and SpotCo chief strategy officer Tommy Greenwald on the set of our *In the Heights* TV commercial.

Dolly Parton on the set of *9 to 5* with me, gingham vs sequins.

AND AFTER THAT, I ASKED DREW FROM SPOTCO

Onstage at the encore of *Hair*, opening night on Broadway. Let the sun shine in.

Using a string to sail Sutton Foster's scarf aloft on set.

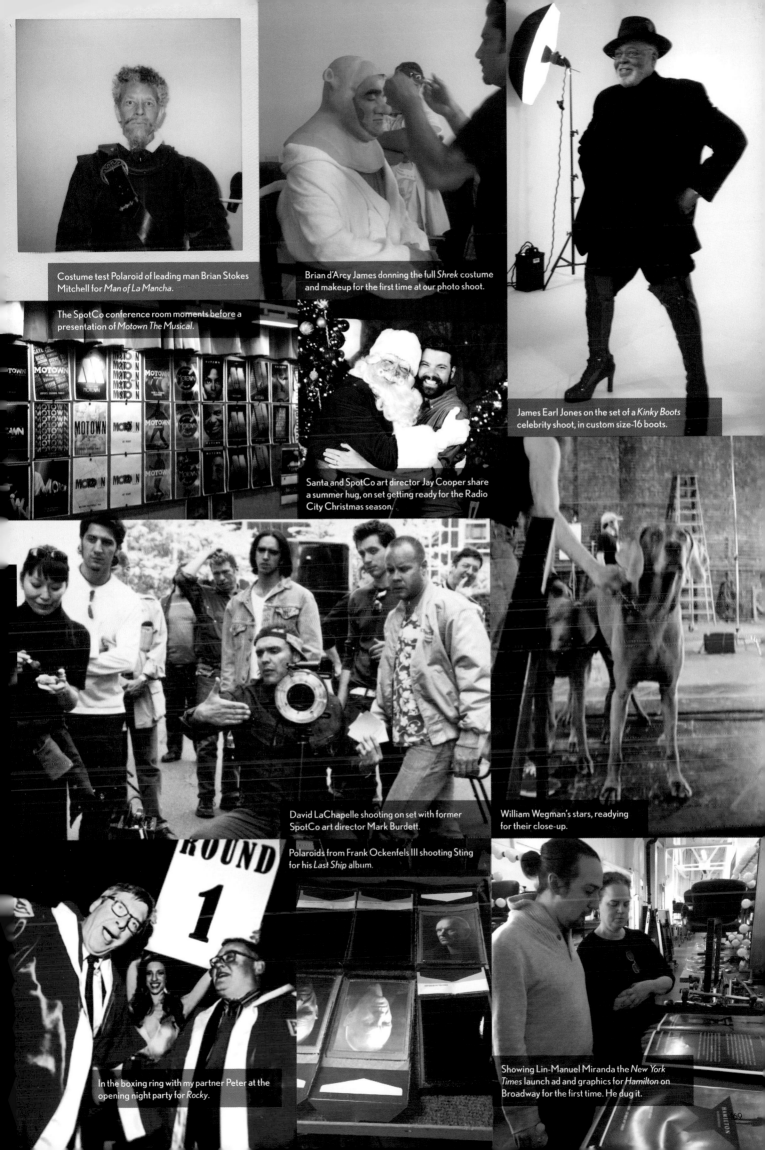

Costume test Polaroid of leading man Brian Stokes Mitchell for *Man of La Mancha*.

Brian d'Arcy James donning the full *Shrek* costume and makeup for the first time at our photo shoot.

The SpotCo conference room moments before a presentation of *Motown The Musical*.

Santa and SpotCo art director Jay Cooper share a summer hug, on set getting ready for the Radio City Christmas season.

James Earl Jones on the set of a *Kinky Boots* celebrity shoot, in custom size-16 boots.

David LaChapelle shooting on set with former SpotCo art director Mark Burdett.

William Wegman's stars, readying for their close-up.

Polaroids from Frank Ockenfels III shooting Sting for his *Last Ship* album.

In the boxing ring with my partner Peter at the opening night party for *Rocky*.

Showing Lin-Manuel Miranda the *New York Times* launch ad and graphics for *Hamilton* on Broadway for the first time. He dug it.

ANYTHING GOES

THE NON-EVENT

OFTEN REVIVED REVIVAL.

THE EVENT

A LONG-LEGGED STARLET *WHO BELTS AND TAPS*, ALONG WITH A CAST OF SEEMING THOUSANDS.

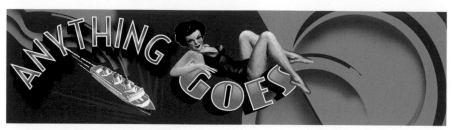

SUTTON FOSTER
ACTOR

I JUST REMEMBER THINKING, "They want me on the poster?" We shot the art before we even started rehearsals. I was already so intimidated playing this character, and we were trying to find my version of Reno. We knew she was going to be blonde . . . sexy . . . a dancer. Kathleen Marshall was thinking Barbara Stanwyck in *Ball of Fire*. First I had a wig fitting with Paul Huntley to find the right color. I had a costume fitting with Martin Pakledinaz, who ended up buying a "sexy sailor costume" from a Halloween store and BeDazzling it. All I saw was CROP TOP! That shoot was my first step into becoming Reno. They had all these ideas of body shapes, and I was contorting myself in a Plexiglass chair so they could Photoshop it out—I think at one point they even had a piece of string tied to the red kerchief around my neck so it would look like it was blowing in the wind. It was wild later to see the photos all over Manhattan. There was a huge billboard in Times Square and on every crosstown bus and taxi top. People asked me what it felt like. It didn't feel like me. It felt like Reno.

HAROLD WOLPERT
MANAGING DIRECTOR, ROUNDABOUT THEATRE COMPANY

I REMEMBER THE INITIAL marketing meeting with Kathleen Marshall, the director, and she gave us her vision of the show. And she wanted to show Sutton in a slightly different way than most people think of her or the show. She's not your father's Reno Sweeney. So there was this notion of this leggy, '30s- or '40s-style pinup. And there's the ship with its bright colors, which actually tied in to what people eventually saw on the stage. It's period but fresh.

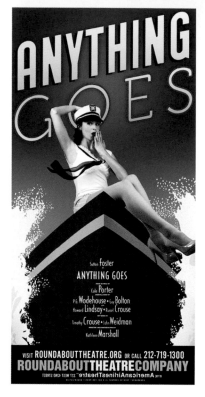

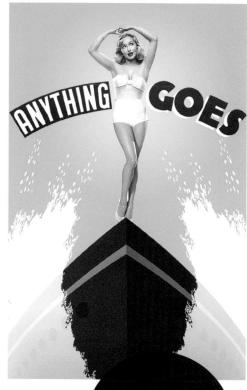

ALL I SAW WAS *CROPTOP!*
SUTTON FOSTER

below
The cast of *Anything Goes* saluting our armed services during New York's Fleet Week. This picture was taken from on top of the set, looking back at the stage and the audience, who were also given hats to fling.

SUTTON FOSTER
AND
JOEL GREY
IN
ANYTHING GOES

MUSIC & LYRICS BY
COLE PORTER
ORIGINAL BOOK BY
P.G. WODEHOUSE & GUY BOLTON
AND
HOWARD LINDSAY & RUSSEL CROUSE
NEW BOOK BY
TIMOTHY CROUSE & JOHN WEIDMAN
DIRECTED AND CHOREOGRAPHED BY
KATHLEEN MARSHALL

Proud Sponsor
Bank of America

Anything Goes benefits from Roundabout's **Musical Theatre Fund** with gifts from Marty and Perry Granoff, HRH Foundation, Ted and Mary Jo Shen, Peter and Leni May, Tom and Diane Tuft, The Kaplen Foundation, and one anonymous donor.
Roundabout gratefully acknowledges partial underwriting from Goldman Sachs Gives at the recommendation of R. Martin Chavez.
Major support for *Anything Goes* provided by The Blanche and Irving Laurie Foundation.

Roundabout thanks the Henry Nias Foundation, courtesy of Dr. Stanley Edelman, for their support of *Anything Goes*.

SUTTON FOSTER AND JOEL GREY IN ANYTHING GOES MUSIC & LYRICS BY COLE PORTER ORIGINAL BOOK BY P.G. WODEHOUSE & GUY BOLTON AND HOWARD LINDSAY & RUSSEL CROUSE
NEW BOOK BY TIMOTHY CROUSE & JOHN WEIDMAN WITH COLIN DONNELL ADAM GODLEY LAURA OSNES JESSICA STONE WALTER CHARLES ROBERT CREIGHTON ANDREW CAO
RAYMOND J. LEE CLYDE ALVES WARD BILLEISEN JOYCE CHITTICK NIKKI RENEÉ DANIELS MARGOT DE LA BARRE DANIEL J. EDWARDS KIMBERLY FAURÉ JOSH FRANKLIN JUSTIN GREER
TARI KELLY SHINA ANN MORRIS LINDA MUGLESTON KEVIN MUNHALL ADAM PERRY WILLIAM RYALL JENNIFER SAVELLI ANTHONY WAYNE KRISTEN BETH WILLIAMS WITH JOHN McMARTIN AND
JESSICA WALTER SET DESIGN DEREK McLANE COSTUME DESIGN MARTIN PAKLEDINAZ LIGHTING DESIGN PETER KACZOROWSKI SOUND DESIGN BRIAN RONAN ADDITIONAL ORCHESTRATIONS BILL ELLIOTT
ORIGINAL ORCHESTRATIONS MICHAEL GIBSON DANCE ARRANGEMENTS DAVID CHASE MUSIC DIRECTOR/CONDUCTOR JAMES LOWE MUSIC COORDINATOR SEYMOUR RED PRESS HAIR & WIG DESIGN PAUL HUNTLEY
MAKEUP DESIGN ANGELINA AVALLONE PRODUCTION STAGE MANAGER PETER HANSON CASTING JIM CARNAHAN, C.S.A. & STEPHEN KOPEL ASSOCIATE DIRECTOR MARC BRUNI
ASSOCIATE CHOREOGRAPHER VINCE PESCE TECHNICAL SUPERVISOR STEVE BEERS EXECUTIVE PRODUCER SYDNEY BEERS MUSIC SUPERVISOR/VOCAL ARRANGER ROB FISHER DIRECTED AND CHOREOGRAPHED BY KATHLEEN MARSHALL

ROUNDABOUTTHEATRECOMPANY
VISIT TELECHARGE.COM/AG OR CALL 212-239-6200 • AT THE STEPHEN SONDHEIM THEATRE, 124 WEST 43RD STREET (BETWEEN 6TH AVENUE & BROADWAY)
ROUNDABOUT THEATRE COMPANY IS A NOT-FOR-PROFIT ORGANIZATION.

171

CATCH ME IF YOU CAN

SPIELBERG MOVIE WITHOUT LEONARDO, AND HAVEN'T WE HAD ENOUGH MOVIES AS MUSICALS?

— THE EVENT —

SWINGING '60s AND SUAVE AIRLINE PILOTS IN LOVE— *THE MILE HIGH CLUB OF BROADWAY.*

SCOTT WITTMAN
LYRICIST

MARC SHAIMAN
COMPOSER/LYRICIST

OUR MUSICAL, CATCH ME *If You Can,* evokes a time long gone, the time of the Jet Set. It was a glamorous decade when Americans took to the skies: the age of *Camelot* and "Come Fly with Me," the Rat Pack, miniskirts, and swingin' London. Men wore hats and ties to fly on airplanes, and stewardesses showed plenty of leg. It was a sexy romp through the ring-a-ding years when flying was an aphrodisiac—when romance was giving way to the sexual revolution.

While writing the show, we surrounded ourselves with images from the period— it was a time of visual evolution: the Dell book covers of Robert E. McGinnis, the print ads of Paul Rand and Bob Gill, and especially the travel graphic works of David Klein, Joseph Binder, and Aaron Fine. They would distill exotic locales to single and sometimes bold and abstract images. Ads were filled with castles in Spain, Hawaiian beaches, and sexy showgirls beckoning you to "cruise the world to find your perfect playmate." The way to get there was as sexy as the destination. [This is] exactly what SpotCo did for our show. It had the clean lines of the Eero Saarinen–designed terminal at JFK or the Seagram Building in New York and the coolness of an extra dry martini with a twist.

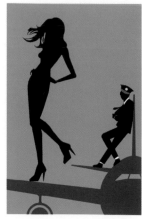

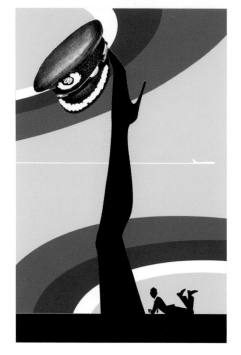
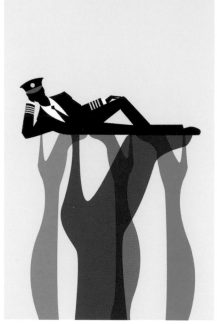

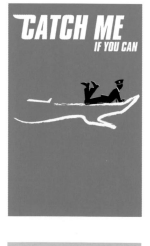

IT WAS A *GLAMOROUS* DECADE WHEN AMERICANS TOOK TO THE SKIES.
SCOTT WITTMAN & MARC SHAIMAN

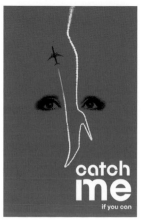
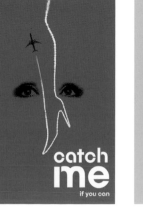
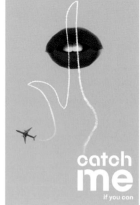

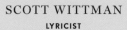

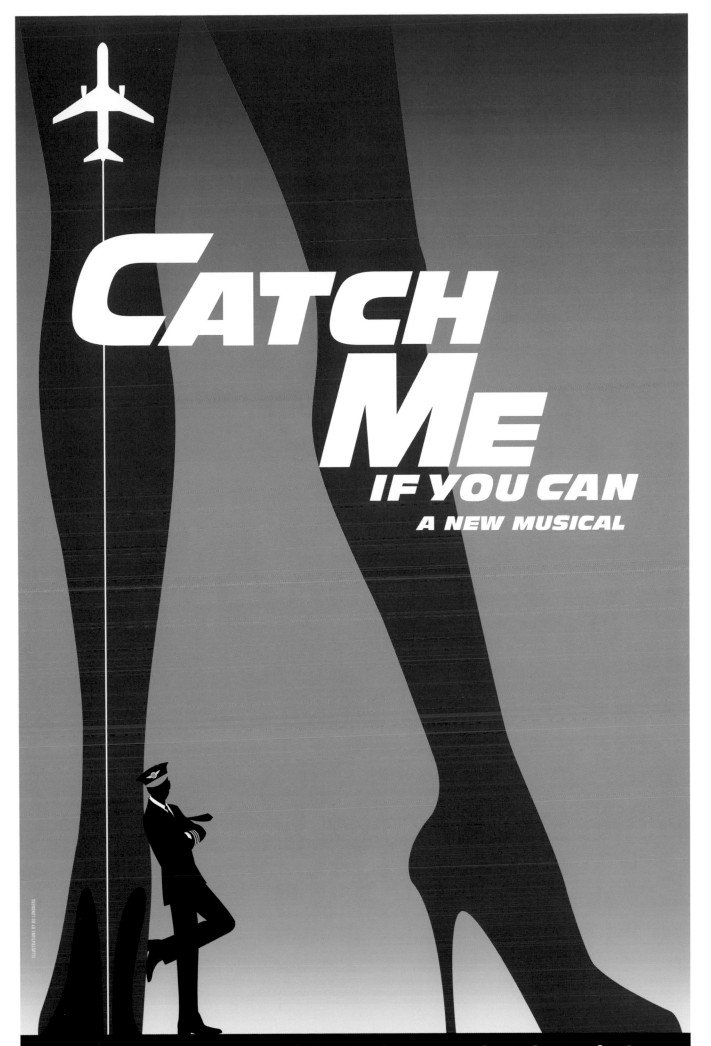

MOUNTAINTOP

THE NON-EVENT

BIOGRAPHY OF A CHARACTER ASSASSINATION.

THE EVENT

MYSTERY, RESPECT, THE PERFECT CAST, AND–SPOILER ALERT– *A SPIRITUAL SECRET.*

DARREN COX
SPOTCO

WE TRIED TO DISTILL THE scope of *The Mountaintop* into a simplified graphic that embodied not only the play's realism and touching message, but also its magical and spiritual aspects. After a few rounds, the producers felt we hadn't yet nailed it. To help facilitate a breakthrough, Drew called all the creatives together for a critique of our comps. We analyzed the advantages and disadvantages of all the work. I remained introspective and silent. How could we ever do any justice to the play and Dr. Martin Luther King Jr.'s legacy? An impossible task, I thought. As the meeting was drawing to a close without resolution, I recalled the old adage, "Keep it simple." I blurted out, "Let's frame the poster with an 'M.'" It speaks to the iconic nature of his initials and to the title of the play. Compositionally, the "M" would create piercing portraits of our compelling leads, Samuel L. Jackson and Angela Bassett.

The question remained, who could create a potent image of our leads and be sensitive to the subject? Mary Ellen Mark. Her work had a tough exterior with a heartbreaking core. This made for such a great shoot with Sam Jackson and Angela Basset. Mary Ellen was light and effervescent all day, but when she grabbed the camera to make an exposure, she demanded they give it all. You can see this in the final result, and surely you see it throughout her body of work.

THE QUESTION REMAINED, WHO COULD CREATE A POTENT IMAGE OF OUR LEADS AND BE SENSITIVE TO THE SUBJECT? *MARY ELLEN MARK.*
DARREN COX

above
Brad Holland's sketches of Martin Luther King Jr. and a more literal interpretation of Dr. King on a mountaintop.

left
Matt Mahurin's concept of Martin Luther King Jr. blowing away as floral blooms. Both were ultimately rejected by the team, principally for having an epic sense of the legend, but proving less successful at illuminating the man behind the legend, a goal of the production.

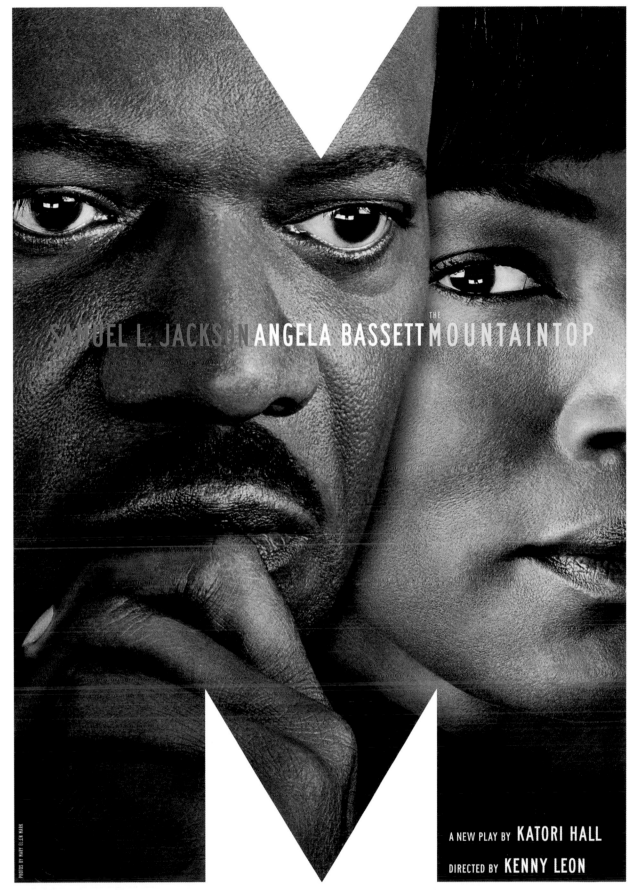

SAMUEL L. JACKSON ANGELA BASSETT THE MOUNTAINTOP

PHOTOS BY MARY ELLEN MARK

A NEW PLAY BY **KATORI HALL**
DIRECTED BY **KENNY LEON**

LIMITED ENGAGEMENT | TELECHARGE.COM OR 212.239.6200 | THEMOUNTAINTOPPLAY.COM

JEAN DOUMANIAN SONIA FRIEDMAN PRODUCTIONS AMBASSADOR THEATRE GROUP RAISE THE ROOF 7 TED SNOWDON ALHADEFF PRODUCTIONS/LAUREN DOLL
B SQUARE + 4 PRODUCTIONS/BROADWAY ACROSS AMERICA JACKI BARLIA FLORIN/COOPER FEDERMAN RONNIE PLANALP/MOELLENBERG TAYLOR MARLA RUBIN PRODUCTIONS/
BLUMENTHAL PERFORMING ARTS PRESENT SAMUEL L. JACKSON ANGELA BASSETT IN THE MOUNTAINTOP BY KATORI HALL ORIGINAL MUSIC BRANFORD MARSALIS
SET & PROJECTION DESIGN DAVID GALLO COSTUME DESIGN CONSTANZA ROMERO LIGHTING DESIGN BRIAN MacDEVITT SOUND DESIGN DAN MOSES SCHREIER HAIR & WIG DESIGN CHARLES G. LaPOINTE
CASTING JIM CARNAHAN, C.S.A. PRODUCTION MANAGEMENT AURORA PRODUCTIONS PRODUCTION STAGE MANAGER JIMMIE LEE SMITH PRESS REPRESENTATIVE O&M CO. ADVERTISING SPOTCO
ASSOCIATE PRODUCER PATRICK DALY COMPANY MANAGER BRIG BERNEY GENERAL MANAGER RICHARDS/CLIMAN, INC. PRODUCED IN ASSOCIATION WITH SCOTT DELMAN DIRECTED BY KENNY LEON

♿ BERNARD B. JACOBS THEATRE, 242 WEST 45TH STREET

ONCE

— THE NON-EVENT —

UNKNOWN MOVIE, BOY LOSES GIRL.

— THE EVENT —

AUTHENTIC, PERSONAL, ORIGINAL, AND *ACHINGLY ROMANTIC.*

FRANK OCKENFELS III
PHOTOGRAPHER

DOWN AND DIRTY. "ALL you'll need is a bag of cameras," was the note I received from Drew. So I jump on a plane and land in New York. A few hours later, I'm onstage in an East Village theater drinking a beer waiting to see the performers I will spend the next day with. It was like sitting in a pub in Dublin—the energy, the storytelling and the music . . . amazing! The next day, the two leads meet me at an Irish pub down the street where the cast often hung out and played after the show. After seeing the performance and the emotion of the show, I realized that the images needed to be moments, not set up but found and captured and then gone in the same breath, without direction. A large window in the front of the bar looked out into the street. I asked them to go over to the window and just talk to each other. The light separated them from the darkness, the shadows creating the connection. The rest of the cast came in and immediately started playing, shifting the energy. Surrounded by music and drink, it felt like we were in Dublin. I moved around, shooting wide and tight, finding the energy. We then took that energy out into the street. I photographed them as they wandered and talked. We landed on the corner of Bond and Lafayette, at which point he [Steve Kazee] took out his guitar and started to play. The cobblestone streets and the end of daylight that separated them from the surrounding building was a perfect final moment to observe them.

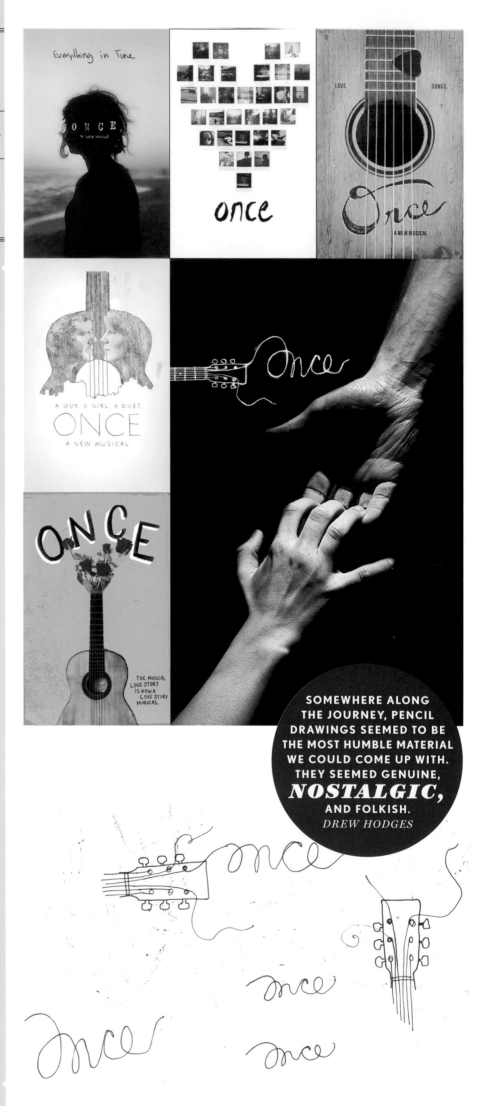

SOMEWHERE ALONG THE JOURNEY, PENCIL DRAWINGS SEEMED TO BE THE MOST HUMBLE MATERIAL WE COULD COME UP WITH. THEY SEEMED GENUINE, *NOSTALGIC,* AND FOLKISH.
DREW HODGES

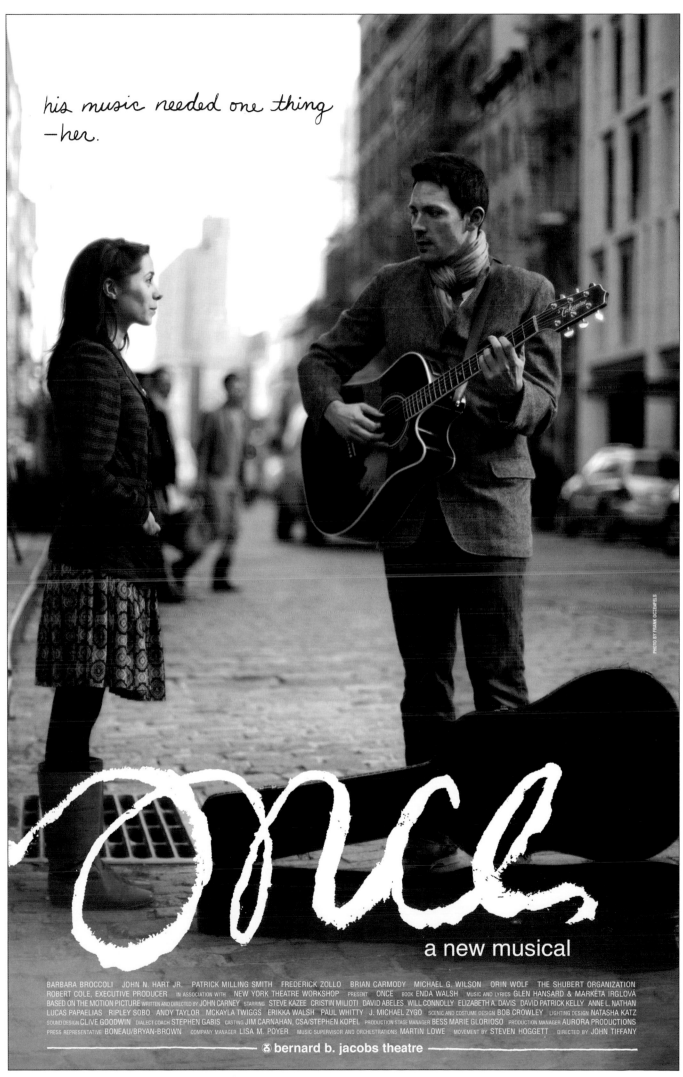

his music needed one thing
—her.

Once

a new musical

BARBARA BROCCOLI JOHN N. HART JR. PATRICK MILLING SMITH FREDERICK ZOLLO BRIAN CARMODY MICHAEL G. WILSON ORIN WOLF THE SHUBERT ORGANIZATION
ROBERT COLE, EXECUTIVE PRODUCER IN ASSOCIATION WITH NEW YORK THEATRE WORKSHOP PRESENT ONCE BOOK ENDA WALSH MUSIC AND LYRICS GLEN HANSARD & MARKÉTA IRGLOVÁ
BASED ON THE MOTION PICTURE WRITTEN AND DIRECTED BY JOHN CARNEY STARRING STEVE KAZEE CRISTIN MILIOTI DAVID ABELES WILL CONNOLLY ELIZABETH A. DAVIS DAVID PATRICK KELLY ANNE L. NATHAN
LUCAS PAPAELIAS RIPLEY SOBO ANDY TAYLOR MCKAYLA TWIGGS ERIKKA WALSH PAUL WHITTY J. MICHAEL ZYGO SCENIC AND COSTUME DESIGN BOB CROWLEY LIGHTING DESIGN NATASHA KATZ
SOUND DESIGN CLIVE GOODWIN DIALECT COACH STEPHEN GABIS CASTING JIM CARNAHAN, CSA/STEPHEN KOPEL PRODUCTION STAGE MANAGER BESS MARIE GLORIOSO PRODUCTION MANAGER AURORA PRODUCTIONS
PRESS REPRESENTATIVE BONEAU/BRYAN-BROWN COMPANY MANAGER LISA M. POYER MUSIC SUPERVISOR AND ORCHESTRATIONS MARTIN LOWE MOVEMENT BY STEVEN HOGGETT DIRECTED BY JOHN TIFFANY

— ⑤ bernard b. jacobs theatre —

ONE MAN, TWO GUVNORS

THE NON-EVENT

SO BRITISH YOU CAN'T SPELL IT.

THE EVENT

SO SO SO WELL REVIEWED, AND SO SO SO BRITISH IT'S GOT TO BE *SCREAMINGLY FUNNY.*

NICHOLAS HYTNER
DIRECTOR

ONE MAN, TWO GUVNORS started life as a solution to a scheduling problem. I was the director of the National Theatre, and we were about to commit to a repertoire for the summer of 2011 that was unremittingly serious and high-minded. I think the nearest we had to a barrel of laughs was *Antigone*. So I thought we had to give our audience something that had nothing in its head besides the desire to entertain. One of my team remembered *The Servant of Two Masters*, Carlo Goldoni's eighteenth-century Italian comedy. I'd played the central character at school, and I thought James Corden would be great in it. He'd been terrific as the class clown in *The History Boys*. I'd also just worked happily with the playwright Richard Bean on an uncredited makeover of an old English comedy, *London Assurance*, so I wondered if he'd do a more comprehensive job on *The Servant of Two Masters*. I had an idea that the traditions of the old Italian commedia dell'arte might have a lot in common with old English comic traditions of slapstick farce. Richard's script was hilarious, James was hilarious, and the work of Cal McCrystal—who helped create the physical comedy sequences—was hilarious too. Grant Olding wrote wonderful songs for a skiffle band. The show was particularly popular with visiting Americans, who probably like the British best when they're dropping their trousers, falling downstairs, and being unpretentiously silly. (I assume they hate us most when we arrive with upturned noses and start to pontificate about art.)

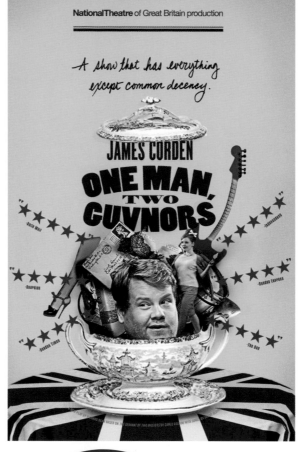

THE CAMPAIGN WAS AS FUNNY AND QUIRKY AS EVERYTHING ELSE IN THE SHOW, AND WAS THE MOTOR OF A BIG AND VERY *UNLIKELY HIT*.
NICHOLAS HYTNER

above
A body double was used as a stand in for James Corden to create these designs.

below
Television footage was shot at the National Theatre's rehearsal space by our sister company Dewynters, with Mr. Corden executing perhaps the funniest pratfall we have ever seen. When we received the raw footage, we played it over and over, laughing every time. — D.H.

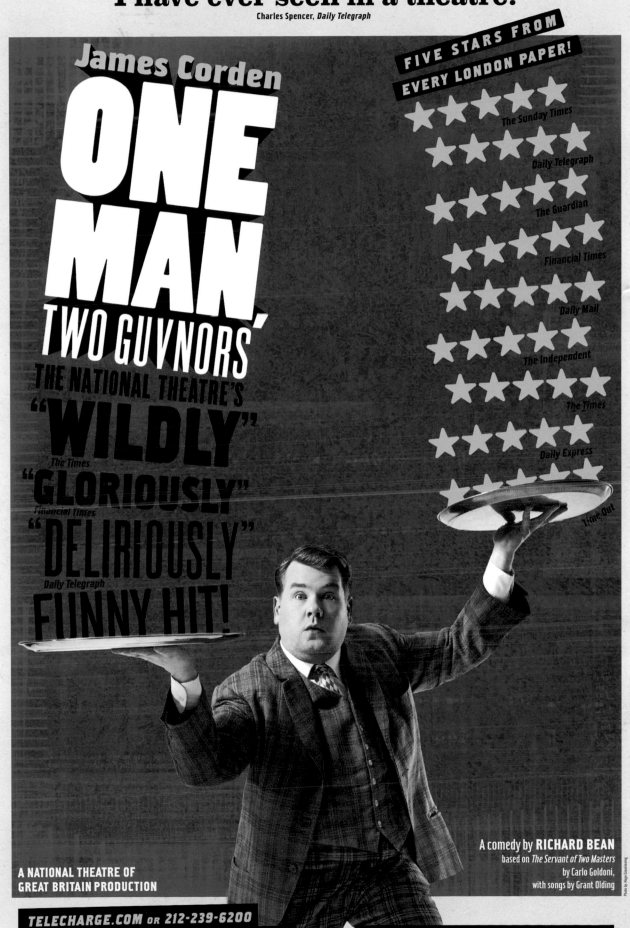

CAT ON A HOT TIN ROOF

THE NON-EVENT

AFTER MANY REVIVALS, IS THIS AN EVENT?

THE EVENT

THE SULTRIEST CHARACTER OF THE STAGE, PLAYED BY THE SULTRIEST-SEEMING CHARACTER OFF IT.

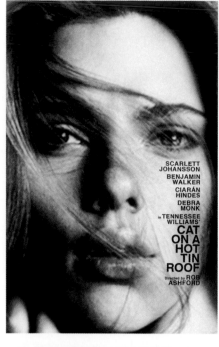

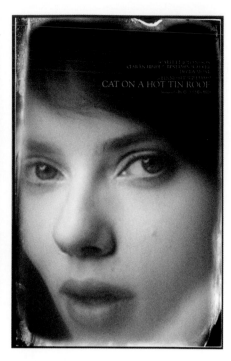

STUART THOMPSON
PRODUCER

THE DIRECTOR OF CAT, Rob Ashford, told Drew and me early on that he had an idea the art for our show should resemble this iconic Sally Mann photograph, and we readily agreed because of the way in which it captured the spirit of the South and of the character of Maggie the Cat that Scarlett Johansson would be playing. However, we needed to schedule a shoot with Scarlett. But because she was traveling around quite a lot, it turned out to be difficult to coordinate schedules with photographers and locations (not much of France looks like the American South). Therefore, necessity became the mother of invention, and the talent of Drew and SpotCo enabled an existing photo of Scarlett by Hedi Slimane to become our image, and it was designed into our art. I believe this final design represented the spirit of Maggie. And I also thought the art was beautiful and provocative—and it helped us to pre-sell a lot of tickets.

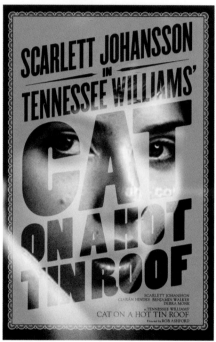

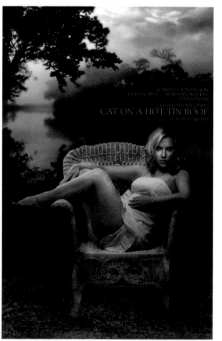

NECESSITY BECAME THE MOTHER OF INVENTION.
STUART THOMPSON

SCARLETT JOHANSSON

CIARÁN HINDS BENJAMIN WALKER

in TENNESSEE WILLIAMS'

CAT
ON A
HOT
TIN
ROOF

With DEBRA MONK

Directed by ROB ASHFORD

STUART THOMPSON JON B. PLATT THE ARACA GROUP ROGER BERLIND SCOTT M. DELMAN ROY FURMAN RUTH HENDEL CARL MOELLENBERG SCOTT & BRIAN ZEILINGER NEDERLANDER PRESENTATIONS, INC.
TULCHIN/BARTNER PRODUCTIONS SCOTT RUDIN present SCARLETT JOHANSSON CIARÁN HINDS BENJAMIN WALKER in Tennessee Williams' CAT ON A HOT TIN ROOF with DEBRA MONK
EMILY BERGL MICHAEL PARK VIN KNIGHT BRIAN REDDY TANYA BIRL WILL COBBS LANCE ROBERTS CHERENE SNOW LAUREL GRIGGS VICTORIA LEIGH CHARLOTTE ROSE MASI GEORGE PORTEOUS
NOAH UNGER Scenic Design CHRISTOPHER ORAM Costume Design JULIE WEISS Lighting Design NEIL AUSTIN Composer & Sound Design ADAM CORK Hair & Wig Design PAUL HUNTLEY Casting by DANIEL SWEE
Fight Director RICK SORDELET Production Stage Manager LISA DAWN CAVE Production Management AURORA PRODUCTIONS Press Representative BONEAU/BRYAN-BROWN Associate Producer KEVIN EMRICK
General Management STP/PATRICK GRACEY Directed by ROB ASHFORD Cat on a Hot Tin Roof is presented by special arrangement with The University of the South, Sewanee, Tennessee.

RODGERS + HAMMERSTEIN'S CINDERELLA

— THE NON-EVENT —

DISNEY FOR KIDS.

— THE EVENT —

FRESH, SMART, AND PERFECT FOR DATE NIGHT.

ROBYN GOODMAN
PRODUCER

PROBLEM: HOW TO TELL the public that the new *Rodgers + Hammerstein's Cinderella* has a fun new book by Douglas Carter Beane with a Cinderella who saves the Prince as much as he saves her? How do you tell the ticket buyer that we also honor the fairy tale that they love? We will give them the same gorgeous score with their favorite songs, the ball gowns, glass slippers, Fairy God Mother, etc., but also they will experience a modern girl at the center of the story who believes she can change the world. We didn't want to turn off the classicists or the feminist moms. What does that look like? Should we bifurcate our marketing? Solution: SpotCo.

With our director Mark Brokaw, the producers were all leaning toward a modern look at first. We thought that the title would state the classic fairy tale and a funky colorful shoe they presented would say "modern." However the more we looked at it, the more we realized that this image did not have the weight and beauty of the story and of our production. We finally chose the elegant purple shoe with Cinderella embedded in it because it was important and regal and stunning. It was what others call "a big brand." However, we also needed to add something that said . . . wink . . . we are updating the show in subtle ways. Then SpotCo did what they do best. They gave us a witty tag line that said everything: "Glass Slippers Are So Back." Success: Two matinee ladies walking by the theater before first preview: "Ha ha, Glass Slippers Are So Back . . . that's funny!" "Shirl, I love *Cinderella*, let's take the grandchildren." Bull's-eye!!

WE DIDN'T WANT TO TURN OFF THE CLASSICISTS OR THE *FEMINIST MOMS.*
ROBYN GOODMAN

GLASS

SLIPPERS

ARE

SO

BACK.

RODGERS + HAMMERSTEIN'S
CINDERELLA
ON BROADWAY

⑤ BROADWAY THEATRE | CinderellaOnBroadway.com 🐦 f
1681 BROADWAY AT 53RD STREET | TELECHARGE.COM • 212-239-6200

VANYA AND SONIA AND MASHA AND SPIKE

THE NON-EVENT

CHEKHOV, AND HOW DO YOU SAY THAT TITLE?

THE EVENT

STARRY, FUNNY, FARCICAL, AND TIME FOR CHRISTOPHER DURANG TO GET HIS DUE.

JOEY PARNES, SUE WAGNER, AND JOHN JOHNSON
PRODUCERS

THE THING WE REMEMBER most about the road to *Vanya and Sonia and Masha and Spike* on Broadway was the feeling that we had all been shot out of a cannon. There was a very small window of time we had in order to pull the trigger on moving the show to Broadway, and the reality was the play would only be on sale four weeks before our first preview. Most people thought we were nuts—hell, most people at SpotCo thought we were insane. But when Drew went to see the show at Lincoln Center, he sent us a note that said, "Two things come to mind in terms of a sell—bucolic spring always feels good in the dead of winter, and then of course, wacky comedy." The idea of bucolic spring inspired us, and we jumped headlong into creating an image as quickly as we could. SpotCo put together comps in record time—it was only about a week from the time they saw the show until the time we saw our first comps. At the same time, we got word that a Brigitte Lacombe photo that she shot of the cast for a *New Yorker* piece could be used. Once SpotCo got the photo, they immediately put it into action, and it became clear to all of us that the photo was the way to go. We didn't get bucolic spring out of it but, hey, we had a hilarious photo with a hot nearly naked guy in it—it would sell tickets. That June, we got to toast with Drew and crew with our glasses of Veuve Clicquot, and with our Tony for Best Play in tow!

THERE WAS SOME HESITATION ABOUT ABANDONING OUR BUCOLIC LOOK UNTIL DREW SAID, "IT'S NOT THE MONA LISA— *SELL SOME TICKETS!"*
JOEY PARNES

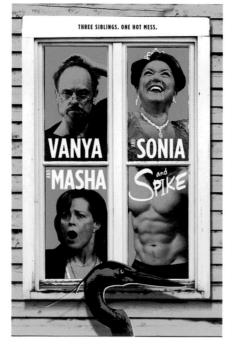

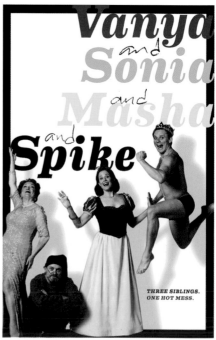

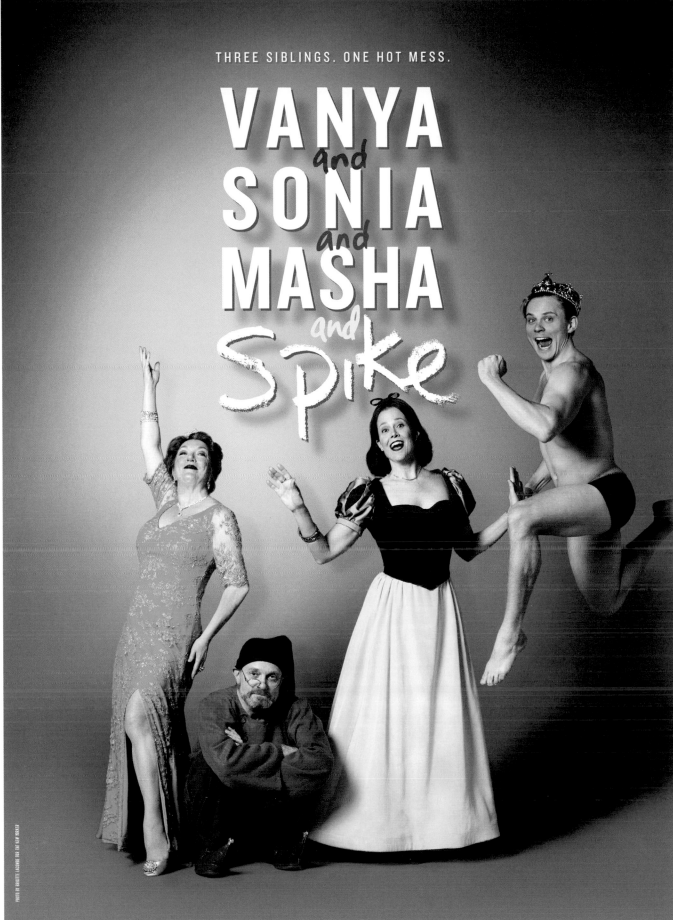

THREE SIBLINGS. ONE HOT MESS.

VANYA
and
SONIA
and
MASHA
and
Spike

JOEY PARNES LARRY HIRSCHHORN JOAN RAFFE & JHETT TOLENTINO MARTIN PLATT & DAVID ELLIOTT PAT FLICKER ADDISS CATHERINE ADLER JOHN O'BOYLE JOSHUA GOODMAN
JAMIE DEROY / RICHARD WINKLER CRICKET HOOPER JIRANEK / MICHAEL PALITZ MARK S. GOLUB & DAVID S. GOLUB RADIO MOUSE ENTERTAINMENT SHADOWCATCHER ENTERTAINMENT
MARY COSSETTE / BARBARA MANOCHERIAN MEGAN SAVAGE / MEREDITH LYNSEY SCHADE HUGH HYSELL / RICHARD JORDAN CHERYL WIESENFELD / RON SIMONS S.D. WAGNER
JOHN JOHNSON IN ASSOCIATION WITH McCARTER THEATRE CENTER LINCOLN CENTER THEATER PRESENT SIGOURNEY WEAVER DAVID HYDE PIERCE IN VANYA and SONIA and MASHA and SPIKE
A NEW COMEDY BY CHRISTOPHER DURANG WITH KRISTINE NIELSEN AND BILLY MAGNUSSEN SHALITA GRANT GENEVIEVE ANGELSON SCENIC DESIGN DAVID KORINS COSTUME DESIGN EMILY REBHOLZ LIGHTING DESIGN JUSTIN TOWNSEND
ORIGINAL MUSIC & SOUND DESIGN MARK BENNETT CASTING DANIEL SWEE PRODUCTION STAGE MANAGER DENISE YANEY PRESS REPRESENTATIVE D&M CO. ADVERTISING & MARKETING SPOTCO DIRECTED BY NICHOLAS MARTIN

♿ GOLDEN THEATRE, 252 WEST 45TH STREET (BETWEEN BROADWAY & 8TH AVENUE) VSMSPLAY.COM

185

BREAKFAST AT TIFFANY'S

2013

THE NON-EVENT

NO ONE CAN BE AUDREY HEPBURN, OR FORGET THAT SCORE.

THE EVENT

GLAMOUR IS ALIVE AND CHIC IN BLACK AND WHITE NYC.

THIS SHOW BEGAN WITH such a strong visual that everything we did had to live up to an image almost everyone carries in their head. We were also not allowed to use the color Tiffany blue, as the elements of the original story included a call girl of sorts, a closeted Southerner, not to mention drugs and, in the film, Mickey Rooney's impossibly racist sendup of Mr. Yunioshi. So to start, we had potholes everywhere. But it's such an evocative view of New York that you couldn't help but be romanced by it. After many illustration attempts, it was decided we had to support our leading lady by letting everyone know she had "it" via photography. Elegant black and white was an easy decision. And designer Dan Forkin painstakingly made a logo out of diamonds on his computer. I really don't know how he did it, but logo-as-brooch looked spectacular, even if it doesn't exist in the real world. I wish it did. The producer made a sponsorship deal with a makeup company unbeknownst to us that we ended up having to explain to Emilia Clarke's furious agent, and as if predicted, she broke out into hives when we applied it. But the images worked. I wish the show did. Alas, it was not to be. But we very much enjoyed being made graphic design jewelers for a few weeks.
—D.H.

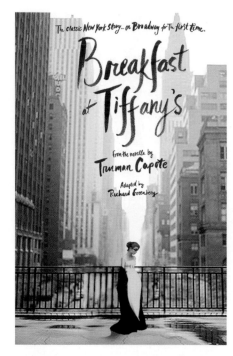

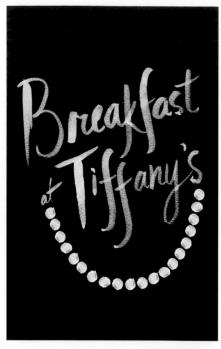

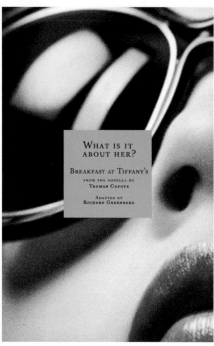

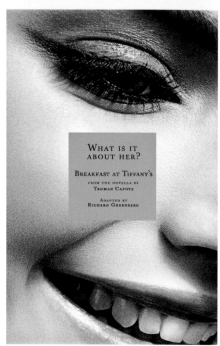

IT'S SUCH AN ***EVOCATIVE*** VIEW OF NEW YORK THAT YOU COULDN'T HELP BUT BE ROMANCED BY IT.
DREW HODGES

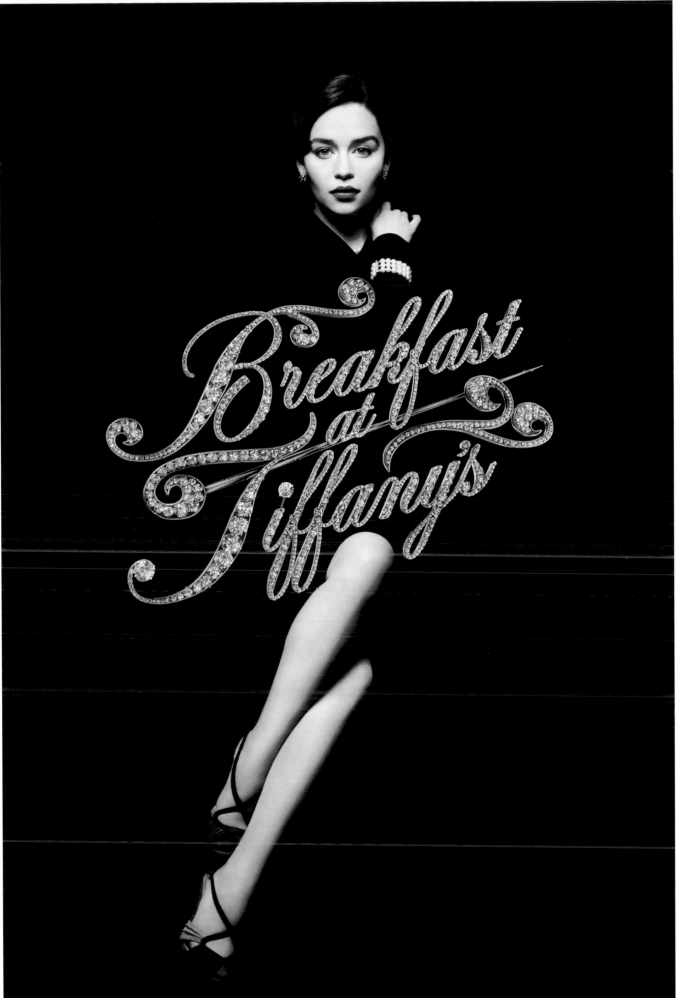

Breakfast at Tiffany's

The classic New York story comes to Broadway.

LUCKY GUY

THE NON-EVENT ———
THE TOM HANKS SHOW.

——— THE EVENT ———
NORA EPHRON'S MASTERFUL AND GRITTY SALUTE TO THE CITY OF THE *"HEADLESS BODY IN TOPLESS BAR"* ERA.

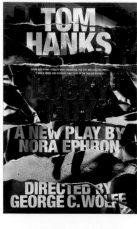

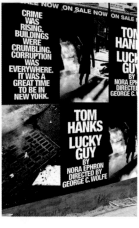

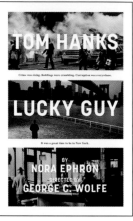

LUCKY GUY IS A TALE OF why Broadway posters sometimes look the way they do. We began with a beloved writer who had tragically passed away before her production reached Broadway. The esteemed director George C. Wolfe came to our office and implored us to understand that this was a love letter to a specific time and tone in New York. George had no interest in seeing Tom Hanks's face anywhere near the poster—his name would be enough. So we began with images of gritty *New York Post* headlines and black-and-white street art that we thought expressed what so many felt about New York then—that it was tough, but freewheeling fun too. And slowly, all of the grit began to fade in the meetings with the producing team. Once we went on sale, without the meteoric rise in ticket sales everyone expected, worry set in. Worry usually means changing the poster. It's the easiest fix to make. There were quite a few dead ends in the new approaches. Finally, the team discussed putting Tom's image on the poster, even if the approved images were historically and mustache-wise inaccurate. We'd hoped the red poster seen here still held on to a little of what we had all been going for from the beginning. But alas, no concensus. The final poster has a full-color image of our lead actor floating above the city. It told you one important thing—Tom Hanks was in a play about New York. But it sadly lacked all of those things George so passionately asked of us. I have always believed that the imagery for a production is an emotional promise to a ticketbuyer. That's what I find so disappointing about *Lucky Guy*'s imagery—it tells you no more than what you probably already knew, and not enough about how we hope you will feel after seeing this wonderful play.—D.H.

IN BREAKING WITH THE TRADITION OF THIS BOOK, I AM FEATURING *THE POSTER I DESPERATELY WISH HAD RUN* INSTEAD OF THE ONE THAT DID.
DREW HODGES

CRIME WAS RISING. STREETS WERE CRUMBLING.
IT WAS A GRAND AND GLORIOUS TIME TO BE IN NEW YORK.

TOM HANKS

LUCKY GUY

A NEW PLAY BY
NORA EPHRON

DIRECTED BY
GEORGE C. WOLFE

KINKY BOOTS

MORE DRAG QUEENS ON BROADWAY.

—— THE EVENT ——

A NEW MUSICAL FROM CYNDI AND HARVEY THAT *LIFTS YOUR SPIRIT* TO BROADWAY HEAVEN.

DARYL ROTH
PRODUCER

I HAD GONE TO THE AGENCY with this possibly naïve, probably wide-eyed idea for the logo of *Boots* to be like the eyes from *Cats* or the mask from *Phantom*. This was very early on, and we didn't know how the show would do, but I believed in it so much. And I said to Drew and everyone around the table that if we have a success, the logo can be this standalone mark, and everyone around the world will see it and immediately think, "*Kinky Boots.*" So they did that. They made what I like to call the "Big K" in the title treatment as a pair of legs and boots that spell out the name of the show. And it does stand alone. Also, we've made it seasonal. In the winter, we've added a muff. And during the holidays, we've added a wreath. And we've started using it on its own, as a mark, and people do see it and get that it's our show. The agency listened to what was in my head and in my heart and really delivered it all in this brilliant way. We were dreaming big with this perhaps crazy confidence that we'd get there with the show. But the people at SpotCo are highly collaborative, and I really like that about that shop. I mean, *Kinky Boots* is now in its second year, and every week we all get together, and the agency is very open to hearing ideas. And some get thrown out, and some get considered—and some get made. And now, for the rest of my life, when I see that Big K, I'll think about that wonderful creative collaboration.

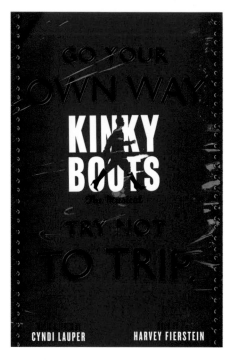

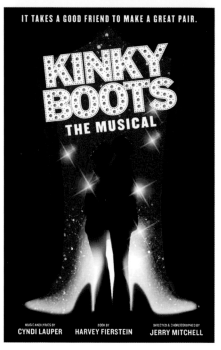

Kinky Boots' logo represents a collaboration with London sister company Dewynters. They did the above comp with our leading men back to back in the shoe, and ultimately provided the "K" in our logo, while we added the "inky Boots." — D.H.

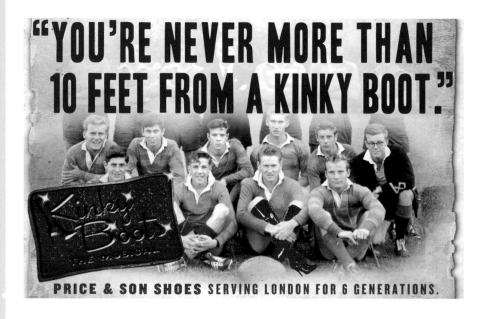

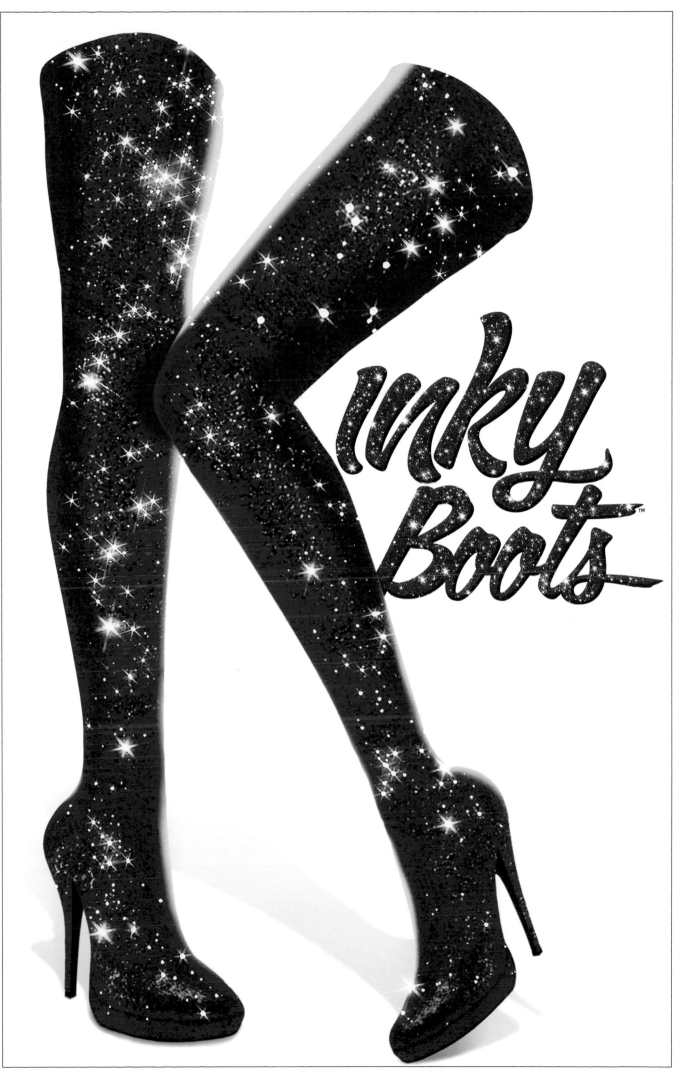

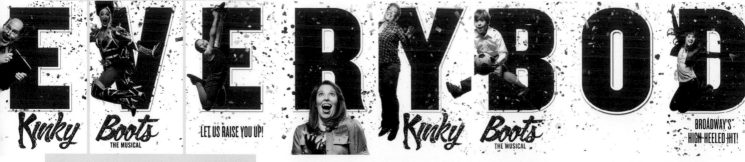
HAL LUFTIG
PRODUCER

WHAT TOUCHED ME AND moved me about SpotCo and made us choose them to do the advertising for *Kinky Boots* was the very first meeting. They really focused on the idea of fathers and sons. And they'd actually put together a video with employees from the office talking about their own relationships with their dads. Some of them moved me and Daryl to tears. And we thought, "If they're focusing on this aspect of the show—the two main characters and their parental expectations—that's really key." And I can remember leaving the meeting and saying, "They get this show." That video really sold me on SpotCo.

JERRY MITCHELL
DIRECTOR/CHOREOGRAPHER

DREW CAME TO ME AND HAD an idea—he wanted to shoot the actors in costumes and in makeup for a day— and this was when we were in rehearsal for *Kinky Boots*. And I said, "Absolutely yes, but this is really difficult, and I'm not sure how to make this happen." This was the "Everybody Say Yeah" campaign. So we rehearsed in groups, and then we got the company to go to the lobby to get shot on a trampoline in various ways. There was this amazing exuberance about the whole thing.

BOB KING
CHIEF EXECUTIVE, DEWYNTERS (LONDON)

I GOT A CALL FROM DREW saying that they were about to start work on an exciting new musical, and that the producers, knowing that we were sister agencies, had asked if we could collaborate on designing an iconic brand for the show. The usual ask of us is to design a brand as strong and simple as *Cats* or *Phantom*, so no pressure! We played around with dominatrix boots referencing Brit pop artist Allen Jones. The "K" was an immediate hit, and SpotCo completed the design with a glittery-script font that perfectly complements the Kinky K.

#KinkyBoots

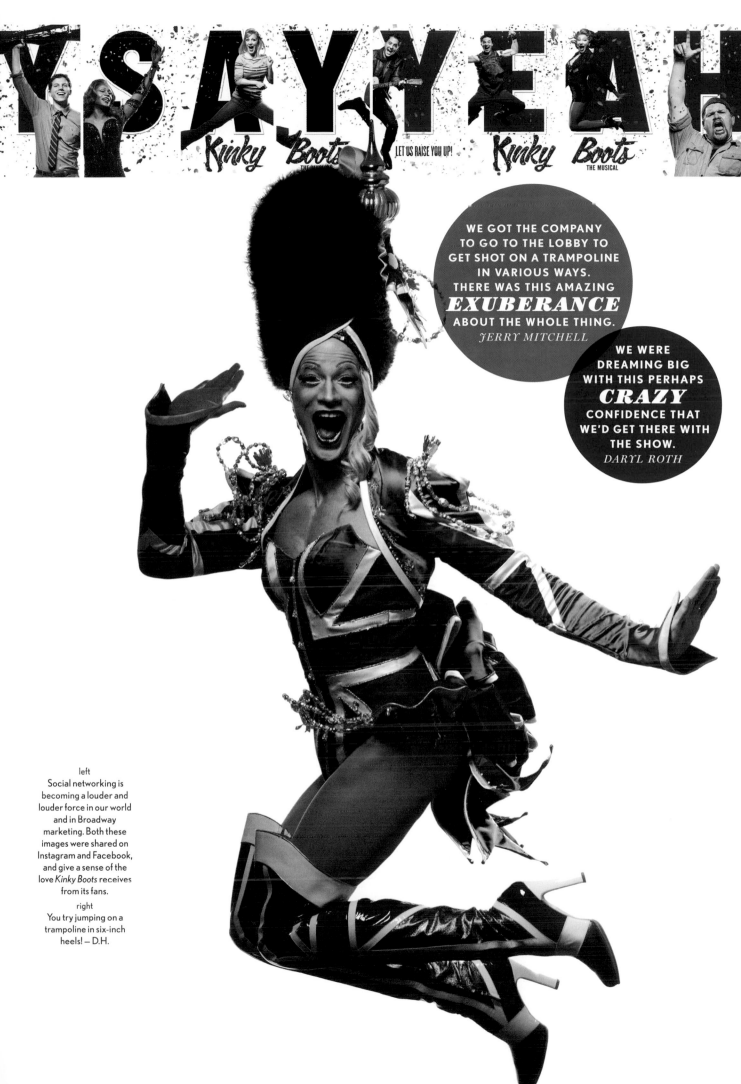

Y SAY YEAH

Kinky Boots
THE MUSICAL

LET US RAISE YOU UP!

Kinky Boots
THE MUSICAL

WE GOT THE COMPANY
TO GO TO THE LOBBY TO
GET SHOT ON A TRAMPOLINE
IN VARIOUS WAYS.
THERE WAS THIS AMAZING
EXUBERANCE
ABOUT THE WHOLE THING.
JERRY MITCHELL

WE WERE
DREAMING BIG
WITH THIS PERHAPS
CRAZY
CONFIDENCE THAT
WE'D GET THERE WITH
THE SHOW.
DARYL ROTH

left
Social networking is
becoming a louder and
louder force in our world
and in Broadway
marketing. Both these
images were shared on
Instagram and Facebook,
and give a sense of the
love Kinky Boots receives
from its fans.

right
You try jumping on a
trampoline in six-inch
heels! — D.H.

MOTOWN THE MUSICAL

THE NON-EVENT

JUKEBOX MUSICAL.

THE EVENT

THE SOUL OF A NATION—
THE STORY OF YOUR MUSIC.

BERRY GORDY
PRODUCER/BOOK WRITER

I CAN NEVER DO ANYTHING the way someone else does—it's just not me. So when we thought about bringing *Motown The Musical* to Broadway, I wanted to do just that. Not Broadway-ize Motown itself, but bring Motown to the stage for the world to experience again. Now, we were new to Broadway in every way. But in the end, the thing that ended up the same as my roots, was the community you build. At Motown, I was growing talent. Here, the talent was formed, but our show—the unique thing that is Motown—that took a whole backstage family to bring to life. And in the end, that same love that I had known making the world of Motown I found making something for Broadway—it was like being in Detroit all over again! I found a whole new, joy-filled world of artists working together again on Broadway.

KEVIN McCOLLUM
PRODUCER

MOTOWN WAS THE FIRST time I'd worked with an iconic brand that was an original show. This was also the first time I'd really delved into research before we began creating the artwork. Motown has had so much branding, and I learned that people were interested in the story of Berry Gordy. We were interested in authenticity, and that's when we realized that people know Motown for its hit records. We'd tried out a bunch of stuff, and it wasn't working. We'd tried showing pictures of Diana Ross, but then people were confused. We wanted to say, "This is a story about a man, a place, the songs, the sounds, and the stories." That first announcement ad did the trick. We said get ready, here we come, the sound of a nation. We were saying that this show was authentic, written by the man who created it.

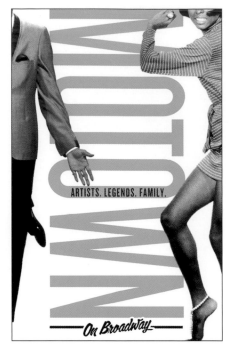

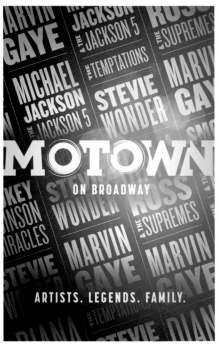

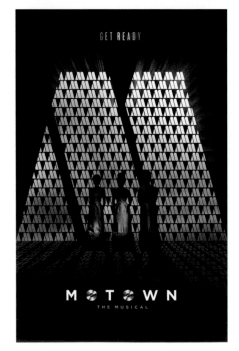

There were many conversations with Berry Gordy and producer Kevin McCollum and executive producer Nina Lannan regarding what was the correct logo to represent Motown. Ultimately the '70s logo was rejected (left, below) in favor of the Detroit-centric rainbow logo.

below
The opening night party at Roseland before it was demolished, where The Commodores serenaded the crowd live with their early hits.

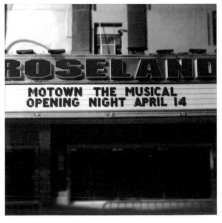

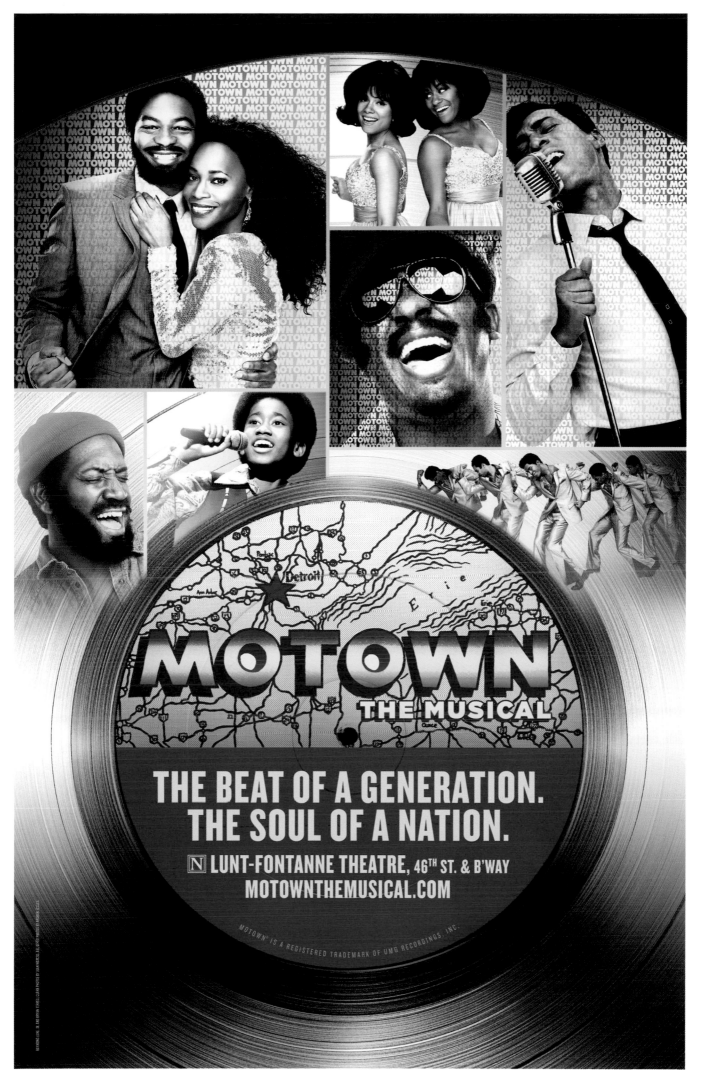

THE BEAT OF A GENERATION.
THE SOUL OF A NATION.

Ⓝ LUNT-FONTANNE THEATRE, 46ᵀᴴ ST. & B'WAY
MOTOWNTHEMUSICAL.COM

PIPPIN

THE NON-EVENT ———

THAT '70S SHOW.

——— THE EVENT ———

FAME, FOSSE,
AND RUNNING AWAY TO JOIN
THE CIRCUS.

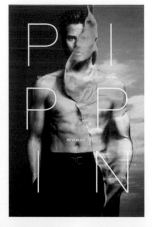
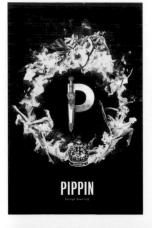

DIANE PAULUS
DIRECTOR

I GREW UP IN NEW YORK
City and saw the original production
of *Pippin* as a young girl. The music
from *Pippin* became the soundtrack
of my life, as it did for so many of my
generation. The main question in
Pippin is how far will we go to prove we
are extraordinary? Stephen Schwartz
told me that Bob Fosse had always been
interested in the circus. The essence of
the circus acrobat is to strive for the
extraordinary, which led to idea of
"the players" being a circus troupe in
our revival. I remembered the original
artwork on the *Pippin* album spelled
out the title of the show with images of
contorted circus performers—and we
actually paid homage to this artwork by
re-creating this image in our production.

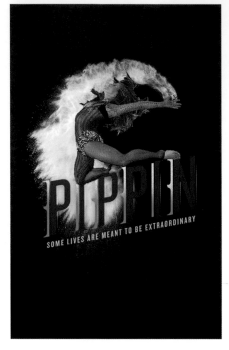
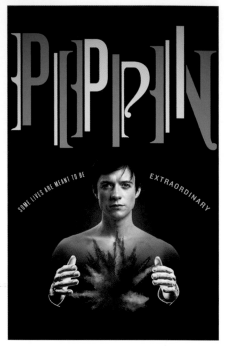

STEPHEN SOSNOWSKI
SPOTCO

I REMEMBER BARRY
[Weissler] calling me early in the
campaign after our huge Times Square
billboard went up. He simply said,
"Stephen, I am staring out at our board
from my office window now, and there
are a ton of street people, all types and
colors, standing all around it chanting,
'Pippin, Pippin, PIPPIN!' Great work!"
Barry kept me (and still keeps me) on
my toes. I never know what he's gonna
come up with when his calls comes
through. But I always pick up the phone.

Among other campaigns we tried over a year of experimentation was a campaign that
(at least in my mind) was going to embrace rainbow colors, magic, and mystery in the
form of explosive powder. Ultimately, this campaign never pleased everyone and
ended up in the flat-file drawers, the visual equivalent of the cutting-room floor. — D.H.

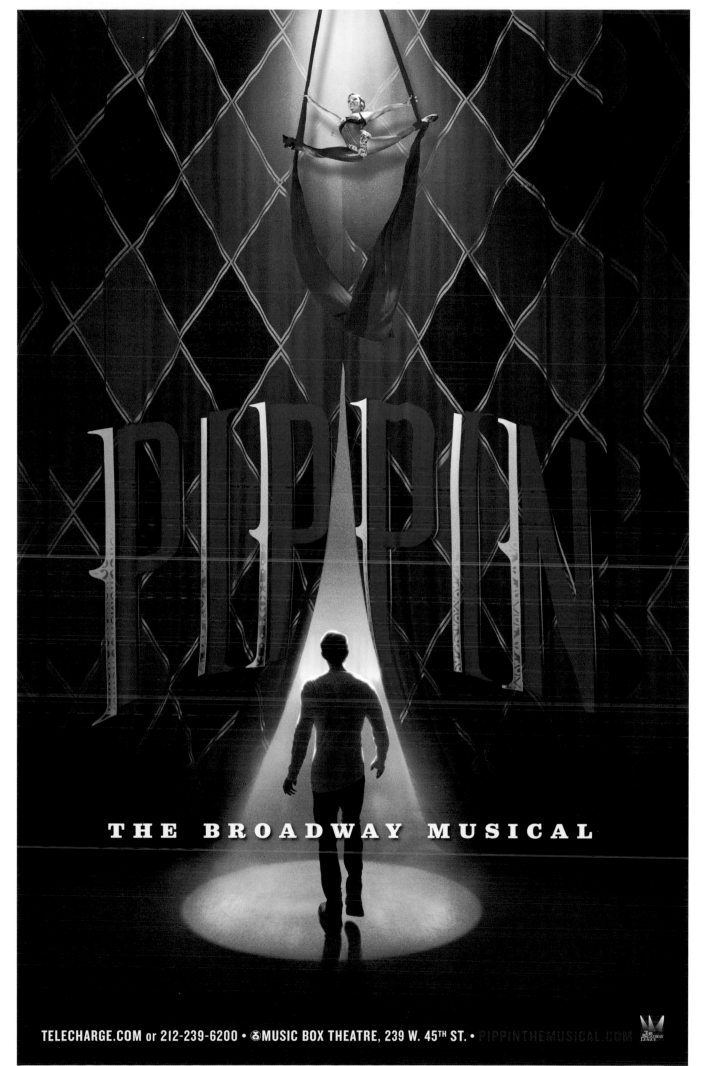

RICHARD III/ TWELFE NIGHT

--- THE NON-EVENT ---

FIVE PRODUCTIONS OF SHAKESPEARE IN ONE SEASON.

--- THE EVENT ---

THE FINEST, FUNNIEST SHAKESPEARE
YOU WILL EVER SEE, DONE ONLY THE WAY ENGLAND CAN.

SONIA FRIEDMAN
PRODUCER

MARK RYLANCE IS ONE OF the world's greatest actors and with the *Twelfe Night* and *Richard III* double bill, he proved it night after night to audiences—first in London at the Globe Theatre, then at the Apollo Theatre in the West End, and finally at the Belasco Theatre on Broadway. Our productions used original practices that were in place around the time of the world premiere of these plays (circa 1600) with almost no technical backup, and were anchored solidly in the tradition of storytelling. Mark led both of these productions with masterful performances, but at their heart was a celebration of the ritual and interplay of the company, the text, the audience, of theater and, in a wider sense, of connection and community. I wanted to make Mark the central figure of the artwork, but it was also vital that we captured this theatrical spirit. We had gone through multiple incarnations using the West End artwork as a jumping-off point and then refined the artwork to the mirrored heads of Mark as Olivia for *Twelfe Night* and as King Richard for *Richard III*, set against a white background with a black vine border. But something was missing—it was feeling too serious and worthy and a bit too old-fashioned. We added color to the vine and, more importantly, added the actors' faces that ran along the sides, and that injected humor, which was the missing piece of the puzzle. Now we had the artwork that represented the essence of our shows while still feeling fresh and timeless.

Mr. William Shakespeares

TWELFE NIGHT,
OR WHAT YOU WILL.

THE TRAGEDIE OF
KING RICHARD
THE THIRD

A GENTLEMAN'S GUIDE TO LOVE & MURDER

THE NON-EVENT ———

BRITISH-Y OPERETTA.

——— THE EVENT ———

THE MOST-AWARDED NEW SHOW ON BROADWAY *(IT'S FUNNY TOO)*.

JOEY PARNES, SUE WAGNER, AND JOHN JOHNSON
PRODUCERS

THE A GENTLEMAN'S GUIDE *to Love & Murder* campaign went through multiple mutations and shifts (and further shifts within the shifts) during the first nine months of its life. It started with a series of Lou Beach sketches of a hat, dumbbell, poison bottle, and bee as well as Jib Jab-esque figurines with a likeness to our leading man, Jefferson Mays. All of these orbited around a central image of a top hat with our title treatment. Post-opening, we evolved to our "Sergeant Pepper" look so that we could not only "show the show" more but also try to reveal our bigness by portraying our cast of characters along with the cast of characters Jefferson Mays played too. After a nice post-opening pop and a good push during the holidays, we hit a slump not only in terms of sales but in identity. We tried many different ways of highlighting the comedy, but for some reason it wasn't landing. Perhaps it had something to do with that wordy and sophisticated title. The next evolution came as we headed (limping) toward the awards season. We tried to solve the identity problem by evolving to a falling piano image with one of our aforementioned Jib Jabs under it. The campaign also evolved toward a bright orange, a color that Drew mentioned to all of us was the color that sold the most cereal on supermarket shelves. Amid the spring scrum of musicals that was coming in with force but not with complete critical success, we decided to take a shot after the last musical that opened by preparing banner ads to run on theater sites calling ourselves "The best reviewed new musical of the season." We didn't

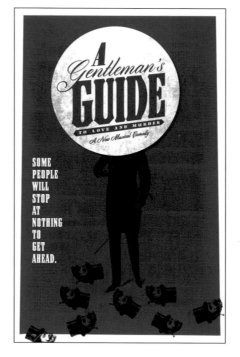
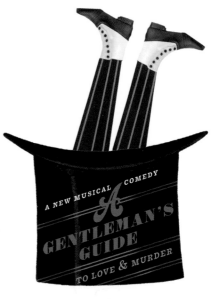

WE ALL BROKE OUR BACKS (GLADLY) TRYING TO GET THIS SEEMINGLY *UN-COMMERCIAL* MUSICAL THROUGH THE TOUGH WINTER MONTHS.
STEPHEN SOSNOWSKI
VICE PRESIDENT OF MEDIA AND ACCOUNT SERVICES, SPOTCO

V.O. This season, there's one show that critics are calling "DESPICABLE," "DIABOLICAL," "BRAZEN," "UNSEEMLY,"

and oh yes!—"INGENIOUS." The New York Times' Charles Isherwood calls it "Among the MOST INSPIRED AND ENTERTAINING NEW MUSICALS

I've seen in years!" A GENTLEMAN'S GUIDE TO LOVE & MURDER, on Broadway.

above
The storyboard for *A Gentleman's Guide to Love and Murder*'s television commercial. The end product looked remarkably like this.

below
Gentleman's Guide borrowed a page from *Avenue Q* and welcomed each new show as they opened on Broadway with murderous mayhem on social media.

have a big musical feel, we didn't have big musical sales, and we didn't have a big musical ad spend, but we leaned on our reviews in the two weeks leading up to the Tony nominations to get us back in the conversation among the theater community. Two weeks later we received the most Tony nominations of any show that season, so our "best reviewed" line changed to "the most nominated." Our awards campaign started small but eventually snowballed into a bright orange take-over of online banner ads and print ads that would push our unlikely Best Musical candidate over the top. [Ed. note: The show won the 2014 Tony Award for Best Musical.]

STACEY LIEBERMAN
PRINCE
SPOTCO

BRANDING A SHOW WITH a long, obscure title that no one has ever heard of is a particular challenge. We knew we wanted something that would be an icon for the show, since it would take some time for the title to stick in people's minds. We created our mascot, who was always in a precarious situation—dodging falling pianos, anvils, giant top hats. Although no one knew what *A Gentleman's Guide to Love & Murder* was about, they knew it had a funny little guy with the face of Jefferson Mays. The campaign's sense of humor translated across all media, and continues to evolve over time. The theater became a beacon of orange. We had many conversations with the producing team about that orange. We landed on "tomato soup" orange—comfort-food orange that warms you up and makes you feel good.

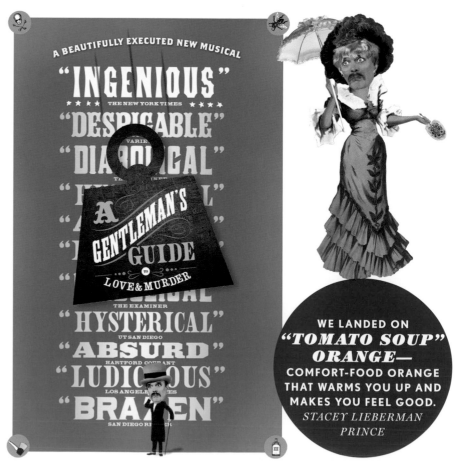

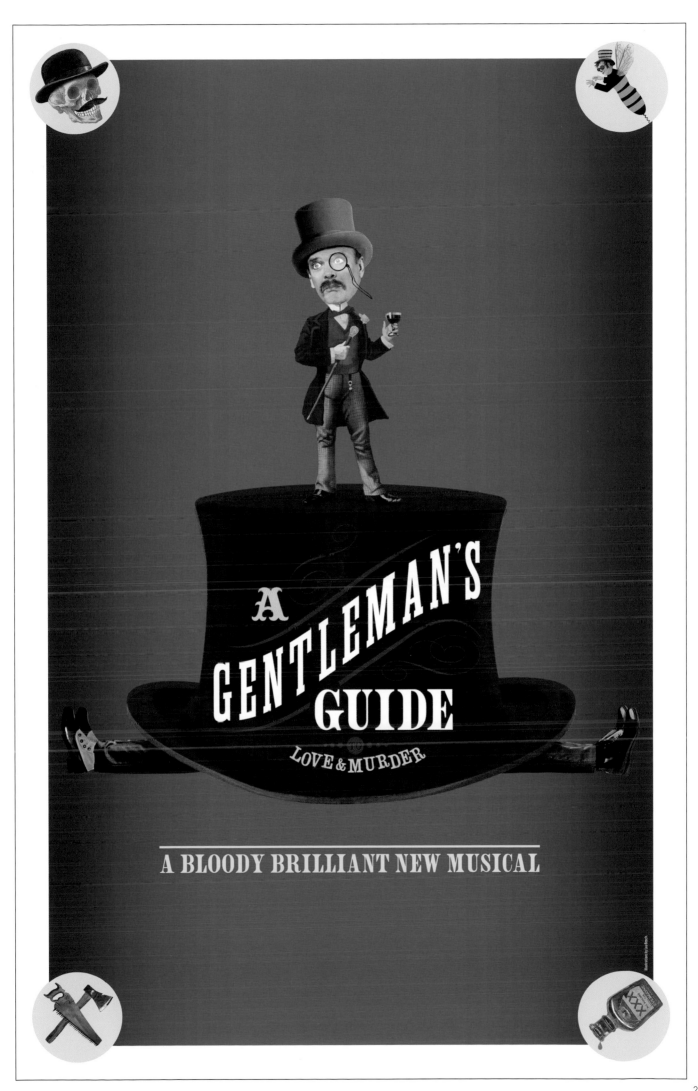

NO MAN'S LAND/WAITING FOR GODOT

THE NON-EVENT

DIFFICULT CLASSICS.

THE EVENT

THEATRICAL VAUDEVILLE, *WITH A ONCE-IN-A LIFETIME CAST.*

PATRICK STEWART

PRODUCER/ACTOR

WAITING FOR GODOT *AND* NO *Man's Land* presented an unusual challenge with regard to marketing and promotion. *Two Plays in Rep* was the title we settled on. I don't think any of us loved it, but it served the purpose of saying, literally, what we were doing (as we changed each production after the Wednesday and Saturday matinee). In the same way, promotion was tricky, as the system is geared to one play, one playwright. It was hard to get out of people's heads that we weren't doing the two plays on the same evening—God help us. Ian McKellen and I—along with our director, Sean Mathias, and Stuart Thompson—were producers so, unusually, every detail of the production's advertising came into our mailboxes. The meetings I found very interesting at first, with thirty or so people in the room, and each one it seemed a specialist: print media, radio (local, national, and NPR)—the latter kept me sane during the seventeen years I had previously lived in the U.S.—Internet, TV morning shows, and late night. Perhaps the most notable feature of the advertising and promotional side was the way in which the Internet has taken over almost entirely from the conventional areas of media, particularly print. A page in the *New York Times* is fabulous and ego-massaging but expensive and will certainly reach a

smaller potential audience than a single free Tweet or Instagram post can (if it comes from the right source). And finally, there was #gogodididonyc. Perhaps the most commented on, reproduced, and viral of anything we did was not the product of any of our meetings. It all came about over a margarita-fueled Mexican dinner my wife, Sunny, and I had one night on 7th Avenue in Brooklyn. The idea was entirely Sunny's, but as soon as she had described it, we fell over ourselves with giddy excitement, building the idea into a campaign. It was very simple: Sir Ian McKellen (Gandalf, Magneto) and Sir Patrick Stewart (Jean-Luc Picard, Charles Xavier) touring iconic New York City locations and being photographed on an iPhone by Sunny. Just tourists in our everyday clothes, except for . . . a black bowler hat on each of our heads, representing *Two Plays in Rep* and particularly the characters of Vladimir (Didi) and Estragon (Gogo) in *Waiting for Godot*. Lord, did we have fun. We were given a couple of hours off by Sean Mathias, and with our trusty driver Rudy, we started at the Wall Street Bull, politely elbowing aside a crowd of young Japanese tourists, who had no idea who the two eccentric old geezers in the bowler hats were. From there we made our way up through SoHo, to the Village (with stops at McSorley's Ale House and the Stonewall Memorial) and then the East Village to snap a quick pic outside Katz's Deli. We then capped the day off at the Empire State Building and Times Square. Another day found us heading out to Coney Island, where we hit all the tourist spots: Nathan's for a hot dog, the Wonder Wheel, and the boardwalk. We played Skee-Ball, had silly T-shirts made (that we later auctioned off to benefit City Harvest), and ate cotton candy and ice cream. All in all, it was almost certainly the most successful aspect of the production's promotional plan, and it cost us virtually nothing, and was loads of fun to boot. Additionally, in retrospect, it had the added value of "humanizing" the work we were doing; it could be argued that both plays are challenging, but the #gogodididonyc campaign, I think, allowed people to be brought into our world in a friendly and playful way.

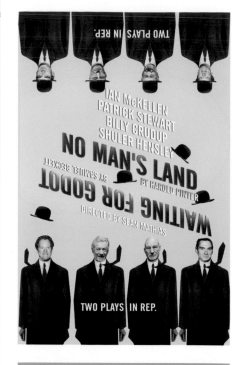

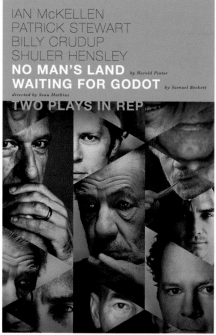

JUST TOURISTS IN OUR EVERYDAY CLOTHES, EXCEPT FOR . . . *A BLACK BOWLER HAT* ON EACH OF OUR HEADS.
PATRICK STEWART

IAN McKELLEN

PATRICK STEWART

BILLY CRUDUP

SHULER HENSLEY

NO MAN'S LAND →
HAROLD PINTER

← **WAITING FOR GODOT**
SAMUEL BECKETT

FOUR GREAT ACTORS.
EIGHT GREAT ROLES.
TWO GREAT PLAYS.

♿ **CORT THEATRE** | 138 WEST 48TH STREET | VISIT **TELECHARGE.COM** OR CALL **212-239-6200**

ROCKY

─── THE NON-EVENT ───

ROCKY SINGS.
HOW CAN THAT WORK?

─── THE EVENT ───

THAT LOVE STORY IS A
CLASSIC FOR A REASON.

ALEX TIMBERS
DIRECTOR

DREW CAME TO HAMBURG to see the musical there, where the show premiered (in German!). The producers decided that the U.S. campaign would favor the show's love story, over the German artwork, which highlighted the title character's underdog status and triumphant rise. My directorial approach to the physical production was to go for a certain grit, butchness, and authenticity to the working-class world depicted onstage. As such, the look of the show was edgy, dark, muscular, and very specific and limited in its use of color.

NIGEL PARRY
PHOTOGRAPHER

THIS IS THE ONE AND ONLY poster that I've ever shot that didn't feature the actors who were actually performing in the show. Due to the simultaneous opening nights throughout different countries, the poster had to convey the emotions running through the minds of the two protagonists who could be imagined playing the lead roles. We shot three different couples through every combination imaginable to arrive at the feelings of hope, desperation, closeness, and support between Rocky and Adrian.

MICHELE GRONER
VICE PRESIDENT, MARKETING AND SALES,
STAGE ENTERTAINMENT

THERE WERE A LOT OF conversations about getting back to the Best Picture—small, gritty. When people think about *Rocky*, they think about the boxing and sequels, but people had forgotten about what the original movie was. So we talked and talked for weeks and put together a five-page document about how we were going to talk about the show. Only then did we say, "Let's make a piece of art."

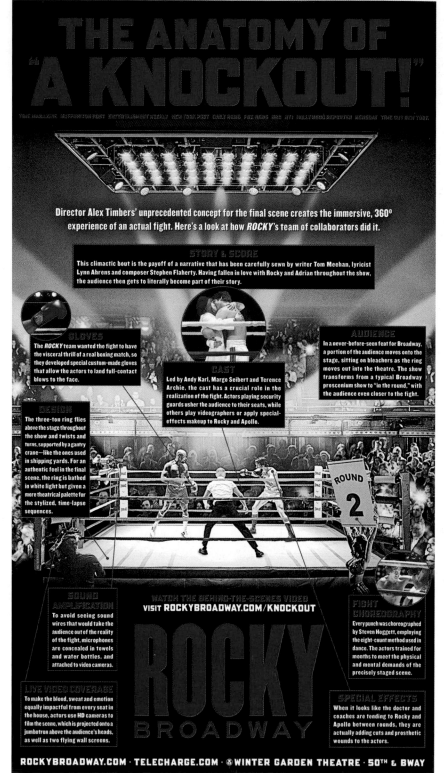

The anatomy of a knockout *New York Times* full-page ad revealed our eleven o'clock number that audiences could not stop talking about, and showed how much expertise and artistry really went into pulling off this "knockout."—D.H.

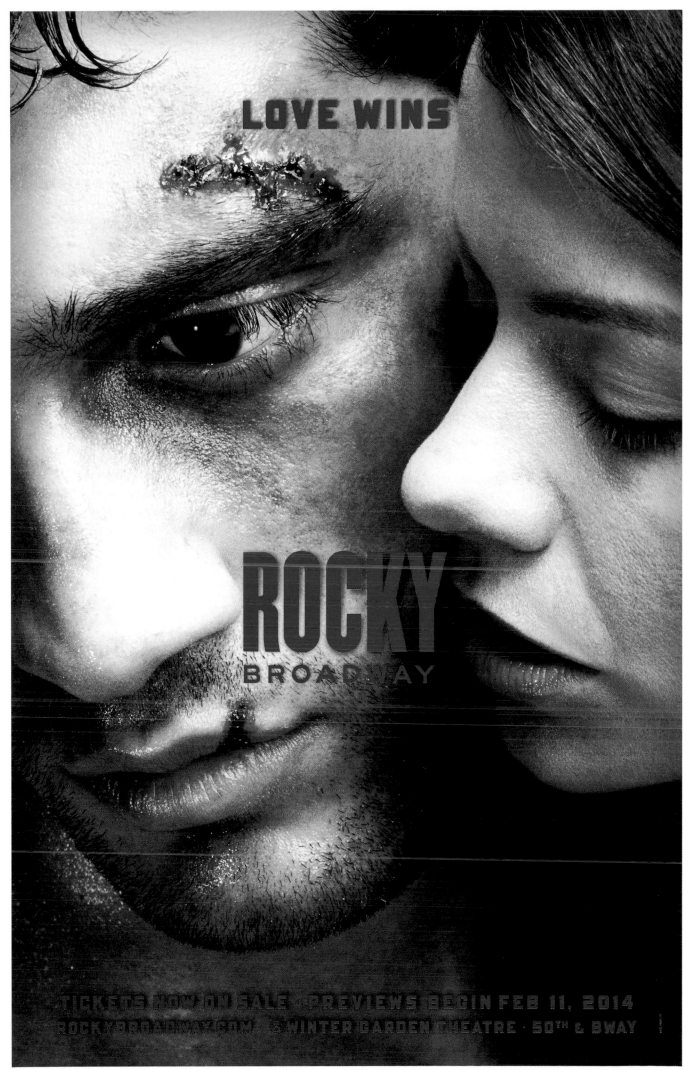

LOVE WINS

ROCKY
BROADWAY

TICKETS NOW ON SALE · PREVIEWS BEGIN FEB 11, 2014
ROCKYBROADWAY.COM · WINTER GARDEN THEATRE · 50TH & BWAY

THE LAST SHIP

2014

— THE NON-EVENT —
SHIPBUILDERS' LAMENT.

— THE EVENT —
THE ROMANTIC STING YOU LOVE, *FILLED WITH ARTISTRY,* AND AN EXTRAORDINARY SCORE.

STING
COMPOSER/LYRICIST/ACTOR

AS A RELATIVE NEWCOMER to Broadway, I had few concrete ideas to offer as to how *The Last Ship* ought be marketed, except that because of the unusual nature of the musical and its subject (a shipbuilding town in the North of England), we should perhaps embrace that uniqueness rather than attempt to cloak the project in arguably tried and tested or more established marketing models. As a theatrical experience, what we hoped to deliver was an allegory, a dream in the form of an extended poem, rooted in a gritty social history and yet not confined by it. A musical about the importance of work, of community, of blood and commitment, devoid of fashionable irony or jokey contemporary cynicism and unapologetically emotional. The poster, comprising the prow of a ship aloft a circular wave, was reminiscent of Japanese artist Hokusai's iconic painting and seemed to stand out from all the other choices, as well as from the posters of other plays. I imagine that's why it was chosen despite it being rather cryptic and mysterious. It just didn't look like anything else on offer, and proclaimed that this [show] was something different. The town portrayed in *The Last Ship* is the town I was born and raised in, the same town I exiled myself from as a young man, and the story is full of those ambiguities of longing and belonging, of duty and escape, of debts owed and debts yet to be paid; if no longer in the conceivable present then in the psyche/drama of the symbolic past. There was perhaps more of me up on the stage than I originally intended.

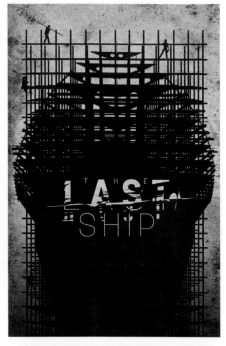
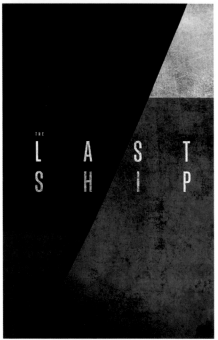

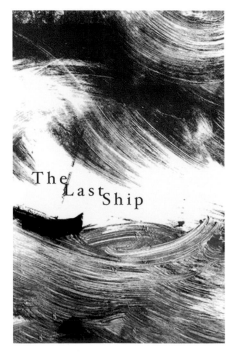

THE **Last
Ship**

Music and Lyrics by
STING

Book by
John
LOGAN
and
Brian
YORKEY

Choreography by
Steven
HOGGETT

Directed by
Joe
MANTELLO

THE ELEPHANT MAN

THE NON-EVENT

CAN THE HOTTEST, HANDSOMEST MOVIE STAR IN HOLLYWOOD REALLY LEAD ON BROADWAY?

THE EVENT

BRADLEY COOPER IS EXTRAORDINARY.

SCOTT ELLIS
DIRECTOR

THE EXTERIOR OF THE theater was always Bradley's idea first and foremost—he wanted to take it and do something theatrical. The whole concept of wrapping the theater was his. He was interested in what it was like to pull people in from the street at that time. There's the circus aspect. There's the freak-show nature. There's this mystery. And he wanted it inside the theater too—with the red curtain and the chandeliers that were redone. It had to be darker. I remember him saying, "If I was walking down the street in London at that time, what might I see across from the hospital, where John Merrick was at first?" So we looked at what was going on in sideshows, what that art might look like. We were all focused on and intrigued with this idea of looking back at history and this gorgeous artwork. There were no photographs of the show itself, no production shots. We thought, "What is the journey that started from right there, from when you entered the theater?"

JAMES L. NEDERLANDER
PRODUCER

WHEN THE ARTWORK WAS first presented to Bradley, Scott, and me, we were astounded by how good it was. The strategy was to bring as many Bradley Cooper fans together with theatergoers. We captured this by throwing a net around the NYC Tri-State region, Philadelphia and Baltimore, priming major towns across the country to hit on Facebook when Bradley made an appearance on a TV show or in a magazine article. Having the movie *American Sniper* didn't hurt matters either.

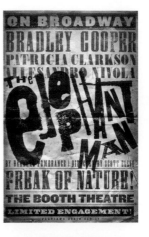

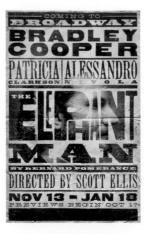

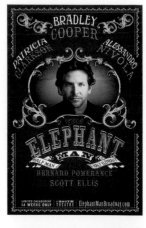

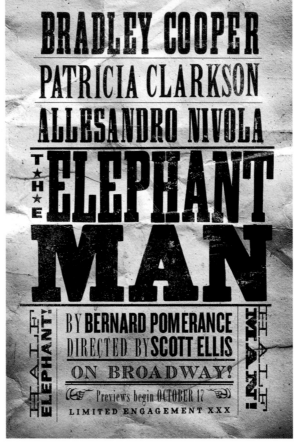

Bradley Cooper had the idea to "dress" the front of house in Victorian garb, right down to gaslights and rope. I don't think the Booth Theatre has ever looked so inviting.

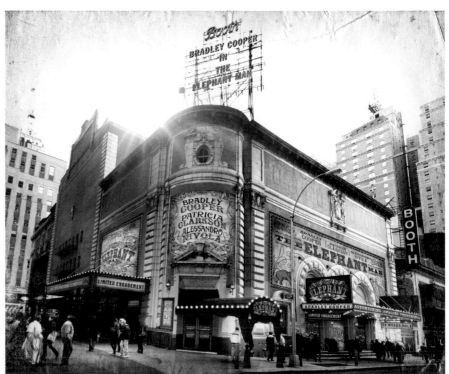

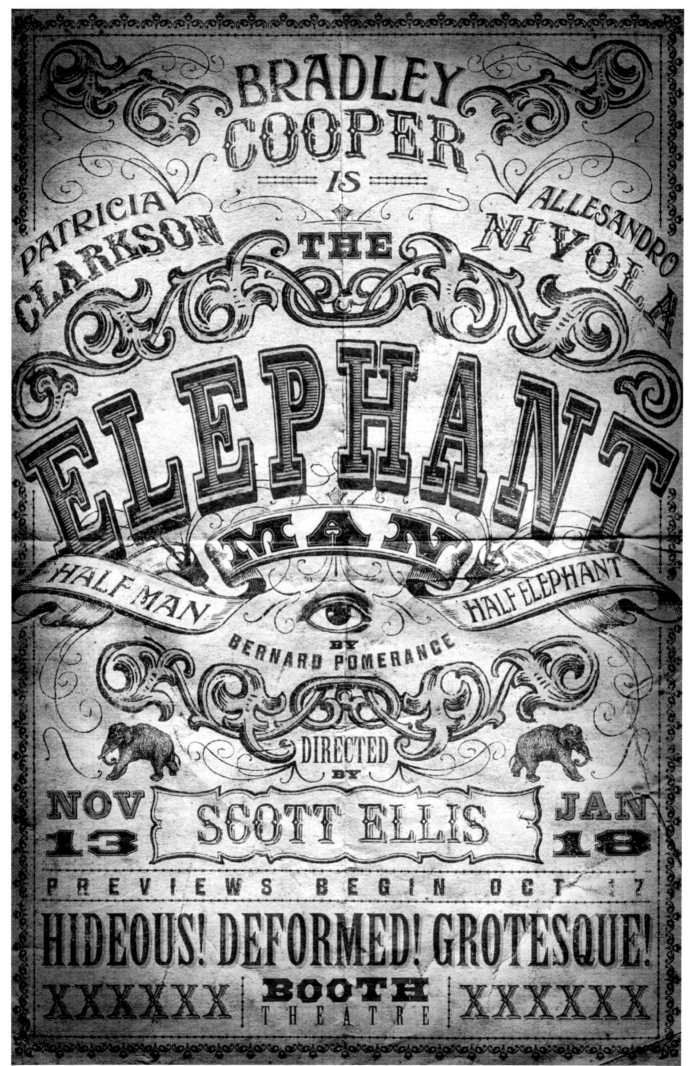

BRADLEY COOPER IS

PATRICIA CLARKSON

ALLESANDRO NIVOLA

THE

ELEPHANT MAN

HALF MAN HALF ELEPHANT

BY BERNARD POMERANCE

DIRECTED BY

SCOTT ELLIS

NOV 13

JAN 18

PREVIEWS BEGIN OCT 17

HIDEOUS! DEFORMED! GROTESQUE!

XXXXXX BOOTH THEATRE XXXXXX

FUN HOME

THE NON-EVENT

FUNERAL HOME LESBIAN MUSICAL.

THE EVENT

THE MOST ASTONISHINGLY REVIEWED MARVEL OF A *FATHER-DAUGHTER-FRIENDSHIP MUSICAL.*

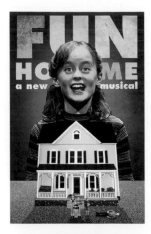
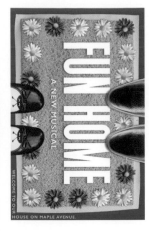
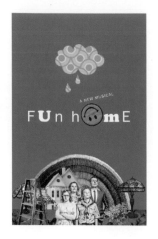

KRISTIN CASKEY, MIKE ISAACSON, AND BARBARA WHITMAN

PRODUCERS

VOICEMAIL FROM DREW Hodges, December 2013: *"Just saw* Fun Home. *It absolutely has to be on Broadway, and we must be a part of it. Let's talk."* You may expect this kind of message when your show opens to glowing reviews Off-Broadway. But after *Fun Home* opened at The Public Theater, we heard a thunderous cacophony of silence. The uptown hunch was *Fun Home,* however brilliant, could never work on Broadway. But Drew had reached out, and that gives producers hope. Back when *Fun Home* was still bumpy and odd and finding itself, Drew had seen a musical he loved, and he believed others would love it too. The art investigation was hard. Most Broadway show art represents what you'll experience at the show. Because *Fun Home* was unlike anything else on Broadway, this demand felt particularly oppressive: Let them know what this *is.* So we began with Alison Bechdel's brilliant original illustrations. Then we tried a photo of the Bechdel family. There were even a few abstract ideas of "homes." Every promising idea crumbled when we saw it. They all made the show seem what it was *not.* The more we articulated any idea of *Fun Home,* the less the show seemed. So you know what? Don't explain. The art for *Fun Home* created a compelling invitation to something special, and left it at that. Let others—the critics, at first, then the audience—define how special the show is. SpotCo's work celebrated the rare kind of passion that surrounded *Fun Home*—the rare kind of passion that inspires a creative head to call producers while an original, odd show is in previews Off-Broadway and say it must move to Broadway.

Doesn't happen often. But it did.

> SPOTCO'S DESIGN FOR *FUN HOME* CAPTURES THE ESSENCE OF MY MEMOIR AND *THE SPIRIT* OF THE MUSICAL IN ONE POWERFUL GRAPHIC.
> *ALISON BECHDEL*
> **GRAPHIC NOVELIST**

above
Early directions for *Fun Home* advertising. Eventually we decided that the plot was a message we wanted you to have after we tried to win the Tony, not before, and we led with the extraordinary acclaim.

left
As the Tonys approached, we all got the great honor of meeting Alison Bechdel. Here is a note drawn on lead designer (from SpotCo) Jacob Cooper's notebook, as a well-earned thank you. —D.H.

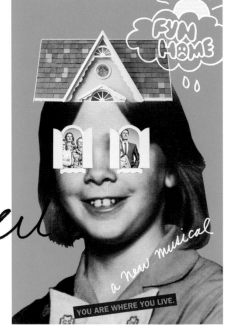

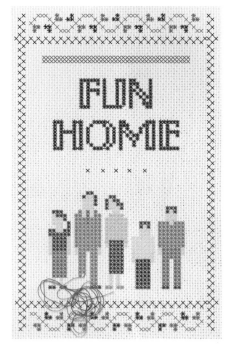

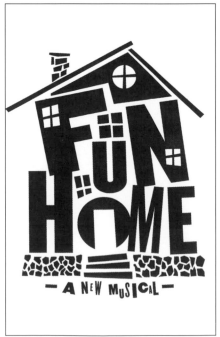

SOMETHING ROTTEN!

— THE NON-EVENT —

A SHAKESPEARE MUSICAL.

— THE EVENT —

A FUNNY, ORIGINAL, *SOPHISTICATED BACKSTAGE ROMP* ABOUT THE MAKING OF THE FIRST MUSICAL.

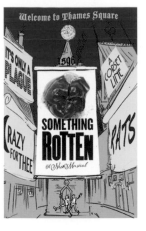

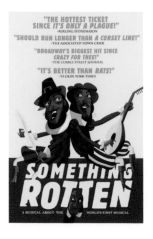

PETER DE SÈVE
ILLUSTRATOR

I HAD AN IDEA RIGHT OUT of the gate. I did a sketch of Shakespeare holding Yorick's skull, which is in full song, and lots of shenanigans going on in the background. The only real problem with this idea was that SpotCo didn't like it. They strongly *suggested* I consider doing the Bottom Brothers obliviously bombing onstage, plus lots of shenanigans in the background. So I did sketch after sketch of the characters Nigel and Nick bowing congratulations to each other, but I just couldn't make it work. After all, if they were both bowing, wouldn't they bang their heads together? It wasn't until I was on the subway heading to SpotCo's offices, armed with the wrong sketches, that I frantically scribbled the right one in my sketchbook. One Bottom up, the other down, plus lots of shenanigans in the background.

KEVIN McCOLLUM
PRODUCER

THE SHOW IS COMPLETELY original, without a brand, and with writers that hadn't been on Broadway. The score was so fresh, so we wanted to look at images of something Jack Gilford would have been in. As soon as I met Peter de Sève, I knew he was the guy, because like all of us, he was a true collaborator. Knowing Peter's experience working with *The New Yorker*, we thought to add a *New Yorker*–esque caption. In our very first *New York Times* ad, it's an image of the audience hating the show. After all, the musical's called *Something Rotten!*, so we thought the best line would be, "I think they liked it." Since then, we've continued to riff off of that, and it's been a wonderful way to talk directly to the audience, and to keep the message changing as the show grows.

> IT WASN'T UNTIL I WAS ON THE SUBWAY HEADING TO SPOTCO'S OFFICES, ARMED WITH THE WRONG SKETCHES, THAT I *FRANTICALLY SCRIBBLED* THE RIGHT ONE IN MY SKETCHBOOK.
> *PETER DE SÈVE*

top
Early directions for our ad campaign.

middle and below
Sketches by the great Peter de Sève, including a portrait taken by one of his kids to help him draw a bow for Nigel Bottom of the Bottom brothers. — D.H.

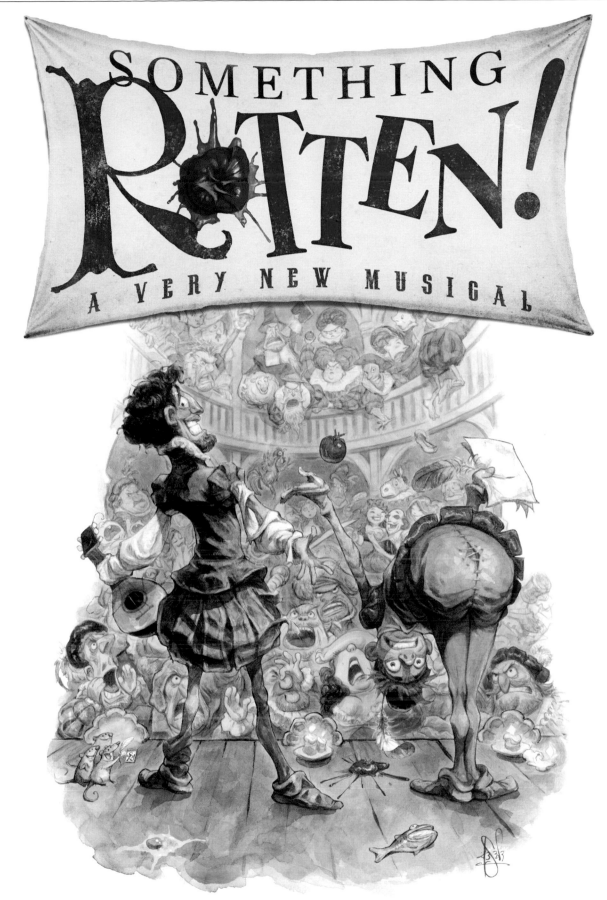

"I think they liked it."

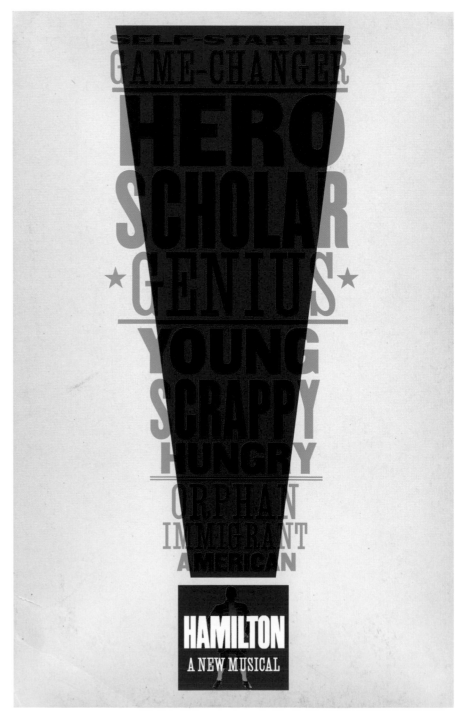

HAMILTON

— THE NON-EVENT —

HIP-HOP HISTORY.

— THE EVENT —

MAJESTIC, DYNAMIC, AMERICAN *STORYTELLING,* TOLD WITH SUCH CONFIDENCE THAT IT CHANGES MUSICAL THEATER.

LIN-MANUEL MIRANDA
LYRICIST/COMPOSER/BOOK WRITER/ACTOR

WHEN SPOTCO IS IN FULL inspiration mode, there's really nothing better in the world. At our first meeting, I said, "My *nightmare* version for the artwork is founding fathers with gold chains or teeth, or any other hackneyed hip-hop trope that people who have no idea about hip-hop think hip-hop is." And they had a million pieces of artwork on the board, and we had fun taking away anything that had a whiff of "Aren't we clever" or "Gangsta" anything. The musical contains a lot of hip-hop and R&B and pretty much anything else that is lurking in my heart, but it's all in the service of telling Hamilton's story as accurately and full-bloodedly as possible. I was thrilled with where they landed, and the notion of these founding fathers completing the star. Their sweat, their blood, their lives in the service of forming a more perfect union.

NICKY LINDEMAN
SPOTCO

TO ME, THE KEY ART FOR *Hamilton* needed to express Hamilton's complex, heroic character and the profound emotional experience of this unique musical. As I sketched, I played with some deconstructions of the American flag, making the stars and stripes black. Replacing the top of a star with the figure of a silhouetted man, the star graphically transformed as a stage for the character of Hamilton, his arm raised representing the iconic movement and hopeful emotion of the musical. The black star and the black silhouette were a nod to portraits of the period, but merged together they seemed like a modern image. For the typography, I wanted the type to be very classic, elegant, somewhat referential to the time period of the story and confident in its simplicity.

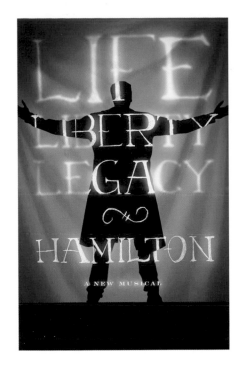

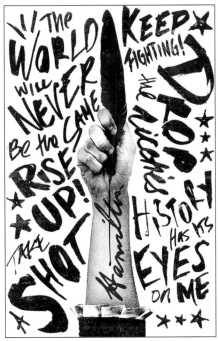

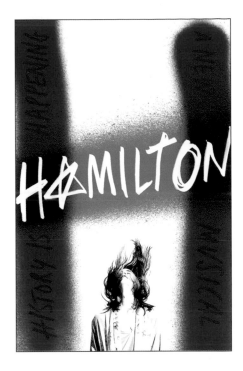

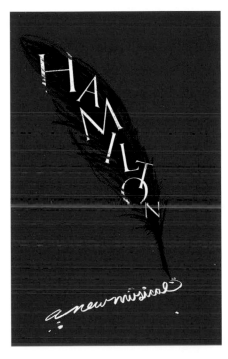

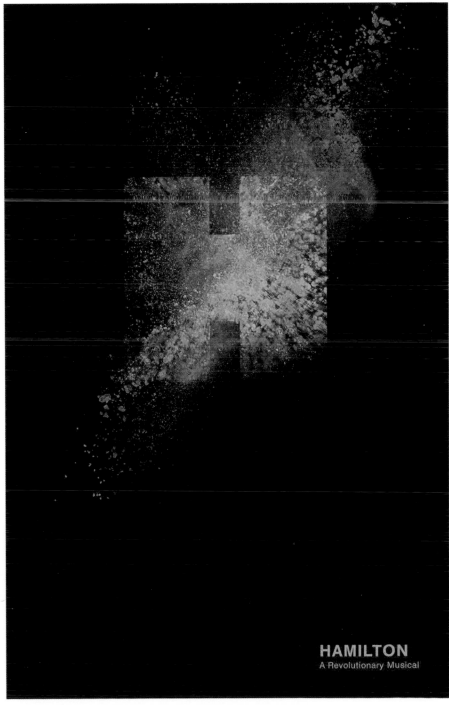

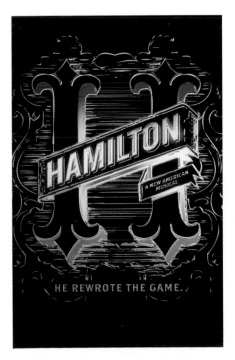

HAMILTON
A Revolutionary Musical

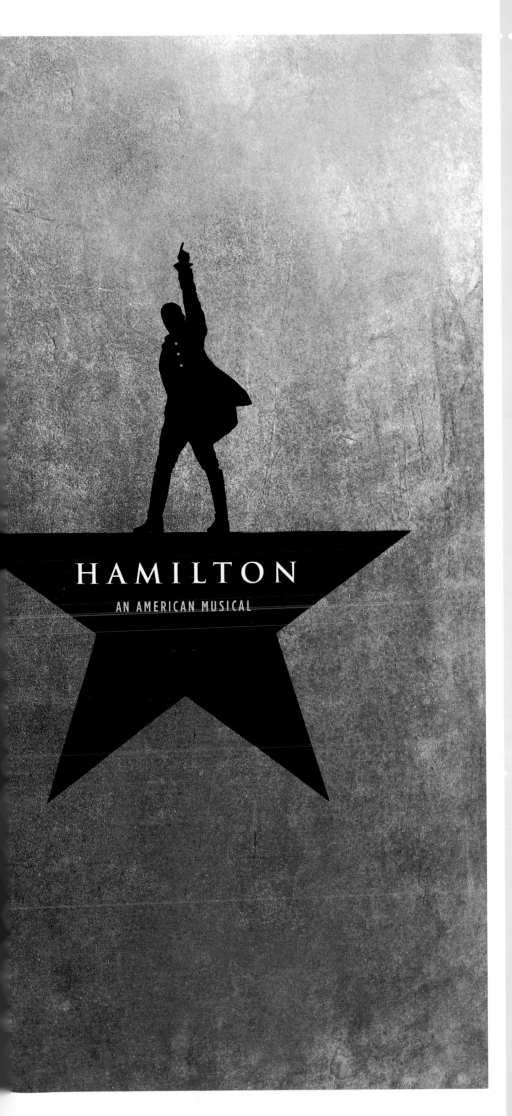

HAMILTON

AN AMERICAN MUSICAL

HAMILTON *IS THE BEST*
show I have ever seen. I don't say that to
minimize any others. I don't even say it
with exuberance. It just came into my
head as a fact as I sat and watched the
workshop with Mike Nichols and every
other theater luminary I had the gift
and privilege to be in the room with.
It moves the art form forward. It begins
where *In the Heights* left off—and that
was quite a high note. Three songs in,
it downshifts into a song called "Wait
for It," a completely new sound from
this composer, Lin-Manuel Miranda.
It then makes that shift again and again.
Every time you think you have it pegged,
it stretches its arms and legs and
becomes something else, something
undeniably new. Finally, when it's almost
done, and you are thoroughly thrilled
and moved, it does it one more time, by
letting Hamilton himself go and inviting
his rock and joy of a wife to finish the
story, celebrating their love and commit-
ment over adversity, ambition, and ego.

What a perfect place to end this book.
I was gifted from the start to begin with
Rent and its revolution, and the idea
that I could be lucky enough to close
with another revolution is a wonder to
me. I now know you wait twenty years
for such a wonder, and even then, it's
pure luck to be standing in "the room
where it happens."

My hope is that we at SpotCo have
moved the form forward a bit too, and
that every time we were all certain
what it was supposed to be and do, we
stretched and tried to surprise. And in
the end, the biggest joy and honor of
this ride was to be in the room where it
happened with so many exquisite
talents, and maybe share with others
that it is indeed still happening.

DREW HODGES

THE ONES THAT GOT AWAY

YOU WIN SOME, YOU LOSE some. And some never happen at all. This last spread is dedicated to all of the work we've done that we loved but never went forward. Quite a few came from pitches we did not win (see the first sentence): *Wicked*, *Lysistrata Jones*, *Hands on a Hardbody*, *Matilda*. They're all pitches we did well on, but not quite well enough. *Unchain My Heart*, *Fatal Attraction*, and a revival of *Titanic* never quite materialized on Broadway. And *King Kong* is coming, but these designs are not. They were deemed so good "they should be in a coffee-table book," so now they are. The 2002 revival of *Oklahoma!* was ours for a week or two—that happens, too. Of special note is the drawing that Chris Van Allsburg, of *Polar Express* fame and certainly one of our finest children's books authors, did for *Wicked*. I hated that it sat in a drawer unseen these last ten years—it's such a wonderful piece. And Van Allsburg almost never does commissioned work beyond his books. So, as a final image, or several, I leave you with what could have been.

DREW HODGES

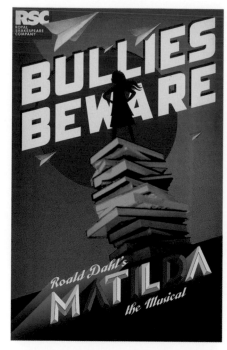

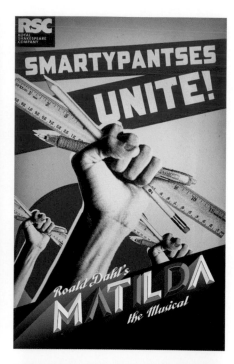

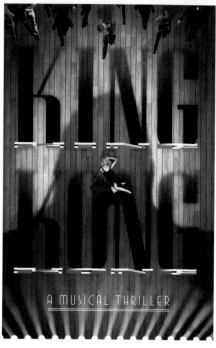

We wanted to make the character of Matilda into a hero and position the show as bigger than a family show. So we made posters to cheer on her cause. For *Hands on a Hardbody*, we swore no one would go to a musical about a truck, so we made a poster that never showed one. *King Kong* features perhaps the best poster I think the shop has made, by designer Paul Jeffrey. It features an ape made up entirely of Art Deco buildings of New York in the '20s. *Fatal Attraction*, *The Invisible Man*, *Titanic* (the revival) and *Unchain My Heart* never came to fruition, or at least never came to Broadway. *Bobbi Boland* had a six-hour photo shoot that was primarily Farrah Fawcett in the makeup chair and dressing room, stalling to be photographed. She was terribly nervous and seemingly insecure—ultimately so much so that the show never opened and closed after a few previews. I don't know why we didn't get *Lysistrata Jones*—I loved this poster of blue balls. And finally, *Wicked*. Both agencies pitched this show for months, making art, calling in friends as supporters, and begging. But it was not to be for us. Chris Van Allsburg of *Polar Express* and *Jumanji* fame did this final drawing, and I still think it's exquisite. —D.H.

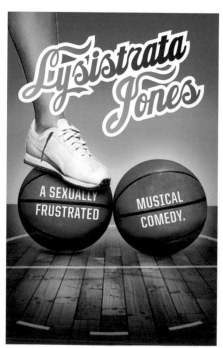

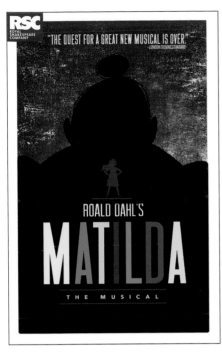

ROALD DAHL'S
MATILDA
THE MUSICAL

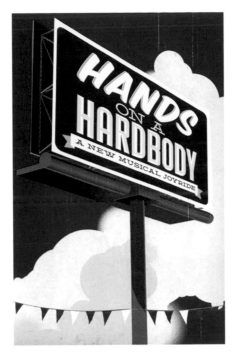

HANDS ON A HARDBODY
A NEW MUSICAL JOYRIDE

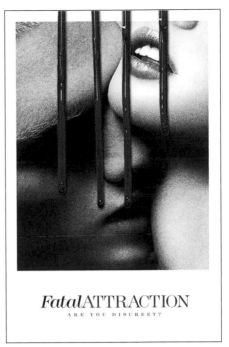

FatalATTRACTION
ARE YOU DISCREET?

THE INVISIBLE MAN

UNION SQUARE THEATRE 100 E17TH ST.

SHIP OF DREAMS

TITANIC
THE MUSICAL

UNCHAIN MY HEART
THE RAY CHARLES MUSICAL

PREVIEWS BEGIN OCTOBER 8TH | TELECHARGE.COM | 212-239-6200
UnchainMyHeartOnBroadway.com • &Barrymore Theatre 243 West 47th St

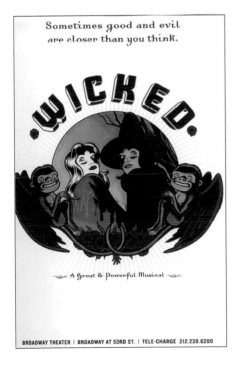

Sometimes good and evil
are closer than you think.

WICKED

A Great & Powerful Musical

BROADWAY THEATER | BROADWAY AT 53RD ST. | TELE-CHARGE 212.239.6200

DON'T JUDGE A WITCH
BY ITS COLOR

Wicked

A GREAT AND POWERFUL MUSICAL

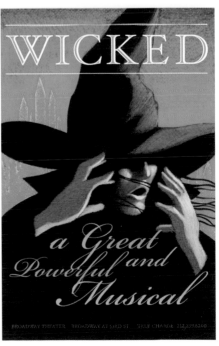

WICKED

a Great and Powerful Musical

BROADWAY THEATER BROADWAY AT 53RD ST TELE-CHARGE 212.239.6200

CAST

SPOTCO WOULD NEVER BE WHAT IT IS without each and every person who has worked there. So rather than try and credit individuals, where I would inevitably leave out someone, here is just that—each and every person who has worked there, listed in alphabetical order. Thank you to all of you. Your spirit inspires us, and your laughter makes us wish we saw you all of the time.

Laura Abbott
Gail Anderson
Bashan Aquart
Jim Aquino
Leah Averre
Aram Ayvazyan
Amanda Baker
Kristen Bardwil
Melissa Barry
Sara Barton
Corey Beasley
Jill Beckman
Tyler Beddoe
Warren Beishir
Brian Berk
Amy Bizjak
Chris Blondel
Jackie Bodley
Andy Bond
Rex Bonomelli
Julie Boor
Megan Bowers
Kevin Brainard
Sarah Braun
Allison Broder
Marlene Brooker
Natalie Budnyk
Stella Bugbee
Mark Burdett
Jean Carbain
John Carbonella
April Cargill
Kara Carothers
Kyle Carter
John Casavant
Alexis Casson
Anthony Catala
Dana Cavallo
Eliza Cerdeiros
Lia Chee
Rebecca Cohen
Paul Colaizzo
Greg Coleman
Sheila Collins
Casey Conti
Jacob Cooper
Jay Cooper
Tom Coppola
Darren Cox
Grayson Craddock
Brittney Crawford
Taylor Crews
Michael Crowley
MaryRose Curry
Sloane Davis

Kristina Decorpo
Tucker Delaney-Winn
Marisa Delmore
Ben Downing
Martin Drobac
Pete Duffy
Sam Eckersley
Dale Edwards
Jim Edwards
Andrew Eisenhower
Laura Ellis
Jeff Faerber
Tim Falotico
Cory Fenton
Silvia Figueroa
Sara Fitzpatrick
Dan Forkin
Kyle Fox
Juliet Fox
Laura Fraenkel
Josh Fraenkel
Tanya Francis
Scott Frost
Krissy Fullerton
Denise Ganjou
Frank Gargiulo
Rudy Garnier
Roger Gaskins
Callie Goff
Gina Green
Tom Greenwald
Bob Guglielmo
Michelle Haines
John Halbach
Kyle Hall
Ben Halstead
Emily Hammerman
Juliana Hannett
Amelia Heape
Karen Hermelin
Josh Hester
Erin Hiatt
Ijan Hilaire
Harrison Hill
Drew Hodges
Lauren Hu
Jim Hubbell
Lauren Hunter
Wendy Hutton
Brandon Jameson
Vince Jannone
Paul Jeffrey
Lavonia Johnson
Mia Johnson
Robert Jones

Lisbeth Kaiser
Peter Kaplan
Remy Kass
Sara Kay
Lee Kimble
Shannon Kingett
Chris Kline
Jurgen Koch
Maura Koenig
Rob Kolb
Shelby Ladd
Alex Lalak
John Lanasa
Blair Laurie
Rachel Lederman
Angel Lee
Han-Yi Lee
Michael Lee
Lisa Lewis
Tiffany Licorish
Stacey Lieberman Prince
Nicky Lindeman
Mary Littell
Chris Loduca
Brent Lomas
Darby Lunceford
Billy Lyons
Lauren Machlica
Shawn Mahoney
Diana Maloney
Morgan Martin
Rymn Massand
Mark Masyga
Stacey Maya
Tom McCann
Jen McClelland
Michael McCracken
James McGowan
Cletus McKeown
Darby McKinney
Jimmy McNicholas
Zzander Meisner
Darren Melchiorre
Anna Mercado
Marc Mettler
Pete Milano
Max Milder
Todd Miller
Billy Mitchell
Erin Moeller
Gary Montalvo
Ben Moran
Travis Moser
Stephanie Munoz
Caroline Newhouse
Meghan Ownbey
Tim Pappalardo
Jeff Perri
Neal Phelps
Mikel Lynn Pihakis
Sandra Planeta
Logan Porter
Nick Pramik
Lexie Pregosin
Denise Preston
Laura Price
Mary Ragus
Kristen Rathbun
Samantha Rauchwerger
David Renshon

Mark Rheault
Courtney Rice
Mike Rivamonte
Kristin Robinson
Andy Roebuck
Jeff Rogers
Ilene Rosen
Scott Rosen
Ethan Ross
Adam Rothenberg
Sharyn Rothstein
Steven Rowe
Jesse Rueckert
Jennifer Sacks
Vinny Sainato
Carrie Salem
Justin Salvas
Stephen Santore
Chris Scherer
Melissa Scherling
Danny Schmittler
Bill Schultz
Corey Schwitz
Christina Sees
Linda Sees
Derril Sellers
Craig Shaloiko
Tim Shultheis
Laura Siciliano
Rebecca Simnowitz
Cameron Skene
Kim Smarsh
DeWayne Snype
Jeronimo Sochaczewski
Caraline Sogliuzzo
Steve Sosnowski
Amanda Spielman
Cory Spinney
Brandon Stansell
Aaliytha Stevens
Lesley Ann Stone
Kinsley Suer
Darius Suyama
Jessica Talley
Dana Tanamachi
Danielle Tandet
Steven Tartick
Lorin Taylor
Nora Tillmanns
Heather Troy
Jason Vanderwoude
Nicky Vennera
Edgar Vicioso
Jeff Walters
Jesse Wann
Beth Watson
Julie Wechsler
Kasey Weil
Rachel Weiss
Jessica Wetterer
Johnny Wilches
Alexis Wilcock
Hillary Wilson
Matt Wilstein
Garth Wingfield
Esther Wu
Chris Yates
Kyle Young
Ryan Zatcoff

CREDITS

TO PETER,
FOR TEACHING ME
ABOUT JOY,
AND FOR HAVING
A BETTER HUG THAN
ALL OF BROADWAY.

I WOULD LIKE TO THANK
Paula Scher and Carin Goldberg, who taught me pretty much all I know about design, typography, and setting trash cans on fire.

I WOULD LIKE TO THANK
Jeffrey Seller and Kevin McCollum for their friendship and for believing in theater, originality, and me simultaneously.

I WOULD LIKE TO THANK
Brian Berk, Jim Edwards, and Tom Greenwald, for laughing, screaming, fighting, and forgiving, and then doing it all again the next day. And for calling the fire department to get us out of the office the first night.

I WOULD LIKE TO THANK
Ilene Rosen, Steve Sosnowski, Nick Pramik, Stacey Lieberman Prince, and Aaliytha Davis for imagining the next generation, and equal parts dismissing and respecting the old one.

I WOULD LIKE TO THANK
Garth Wingfield, Mark Rheault, Mary Littell, Nicky Lindeman, and Naomi Mizusaki for tireless work and a sense of humor helping me make this book.

I WOULD LIKE TO THANK
Charles Miers, Robb Pearlman, and everyone at Rizzoli Publications for guiding me in the creation of this work.

I WOULD LIKE TO THANK
Spot Design's wondrous staff: Brian Berk, Kevin Brainard, Lia Chee, Kristina DeCorpo, Bob Guglielmo, Robert Horansky, Adam Levite, Mary Littell, Rymn Massand, Naomi Mizusaki, Vinny Sainato, with special thanks to interns James Spindler, Frank Harkins, Jason Huffman, and many other interns we apologize for not including and we can't forget our accountant Adam Urban. Without each and every one of them I would never have learned what I learned, and been ready for this adventure.

AND LASTLY, I WOULD LIKE TO THANK
our clients, whose passion and funds make these shows happen, almost on faith and hope alone.

This edition published in the United States of America in 2016 by
Rizzoli International Publications, Inc.
300 Park Avenue South
New York, NY 10010
www.rizzoliusa.com

Text © 2016 SpotCo
Foreword © 2016 David Sedaris
Introduction © 2016 Chip Kidd

Design: Naomi Mizusaki, Supermarket
Archival and Digital Production: Mary Littell
Photo Editing: Mark Rheault

2017 2018 2019 2020 / 10 9 8 7 6 5 4 3 2

Printed in China

ISBN: 978-0-8478-4824-9

Library of Congress Control Number:
2015944890

MAURICE VELLEKOOP
ILLUSTRATOR

THE COLOURFUL ILLUSTRATION
you're seeing on the endpages of this book
are a mural that Drew contacted me to create
for the foyer of SpotCo's glamorous new
Seventh Avenue offices in 2003. Other than
wanting to feature Times Square prominently,
the brief was vague to the point of nonexistent.
I recall the phrase "You know what to do"
issuing airily from the NYC end of the phone.
Er, okay, sure, fantastic! Apparently, what I
knew was that nothing less than a hundred-
year pictorial history of Broadway would
suffice for the roughly 8' x 25' area. The "story"
begins in the 1890s, with P.T. Barnum in the
upper left corner and features a chronological
montage of over seventy-five fabulous *monstres
sacrées* of the American stage throughout the
twentieth century. Along the bottom, various
forms of transport "progress" through the
decades towards a gloriously sleazy, mid-
century-era Times Square, replete with neon
Canadian Club sign, topless bars, hustlers,
and johns and, of course, the sorely missed
Howard Johnson's on 46th Street and
Broadway. The bottom right corner brings
us up to 1996 with the Broadway production
of *Rent*, the breakout show that launched
Spotco's preeminence in the world of theatri-
cal advertising. The art was created over a
dizzying, daunting, month-long period.
Wanting to get the likenesses right, and pay
appropriate homage to so many beloved
figures meant, for this perfectionist, a pun-
ishing schedule of early rising and long days
of toil, weekends included, in order to meet
the deadline. Yet it was a rapturous time:
throughout, music was my inspiration. Cast
albums, iconic and obscure, thundered out of
my Toronto Island cottage, morning to night
(the poor neighbours: "MAKE IT STOP!")
with each day culminating in an ecstatic,
orgasmic climax—the *Dahomey* chorus and
Zulu dance from Act Two of *Showboat*!!
Collapsing in a quivering, over-stimulated
heap, I'd press "repeat," and give that Paul
Robeson drawing just one more try. . . .

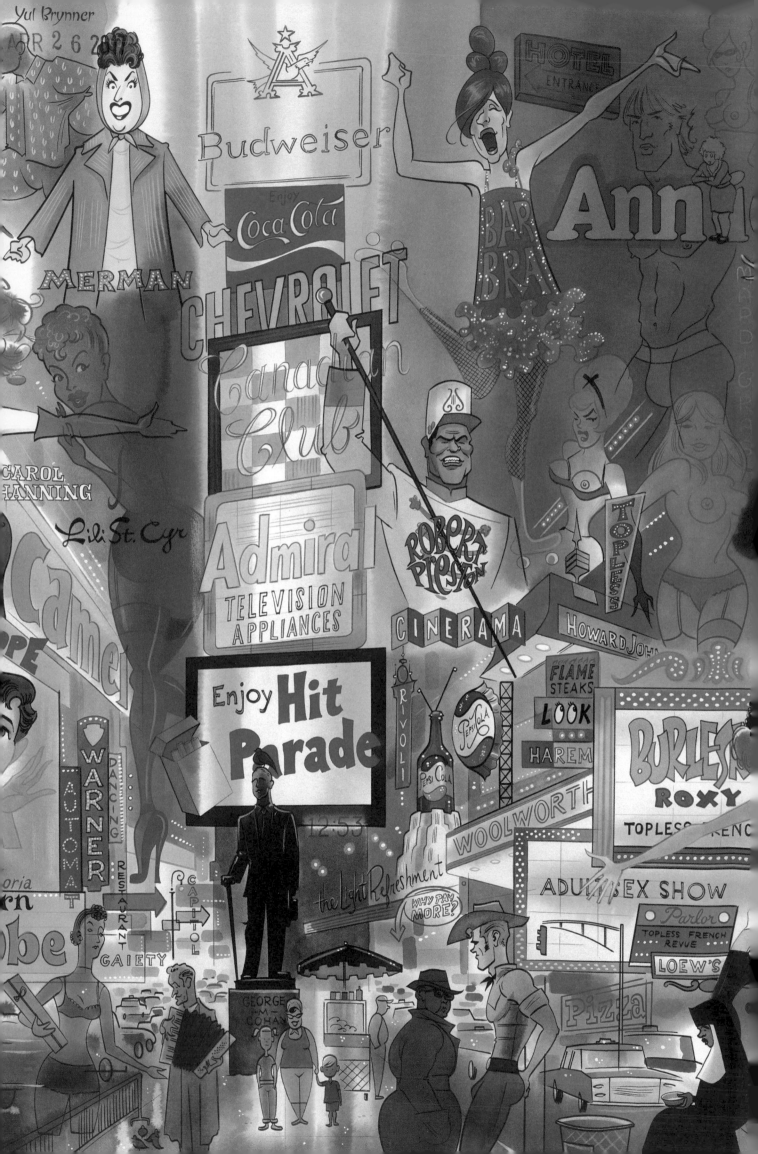